The
Hillman Family
Collection

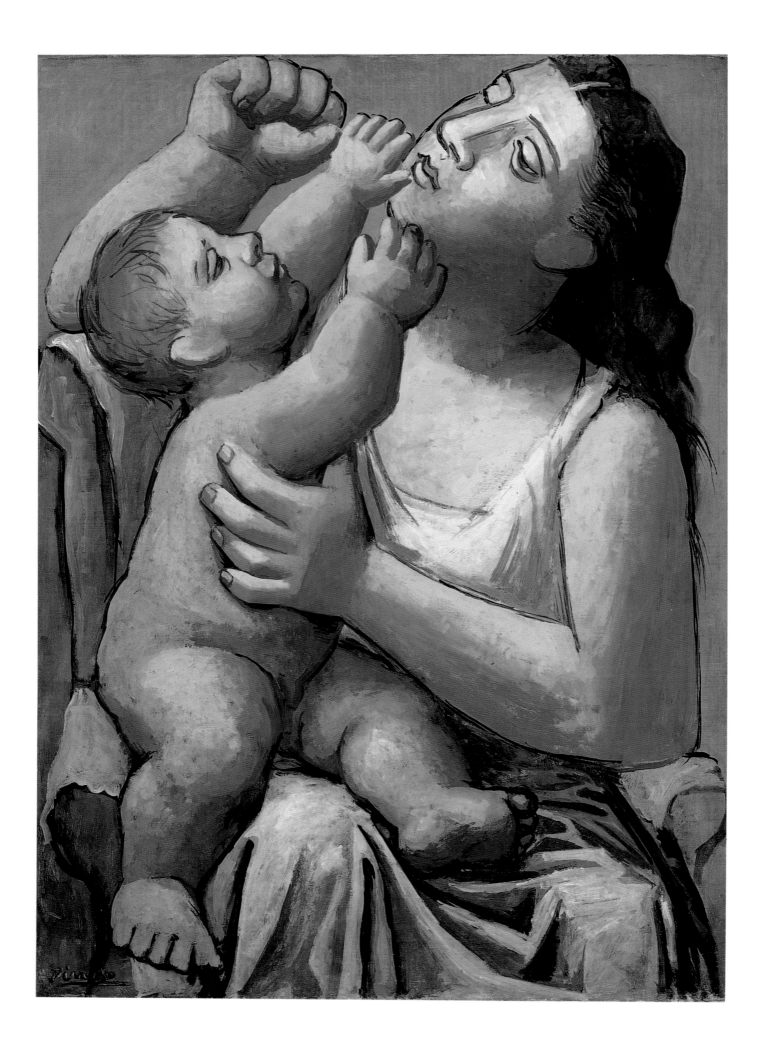

Manet to Matisse

~

The Hillman Family Collection

~

Emily Braun

with contributions from

Julia Blaut

Elizabeth Easton

Sarah Faunce

Pepe Karmel

Karl Katz

Gail Stavitsky

THE ALEX HILLMAN FAMILY FOUNDATION
New York

in association with

UNIVERSITY OF WASHINGTON PRESS
Seattle and London

Alex Hillman Family Foundation
630 Fifth Avenue
New York, NY 10111

Distributed by the University of Washington Press
ISBN: 0-295-97387-0

FRONT COVER: Matisse, *The Pineapple,* 1948 (cat. no. 35)
FRONTISPIECE: Picasso, *Woman and Child,* 1921 (Appendix no. 74)

Manufactured in Italy

Contents

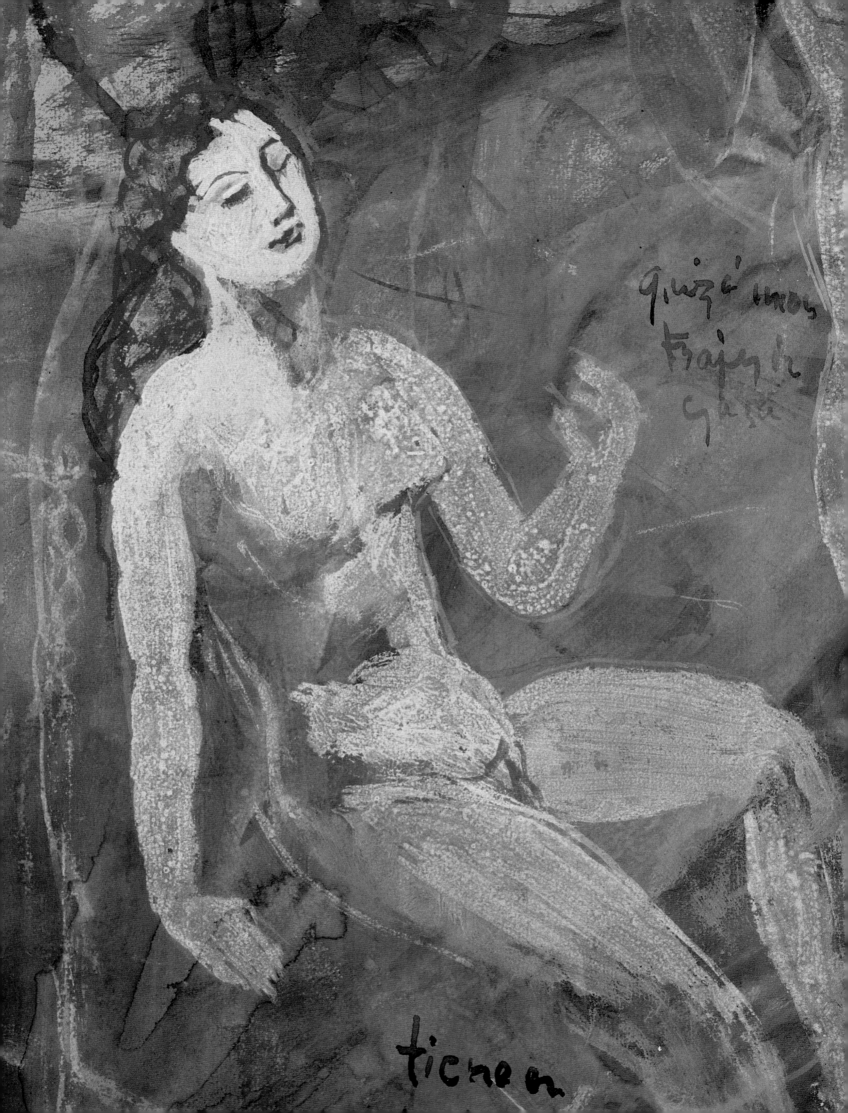

Preface

Detail of Picasso, *Nudes/Three Nudes,* 1906 (cat. no. 43)

I CAME TO KNOW ALEX AND RITA HILLMAN IN 1961, four years after being appointed chief curator of the Israel Museum in Jerusalem. Mutual friends, Siegfried and Lola Kramarsky, told me that I must not miss the opportunity of seeing the Hillmans' remarkable collection of nineteenth- and twentieth-century European paintings, drawings, and sculpture. (The Kramarskys, extraordinary collectors themselves, were among the first supporters of the soon-to-be-built Israel Museum.) They were absolutely correct. The Hillmans' collection was marvelous, and they could not have been more gracious, but it was the Hillmans themselves—Rita and Alex—who were so very wonderful. They did not make me feel as if I were a mendicant (as most museum professionals feel from time to time) but accorded me the status of a favored museum director. They were familiar with the best of that breed of museum personnel, having been great friends of Theodore Rousseau, the legendary chief curator of the Metropolitan Museum of Art. But more than that, they enabled this neophyte director to visit other collections, smoothing the way each time. On occasion, I would visit with the Hillmans at home, and they would cleverly place me next to a potential donor in the hope of my getting yet another gift for the Israel Museum.

The diversity of the Hillmans' art collection mirrors the personalities of the owners. The art—thoughtful, exuberant, strict, imaginative, generous—is very much like the people who bought it. The art in their comfortable apartment was never there to impress. It was there

precisely because the Hillmans wanted to live with these works of art, and Rita and Alex were very happy to let their guests enjoy them, just as they did the conversation, the companionship, and the food. Paralleling the spectrum of interests within the collection, Rita's character, like her taste in art, runs the gamut from the highly abstract (Pevsner) to the assuredly realistic (Degas). When viewing the art in the Hillman Collection, one is inevitably reminded of the owners' tastes, attitudes, and politics.

There is nothing frivolous in anything Rita says or does; indeed, the most remote characteristic one could ascribe to her is frivolity. Recently, during a dinner, while she was eating "the spinach she loves," her comments were gloved in casual asides: "The Ten Commandments were not the Ten Suggestions" or "Isn't it astonishing that today this country's highest achievements are Disneyland and Disney World?" But there is nothing ponderous about Rita either. Even after the death of her only son, Richard, in a tragic accident, followed shortly by the loss of Alex, Rita just became more herself. Deferential, yet self-assured, out-spoken, and ubiquitous, Rita started to entertain a variety of interests. As she recalled the other evening, Alex and Richard had affectionately dubbed her the "Fighting Bantam."

At a small luncheon in 1972 at the Metropolitan given in Tom Hoving's office in honor of the opening of *Behind the Great Wall* (an exhibition of photographs of China before and after the revolution), Rita was seated next to the photographer Cornell Capa. As a result of that encounter, she initiated her commitment to the fledgling International Center of Photography (ICP), of which Capa became director. Rita and Cornell understand each other ("both Hungarians") and have had an extraordinary, often wordless, rapport. In 1974 Rita became a founding trustee of ICP and has not only played an important role in its nearly two decades of existence but has been its chairman and its unofficial diplomat, both within the organization and to the public at large.

Rita smoothes things over and makes the impassable surmountable. It was Rita who funded the first art video—on the newly acquired Velázquez painting *Juan de Pareja*—at the Metropolitan Museum of Art, in a prescient acknowledgment of the importance to the fine arts of new communications media. (Although Rita will tell you she did it to help Ted Rousseau who was criticized at the time for having paid such a high sum for the painting.) In addition to her involvement with the American Friends of the Israel Museum and the ICP, Rita has also assumed an important role as a trustee of the Brooklyn Academy of Music, and though she claims that much of what she sees and hears there is not necessarily her cup of tea, she feels it is exceedingly important to support the arts and to encourage a diversity of creative people.

Rita is genteel reality. She is so real that when you speak with her on the phone or try to decipher her handwritten notes, you feel that she is at your side talking, with her eyes wide and hands busy or laughing at herself as you try to read her lilliputian penmanship.

Most recently, Rita has undertaken a groundbreaking project, one that has put her at the forefront of what is now a crucial concern: health

care. After a stay in the hospital, she realized the critical importance of well-trained nurses who could take pride in their profession and satisfaction in their remuneration. Enhancing one creative vision with another, Rita sold the superb Picasso *Mother and Child* at auction in November 1989, and with the proceeds established the Hillman Scholarship Program for Nursing. The scholarship supports students at the University of Pennsylvania (to train in New York City hospitals), Beth Israel, New York University, and Lenox Hill hospitals, and addresses different levels of training and career experiences. A stalwart New Yorker and practical economist, she also realized the potential for nursing as a second career and was determined to attract the best men and women to Manhattan: "The smartest people I know are the R.N.'s with Ph.D.'s." This new departure is consistent with the other innovative words of encouragement that make up a day in the life of Rita Hillman.

Such a day might also include a Philip Glass opera or a Clint Eastwood movie (which she might have to leave halfway through to attend to something else); a meeting to smooth ruffled feathers at the Israel Museum; a benefit for MUSE (a nonprofit company that produces documentary films on art and culture) or ICP; a lunch with her inspirational nurses; concern over a personal friend; a little story told in confidence about how smart someone is; and the discovery of yet another Italian restaurant with "good-looking waiters." Just like the daily trek from 79th Street down to her Rockefeller Center office that she has taken, in any weather, for over twenty-five years, hers is an indefatigable, exhilarating, warm, and empathetic journey.

KARL KATZ

Acknowledgments

WE WISH TO THANK the following colleagues and friends whose research and advice were indispensable for the realization of the Hillman Collection catalogue: Andrea Bayer, Julia Blaut, Anne Beere, Edith Dunker, Estee Dunow, Carol Eliel, Milly Glimcher, Pepe Karmel, Sandra Kaspar, Karl Katz, Bob Shaver, Arthur Smith, and Gail Stavitsky; Hildegarde Bechert of the Galerie St. Etienne, New York; Elizabeth Easton, Sarah Faunce, and Kenneth Moser of the Brooklyn Museum; Dina Vierny and Susu Durst of the Fondation Maillol; William Walker, Director, and Patrick Coman and Ronnie Fein of the Watson Library, The Metropolitan Museum of Art; William Lieberman, Director, and Kay Bearman and Ida Balboul of the 20th-Century Art Department, The Metropolitan Museum of Art; Lucy Belloli and Helen Otis, Conservators, The Metropolitan Museum of Art; Victoria Garvin, Curatorial Assistant, The Museum of Modern Art, and Rona Roob, Director, The Museum of Modern Art Archives; David Nash, Director, Department of Modern Paintings and Sculpture, Sotheby's, New York.

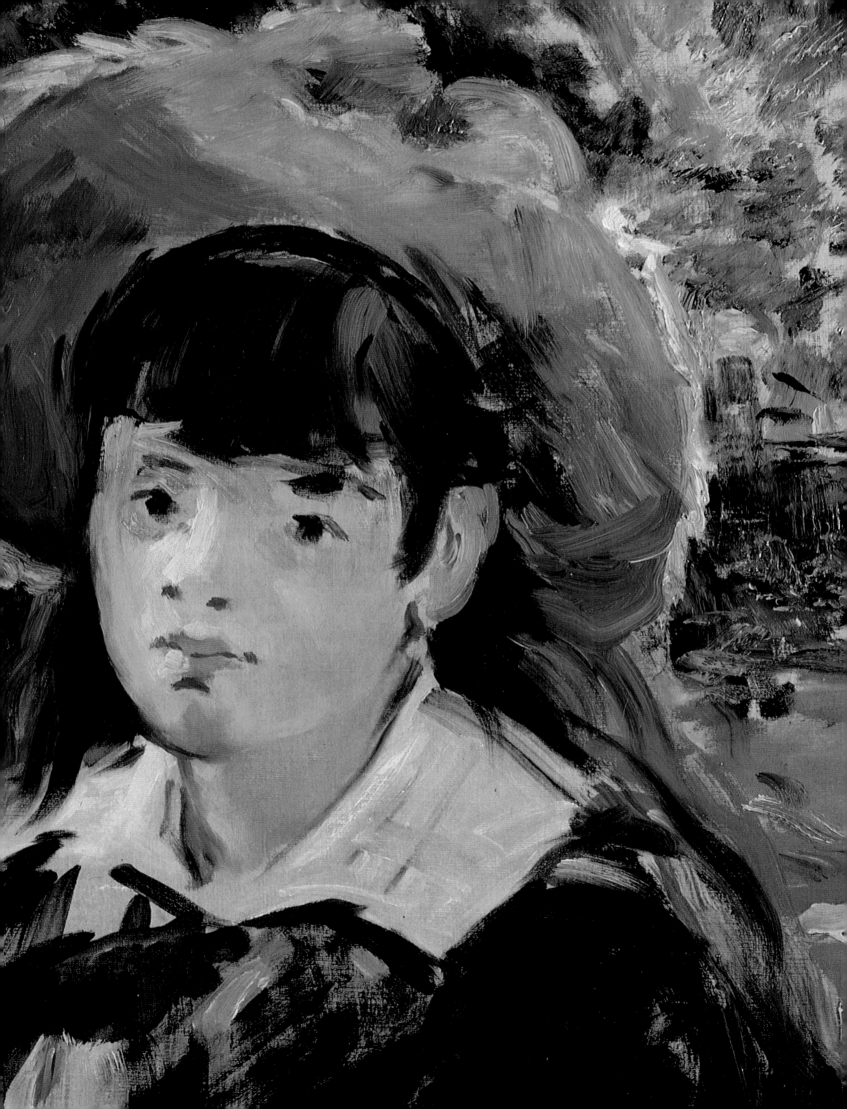

A Modern Collection

T HE PERIOD THAT GAVE RISE to the paintings and drawings in the Hillman Collection was one of the most innovative and productive in the history of European art. During the years between the Franco-Prussian war of 1870–71 and the world war of 1914–18, Paris became the unquestioned mecca not only for artists from the French provinces but for those from other countries. Since the late eighteenth century, with the establishment of the teaching studio of Jacques-Louis David, Paris had drawn young artists seeking the best training in academic principles. But the time spent with David and his various rivals and followers was seen as only a stage of the artistic career, in which the most successful would achieve the prized goal of a long period of study in Rome. Rome was the heart of the grand classical tradition, still a source of intellectual energy and conceived as the indispensable basis for artistic learning and production. Once formed by this tradition, the artist was ready to present his work at the annual or biennial Paris Salons, held to be the final test of achievement for French artists and a standard for all others as well.

By the 1870s, a great cultural shift had occurred. The structure of academic training and rewards remained, both in studios and in the traditional Salons, but it was fatally undermined by the force of the new ideas generated during the course of the nineteenth century up to that time. The strongest of the artists—Géricault, Delacroix, Courbet—while forced to confront varying aspects of the academic structure, were essentially in conflict with its narrowness and rigidity. Courbet's uncompromising

Detail of Manet, *Young Girl on a Bench,* 1880 (cat. no. 28)

13

insistence on rejecting the fantasy of myth for the reality of modern life, together with the more discreet but equally subversive explorations of the landscape painters—such as Corot and Rousseau as they mapped their own perceptions in the face of nature—formed a new and vital current of thought. It was focused on the human and natural world as a potentially endless source of meaning, requiring for its discovery not a preformed set of ideals but a forceklful and self-aware capacity for grasping and illuminating experience.

In the early postwar years the fledgling Third Republic, while rejecting the military imperialism of Napoleon III, acted to expand and intensify the former emperor's successful efforts to make Paris a cultural center for the Western world. By far the larger number of artists who came to study and often show in Paris were drawn to well-placed academicians like Gérôme and Carolus-Duran; they were only marginally aware of what was happening outside the system of Salons and Universal Expositions. But it was in this decade of the 1870s that a group of artists, led by Degas, Pissarro, Renoir, Monet, Morisot, and others, first turned their backs on the Salon and began to show together unofficially in temporarily rented rooms. This series of exhibitions, from 1874 to 1886, was the germ of the Salon des Indépendants, which became the forum for the most searching and adventurous artists. In these exhibitions, as well as in the rooms of the few perceptive dealers and collectors who sensed the significance of the new work and in the studios of the painters themselves, were to be seen the works of art by which younger artists—together with the more lively of the poets and critics—could come into contact with a tradition that was alive and in the making. There they could learn a pictorial vocabulary that was radically different from established academic practice and through which they could construct their own meanings. Thus Van Gogh arrived from Holland to spend the year 1886–87 in Paris, cleansing his eye and palette by his study of Monet, Pissarro, and Seurat; by the turn of the century, Picasso had arrived from Barcelona when he was not yet twenty; later, Modigliani came from Italy, Gris from Spain, Soutine from Lithuania. Though retaining their nationality, these artists tacitly demonstrated the limitations of nationality by becoming citizens of Paris, which during these years was as much as to say citizens of the world of art.

This citizenship, representing a commitment to the world of the mind as opposed to that of orthodoxy and parochial interests, formed part of the culture of modernity, emerging from the conflicts and discoveries of the nineteenth century to become the living, if often terribly challenged, culture of the twentieth. Thus, collections like the Hillmans' are collections of modern art, not just in a simple chronological sense but in the added sense that they represent aspects of the culture of modernity. They were chosen by the Hillmans not for didactic or historical purposes but rather because of the collectors' love of individual artists and their response to the qualities of individual works. Nevertheless, the range of objects chosen, from the Renoir of the late 1870s to the Matisse of the late 1940s, does present a spectrum of the ideas and achievements of the period.

The two small Renoirs capture in gemlike form the fresh-

ness of the perception of landscape that is the hallmark of the impressionism of the seventies. Similarly, Manet shows in his *Young Girl on a Bench* of 1880 how his awareness of a specific personality can be constructed with the greatest simplicity and economy of touch, conveying a new kind of immediacy in the relation between subject and viewer. Pissarro's studies of village landscape and of farm women give us the essence of the artist's concern with ordinary people whose lives are shaped by physical labor. It was from Pissarro, with whom he worked closely in 1874–75, that Cézanne learned the disciplines of observation and began to develop out of the impressionist brushstroke the mature planar touch which became his own instrument of perception and pictorial construction. This touch, which opens up the surface of the painting at the same time as it can create an unparalleled sense of formal solidity, is revealed in the Hillman Collection's beautiful *Still Life with Fruits and Plate*; its metamorphosis into vibrant light can be seen in the late watercolor *The Cathedral of Aix*. As Cézanne's watercolors are independent works of art, intrinsic to his oeuvre, so too are the drawings of Seurat. *The Square House* is one of the extraordinary series of Conté-crayon drawings Seurat made in and around Paris during the years in which he was working on *Bathers at Asnières* and *La Grande Jatte* in the first half of the 1880s. These drawings, which often took as their subject the desolate areas at the edge of the city known as the *terrain vague*, have a haunting quality born of the fact that by their very medium they are nocturnes, as well as from the sense of solitude that pervades them. Seurat's feeling for these unfashionable regions and for the life at the margins of the great humming city of Paris expanded in the later eighties into a concern with another kind of marginal life, which nevertheless took place at the heart of the city's attractions: the world of popular entertainment, the cafés, dance halls, and circuses that were eventually to become the symbol of the *gaieté Parisienne*. But gaiety was not the motive of Degas and Manet in the seventies, Seurat in the eighties, or Toulouse-Lautrec in the nineties, when they turned to these scenes of popular culture. They were attracted by the color, the excitement, and the human variety, of course. But they were even more attracted by the differences between this motley world and that of the tradition of high art, and at the same time by the affinities that could be felt between the status of these performers, players directing their skills to an audience that must be satisfied, and their own newly uncertain place in society as independent artists cut loose from the ancient modes of patronage.

This life of the circus performer, the dance hall *artiste*, the cabaret singer, the acrobat, and the harlequinade would be very much a part of Picasso's visual vocabulary from the time he arrived in Paris through World War I; indeed, these figures reappeared in his work throughout his life. Also included in the world of performance, fantasy, and artifice is the brothel, a particular milieu for Toulouse-Lautrec and for Picasso the setting of that detonating work of 1907, *Les demoiselles d'Avignon*. The Hillman gouache, *Nudes* of 1906, is a study for one of the early conceptual phases of that revolutionary masterpiece. From the summer of that same year comes a painting very different in mood and formal character from the *Demoiselles*

15

but not unrelated in theme, the *Toilette* now in the Albright-Knox Art Gallery, in Buffalo. The Hillman drawing, a close study for the painting, shows us Picasso treating the image of female privacy in a mood of tenderness and serenity that is not frequent but does recur throughout the artist's oeuvre. In the years following the 1914–18 war, this mood was expressed through the forms of classicism, a reference to the figural nobility that is the heritage of Mediterranean antiquity. It is this heritage, however transformed by the force of Picasso's artistic personality, that can be perceived in one of the major works of the Hillman Collection, the *Mother and Child* of 1921 (Appendix no. 74; frontispiece).

In the years before the war, Picasso and Braque worked together in an unprecedented dialectical collaboration out of which developed the pictorial structure called cubism. Braque's *Violin and Sheet Music* from 1913 is a classic piece from that moment of cusp between analytical and synthetic cubism, when the elegant planar structure of the composition is conceptually complicated first by actual collaged papers and then, as in this painting, by the areas of painted *faux bois* that simulate cut shapes of papers printed in *faux bois*. Here the play between layers of illusion and reality deepens that sense of the shifting, unfixed, and uncertain nature of being that was a major achievement of the two painters' work. Once separated by the war, which came as a brutal confirmation of their intuitions, Picasso and Braque went their different ways. Braque, a composer and colorist of great subtlety, developed cubist form through the classic themes of still life and studio interior, in which he could explore formal complexity within strictly defined limits, as he does in the Hillman *Still Life with Peaches* of 1927. Another contemporary, Fernand Léger, was devoted to the human figure and tackled cubist structure with boldness and gusto, characteristics clearly visible in the Hillman study for *Nude Model in the Studio*, a painting now in the Guggenheim Museum. Juan Gris, six years younger than his compatriot Picasso and like him an émigré to Paris, worked out his own very elegant rendering of cubist form. *Harlequin with a Guitar* is a splendid example of his precisionist approach to a favored theme from that marginal, bohemian world of those who lived precariously by their art in an uncertain world.

Matisse was never unaware of that uncertainty but chose to assume it rather than to explore it, concentrating in his work on the serious possibilities of pleasure and of that condition of human existence to which the French refer in great respect with the word *bonheur*. His work in the Hillman Collection is from his last decade, a period when his artistic energy enabled him, among other things, to take up the technique of papier collé and make of it a wholly original source of imagery that distilled a lifetime of intense feeling for color and shape. Matisse is often thought of as a painter of the south, that Mediterranean world of color and decoration, and this is supported by his thirty years based in Nice, by the settings and qualities of his work of the Fauve period and the Morocco series, and by his monument at Vence. But he was also a Parisian who spent his first fifty years in that city, which gave him, through its critical mass of independent artists, a base on

which to build his vision. Like the others, native and foreign, he took much from Paris and gave much back to the world at large, playing his role in the construction of a modern vision. It was a vision that encompassed a sophisticated awareness of both the uncertainties and the possibilities of life in this world, together with an understanding of the importance of standing apart and aiming at truth from the edge, from a perspective outside that of doctrine and convention.

Matisse was just beginning the experiments of the Fauve years at the time of Bonnard's *Shops on the Boulevard des Batignolles* of around 1899, in which we are given an intimate, subtle view of the essentially domestic life of a Parisian street. It is an image of modern civilized life, of shifting perspectives and the self-awareness of the changing and nuanced movement of private experience. In 1944 Matisse was entering his last decade; the Paris of Dubuffet—the Hillman painting of 1944 is also called *Shops*—represents a very different world, born of the harsh knowledge of the kinds of terrors and ironies that did not force themselves on the consciousness of the early Bonnard. Nonetheless it represents Paris, whose urban structures and creatures would be the energizing source of a lifetime for Dubuffet's pictorial experiments. For the modern world, it was the city that conferred a citizenship of consciousness that, once achieved, could be acted upon everywhere, but which found perhaps its best welcome at its source.

SARAH FAUNCE
The Brooklyn Museum

The Hillman Family Collection

ALFRED H. BARR, Jr., once remarked that Alex Hillman was a conundrum to everyone: "to the art community he is a businessman; to the business community he is an intellectual."[1] Hillman led successful careers as a book and magazine publisher and later as a financial investor. Paintings, publishing, and politics were the driving forces of his life, yet it was the first of these that granted him the most pleasure. In an autobiographical sketch of 1951, Hillman admitted, albeit rather wryly, that he spent most of his time "trying to make enough money to buy pictures."[2] In 1964 Hillman attempted to merge his interests in business and art by aggressively vying for ownership of Parke-Bernet, the New York auction house, but was barely outbid out by Sotheby's, of London.[3]

Born in Chicago in 1900, Hillman started to collect art as a young man during his years at the University of Chicago Law School, from where he graduated in 1923. He claimed that his interest in art was developed in Chicago under the tutelage of a local artist, Rudolph Weisenborn, whose early work was of an expressionist bent. Nothing remains of his first acquisitions, and it was only after he established himself as a book publisher in New York by 1927 that he began to buy in earnest. In 1932 he married Rita Kanarek, and subsequently, the pair decided on every new purchase together. Some three decades later, articles in *Art News* (1959) and *Esquire* (1963) documented the Hillmans among the nation's leading art patrons.[4] Many of the works from the Hillman Collection became, in the words of the *New York Times* critic, "what might be called

household images, so frequently have they been seen in art-history lectures and reproduced in art-history textbooks."[5]

The profile of the collection itself was never fixed: the Hillmans acquired while they also traded and sold, refining their choices or simply pursuing new tastes. Yet within the history of the collection, four distinct areas emerge: Hillman's initial interest in American art during the 1930s was superseded in the early forties by his and Rita's desire for French impressionist, post-impressionist, and early modern works, for which the Hillman Collection was subsequently best known. Beginning early in the 1950s, however, the Hillmans began buying the works of contemporary postwar French artists of the *informel* style. They were among the first Americans to acquire works by Jean Dubuffet and Jean Fautrier. In 1956 they delved into contemporary British sculpture, purchasing bronzes by Kenneth Armitage and Lynn Chadwick, and a marble by Barbara Hepworth. While the American paintings represent Hillman's youthful tastes and social circles early on in his publishing career, the subsequent focus on modern French art was typical for moneyed American patrons by World War II. Far more daring was the attention the Hillmans gave to postwar trends in France and England; this lesser-known area of the Hillman Collection was truly unorthodox and prescient for its time.

After graduating from law school, Hillman went to China to work at the United States Consulate in Shanghai. He decided on a career in publishing after serving as editor of *The Shanghai Press*, an English-language newspaper, in 1925, and came to New York the following year. From 1927 to 1931 he headed the book publishing firm William Godwin. He began to reissue illustrated versions of the classics, some of which he translated into English himself, in order to save costs. Among these beautifully printed, collectors' editions was *Casanova's Memoirs* with drawings by Vincente Minelli, who later became a famous movie director. Minelli was a close friend of the Hillmans during the early years of their marriage. He helped decorate their Greenwich Village apartment, where he also painted a mural (influenced by de Chirico, as Rita Hillman recalls) in the living room.

In the 1930s the Hillmans continued Alex's first forays into collecting, purchasing works by contemporary American artists, many of whom Alex acquired on his Saturday morning strolls at the Associated American Artists and other New York galleries. Some of the illustrators for Hillman's publications had also introduced him to New York artists of the American scene. Among others, the Hillmans had works by Peggy Bacon, Arnold Blanch, Eleanor Boudin, Alexander Brook, Charles Burchfield, Preston Dickenson, Ernest Fiene, Leon Kroll, William Littlefield, Raphael Soyer, Eugene Speicher, Ernst Trubach, and Frederick Taubes. Around this time he also met the sculptor William Zorach, who was working on a commission for Rockefeller Center, near Hillman's offices at Fifth Avenue and 44th Street. The result of this encounter was the bust of Rita commissioned in 1935, one of the artist's first works in bronze (cat. no. 78).

Little documentation on the extent of Hillman's early

purchases survives: he sold off many of the American works in the 1940s, before accurate records of the collection were kept. Several smaller portraits and nudes (see cat. nos. 4, 66, and 68), whose intimate quality continued to appeal to Mrs. Hillman, remained in the collection. The realist style and dark, glowing palette of the American canvases influenced the choice of their first painting by a French artist—the *Head of a Girl* by André Derain (cat. no. 12), bought from Knoedler Gallery in New York in 1941. The purchase early in 1943 of two works—Renoir's *Bather* (Appendix no. 76) and the Utrillo *Moulin de la Galette* (cat. no. 72)—signaled the beginning of the Hillmans' venture into nineteenth- and early twentieth-century French masters. The change in taste also coincided with the Hillmans' move uptown to Park Avenue. Significantly, it was only after they had shifted in this new direction that the Hillmans went on to appreciate nineteenth-century American art, acquiring works by Winslow Homer and Thomas Eakins, which are still in the collection (cat. nos. 23 and 17). During these initial years of collecting European art, the Hillmans also briefly held paintings by Dunoyer de Segonzac, Monticelli, and Chagall, of which only traces remain in the records.

During the 1930s Hillman was involved in several publishing ventures, including the distribution of classics in paperback, and he founded Hillman-Curl to publish new titles of his own choosing. He sold the book company in 1938, shortly after the resounding success of its biggest seller, Pierre Van Paessen's *Days of Our Years*. That same year he turned his instinct for the media to mass circulation and, under the name Hillman Periodicals, acquired or started a string of popular magazines featuring detective stories, romance, real-life drama, or movie gossip. The best known of these was the Los Angeles–based *Pageant* (started in 1944), whose endearing low-brow content and cheesecake covers led Alfred H. Barr, Jr., to compliment it as "one of the most energetic pocket-size periodicals I ever saw."[6]

By 1948, a decade after its founding, Hillman Periodicals began to boom, allowing the Hillmans to set a new pace with acquisitions. In that year they chose a Bonnard (cat. no. 1) and Seurat (cat. no. 63), the first of four Cézannes (cat. no. 7), and a nearly contemporary Picasso of 1942, *Woman in Gray* (cat. no. 47), marking their entry into European modernism. Though the Hillmans went on to acquire several works by Picasso (mostly from the early Rose and the neoclassical periods), *Woman in Gray*, which depicts Picasso's mistress Dora Maar, with equine features and stark grisaille tones, remained the most radical. This diversity of period, style, subject matter, and mood within the group acquired in 1948 alone was typical of the Hillmans' choices throughout the following decade. The diversity of taste accounts for the personal, even intimate, character of the collection. In the 1950s the number of acquisitions augmented each year, reaching the highest number (fifteen) in 1959.

In their decisions the Hillmans were often guided by a small circle of museum curators and dealers. They nurtured a particularly close friendship with Theodore Rousseau, chief curator at the Metropolitan Museum of Art, until his death late in 1973. For two decades, their

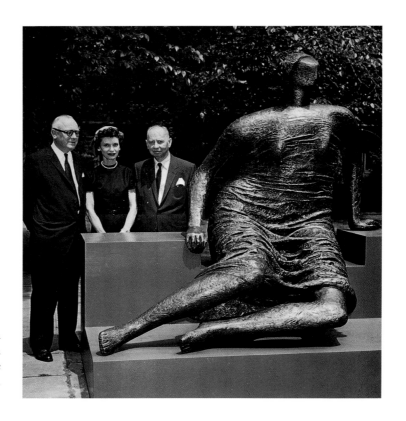

Mr. and Mrs. Alex Hillman with curator Andrew Carnduff Ritchie on the occasion of the dedication of the Henry Moore *Draped Seated Woman,* Yale University 1959.

paintings were repeatedly featured in the summer shows at the Metropolitan Museum of Art, which drew on the finest private holdings of New York–area collectors. Paintings from the Hillman Collection, including Gris's *Harlequin,* Soutine's *Little Girl with a Doll,* de Chirico's *Metaphysical Composition,* Matisse's *Pineapple,* and Modigliani's *Anna Zborowska* regularly hang in the museum's twentieth-century gallery (cat. nos. 20, 65, 8, 35, and 37).

Little correspondence remains between Hillman and Rousseau, because they discussed matters in person over their weekly lunch at the restaurant Le Veau d'Or. When criticism surrounded Rousseau and the museum for having paid at auction what was then considered an exorbitant sum (five and a half million dollars) for the Velázquez portrait *Juan de Pareja,* Rita Hillman decided to fund a film on the painting to support her old friend. The project, which was soon followed by a video on Rembrandt, also funded by Rita Hillman, gave rise to the museum's department of Film and Television.

Rousseau may also have been responsible for introducing the Hillmans to Alfred H. Barr, Jr., around 1949.[7] Throughout the fifties and early sixties, Barr and Hillman shared a close rapport, informing each other of works they had seen in galleries in New York and abroad, of current artists, and discussing possible acquisitions. Although their politics differed, the two men respected each other intellectually. In one exchange of letters, Barr gave his advice on possible speakers for a lecture series Hillman was

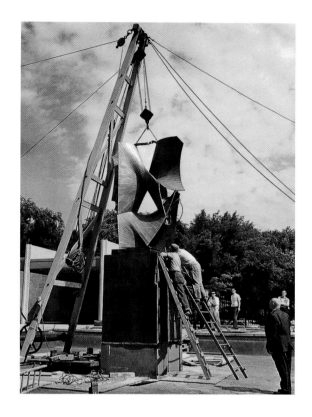

ABOVE: Installation of the Antoine Pevsner sculpture, *Construction in Space in the Third and Fourth Dimensions*, The Law School, University of Chicago, 1963.

RIGHT: Antoine Pevsner, *Contruction in Space in the Third and Fourth Dimensions,* Laird Bell Law Quadrangle, the Law School, University of Chicago.

planning for the University of Chicago on "crowd culture and man against mass society."[8] Hillman, in turn, always wrote to Barr in a tone of emphatic praise, bordering on reverence. He would not permit Barr to modestly play down his role in the creation of the institution, its collection, or his influence on patrons like himself: "There I think you have inspired, guided and sometimes advised collectors," Hillman wrote to Barr, "but above all, you have helped to create a taste which has made many of us see things as we would never have seen them otherwise."[9]

The Hillmans donated numerous works to the Museum of Modern Art, under either their own names or that of the Hillman Periodicals Fund. In the early years they gave from their own collection, among others, works by Graham Sutherland and Charles Burchfield and Fernand Léger's *Still Life*. The Soutine *Portrait of a Woman* and Renoir's *Woman in a Blue Blouse* were expressly donated to be sold for the benefit of the MoMA (see Appendix nos. 84 and 77). In 1953 Hillman established the Periodicals Fund to allow Barr to acquire key works for the museum's permanent collection, among them Giacomo Balla's *Street Light* (1909), Francis Picabia's *I See Again in Memory My Dear Udnie* (1914), Picasso's *Woman in a Chair* (1910), *Bather and Cabin* (1928), and the watercolor *Bathers in a Forest* (1908), and several paintings by Franz Kupka.[10]

Among New York dealers, they bought regularly from Morris Guttman of the French Art Galleries; Eugene Thaw, then of the New Gallery; Klaus Perls; Curt Valentin of the Buchholz Gallery; Pierre

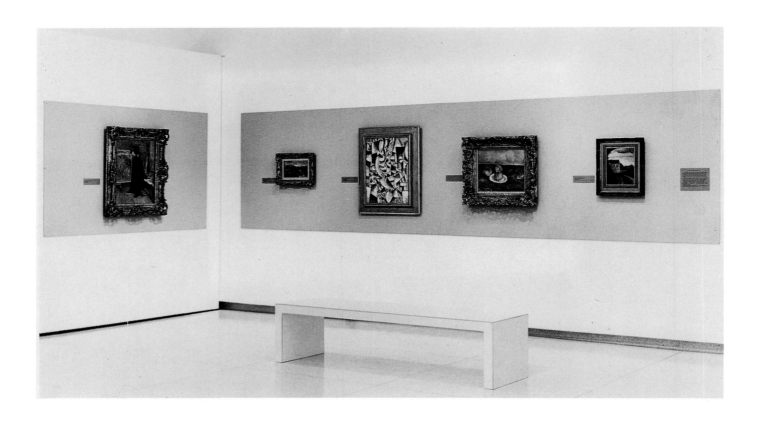

Exhibition of modern French paintings from the Alex Hillman Family Foundation at the David and Alfred Smart Gallery, University of Chicago, October 9-December 15, 1975

Matisse; and Herb Elfers of the American branch of Durand-Ruel. The Hillmans had limits on what they could, or were willing to, spend, and prices continued to rise on the impressionist and post-impressionist works they had been seeking out since the forties. For example, the Hillmans had been eyeing Manet's *Young Girl on a Bench* (cat. no. 28) for years, but it only came to be theirs when, at sudden notice, Durand-Ruel decided to close its New York operation. Elfers called them at dawn one morning to offer it, underpriced, with the understanding that they could not afford not to buy Renoir's *Woman with Mandolin* (cat. no. 56) at the same time.[11] Alex Hillman once commented to the dealer René Drouin, "I can't buy all the things that I love — I can only buy some and at the price that I can afford."[12] As a result, the Hillmans often traded or sold earlier favorites to acquire others that they felt had to be had (see Appendix).

Politics were Hillman's passion, second only to art collecting. He served on government advisory panels during the Truman and Eisenhower presidencies and used his presses to support the Republican cause. As an intellectual involved in the political sphere, Hillman was little known to the public, but behind the scenes he wrote speeches, served as an advisor to the Senate Republican policy committee (1948–61), and published writings by William Buckley, Jr., and the paperback version of Barry Goldwater's *Conscience of a Conservative* (1960). His interest in avant-garde art belied his more traditional views in politics. But his service to the United States government, which took him to Europe in the immediate postwar

years, pushed him into a new phase of collecting. In 1948 he was sent by the State Department to observe the postwar elections in Italy. Though Alfred H. Barr, Jr. gave him a list of current artists to look up in Rome, there were no acquisitions at that juncture.[13]

During the subsequent trips to Paris in the early 1950s, when Alex served as a foreign advisor on the Marshall Plan to Senator Styles Bridges (then head of the Senate Appropriations committee), he and Rita became intrigued with the local French scene and the style they termed "French expressionism." The Hillmans' focus on up-to-the-minute European art was unusual for American collectors of contemporary art, who supported abstract expressionism and the New York School as part of the cultural politics of the Cold War era.[14] While the Hillmans were drawn to foreign trends by their avant-garde eye, their interest was also encouraged by having witnessed, firsthand, postwar European economic recovery and political reorganization.

Hillman was a stickler on quality, but open to experimentation. It is a measure of his perspicacity that he was among the first collectors in America, especially in New York, to acquire works by Dubuffet. The first of three Dubuffet paintings, *Charcoal Landscape* (Appendix no. 27) was purchased around 1950, likely through René Drouin from whom he had bought Modigliani's *Anna Zborowska* (cat. no. 37) that year.[15] The five exquisite Wols watercolors (cat. nos. 73–77) also entered the collection around this time. Drouin had given Wols his first show in Paris before the end of the war and continued to promote the artist's legacy long after his premature death. Wols had been an inspiration to the younger generation of French painters, who rejected the geometric abstract art of their immediate predecessors in favor of *tachism,* a style of lyrical abstraction arising from staining or marking the canvas with touches of pure color.

While Hillman bought from several Paris galleries (Claude Bernard, Rive Droite, Louis Carré), it was mainly through his friendship with René Drouin that he was introduced to the postwar artistic milieu. In 1954 Hillman began acquiring works by key figures of the new movement: Georges Mathieu (cat. no. 32), Jean-Paul Riopelle (Appendix no. 78), and Pierre Soulages (Appendix nos. 82 and 83). All three had been included in the late 1953 exhibition *Younger European Painters,* at the Solomon R. Guggenheim Museum, which was one of the first surveys of postwar trends. It was followed the next year by a comparable exhibition at the Museum of Modern Art, *The New Decade: 22 European Painters and Sculptors,* organized by Andrew Carnduff Ritchie, who had been instrumental in the Hillmans' acquisition of the Soulages.

Through Drouin, the Hillmans visited the studios of a number of the younger artists, including Mathieu, Cesar, and Etienne Martin, who did a portrait bust of Alex (cat. no. 31). In the latter half of the 1950s they went on to buy Beti, Chereau, Claude Georges, Alberto Giacometti, Jean Ipousteguy, Levee, Pantzer and Claude Viseux, as well as two works on paper and an *Otage* bronze by Fautrier (Appendix no. 29). The Hillmans were particularly taken by a new star on the scene, the Spanish abstract

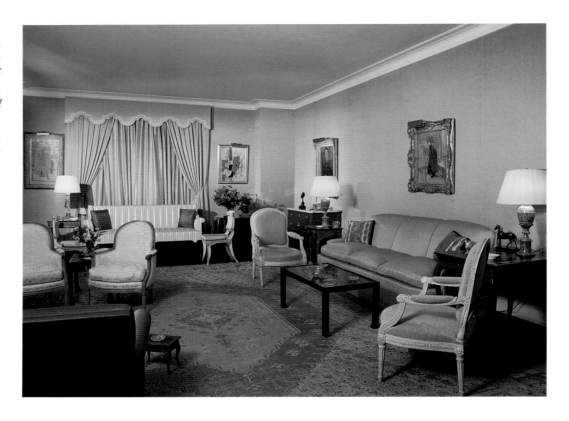

Apartment of Mr. and Mrs. Alex Hillman, New York City, with interiors by Billy Baldwin (c. 1960). View of the entrance foyer (opposite left) with *Mother and Child* by Pablo Picasso (see frontispiece and Appendix no. 74) Photographs by Peter Vitale, 1976.

painter Modest Cuixart, and owned some half dozen of his works at one time.[16] Later Drouin intimated to Hillman that he bought several of these artists at bargain prices, but the collector retorted that he had the eye to see what other people had overlooked.[17]

The Hillmans also ventured into contemporary British sculpture, mostly acquired through the Gimpels Fils gallery in London. In addition to older, established figures like Henry Moore and Barbara Hepworth, the collection included works by the younger generation of sculptors —Kenneth Armitage, Lynn Chadwick, Anthony Caro, Bernard Meadows, and Leslie Thorton (see Appendix nos. 1–3, 12, 9, 61, and 87). They also commissioned Henry Moore to make an enlargement of the bronze *Draped Seated Woman*, which was intended as a public sculpture and installed on the grounds of Yale University in 1959.

The Hillmans placed the postwar French paintings, along with the British sculpture, in their second residence, a New Hampshire farmhouse, which they had acquired in 1952. This area of their collecting was separated from the early-modern pieces and the more formal decor of the Park Avenue apartment, which had been decorated by Billy Baldwin. After Alex Hillman's death in 1968, which followed the loss of her only son Richard two years earlier, Rita Hillman sold the New Hampshire residence. Most of the contemporary works were sold at auction in the 1970s.

In 1961 Alex Hillman retired from the publishing business to run a personal investment company, and the pace of collecting dimin-

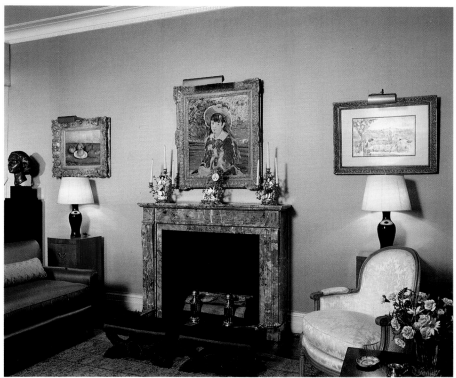

ished thereafter; nothing was acquired after 1965. In the early sixties, however, in addition to the works by contemporary Europeans, the Hillmans added a Degas bronze (Appendix no. 23) two Dufy oils (cat. nos. 14 and 16), and a Redon pastel (cat. no. 52). The Hillmans considered the latter work, purchased in 1964, to be the only "pretty" work in the collection. It was bought in reaction to the rise of Pop Art, which had prompted Hillman to say to Rita, "I think we may have lost our eye."[18]

During this period much of Alex Hillman's energy was taken up with a project beyond the walls of the collection: commissioning a sculpture by the constructivist Antoine Pevsner for the plaza of the new University of Chicago law school, designed by Eero Saarinen. Hillman took on the project for his alma mater as early as 1960: he had earlier donated a classroom at the law school in the memory of his father and had established a lecture series in art history in his mother's name at the university. Hillman initially considered a work by Kenneth Armitage for the site, which was dominated by a rectangular reflecting pool. But the choice of Pevsner was prompted by the Hillmans' purchase of a small bronze by the artist, *Construction in Space in the Third and Fourth Dimensions*, from Drouin in 1961. According to Hillman, it was "one of the most beautiful and impressive works which I have been privileged to see in my entire collecting experience. It may well be the final determinant of all of the work done in sculpture on the problem of volume and space up to 1960."[19] Pevsner had worked with Saarinen on an earlier project, the General Motors complex in

Warren, Michigan (1945–55), and the architect approved of the choice for the law school, just shortly before his death in 1961.[20]

Through the mediation of Drouin, Pevsner agreed to rework *Construction in Space* as a large sculpture, making a new maquette in plaster measuring 10 ½ x 8 x 7 ¼ feet. He also designed a base to elevate the piece above the surface of the pool. The collaboration was thrown into crisis when Pevsner died unexpectedly in April 1962, and Hillman expressed grave doubts about proceeding without the artist's supervision.[21] The Susse foundry in Paris had worked regularly with Pevsner, however, and successfully cast the large bronze according to the artist's specifications. After the installation in 1963, Hillman convinced Pevsner's widow to donate the plaster maquette to the Museum of Modern Art.[22]

After 1968 Rita Hillman did not add to the collection, preferring to preserve its integrity as a "joint effort." Though it was never as avant-garde as the Gallatin or Arensberg collections, for instance, and never attained the magnitude of better-known post-impressionists bequests, the Hillman Collection made a significant contribution to the public awareness of modern art.[23] It was extensively exhibited in regional centers across the country. In addition to individual loans for temporary exhibitions, beginning in the early 1970s, Rita Hillman regularly lent a core group of works to smaller museums and university galleries, which would normally not have such a representative and high-quality array of impressionist and early-modern works at their disposal. The Hillman paintings traveled to the Bronx (1972); Laramie, Wyoming (1972); Jacksonville, Florida, and Corpus Christi, Texas (1973); Phoenix (1975); and Chicago (1975). The first curator of the Hillman Collection, William Miller, Jr., published a catalogue on the occasion of the exhibition at the Nassau County Museum of Fine Arts in Rosyln, New York (1977–78). At the initiative of Miller, the Hillman Collection continued on tour from 1979 to 1985 as part of the American Association for Arts exhibition program, educating audiences in ten different states in the South, Southeast, and Midwest.

The widespread exposure of the collection as a whole revealed the Hillmans' philosophy of collecting, which was informed, in turn, by their conservative political ideals. In 1955 Alex Hillman wrote to Alfred H. Barr, Jr., of the social duty involved in collecting art: "The creating of taste is, I think, the most important function of a ruling class."[24] A decade later, Hillman was invited to debate on the status of art and the art market at the first National Conference on the Arts and the Law, at the University of Chicago. He was described in press reports as "one of the old aristocrats of the art world," by contrast to the "new rich" suddenly crowding the art market.[25] As the leading expert on whether art objects would retain long-term value given the expanding field of investors, Hillman's comments were remarkably straightforward, reflecting the reasoning behind his own choices: "It does not matter where great art is sold; it will still bring in big prices. What we pay for in art is basically invention. We pay for a new way of seeing."[26]

EMILY BRAUN
Curator, The Hillman Family Collection

28

1 Alfred H. Barr, Jr., quoted in James Kiepper, "Unpublished Biography of Alex Hillman," New York, 1984. The following history of the Hillman Collection owes much to the research of William Miller, Jr., who authored the exhibition catalogue *Modern Masters: Paintings and Drawings from the Alex Hillman Family Foundation*, Nassau County Museum of Fine Arts, Roslyn, New York, December 19, 1977–February 12, 1978, and an unpublished, untitled history of the collection (Hillman Family Archives, New York). Miller died in 1988; he had curated the Hillman Collection since 1972.

2 Letter from Alex Hillman to Charles Offin, May 31, 1951. Hillman Family Archives.

3 On the contest between Hillman and Sotheby's see "Takeover Bid Shakes Art Market," *Business Week*, July 11, 1964. Hillman's obituary in the *New York Times*, March 27, 1968, states that "when it first was disclosed that some 75 percent of Parke-Bernet stock had been purchased by Sotheby's for between $1.25-million and $1.5-million, it was also said that there had been 'little difference' between that offer and the one made by Mr. Hillman."

4 H.L.F., "Alex L. Hillman: Courbet to Dubuffet," *Art News*, vol. 58, October 1959, pp. 30–34; Harold Rosenberg, "The Art Establishment," *Esquire* 63 (January 1965), pp. 43–46, 114. In the list of some forty-two prominent collectors, p. 45, Mr. and Mrs. Alex Hillman are included along with Mr. and Mrs. Burton Tremaine, Jr., Philip Johnson, Mr. and Mrs. Robert Scull, Mr. and Mrs. William Paley, Mr. and Mrs. John Loeb, Mr. and Mrs. Joseph Slifka, David Rockefeller, and others.

5 David Shirey, "Modern Mastery on View in Nassau," the *New York Times*, December 18, 1977. In reviewing the exhibition *Modern Masters: Paintings and Drawings from the Alex Hillman Family Foundation*, Shirey stated: "It is rare that the public gets the chance to see a private collection of such historic and esthetic importance." Among the "household images," Shirey cited Matisse's *Pineapple* (cat. no. 35), Toulouse-Lautrec's *Portrait of Henry Nocq* (cat. no. 69) and Picasso's *Mother and Child* (frontispiece and Appendix no. 74).

6 Alfred H. Barr, Jr., to Alex Hillman, February 3, 1953. Museum of Modern Art Archives, Alfred H. Barr, Jr., Papers (2179; 0457):

> Dear Alex,
>
> I took the copy of *Pageant* home with me and promptly got the flu —perhaps it was the cover girl or maybe Al Capp which was too much for me. I had never seen *Pageant* before, I am ashamed to say. It seems to me one of the most energetic pocket-size periodicals I ever saw. Seriously, I found it really interesting, though Capp was too terrifying to send on to me [*sic*] daughter. . . .

7 The earliest correspondence between Barr and Hillman that has been found dates from 1949. In a letter in the MoMA Archives, (AHB Papers: 2173; 114', Barr writes to Hillman at the request of Rousseau, who wanted names of contemporary painters and sculptors to give to the Hillmans for their upcoming trip to Rome. In this early correspondence, Barr addresses him as "Mr. Hillman." Hillman addresses him as "Mr. Barr" in a letter of April 28, 1950 (Hillman Family Archives). Shortly thereafter they are on a first-name basis.

8 Hillman requested Barr's feedback on a memorandum he sent to Lawrence Kempton at the University of Chicago (MoMA Archives, AHB Papers: 2184; 0293). Barr responded (2184; 0292), "I have read your extraordinary letter to Lawrence Kempton. It seemed to me that both what you said and your list of proposed lecturers was admirable. On the questions of crowd culture and man against mass society, I think that Dwight MacDonald should be considered and possibly David Reisman of the *Lonely Crowd*. Their minds, I think, are a good deal younger and their knowledge more contemporary than Bell's. Let me know what comes of your proposal."

9 Correspondence from Alex Hillman to Alfred H. Barr, Jr., September 22, 1955, in response to a letter from Barr to Rita and Alex Hillman, September 19, 1955 (Hillman Family Archives). See also Hillman's congratulatory letter to Barr, October 25, 1954, MoMA Archives, AHB Papers: 2179; 0461.

10 The following paintings by Franz Kupka were acquired for the Museum of Modern Art through the Hillman Periodicals Fund: *The First Step* (1909), *Mme Kupka among Verticals* (1910–11); *The Musician Follot* (1910–11); *Oval Mirror* (1910–11). In addition, the fund provided for two prints by Paul Klee (*Man on Stilts*, 1912; *Bearded Man*, 1925) and a painting by Modeste Cuixart (*Painting*, 1958). Mr. and Mrs Alex Hillman (along with Mr. and Mrs. N. Richard Miller and Samuel Girard Funds) contributed to the gift of a Jean Dubuffet sculpture, *The Magician* (1954).

11 As told by Rita Hillman and first recorded by William Miller, Jr., in an unpublished, untitled history of the collection. Hillman Family Archives.

12 Letter from Alex Hillman to René Drouin, October 23, 1961. Hillman Family Archives.

13 See note 7.

14 On American cultural politics of the Cold War period see Serge Guilbaut, *How New York Stole the Idea of Modern Art. Abstract Expressinism, Freedom and the Cold War*, trans. Arthur Goldhammer, University of Chicago Press, 1983.

15 Dubuffet was initially supported by Chicago collectors and maintained a close relationship with that city over the years. MoMA received its first Dubuffet in 1949 (Gift of Mrs. Saidie A. May) (the same year that Hillman likely acquired *Charcoal Landscape*) but acquired the bulk of its paintings by the artist in the late 1950s and 1960s. See Alfred H. Barr, Jr., *Painting and Sculpture in the Museum of Modern Art, 1929–1967*, The Museum of Modern Art, New York, 1977.

16 At that time, Cuixart was represented by Drouin in Paris, from whom the Hillmans purchased their works, and by Castelli in New York. He was a prize winner at the V Bienal de São Paulo, 1959, and was included in 1960 in two exhibitions of recent Spanish painting in New York: *Recent Spanish Painting and Sculpture*, The Museum of Modern Art, New York, to which the Hillmans lent *Painting* (1958) and *Painting* (1959); and *Before Picasso; After Miró*, The Solomon R. Guggenheim Museum, New York, 1960, to which they lent *Untitled Composition* (c. 1958) (see Appendix no. 18).

17 Letter from Alex Hillman to René Drouin, October 23, 1961. Hillman Family Archives.

18 As recounted by Rita Hillman and first recorded in an unpublished essay by William Miller on the Hillman Collection.

19 Letter from Hillman to Drouin, October 23, 1961. The small version of *Construction in Space* (*Construction spatiale aux troisième et quatrième dimensions*) was cast in an edition of three and measured 43 x 30 x 20 ½ in. The Hillmans eventually donated theirs to the Israel Museum in memory of their son, Alan Richard Hillman, in 1967. A second Pevsner bronze in the collection, *Column of Peace* (1954), was donated to the Metropolitan Museum of Art in 1981, also in memory of their son.

20 "Arrival of an Unusual Gift," *University of Chicago Magazine*, October 1963, pp. 5–6.

21 Hillman's personal involvement in the Pevsner commission, from the initial negotiations on price to his concerns over the patina, are documented in a series of letters between him, Antoine Pevsner, and René Drouin from 1961 to 1962 (Hillman Family Archives). Hillman also consulted Barr on aspects of the site, casting, and price; see the letter from Barr to Hillman, November 22, 1961, MoMA Archives, AHB Papers: 2186; 1148.

22 See the letters in the MoMA Archives, AHB Papers from Hillman to Barr, January 18, 1963 (2186; 1146), and from Barr to Hillman, January 23, 1963 (2186; 1144).

23 David Shirey wrote in the *New York Times*, December 18, 1977, on the occasion of the exhibition of the Hillman Collection at the Nassau County Museum of Art: "There are bigger and more important art collections in the United States, but not many. Of all of the American collections initiated within the last four decades, the Hillman Collection is one of the best."

24 Letter from Alex Hillman to Alfred H. Barr, Jr. , September 22, 1955. Hillman Family Archives.

25 D.J.R. Bruckner, "Aristocrats, 'New Rich' Debate Status of Art. Recent Collectors in Cultural Boom Differ with Old Families over Taste, Values," *Los Angeles Times*, April 18, 1966.

26 Alex Hillman cited in ibid.

Note to the Reader

Contributors to the catalogue entries:

JULIA BLAUT (J. B.)
EMILY BRAUN (E. B.)
ELIZABETH EASTON (E. E.)
SARAH FAUNCE (S. F.)
PEPE KARMEL (P. K.)
GAIL STAVITSKY (G. S.)

The catalogue is organized alphabetically by artist and then by date, with the earliest works listed first. The title given by the artist, or the one that is generally accepted, is listed first, in English. Other commonly held titles are separated by a slash. The original-language title appears in parentheses. The dates are those inscribed by the artist or verifiable; a question mark follows hypothetical dates. The measurements are given first in inches and then in centimeters; height precedes width, which precedes depth in the case of sculpture.

The entries attempt to give a complete provenance, literature, and exhibition history. In addition to noting the exhibitions in which the work was included, the citations under *Exhibitions* include references to catalogue texts and illustrations. Conversely, when a work is mentioned in an exhibition catalogue but was not actually shown, the reference is listed under *Literature.* In the case of sculpture, additional selected references may be given for other versions of the cast, as indicated in the individual entries. Information that could not be verified is followed by a question mark. All references are in abbreviated form; full citations are found in the Bibliography.

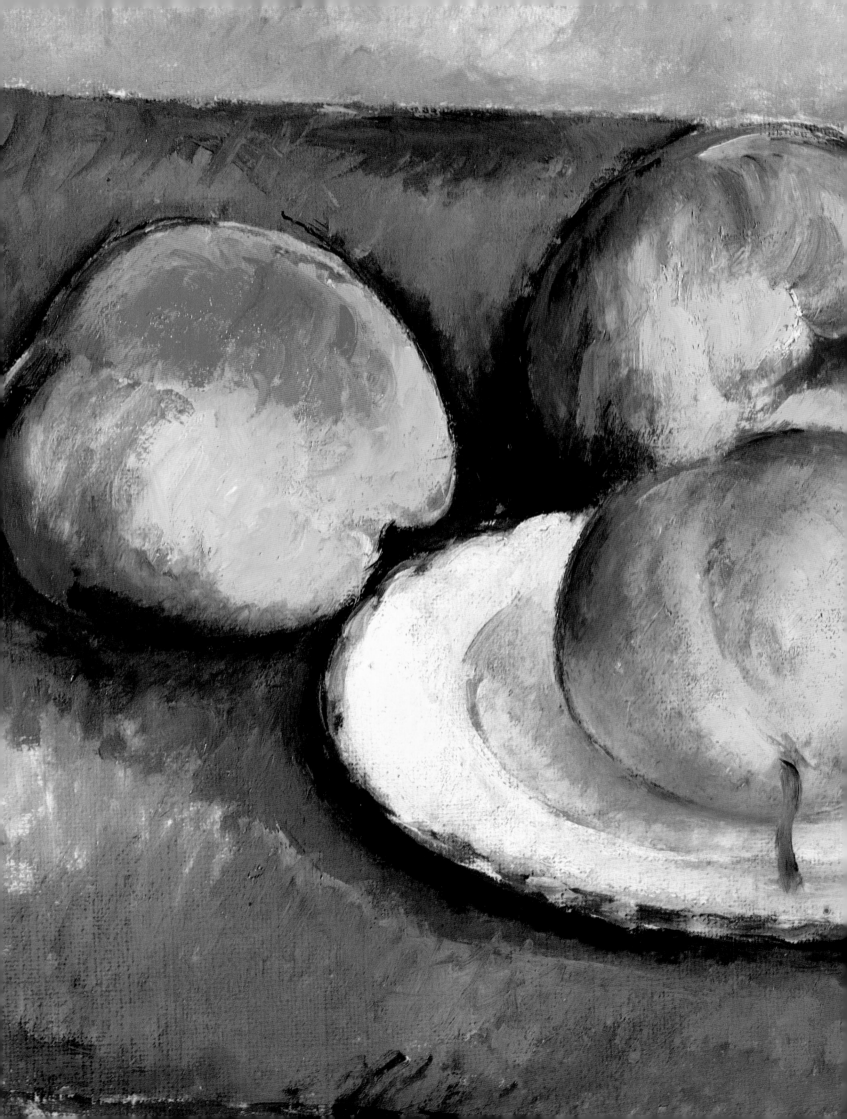

THE
HILLMAN
FAMILY
COLLECTION

A Catalogue

Detail of Cézanne, *Still Life with
Fruits and Plate*, c. 1890 (cat. no. 6)

PIERRE BONNARD (1867–1947)

1. *Shops on the Boulevard des Batignolles*
(*Les Boutiques, Boulevard des Batignolles*), c. 1899
Oil on canvas, 32 x 16½ in. (81.3 x 42 cm)
Signed lower right: *Bonnard*

*S*HOPS ON THE *BOULEVARD DES BATIGNOLLES* has tradition-
ally been dated to 1904, but its style and the facts of
Bonnard's biography argue that it was painted in 1899. The
life of the grand Parisian boulevards, animated by scurrying
pedestrians, hansom cabs, and sedate nannies and playing
children, was a favorite subject of the artist during the 1890s.
The view is typically from above, as if seen from the studio
window, and the swiftness of the passersby is evoked by rapid
annotations of the brush. By comparison to other works of
the second half of the decade, such as the *Les Grands Boule-
vards* of 1898 (R. S. Sainsbury Collection, London, repro.
Dauberville 1992, no. 175, p. 200), this one is more loosely
handled with larger strokes and looks toward his later style.

Bonnard maintained a studio in the Batignolles from
1896 to 1899 and then moved to rue de Douai, also in the
neighborhood of Montmartre. The terminus ante quem for
the painting would therefore be 1899, before the change of
address. That same year Bonnard's interest in the visual
vivacity of the city culminated in a portfolio of twelve
lithographs entitled *Quelques Aspects de la vie de Paris*. These
scenes share with the *Boulevard des Batignolles* many of the
urban motifs as well as the summary style and large areas of
unworked ground.

Bonnard's city scenes decreased significantly in number
after 1900, when he began to live every spring to early autumn
outside of Paris. The move provoked changes in his style,
such as more atmospheric brushwork, a new emphasis on
filling the foreground plane, and a preference for pastel and
floral hues. By contrast, the *Boulevard des Batignolles*, with its
tilted perspective, individuated strokes, and predominant
ocher color and smokey tonality, belongs to Bonnard's earlier
urban period, before the turn of the century.

E. B.

PROVENANCE
Helen Taübler, Berlin; Galerie St. Etienne, New York; Jacques Seligman
and Co., New York; acquired from Parke-Bernet, New York, Decem-
ber 11, sale 1020, no. 79, ill. p. 72; 1948; Hillman Family Collection

LITERATURE
Courthion 1956, p. 75, color ill.

EXHIBITIONS
Springfield 1941–46 (on deposit from the estate of Helen Taübler);
Cleveland–New York 1948, no. 18, p. 139, ill. p. 78 (as *The Boulevard*,
c. 1904); Bronx 1972 (HC); Laramie 1972 (HC); Jacksonville–Corpus
Christi 1973–74 (HC), no. 9, ill.; Phoenix 1975 (HC); Roslyn 1977–78
(HC), no. 1, ill.; Austin et al. 1979–85 (HC); Brooklyn 1986–87 (HC);
Brooklyn 1988 (HC); Brooklyn 1990–91, ill. in exh. brochure.

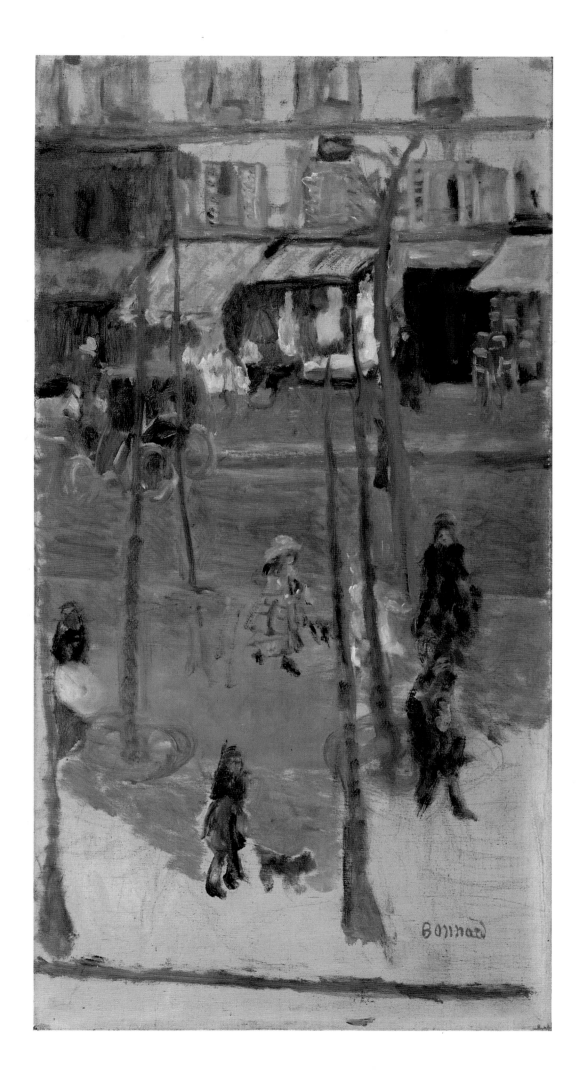

GEORGES BRAQUE (1882–1963)

2. *Violin and Sheet Music on a Table* (*Petit Oiseau*)
(*Violin et partition [Petit Oiseau]*), 1913
Oil, pencil, and charcoal on canvas, 28¾ x 21¼ in.
(73 x 54 cm)

Braque painted *Violin and Sheet Music* at the key moment of transition between analytic and synthetic cubism, soon after the invention of collage. Picasso had incorporated extraneous materials into his *Still Life with Chair Caning* (The Museum of Modern Art, New York) in May 1912. That September Braque used pasted papers (papier collé) exclusively for the first time in *Fruit Dish and Glass* (private collection, Worms de Romilly–Laude 1982, no. 150). Subsequently, the two artists began to adapt the new mode of pictorial composition and representational play made evident by the collage process in their painted images.

While Picasso habitually pasted papers onto canvas, Braque did so only rarely, restricting them to works on paper support. Nonetheless, in 1913–14 he often imitated papier-collé techniques in oil on canvas, as with *Violin and Sheet Music*. Typically, the image is built around a series of colored vertical planes, which, emulating strips of paper, lie flat on the canvas surface. He often determined the compositional framework by pinning cutout shapes to the canvas, experimenting with their placement and then marking their contours in pencil (Golding 1988, p. 123). The abstract shapes then took on specific identity as objects only by virtue of overdrawing, visual clues, or in the context of their placement in relation to other signs on the field. Without recourse to traditional modeling and perspective, Braque depicts a violin, a sheet of music, the corner of a table (set at 45° to the bottom edge of the canvas), and the space in which they rest. The violin is analyzed into its component parts from differing angles of view, its identity made apparent by the distinctive curvaceous profile and the strings, bridge, sound hole, and pegs.

In *Violin and Sheet Music*, the vertical planes are rendered as imitation wood grain, specifically, the *faux bois* printed paper that Braque used for his first series of papiers collés. The fragments paradoxically exist as both pure pictorial elements and referents to the extrapictorial world, while simultaneously signifying the wood of the musical instrument and the table. As the son of a housepainter, Braque knew how to create the effect directly on canvas by drawing a painter's "comb" through wet paint. Braque not only mimics the original wood material but also its faked form, confounding the viewer with conflicting realities. Similarly, the densely painted white rectangle resembles a piece of sheet music pasted onto the canvas. The black oblong that appears to lie under the adjacent brown and white fragments is a painted version of a black paper commonly used by Braque. Moreover, he extends the duplicity by drawing over it in white, as he would in a papier collé, playing with properties of negative and positive space, of opacity and transparency, in yet another series of reversals.

As a transitional piece, *Violin and Sheet Music* demon-strates two distinct modes of cubist rendering. The background is composed of the transparent, interpenetrating planes of analytic cubism, hovering in a shallow space, while the still life is arranged according to the solid-color shapes of synthetic cubism, stacked parallel to the picture plane. According to John Golding, Braque's paintings from 1913 are perhaps the first synthetic cubist pictures, in that the artist now proceeded from abstraction to representation, conscious that "both approaches could be fused in a single painting." In particular, the colored strips of paper made evident that the basic composition "could exist independently of the subject, which was superimposed or laid over it." Golding concludes: "It is this that makes Braque's work of the period enjoyable on so many different levels, both pictorial and intellectual; and an appreciation of these paintings provides the key to the understanding of all of his subsequent works" (1988, p. 124).

In composition and iconography, the Hillman painting bears comparison with two other works of 1913, *Violin and Newspaper* (Philadelphia Museum of Art) and *Violin and Glass* (Kunstmuseum, Basel), the latter one of the few examples of Braque's using oil together with paper on canvas. Yet the Hillman example is the only one of the three to include sheet music and is unique in Braque's oeuvre for the inclusion of actual drawn notes within the staves (Worms de Romilly–Laude 1982, p. 50). With the depiction of instruments and scores Braque makes a deliberate analogy between the two arts of music and painting, and in particular, between the forms of abstract notation and the means of "reading" compositions. Although Braque frequently referred to Bach and classical music, he also appreciated popular melodies such as "Petit Oiseau" (Worms de Romilly–Laude 1982, p. 50), acknowledging the dialogue between refined and low-brow culture, which was fundamental to the revolutionary cubist spirit.

E. B.

PROVENANCE
From the artist to Galerie Kahnweiler, Paris; sequestered Kahnweiler stock, 1914–21; second Kahnweiler sale, Paris, November 17–18, 1921, no. 28; M. Sprechholz, Paris; Jean Coutrot, Paris; Jacques Seligman and Co., New York Meric Gallery, Paris; Buchholz Gallery, New York; acquired from Buchholz Gallery, September 1949; Hillman Family Collection

LITERATURE
L'Esprit nouveau 1921, ill. p. 645; Isarlov 1932, no. 153; Worms de Romilly–Laude 1982, no. 175, p. 193, color ill. p. 281; Valsecchi-Carrà 1971, no. 112, ill.

EXHIBITIONS
New York 1954, no. 14; New York 1957(2); New York 1963, no. 88, p. 9; New York 1971 (HC), no. 1; London 1983, no. 28, p. 90, color ill., p. 91.

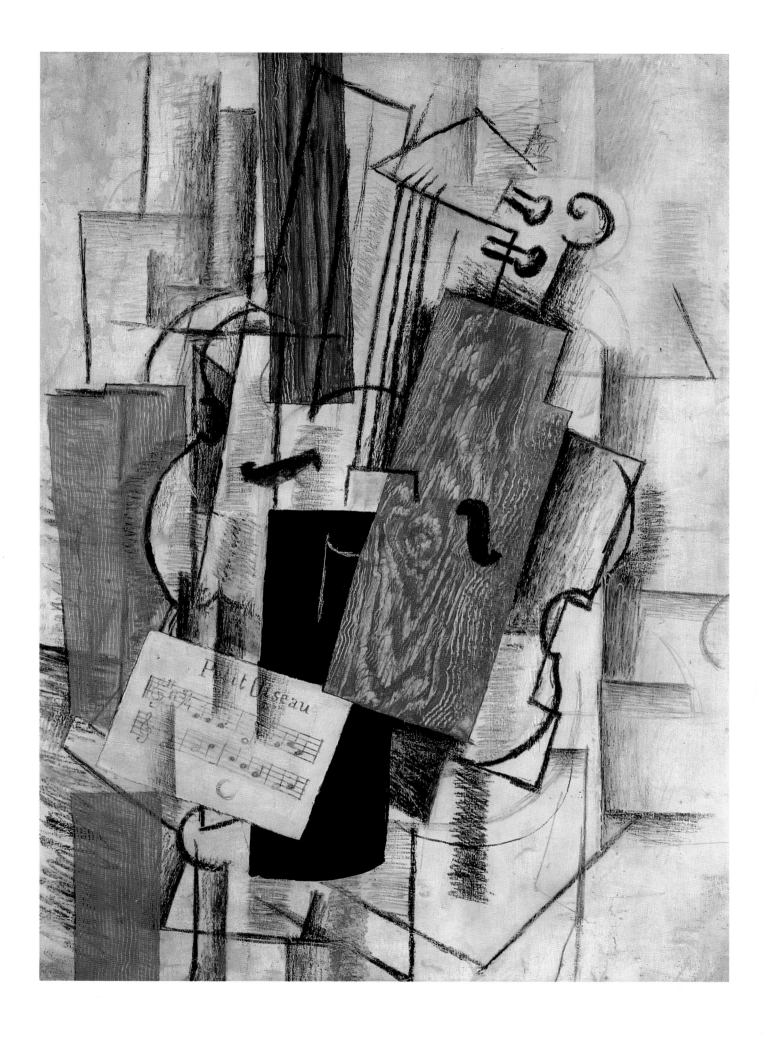

GEORGES BRAQUE (1882-1963)

3. *Still Life with Basket of Fruit/Still Life with Peaches*
(*Nature morte à la corbeille de fruits*), 1927
Oil on panel, 21⅛ x 36¾ in. (53.6 x 93.3 cm)
Signed and dated lower left: *G. Braque/27*

STILL LIFE WAS AT THE CORE of Braque's sensibility and
hence of his work as a painter. During the years 1909–
1914, Braque and Picasso undertook a unique collaboration in
which they invented cubist pictorial structure. Central to this
structure as it developed through its various stages was still
life: the marks on the canvas and paper were the signs of
objects that lay within the hand's reach, that were assembled
in a tabletop's shallow space, whose shapes could be cut into
and shifted around, and that could be imagined as forms
dissolved into planes and interpenetrated by space. They were
objects that referred to the daily private life of the studio and,
by extension, to the sociability of the café: wine and liqueur
bottles, goblets, pipes, cigarette papers, musical instruments,
newspapers. It was with this vocabulary that the great
inventions of cubism were made.

When the works of both painters are examined together,
as they were in the 1989 exhibition *Picasso and Braque:
Pioneering Cubism* at the Museum of Modern Art, it is clear
that while Picasso frequently worked with a figural idea, for
Braque the figure was only an occasional motif; the still-life
structure was his primary mode.

The war of 1914–18 brought to an end both this rare
collaboration and the heroic years of cubism. Braque served in
the army and returned seriously wounded. By mid-1917 he
was able to resume painting, and during the decade of the
twenties he established and refined the kind of classic late
synthetic cubist still-life painting that became the backbone of
his art. The Hillman painting of 1927 is one of those which
represent the fulfillment of this civilized achievement. The
basket, pitcher, and goblet are cut into simple planes of color,
which permit a view of the objects both on the inside and
from the outside; the strong shape of white embracing the
group of objects, although not literally described, has the
structure of an open book of sheet music. These objects are
joined by a still-life element that has roots more traditional
than cubism: the grapes and peaches refer back to Chardin
and to Dutch painting while at the same time being conceived
pictorially in an entirely different way. The palette of subtly
nuanced grays and browns, rooted in cubism, is expanded by the
rich local colors of the fruits. The musical reference, so fre-
quently present in Braque's still-life, gives emphasis to the
quality of the painting as pure composition, in which the still-
life objects cease to be real-world referents and become elements
in a harmonious play of form, color, and space.

S. F.

PROVENANCE
Alphonse Kahn, Paris; acquired from the Dalzell Hatfield Gallery, Los
Angeles, 1951; Hillman Family Collection

LITERATURE
Isarlov 1932, no. 448; *The Metropolitan Museum of Art Bulletin* 1967,
p. 31, ill; Braque 1968, no. 102, ill.; Valsecchi-Carrà 1971, no. 367, ill.

EXHIBITIONS
New York 1953, no. 14, ill.; New York 1956; New York 1957 (1); New
York 1957 (2); New York 1960, no. 6, p. 1; New York 1961, no. 6; New
York 1962, no. 2; New York 1963, no. 88, p. 9; New York 1964, no. 27,
ill.; New York 1966, no. 11, p. 2; New York 1967; New York 1970, no. 8,
color ill.; New York 1971 (HC), no. 2; Bronx 1972 (HC); Laramie 1972
(HC); Phoenix 1975 (HC); Roslyn 1977–78 (HC), no. 2, ill.; Austin et
al. 1979–85 (HC); Hartford 1981 (HC); Brooklyn 1986–87 (HC);
Brooklyn 1988 (HC).

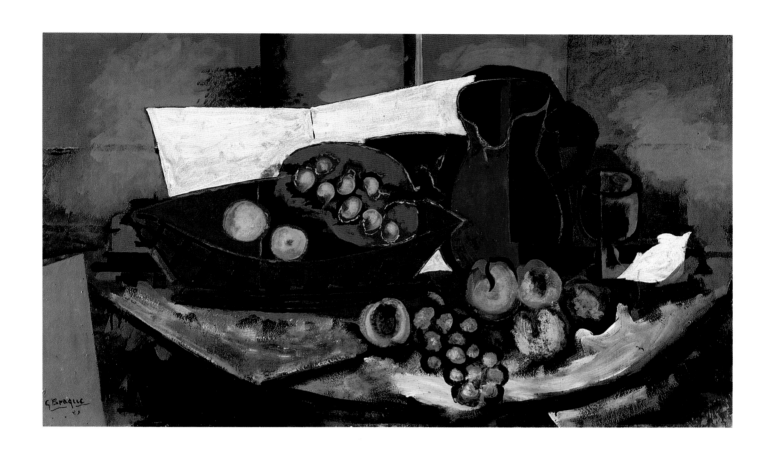

ALEXANDER BROOK (1898–1980)

4. *Madonna*, 1930s
Oil on cardboard, 10 ¼ x 8 in. (25.4 x 20.3 cm)
Signed lower right: *A. Brook*

T HIS SMALL PAINTING of an unidentified woman is one of many poetic figure studies by Alexander Brook. Highly regarded as one of the most influential and important mainstream American painters of his generation, Brook was also active as a critic and arts administrator. As assistant director of the Whitney Studio Club in New York from 1923 to 1927, he was responsible for many exhibitions and discoveries of new talent, particularly Raphael Soyer. Brook is often grouped with Soyer, Reginald Marsh, Kenneth Hayes Miller (with whom he studied at the Art Students' League), and others as part of the Fourteenth Street group which depicted the street life of the Union Square area. Nevertheless, he preferred to paint more lyrical, intimate, studio-oriented themes than his social realist colleagues. From 1925 to 1950, Brook was an enormously successful artist whose nudes, portraits, still lifes, and landscapes won nearly every major prize and who was accorded more solo shows at American museums than possibly any other native painter of his day.

This small-scale figure typifies the privacy, self-absorption, and meditative stillness of Brook's numerous paintings of solitary women. The delicate brushwork, softened contours, subtle colors, and simplified composition are hallmarks of what one critic called "his peculiarly haunting and romantic style . . . imbued with a wistful poetry."[1] A major influence on the development of his style was Jules Pascin, who in 1917 purchased the first painting Brook ever sold.

Although the work is undated, the inclusion of a landscape background suggests that this painting was created in the 1930s. During this decade, Brook's growing interest in situating figures in the out-of-doors culminated in *Georgia Jungle* (1939, Carnegie Museum of Art), for which he won first prize at the 1939 Carnegie International.

G. S.

[1] Elizabeth McCausland, "Alexander Brook Gaining Recognition," *Springfield [Mass.]Sunday Union and Republican*, August 17, 1941.

PROVENANCE
Unknown; no record of acquisition; Hillman Family Collection

PAUL CÉZANNE (1839–1906)

5. *Portrait of the Artist's Son*
(*Portrait du fils de l'artiste*), c. 1885–86
Pencil on paper, 19¾ x 12½ in. (50.2 x 31.7 cm)
Verso: *Scene illustrating a romantic story*, c. 1875
Pencil and watercolor

THIS DRAWING DEPICTS one of Cézanne's favorite portrait subjects, his son Paul, born January 4, 1872, to Hortense Fiquet, the artist's mistress and model whom he married in 1886. The drawing combines a classical pose with anatomical and perspectival distortions, revealing both the awkward adolescent physique of the boy and the antinaturalistic, formal concerns of the artist. By the 1880s, Cézanne had moved away from the empiricism of impressionism to explore the inner world of his subjects, here evidenced by his son's pensive expression.

Paul *fils* poses with his weight on the right foot, in a contrapposto stance. While his posture might suggest classical sculpture, his clothing betrays a strictly contemporary subject; he wears knickers, a long-sleeved shirt, and a buttoned-up vest. Cézanne also departs from the classical example in his rendering of the body and space. Ignoring anatomically correct proportions, Cézanne drew the head too small and the feet too large for the body and the left arm appears to be pivoted sideways in the socket. The room is defined by a few horizontal and vertical lines, rudimentary cross-hatching, and a floral motif on the wall near the model's left hand. The deviant perspective undermines the stability of the setting, and the floor seems to slide out from under Paul's firmly planted feet.

The same architectural background, though with a less skewed perspective, is found in two other sketches: the pencil and watercolor *Study of a Nude Figure* (c. 1885–95, Fogg Art Museum, Harvard University; Andersen 1970, p. 163, n. 1) and another portrait drawing of the artist's son (private collection, Berlin; Venturi 1936, no. 1470). The latter is closely related to the Hillman study: the sheet size is the same, and the subject assumes virtually identical pose and dress. The spatial and anatomical distortions, however, are less pronounced in the Berlin version (Chappuis 1973, p. 210).

The posture and expression of the boy in the Hillman drawing has been compared to the painting *Boy in a Red Waistcoat*, c. 1890–95 (National Gallery of Art, Washington, D.C., Venturi 1936, no. 682; Andersen 1970, p. 163). In this later work, however, the sparse interior and rigid pose are replaced by billowy drapery and an exaggerated sway of the hip, characteristic of Cézanne's more baroque portrait style of the 1890s (Andersen 1970, pp. 34–35).

The Hillman drawing bears comparison to a photograph of Cézanne's son in a formal suit, which is presumed to have been taken at the time of his confirmation (Andersen 1970, no. 148a, p. 151, ill.). The precise date of the photograph, however, remains uncertain. According to Wayne Andersen, children in the late nineteenth century were traditionally confirmed at the age of eleven, and thus he dates the photograph to 1883. Given that the boy looks older in the Hillman image, however, and on the basis of his appearance in numerous portrait drawings over the years, Andersen guesses him to be around fifteen years in the present example. (Andersen 1970, p. 32).

The floral design, which appears in other works by

Cézanne, has been interpreted as a wallpaper pattern that decorated one of his residences during the years 1879–82. Because of its presence in the Hillman drawing, which clearly postdates 1882 (when his son would have been only ten), Andersen argues that the flower motif may be a moveable studio prop (1967, pp. 137–39 and 1970, p. 163). The pattern may also have been carried over at will by Cézanne, who used it as a decorative element and to denote the plane of the wall.

The watercolor on the verso depicts a bearded man on a Gothic throne in the act of writing; his left arm rests on a table, and he holds a quill pen and piece of paper. He turns to look at a document held by another man in a long red robe. Lionello Venturi first identified the image as a scene from Faust, copied after a subject by Delacroix (1936, no. 868, p. 246), yet no such work exists by the latter. Theodore Reff points out that while there are similarities between Cézanne's watercolor and two lithographs by Delacroix, *Mephistopheles Receiving the Student,* a scene from *Faust,* and *Goetz de Berlichingen Writing His Memoirs,* neither can be considered the precise source (1960, p. 149, n. 47). (See Loys Delteil, *Le Peintre-graveur illustré* [Paris, 1906], vol. 3, nos. 63 and 122). The watercolor has been most accurately described by John Rewald as an unidentified scene illustrating a romantic story (1983, no. 63, p. 100). Venturi originally dated the watercolor to 1885, the same year he gave to the portrait drawing, but later revised it to 1872–77. Rewald also places the watercolor before the drawing, dating it to about 1875–78.

J. B.

PROVENANCE
Paul Cézanne *fils*, Paris; César de Hauke, Paris; Richard S. Davis, Minneapolis; acquired from the Buchholz Gallery (Curt Valentin), New York, May 1954; Hillman Family Collection

LITERATURE
Rewald 1936, pl. 47; Venturi 1936, vol. 1, no. 1469, p. 324; vol. 2, recto, pl. 377; De Beucken 1951, ill. pp. 2-32; Reff 1958, p. 25; Canaday 1959, p. 15, ill.; De Beucken 1960, p. 74, ill.; Perruchot 1961, fig. 31; Reff 1962, pp. 188–89 n. 18; De Boisdeffre–Cabanne–Cogniat et al. 1966, p. 19, fig. 7; Andersen 1967, p. 139 n. 32; Andersen 1970, no. 169, pp. 32, 34, 163, ill.; Chappuis 1973, vol. 1, no. 850, p. 210; vol. 2, ill. no. 850; Rewald 1978 (2), no. 24, p. 338, ill.; Venturi 1978, p. 114, ill.; Adriani 1981, no. 55, pp. 53–54, 161, ill.

Verso only:
Venturi 1936, vol. 1, no. 868, p. 246; vol. 2, pl. 277; Berthold 1958, p. 154; Reff 1960, p. 149 n. 47; Lichtenstein 1964, p. 56 n. 6, entry 19; Reff 1964, p. 425; Lichtenstein 1975, p. 123; Rewald 1983, no. 63, p. 100, ill.

EXHIBITIONS
Paris 1935 (verso); Paris 1950, no. 13 (verso); The Hague 1956, no. 117, ill.; Aix-en-Provence 1956, no. 90; Zürich 1956, no. 178, p. 39, ill. no. 74; New York 1959 (1), no. 106; New York 1959 (2), no. 66, ill.; Vienna 1961, no. 98, p. 36; New York 1963 (2), no. 135, p. 70, ill.; Washington-Chicago-Boston 1971, no. 75, p. 105, ill. p. 104; Bronx 1972 (HC), detail ill. in brochure; Newcastle upon Tyne–London 1973, no. 51, p. 161, ill. p. 92; Tokyo-Kyoto-Fukuoka 1974, no. 108, ill.; Roslyn 1977–78 (HC), no. 4, ill. recto and verso; Tübingen 1978, no. 55, pp. 149, 151, and 322, ill.; New York–Ann Arbor 1980; Liège–Aix-en-Provence 1982, no. 39, p. 130, ill. p. 131; Jamaica 1982, ill. in brochure; Madrid 1984, no. 71, p. 216, ill. p. 217; Newark 1984 (HC); Brooklyn 1986–87 (HC); Brooklyn 1988 (HC); Phoenix 1991–92 (HC).

5. PAUL CÉZANNE *Portrait of the Artist's Son*

44

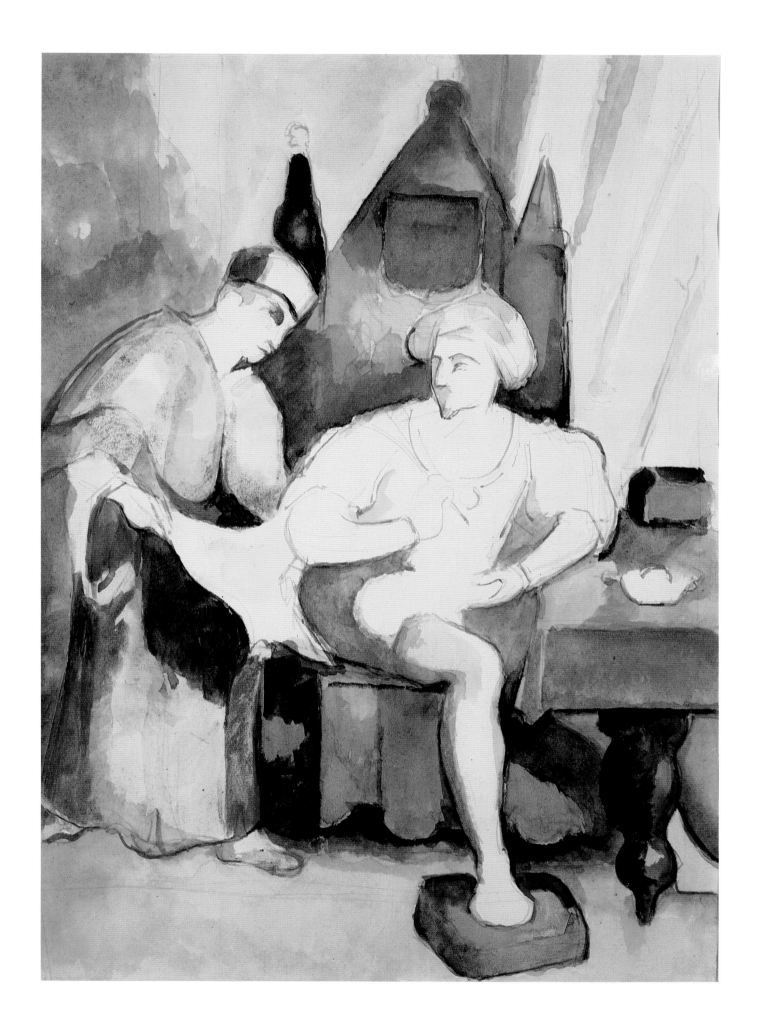

5. (verso) PAUL CÉZANNE *Scene illustrating a romantic story*

PAUL CÉZANNE (1839-1906)

6. Still Life with Fruits and Plate
(*Nature morte, assiette et fruits*), c. 1890
Oil on canvas, 15 x 18⅛ in. (38 x 46 cm)

THE MOST RIGOROUS STUDY of the significance of the
painting of still lifes of fruit in Cézanne's art remains
Meyer Schapiro's 1968 article, "The Apples of Cézanne: An
Essay on the Meaning of Still Life." In it he explores with
great erudition and delicacy the many layers of meaning,
conscious and unconscious, that apples (and by extension such
related fruits as peaches and pears) had for this painter, whose
youthful experience encompassed both classical learning (the
golden apples of Virgil and Theocritus) and Catholic training
(the forbidden apples of Eden); Cézanne also experienced
both the freedom to roam the fertile Provençal countryside
and the complex restraints of sexual inhibition and uncon-
scious displacement of feeling. Schapiro shows that for
Cézanne the painting of still life, far from being subject-
neutral, as has so often been thought, was related in varied
ways to his erotic self and to his way of perceiving and
understanding the world. He chose to paint the subject of
fruits so often, in large compositions and in smaller works like
this one, because of the meanings it held for him.

Cézanne's early paintings from the 1860s included still
life, but not fruits as such. This theme emerged in the mid-
1870s as integral to the process of artistic development in
which he transformed and shaped his turbulent feelings and
romantic imagery by making of mastering the impressionist
brushstroke a deliberate instrument of his own vision. In
Schapiro's words, the fruits of the still life are "suspended
between nature and use, [existing] as if for contemplation
alone" (p. 25), permitting the most detached and selfless kind
of observation. At the same time they are "the objects of a
caressing vision" (p. 27), succulent and sensual in their subtly
rounded shapes and rich coloring. Cézanne's method of
building form and resonant color by layering separate,
nuanced strokes was certainly not limited to the painting of
fruit still lifes, but the theme was particularly conducive to its
development, and Cézanne continued to paint these subjects
throughout his maturity.

The Hillman painting is a particularly fine example of
the artist's smaller still-life paintings, which represent an
informal grouping of a few pieces of fruit. Here the apparent
casualness is underlaid by a symmetrical grouping of 1:2:2:1,
which in turn is undercut by the variants of the angle, shape,
and size among the fruits, as well as by the placement of one
of them on a simple blue-rimmed white dish. The viewer's eye
can penetrate into the luminous layers of color touches as they
build the solid shapes of pear, peach, and apple. The place-
ment on a simple table with a slightly sloping "horizon" and
cut-off front edge is reminiscent of Chardin, the greatest

practitioner of the French still-life tradition of which
Cézanne was such an ardent student.

Although more fully realized, the Hillman painting is
close in type to a somewhat smaller work at Thomas Gibson
Fine Art, London, published as number 57 in the catalogue
of the Cézanne exhibition held at the Kunsthalle Tübingen
in early 1993. Although dated in the mid-1870s by Venturi,
the London painting is stylistically related to the still-life
compositions of the late eighties and early nineties and is
dated around 1890 in the Tübingen catalogue. On this basis,
the Hillman painting is here dated somewhat later than
Venturi's date of 1883–87. The title is also adapted to follow
the Tübingen model.

S. F.

PROVENANCE
Ambroise Vollard, Paris; Karl Henkell, Wiesbaden; acquired from
French Art Galleries, New York, October 1950; Hillman Family
Collection; sold: Sotheby's, New York, November 3, 1993, sale 6490,
no. 20, ill.

LITERATURE
Bernard 1925, p. 84; Venturi 1936, vol. 1, no. 507, p. 174; vol. 2, pl. 156;
Gatto-Orienti 1970, no. 475, ill.; AFA 1983, p. 6, ill.

EXHIBITIONS
The Hague 1956, no. 29, ill.; Aix-en-Provence 1956, no. 42, ill.; New
York 1957; Vienna 1961, no. 23; New York 1966, no. 22, p. 3; Bronx
1972 (HC); Laramie 1972 (HC); Jacksonville–Corpus Christi 1973–74
(HC), no. 13, ill.; Chicago 1975 (HC); Phoenix 1975 (HC); Roslyn
1977–78 (HC), no. 3, ill.; Austin et al. 1979–85 (HC); New York–Ann
Arbor 1980; Hartford 1981 (HC); Brooklyn 1986–87 (HC); Brooklyn
1988 (HC); Brooklyn 1990–91.

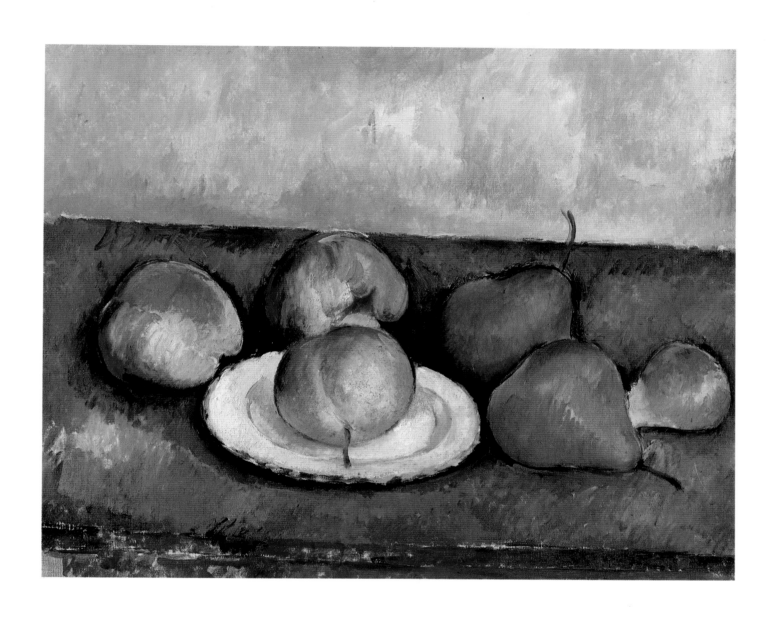

PAUL CÉZANNE (1839–1906)

7. *The Cathedral of Aix Seen from the Studio of the Artist at Les Lauves*
(*La Cathédrale d'Aix vue de l'atelier des Lauves*), 1904–6
Pencil and watercolor on paper, 12 ½ x 18 ½ in.
(31.7 x 47 cm)

THIS WATERCOLOR RECORDS the panorama seen from Cézanne's studio in the hillside village of Les Lauves, overlooking the town of Aix-en-Provence. In the center stands the Romanesque cathedral of Saint Sauveur. Cézanne built the studio in 1902, providing, as John Rewald wrote, "a magnificent view of Aix and, in the far distance, the misty blue mountain range, the Chaîne de l'Etoile, with its protruding, square Pilon du Roi" (1977, p. 95). Cézanne rendered three other versions of the panorama with the cathedral and the buildings of Aix (Rewald 1983, nos. 580, 581, and 622), but the tower is most prominently featured in this example. No oil painting of the landscape exists.

The composition of the watercolor reveals that it was painted from the central window of the ground-floor studio. In the immediate foreground, Cézanne delineated the top of the terrace wall that stood in front of the house. The rectangular plane beyond represents the small garden that extended to the edge of the hill. From this vantage point, the cathedral tower is cut off from its base, and the town of Aix below is completely obscured.

The focus on the church, with its implicit religious symbolism, underlines the renewed spiritualism that Cézanne sought in his old age and late work after 1895 (Newcastle upon Tyne–London 1973, p. 170). It was also during this period that Cézanne became a central figure in the revival of Provençal culture led by the writer Joachim Gasquet. Both the cathedral and the radiating landscape reflect Cézanne's pride in the history of his native region and his affinity with the soil of the south, which he described as austere, vibrant, and full of light (see Reff 1977, pp. 14, 45).

Here the dematerialization of form is complemented by the watercolor medium with its washes of transparent green, blue, and violet, which animate the image with a palpable airiness. On the whole, the composition is an exercise in equilibrium: the vertical thrust of the cathedral is echoed by the tree in the foreground and balanced by the emphatic horizontal sweep of the distant line of hills.

Cézanne used pencil to rough out the contours of the landscape composition, like a scaffold on which he hung the weightless planes of watercolor wash. Aside from the tree at left, which functions as a traditional *repoussoir*, leading the eye into the picture, the sense of spatial recession and proximity is achieved by the subtle contrasts of hue and gradation of tone. Typically, Cézanne leaves areas of the white sheet blank to impart the presence or volume of space; in this case, the top of the terrace wall or the rectangle of the garden is only minimally delineated, bordered by trees and hedges denoted by single strokes.

Lawrence Gowing argues that Cézanne's procedure of creating an image solely through the modulation of color planes reached maturity with the late watercolors, as exemplified by the work in the Hillman Collection: "Painting a watercolor from the window of his studio, he found the tower of the cathedral in the town held palpitating shadow; among the tangled ultramarine and viridian contours, there was fruit on the tree. There had been nothing like this in his work for thirty years and the only similar design was in one of the etchings he made at Auvers. Yet the fullness of color, woven like garlands across the paper, had never been possible before" (1973, p. 22).

E. B.

PROVENANCE
Paul Cézanne *fils*, Paris; Lilli Wulf, New York; acquired from Paul Rosenberg, New York, June 1948; Hillman Family Collection

LITERATURE
Rivière 1923, p. 224 (as *Le Jardin des Lauves*); Loran 1930, p. 545; Venturi 1936, vol. 1, no. 1077, p. 274; vol. 2, pl. 313; Rewald 1936, figs. 79–80 (with a photograph of the motif); Rewald-Marschutz 1936, p. 30 (with a photograph of the motif); Rivière 1936, p. 162, ill.; Novotny 1938 (list of motifs, p. 203, no. 87); Rewald 1939, figs. 88–89; Nicodemi 1944, fig. 74; Frankfurter 1953, p. 47, ill.; *Art News* 1959 (HC), p. 32, color ill.; De Boisdeffre–Cabanne–Cogniat 1966, p. 109, fig. 86; Wadley 1975, pl. 64; Rewald 1977, p. 95; Rewald 1978 (1), p. 37, ill. p. 33; Philadelphia 1983, no. 35b, ill. p. 74; Rewald 1983, no. 637, p. 256, ill.

EXHIBITIONS
Paris 1935; Basel 1936, no. 96; London-Leicester-Sheffield 1946, no. 36; Chicago–New York 1952, no. 122, p. 96, ill.; New York 1953, no. 42, pp. 13, 22, pl. XVI; Paris 1955, no. 59, pl. 72; The Hague 1956, no. 90, ill.; Zürich 1956, no. 143, pl. 65; Aix-en-Provence 1956, no. 83, ill.; New York 1959 (2), no. 86, ill.; New York 1961, no. 69, p. 58, pl. LVII; Poughkeepsie–New York 1961, no. 91; New York 1963 (1), no. 67, pp. 58–59, pl. LVII; Washington-Chicago-Boston 1971, no. 61, ill.; Bronx 1972 (HC); Laramie 1972 (HC); Newcastle upon Tyne–London 1973, no. 101, p. 170, ill.; Tokyo-Kyoto-Fukuoka 1974, no. 86, ill.; Phoenix 1975 (HC); New York–Houston 1977–78, no. 114, p. 414, pl. 100, p. 297; Paris 1978, no. 72, p. 176, ill. p. 178; Austin et al. 1979–85 (HC); Liège–Aix-en-Provence 1982, no. 35, p. 122, color ill. p. 123; Brooklyn 1986–87 (HC); Brooklyn 1988 (HC); Phoenix 1991–92 (HC).

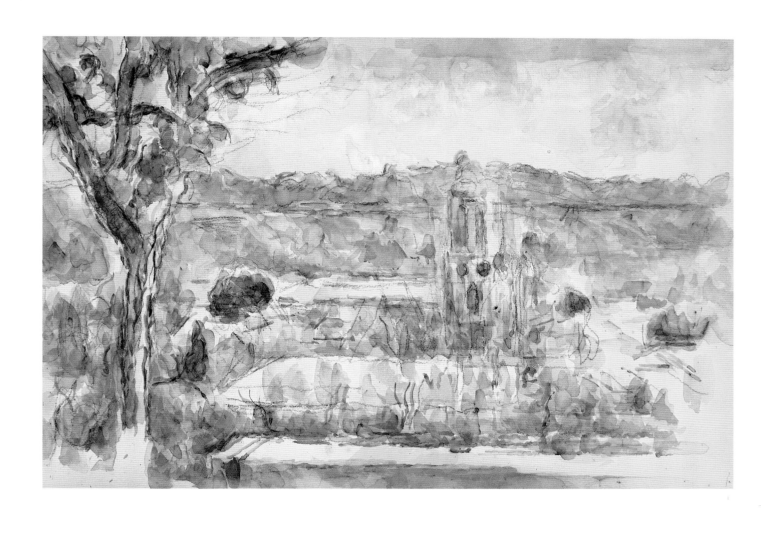

GIORGIO DE CHIRICO (1888–1978)

8. *Metaphysical Composition*
(*Composition métaphysique*), 1914
Oil on canvas, 32 x 21 ½ in. (81.3 x 54.6 cm)
Signed upper left: *G. de Chirico*

METAPHYSICAL COMPOSITION from the Hillman Collection is one of the finest examples of de Chirico's pictorial strategy, which he termed the "solitude of signs": the incongruous juxtaposition of isolated objects that results in a multiplicity of symbolic references and potential meanings. The disparate assemblage includes two chimneys, plaster casts of a pair of feet, a hieroglyphic *X* (a St. Andrew's cross), an egg, and a tube that can be identified as a scroll, a flute, or a fallen tower. A pen-and-ink study for the painting exists in the collection of the Musée Picasso, Paris (Calvesi 1992, repro. p. 251).

The painting has been traditionally called *Self-Portrait*, although it does not depict an image of the artist. It is arguably an erroneous title, assigned to the work when it was first published and exhibited in 1938, while still in the collection of Paul Eluard. It was renamed *Metaphysical Composition* in 1970 (Milan 1970); though not universally adopted, the new title was later reaffirmed by Maurizio Fagiolo dell'Arco (1981, p. 35, and 1984, p. 90). Indeed, the picture belongs to a specific group of still lifes, all dating from 1914 or 1914–15, in which various objects are gathered on a tilted plane and set off against an architectural backdrop. Other compositions of this type include *The Destiny of a Poet, Turin in Spring*, and *The Fête Day* (Soby 1955, nos. 196, 197, and 199).

Similarly, scholars have generally dated *Metaphysical Composition* to 1913, with few exceptions (Fagiolo dell'Arco 1981, p. 90; Ferrara 1981, p. 172–73). On the basis of composition and iconography, Fagiolo dell'Arco places it in the following year. In other still lifes from 1914–15, a ramp dominates the foreground and rises at a precariously steep angle, obscuring the ground level of the distant architecture. The hieroglyph, egg, and scroll also appear regularly in various combinations with other objects, such as an artichoke, a book, or strange toys. *Metaphysical Composition*, however, has a simpler compositional arrangement, the fewest objects, and the least claustrophobic space. Moreover, it is distinguished by the presence of the statuary fragments of feet and the use of two red-brick chimneys in the backdrop instead of a building or an arcade. Plaster fragments and chimneys constitute dominant motifs from a slightly earlier group of landscapes—from late 1913 to mid-1914—in which the compositions consistently open up to the background and the distant horizon line. *Metaphysical Composition* therefore marks a change in de Chirico's development

and is arguably the first in the 1914–15 series of still lifes.

De Chirico typically plays with the conventions of unified, one-point perspective and chiaroscural modeling. Rapid shifts in direction and scale replace any congruent unfolding view. Elements such as the chimney and feet are cut off by the frame, while on the right the ominous shadow of an unidentified object looms outside the picture space. Despite their naturalistic description, the rounded objects defy the laws of gravity, which would normally oblige them to slide down the ramp and topple into the viewer's space. The lack of logical spatial relationships and the ambiguity inherent in the objects themselves contribute to a sense of discomfort, surprise, or what de Chirico termed "revelation" in the viewer. By bringing together disparate objects in a strange context, de Chirico causes us to question their ultimate significance: the egg, for example, not only denotes an egg but begs for a variety of symbolic identifications.

Hence the literature has attempted to attach a precise narrative to the painting, through either a traditional allegorical or psychoanalytic reading. James Thrall Soby noted that it "testifies to de Chirico's rising interest in the symbolic efficacy of objects and signs," and, by example, he discusses the interpretation forwarded by Gordon Onslow-Ford in a lecture of 1943 or 1944 entitled "Chirico City"(1955, p. 67). Onslow-Ford considered the image an allegory of the progress of life, moving from the foreground to the background of the composition, with the plaster toes representing de Chirico's infancy and the chimneys his adult virility. On a more abstract level, the cross is to be read as the artist's "aspiration to faith and knowledge" and the egg as "his renunciation and retreat from reality."

Meyer Schapiro also lectured on the painting (as recorded by Daftari 1976, p. 25), viewing it as "a series of dualities," of crossed and contrasted elements (the two chimneys, the pair of feet), which express "the artist's conception of his own conflicted nature." Joseph Sloane considers the scroll a record of the past and suggests that the egg stands for the hope of rebirth. Combined with the chimneys—a reference to the industrialization of the modern state—he sees the entire image as a meditation on the risorgimento, or the unification of Italy. Consequently, he

relates the prominent plaster casts to a popular print of Garibaldi's feet recording the heroic wounds the risorgimento hero received in the legendary 1862 Battle of Aspromonte (1958, p. 15).

The latter identification is accepted by Fagiolo dell'Arco, who also offers an explanation for the hieroglyph *X* drawn on the wall. He quotes a passage from Nietzsche's aphorisms (de Chirico's favorite source material), in which the philosopher expounds on the phenomenon of revelation that arises after prolonged convalescence: "Great pain alone is the extreme liberator of the spirit, in as much as it is the master of the grand anticipation that makes of every U an X, a true and proper X, that is, the penultimate letter of the alphabet before the final one." In turn, de Chirico stated repeatedly that the invention of metaphysical painting occurred to him after a long period of convalescence from an intestinal illness in 1910. Elaborating on de Chirico's sources in nineteenth-century German philosophy, Fagiolo dell'Arco identifies the tubular object as a flute, "the instrument that Schopenhauer played," and an allusion to Nietzsche's *Thus Spake Zarathustra* (1984, p. 91).

The variety and hermetic quality of the interpretations attest to de Chirico's underlying premise: the futility of striving for a coherent, unified meaning in art or in life. As with *Metaphysical Composition*, de Chirico aimed at systematically generating ambiguity or multiplicity—the enigma— rather than any fixed logical truth. Indeed, in his own words, the picture "must represent something which has no sense in itself, has no subject, which from the point of view of human logic, means nothing at all" (*London Bulletin* 1938, p. 14).

E. B.

PROVENANCE
Galerie Paul Guillaume, Paris; Paul Eluard, Paris; London Gallery, London; Sir Ronald Penrose, London; Gordon Onslow-Ford, San Francisco and New York; Richard S. Zeisler Collection, New York; John L. Senior, Jr., New York and Connecticut; acquired from the New Gallery, New York, April 1956; Hillman Family Collection

LITERATURE
Zervos 1938, ill. p. 384 (as *Portrait of the Artist*, 1910); *Dictionnaire* 1938, ill. p. 39 (as *Portrait of the Artist*); *London Bulletin* 1938, p. 13 (Checklist of the London Gallery exh.: no. 2, as *Portrait of the Artist*); Gaffé 1946, pl. 2 (as *Self-Portrait*, 1910); Soby 1941, pp. 30–32; pl. 9 (*Self-Portrait*); Soby 1955, p. 67, ill. p. 183 (as *Self-Portrait*, Collection Richard Zeisler); Sloane 1958, p. 15, fig. 14, p. 12; *L'Arte Moderna* 1967, ill. p. 15; Rubin 1968, no. 104, p. 96, ill. p. 117 (as *Self-Portrait*); *Encyclopedia universalis* 1972, no. 2, color pl. II (as *Metaphysical Composition/Self-Portrait*); Daftari 1976, pp. 24–25, 179, ill. p. 25 and fig. 24, p. xxiii (as *Self-Portrait*); Schmied et al. 1980, no. 5, p. 135, in color, and p. 286, no. 23 (*Metaphysical Composition/Metaphysical Self-Portrait*); Ferrara 1981, no. 39, pp. 172–73, color ill. p. 241 (as *Self-Portrait*, 1913–14); Fagiolo dell'Arco 1981, no. 58, p. 135, ill. (as *Metaphysical Composition*, 1914); Fagiolo dell'Arco 1984, no. 60, pp. 90–91, ill. (as *Metaphysical Composition [Self-Portrait]*, 1914); Minemura 1986, p. 19, color ill.; Calvesi 1992, p. 33, ill. p. 34 (*Composizione Metafiscâ*).

EXHIBITIONS
Paris 1938, no. 34 (as *Portrait of the Artist*, Collection Eluard); London 1938, no. 2 (as *Portrait of the Artist*, Collection Eluard); New York 1943, no. 2 (Collection Gordon Onslow-Ford); Bennington 1960, no. 4 (as *Self-Portrait*); New York 1968 (as *Self-Portrait*); Milan 1970, no. II, pp. 15, 27, pl. II (as *Metaphysical Composition*); Hanover-Paris 1970, no. 9, p. 62, ill. p. 36 (as *Metaphysical Self-Portrait*); Bronx 1972 (HC) (as *Self-Portrait*); Laramie 1972 (HC) (as *Self-Portrait*); Jacksonville–Corpus Christi 1973–74 (HC), no. 17 (as *Self-Portrait*); New York 1976, no. 16 (as *Self-Portrait*); London 1978 (as *Self-Portrait*) p. 20, no. I.8, in color; Venice 1979, no. 16, p. 50, pl. 16 (as *Self-Portrait*); Austin et al. 1979–85 (HC) (excluding Oklahoma City and Hunstville); New York et al. 1982, p. 151, pl. 26 (as *Self-Portrait*); Munich-Paris 1982–83, no. 15, ill. p. 149 (as *Metaphysical Composition/Self-Portrait*); Brooklyn 1986–87 (HC); Brooklyn 1988 (HC); London 1989, no. 46, color ill. (as *Self-Portrait*, 1913); Phoenix 1991–92 (HC).

53

GIORGIO DE CHIRICO (1888–1978)

9. *Untitled Landscape with Petrified Boat and Figures*
 (*The Dioscuri*), c. 1925 (?)
Pencil on paper, 9 ½ x 12 ¼ in. (24 x 31 cm)
Signed lower right: *G. de Chirico*
Verso: *Untitled drawing with a portrait of Gala Dalí*, c. 1924–25 (?)
Pencil
Inscribed and signed lower right: *Le retour a une suite* and
 G de Chirico; inscribed lower center by another hand: *Madame Gala Dali*

THOUGH DEPICTING WIDELY DIFFERENT SUBJECTS, the two sides of this drawing are related by the theme of voyage, which was central to de Chirico's art. The landscape suggests a port city, with buildings in the background and a lowered sail behind a wall. In the foreground, partially sketched figures pilot a boat: a sailor at the far left grasps the helm, while another sits at the prow. The entire group appears petrified and rendered immobile on a rocky base.

Typically, de Chirico includes multiple and fragmented references to ancient myth as well as to his own work and autobiography. The foreground scene likely alludes to the Argonauts (a metaphor for artistic quest) and the two delineated figures to the twins Castor and Polydeuces, sons of Zeus, known as the Dioscuri, who took part in the mythic expedition. De Chirico frequently depicted himself and his brother Alberto Savinio in the guise of the Dioscuri. The eyes drawn at the lower left are a typical motif for de Chirico and symbolize, alternatively, the visionary powers of the artist, the omnipotence of the gods, or human vigilance. Lastly, the petrification of the boat and the background port most likely refer to a passage from the *Odyssey*: after carrying Ulysses back to Ithaca, the Phoenicians and their ship were turned into a rock by Poseidon as they entered into the harbor. Given the scenographic quality of the composition, it may well relate to de Chirico's set designs for Savinio's *Capitan Ulisse*, which was commissioned by the Compagnia del Teatro, Rome, in 1925. (See Fagiolo dell'Arco–Baldacci 1982, pp. 176–77, 179.)

The image on the reverse includes a portrait of Gala Dalí in costume and hat. She was married to the French poet Paul Eluard from 1917 until 1929, when she left him for Salvador Dalí. Eluard was a principal patron of de Chirico and his entrée to the surrealist group in Paris. Eluard traveled to Rome in 1923 to meet de Chirico—their first encounter; Eluard purchased several of the artist's works from that year's Biennale. The characterization of Gala's features in the drawing closely resembles de Chirico's double portrait of the Eluards of 1924 (location unknown, repro. in Fagiolo dell'Arco-Baldacci 1982, p. 139). The sentence in de Chirico's

handwriting reads *Le retour a une suite* (The return has a sequel). In another contemporary portrait drawing of Gala by de Chirico (private collection, repro. in Fagiolo dell'Arco–Baldacci 1982, p. 140), the artist added the line *Retour en terre de France* (The return to French soil). Though the exact meaning remains obscure, both inscriptions may allude to the return of the Eluards to Paris in October 1924, after a trip around the world. On the basis of this reference, the drawing dates from late 1924–25.

The second inscription at the very base of the drawing —*Madame Gala Dali*—is not in de Chirico's handwriting and was likely added much later, clearly after her 1929 liaison with Dalí. That de Chirico broke with the surrealist circle in 1926 further limits the possibility that he drew the portrait of Gala at a later date.

Finally, the burly mustached man with the furrowed brow rendered beside her corroborates the dating of 1924–25 for both sides. This paternal character is found frequently in the work of both de Chirico and Savinio from the mid-twen-

ties and represents alternatively a father figure, a deity, or a philosopher. He also appears in the guise of Ulysses, specifically in a sketch by de Chirico for Savinio's *Capitan Ulisse* (repro. in Fagiolo dell'Arco–Baldacci 1982, p. 177). The Homeric wanderer next to Gala links the portrait to the scene from the *Odyssey* on the recto, though there is no evidence that the two studies were created together or conceived as a pair.

E. B.

PROVENANCE
Unknown; no record of acquisition; Hillman Family Collection

9. GIORGIO DE CHIRICO *Untitled Landscape with Petrified Boat and Figures*

9. (verso) GIORGIO DE CHIRICO *Untitled drawing with a portrait of Gala Dalí*

EDGAR DEGAS (1834–1917)

10. *Dancer Standing*
(*Danseuse debout*), c. 1878–80
Charcoal on tan paper, 23 x 17 in. (58.4 x 43.2 cm)
Estate stamp lower left: *Degas*

T HE BALLET WAS THE MOST PREVALENT THEME in Degas's work, beginning in the late 1860s and continuing through the next four decades of his career. Like his fellow impressionists, Degas depicted the subjects of modern urban life. While sketching backstage at the Paris Opéra, Degas was able to study the human body in motion and to observe a specifically French and contemporary social phenomenon. His behind-the-scenes view of ballet, beyond the glamour of the performance, revealed it to be a grueling, competitive vocation, filled with adolescent girls from the working class trying to support themselves.

Unlike the plein-air canvases of many of his impressionist colleagues, Degas's paintings were done primarily from memory in his studio and often based on numerous drawn studies. *Dancer Standing* is a study for one of the ballerinas in the *pas de trois* of the upper left-hand corner of *The Dance Class* completed in 1881 (Philadelphia Museum of Art; Lemoisne 1946–49, vol. 2, no. 479; Boggs et al. 1988, p. 337). The young dancer is shown with her arms raised, standing in the fifth position, her expression intent on mastering her technique. The torso and tutu are summarily represented, while most of the emphasis is given to the legs, arms, and head. The adjustments made to the right hand and leg show that Degas used the drawing to clarify his understanding of the dancer's posture before painting the figure on canvas. A dancer in a nearly identical pose is the subject of another study, *Dancer Standing, Arms Raised* (*Danseuse debout, les bras levés*; Vente II, 1918, no. 312; Boggs et al. 1988, p. 337).

It is likely that the study predates *The Dance Class* by a number of years. The drawing has been dated about 1878–80, presumably on the basis of the dates originally given to the painting (Lemoisne 1946–49, 1878; Browse 1949, c. 1880). More recently, the finished painting has been dated firmly to 1881, with a starting date of 1880 and possibly as early as 1879 (Boggs et al. 1988, p. 337). Typical of Degas, he reused the same figure group of the three dancers in several other paintings of the early 1880s (Lemoisne 1946–49, nos. 587, 588, 589, 590, 703; Boggs 1985, pp. 12–13).

As with this example, it was not unusual for Degas to include a number of studies on the same sheet. Here, a second, less fully developed, figure is visible in the upper left corner. It appears to be a study of a woman at a washbasin washing her hair or sponging her neck: her right arm is raised behind her head and the left hand reaches down in a circular, cupping motion. The same subject is more clearly rendered in the charcoal drawing *Woman at Washbasin, Two Studies* (*Femme à sa toilette, deux études*, Vente IV, 1919, no. 159). The bather, emerging from a tub or standing at a washbasin, was another theme Degas regularly treated in the early 1880s.

In the lower left corner is the facsimile stamp of Degas's signature, which was applied in 1919 at the time of the third sale of the contents of the artist's studio. The stamp was not yet evident in the photograph of the work in the sale catalogue (Vente III, 1919, no. 218).

J. B.

PROVENANCE
Vente III, Galerie Georges Petit, Paris, April 7–9, 1919, no. 218, p. 177, ill.; Galerie Durand-Ruel, Paris (inv. no. 11477); acquired from Durand-Ruel Galleries, New York, October 1948; Hillman Family Collection

LITERATURE
Boggs 1985, p. 12 and p. 41 n. 28; Boggs et al. 1988, p. 337.

EXHIBITIONS
Bronx 1972 (HC), ill. in brochure; Laramie 1972 (HC); Jacksonville–Corpus Christi 1973–74 (HC), no. 1, ill.; Roslyn 1977–78 (HC), no. 5, ill.; Austin et al. 1979–85 (HC); Brooklyn 1986–87 (HC); Brooklyn 1988 (HC); Phoenix 1991–92 (HC).

EDGAR DEGAS (1834–1917)

11. *Draft Horse*
(*Cheval de trait*), c. 1865–81
Bronze, cast from a master in an edition of 22, (1919–21)
4 x 7¼ x 2¼ in. (10.2 x 18.4 x 5.7 cm)
Stamped on the base: *Degas;* stamped and numbered on the
base: *Cire Perdue, A.-A. Hébrard; 30/T*

HORSES WERE DEGAS'S FIRST SUBJECTS when he began modeling in wax, probably in the mid-1860s. According to John Rewald, Degas took up sculpture as a compositional aid for his paintings; arguably, the first instance was a horse made as a study for *Mlle Fiocre in the Ballet "La Source"* (1990, pp. 14–15). By the 1870s the race course counted among Degas's favorite scenes of contemporary life, and he regularly used modeling to further his grasp of equine anatomy, motion, and grace. Early on, Degas admired the work of Joseph Cuvelier, a specialist in bronze statuettes of horses, who exhibited regularly in the Salons of the second half of the 1860s (Rewald 1990, p. 14). Some two decades later, Degas was directly inspired by the photographs of Eadweard Muybridge and Etienne-Jules Marey, who captured the precise movements of horses in stop-action sequence.

Despite his avid interest in modeling, Degas never intended to cast his sculptures: only three were produced in plaster during his lifetime. Significantly, Degas preferred the process of constant elaboration and modification, encouraged by the inherent mutability of the wax medium. At the time of his death, some 150 pieces in various states of preservation were found in his studio: seventy-two were deemed salvagable and were repaired and cast by the firm of A.-A. Hébrard in editions of at least twenty-two each (as indicated by the letters *A* through *T*, plus those reserved for the artist's family and the foundry).[1] Given the fragility of the original waxes (acquired by the collector Paul Mellon in 1955), Hébrard made one set of intermediary master bronzes, from which the posthumous editions were actually cast (Tinterow 1988, p. 609). The master bronzes were purchased by Norton Simon for his collection in 1976.

Seventeen of the seventy-two sculptures are of horses. The descriptive titles were also assigned posthumously, on the occasion of the first exhibition of the bronzes, at the Hébrard gallery in Paris in 1921. For the most part, Degas modeled the graceful physiques of thoroughbreds jumping, rearing, trotting, or at rest: the Hillman work is his only sculpted version of a draft horse. With visual acuity Degas analyzes the muscular stress and strain as the horse lunges forward to pull the weight behind, posed in a seemingly impossible instant of imbalance. As Degas rendered the salient physiognomies of people of various social classes, so too he distinguished between equine breeds, truthfully showing the sturdier body, shorter legs, and thicker nose of the working animal.

Dating the Degas bronzes is fraught with difficulty. The artist often reworked the waxes over a period of years, and the posthumous repairs needed to prepare the wax originals for bronze casting complicates stylistic analyses. Rewald places all of the horses in the first of his three chronological groupings for Degas's sculpture—1865–81—within which the *Draft Horse* occurs early on (1990, p. 37). Charles Millard, however, argues that the draft horse "pulls against, rather than hauls a load," and thus belongs to the series of "more movemented poses," influenced by Muybridge's photographs (1976, p. 23 n. 83). He dates the work to 1881 and considers it the first of nine horse sculptures Degas made after his initial contact with the Muybridge studies. Most recently, Gary Tinterow reduced to six the number of waxes securably datable to 1880–90, excluding the *Draft Horse* from the later period (1988, p. 459).

E. B.

[1] The seventy-third sculpture, *The Little Fourteen-Year-Old Dancer,* was cast in an unnumbered edition during the 1920s, and an additional sculpture, *The Schoolgirl,* was cast in the 1950s (Tinterow 1988, p. 609).

PROVENANCE
Atelier Degas, Paris; A.-A. Hébrard, Paris; acquired from the O'Hana Gallery, London, September 1957; Hillman Family Collection

LITERATURE (other versions)
Millard 1976, no. 59, p. 23 n. 83, p. 99, ill.; Rewald 1990, pp. 56–57, pl. 7; Pingeot 1991, pp. 174–75, ill. (with a complete bibliographic reference).

SELECTED EXHIBITIONS
Paris 1921, no. 45; Paris 1931, no. 45, p. 140; London 1957 (Hillman version); Amsterdam 1991–92, no. 30, p. 54.

ANDRÉ DERAIN (1880–1954)

12. *Head of a Girl,* c. 1924
Oil on canvas, 12 ½ x 10 ½ in. (31.8 x 26.7 cm)
Signed lower right: *Derain*

T HOUGH BEST KNOWN FOR his brilliantly colored landscapes painted in the first decade of this century, Derain was a Fauve for only a brief period of his career. His experiment with cubism had an even shorter duration: by 1911–12 he was pursuing a naturalistic style and the cultivation of the grand tradition in painting. Derain's development anticipated that of his peers—including Picasso—who similarly returned to figuration and classicizing themes by 1915. Before World War 1, Derain's art was disparaged as reactionary; afterwards, it was celebrated as part of the return to order and the new conservative national mood.

Derain's reputation soared on both sides of the Atlantic in the late 1920s, supported by the marketing efforts of the dealer Paul Guillaume, who also promoted the artist's work in the United States through other galleries. In 1940, a year before this painting was acquired by the Hillmans, Derain was the subject of a benefit exhibition for the American Friends of France at the Pierre Matisse Gallery, New York. The show, well received and highly publicized, marked the height of his popularity in America (Parke-Taylor 1982, pp. 23–25). Since World War II Derain's late work has been considered outside the modernist mainstream and thus has fallen into neglect as extreme as his earlier success.

Female nudes and portraits, all painted from the live model, were among Derain's favored subjects in the 1920s (Sutton 1959, pp. 41–42). *Head of a Girl* is one of many delicate, bust-length portraits, which, even when identified as specific sitters, are all of one feminine type: olive skinned, brunette, recognizably Latin. They ultimately derive from Corot's series of Italian peasant women, which influenced Derain's classical manner after World War I. Here the facial features are rendered with a few strokes of the brush, emphasizing the curve of the eyebrows, the flat bridge of the nose, and the planes of the lips. The dark contour line used to define the forms is a deliberate allusion to the mannerisms of Egyptian and Fayum portraits. With its limpid brushwork and burnished tones, *Head of a Girl* also exudes the earthy and sensual qualities that Derain admired in the French masters Courbet and Renoir. The soft, broken brushwork and quivering line place the work in the mid-1920s; in later years, the surfaces of Derain's canvases become harder and less modulated.

E. B.

PROVENANCE
Acquired from M. Knoedler and Co., Inc., New York, November 1941; Hillman Family Collection

EXHIBITIONS
Bronx 1972 (HC); Roslyn, 1977–78 (HC), no. 6, ill.; Austin et al. 1979–85 (HC).

JEAN DUBUFFET (1901–1985)

13. *Paris Scenes: Shops*
(*Vues de Paris: Les Boutiques*), 1944
Oil on canvas, 28 ¾ x 36 ¼ in. (73 x 92 cm)
Signed and dated lower right: *J. Dubuffet janvier 44*

*P*ARIS *S*CENES: *S*HOPS dates from the period between Dubuffet's return to painting after a long absence, in 1942, and his first solo show, held at the Galerie René Drouin in 1944, just months after the liberation of Paris. It belongs to the *Vues de Paris* series, images of store and apartment-house façades that Dubuffet painted from January to March 1944. The lower-income neighborhood shown in the painting is likely the one surrounding his residence at 35 rue Lhomond, before he moved to his new studio and house on the rue de Vaugirard sometime in 1944. Dubuffet's first dealer, René Drouin, called the work *Les Boutiques* when the Hillmans bought it in 1952. (The Hillmans were among the very first collectors of Dubuffet in America.)

In the morally devastated milieu of postwar Paris, Dubuffet and his intellectual circle rejected traditional culture in favor of the base and discarded and the evidence of every-day humanity seen on the street. The views of the city and its inhabitants evolved out of Dubuffet's pictures of people on the Parisian Métro of 1943. The puppetlike anatomies and grimacing features, however, have their roots a decade earlier in the artist's series of papier-mâché masks. In a graphic scrawl that looks forward to his later graffiti images, Dubuffet delineates four passersby and the shop fronts of the local vendors—among them a restaurant, a bar, a shoemaker, and a barber. Above, two residents look out their windows, locked into the surrounding edifice, which appears half modern tenement, half prehistoric cave.

Despite the lowly stature of the neighborhood, the image exudes vitality with its raunchy colors, nervous black lines, and rough application of paint. Shunning illusionistic perspective and modeling, Dubuffet's composition asserts the flatness of the picture plane in a naive manner reminiscent of children's art. At the same time, the windows of the facade set up a sophisticated play between surface and depth, creating layers like geological strata. Indeed, Dubuffet expands the metaphor of accumulation with his multilayered application of paint: the underlying areas often show through, and elsewhere the surfaces seem worn or abraded. Shortly after the *Vues de Paris* series Dubuffet renderred close-up images of crumbling walls and actual graffiti. And in 1945 he began his collection of *art brut*, the art of children, the insane, and others outside the mainstream, whose disinterest toward convention supported his own anticultural position.

E. B.

PROVENANCE
Acquired from Galerie René Drouin, Paris, 1952; Hillman Family Collection

LITERATURE
Art News 1959 (HC); ill. p. 33; Loreau 1966, no. 226, p. 127 (as *Vue de Paris: Quartiers résidentiels* and misdated February 1944).

RAOUL DUFY (1877–1953)

14. *Homage to Mozart*
(*Hommage à Mozart*), 1934
Oil on canvas, 50 x 42 ½ in. (128 x 108 cm)
Signed lower right: *Raoul Dufy;* dated lower left: *1934*

*H*OMAGE TO MOZART belongs to a series of images
dedicated to great composers—Bach, Chopin,
Debussy—which Dufy began in 1915 and returned to
periodically until 1952. As in other examples, the composer's
name appears on the title page of sheet music, set prominently
in the foreground plane and accompanied by musical instru-
ments, variously a violin, a piano, or, in this case, a clarinet.
Dufy's passion for music originated in his childhood, nurtured
by his father, Léon-Marius Dufy, an accountant who in his
spare time was an organist and conductor for two church
choirs in Le Havre. The artist's two brothers, Léon and
Gaston, became professional musicians.

The present image is a reworking of the very first in the
series, *Hommage à Mozart* of 1915 (Laffaille 1972–77, no. 385,
p. 318). It depicts the musician's house in Salzburg, as seen
from a window across the street. The view is defined by a
shutter at the left, a curtain at the right, and the curvaceous
lines of a wrought-iron balcony. In this version of 1934, Dufy
added a trompe-l'oeil frame with a scallop shell at its base,
surrounded by a decorative flower garland. A version of the
picture appears without the painted border but in an eigh-
teenth-century frame in Dufy's 1935 painting of his Paris
studio (The Phillips Collection, Washington, D.C.; Laffaille
1972–77, no. 1184, p. 216).

The painting was used as the basis for a tapestry com-
missioned by the dealer and collector Marie Cuttoli. The
tapestry is an exact reproduction of the image in reverse, down
to the placement of the date and signature (sale, Christie's
New York, May 21, 1982, no. 409, p. 45; location unknown).
Though Dufy executed numerous cartoons for furniture
covers and wall decoration for Cuttoli, only one tapestry was
based directly on an oil painting.

E. B.

PROVENANCE
Acquired from the Galerie Marcel Bernheim, Paris, May 1961; Hillman
Family Collection

LITERATURE
Laffaille 1972–77, no. 1490, p. 79, color ill.; Perez-Tibi 1989, p. 245.

EXHIBITIONS
Bronx 1972 (HC); San Antonio 1980, no. 23; London 1983–84, no. 107,
p. 164; Brooklyn 1986–87 (HC); Brooklyn 1988 (HC).

RAOUL DUFY (1877–1953)

15. *The House in Normandy*
(*La Maison en Normandie*), 1935
Oil on canvas, 13 x 31 in. (33 x 78.7 cm)
Signed and dated left of lower center: *Raoul Dufy 1935*

THE HOUSE IN NORMANDY SHOWN in this canvas, also known as the Manoir du Vallon, was the property of Dufy's friend and Paris dealer, Etienne-Jean Bignou. Dufy depicted the Tudor-style building on numerous occasions when he visited there in the years 1934–37. The artist recorded the men's comraderie in a watercolor in which they raise their glasses in a toast, while seated in front of an easel holding a painting of the Manoir du Vallon (Laffaille 1972–77, no. 768, p. 283).

Among approximately ten existing images of the house, this is the only one with a pronounced horizontal format and sweeping view of the surrounding orchard in bloom. Typically, the house is placed in the center of the composition and seen from a three-quarter angle, which reveals its picturesque design at its best. The embracing branches and foliage, depicted in the fullness of the spring and summer months and rendered in Dufy's luxuriant calligraphy, add to the impression of a protected and secluded country domicile.

E. B.

PROVENANCE
Jean Metthey, Paris; acquired from French Art Galleries, Inc., New York, January 1952; Hillman Family Collection

LITERATURE
Laffaille 1972–77, no. 769, p. 284 (as *La Manoir du Vallon*), color ill.

EXHIBITIONS
Paris 1936, no. 26; San Francisco–Los Angeles 1954, no. 55, ill. p. 34 (as *House by the Sea*); Bronx 1972 (HC); Laramie 1972 (HC); Jacksonville–Corpus Christi 1973–74 (HC), no. 5, ill.; Roslyn 1977–78 (HC), no. 8, ill.; London 1983–84, no. 113, p. 165, ill. p. 149; Phoenix 1991–92 (HC).

RAOUL DUFY (1877–1953)

16. *Boatmen on the River Marne*
(*Canotiers sur Marne*), c. 1922
Oil on canvas, 22 ½ x 27 ¾ in. (57 x 70.4 cm)
Signed lower right: *Raoul Dufy*

CANOEING, SAILING REGATTAS, AND HORSE RACING were the scenes of the sporting life that Dufy preferred to paint. The site of this work was the rowing club at Nogent-le-Perreux near Chaumont on the river Marne. Between 1919 and 1940 Dufy painted more than two dozen versions of the clubhouse, its surroundings, and pleasure seekers.

In the early 1870s the impressionists Monet and Renoir established boating scenes in the Parisian suburbs as one of their chief subjects. Their images drew attention to the leisure activities of the growing middle class and the phenomenon of the weekend escape from the city. By Dufy's time, the sociological novelty of the subject had long worn off; his subject is the sheer pursuit of the joys of nature and sport.

Dufy's fascination with aquatic activities and the depiction of water stems from his childhood in the port city of Le Havre. In *Boatmen on the River Marne* the sensation of the animated moment—the rustling of the lush foliage and the fleeting current of the water—arises from the lively graphic notations and the washes of pure, pulsating color. Aside from a few dashes of red, Dufy restricts the image to a blue-green palette, evocative of the subject and setting. Color is not contained within the linear contours but floats on the surface in brilliant, decorative patches, betraying Dufy's stylistic roots in the Fauve movement.

Though undated, the painting belongs to the first views he did at Nogent-le-Perreux in 1921–25 and stylistically resembles those dated to the beginning of the decade (Laffaille 1972–77, nos. 936–43). As in other works, the centrally placed clubhouse dominates the tripartite composition, and the activity is restricted to a single canoe parallel to the foreground plane. The background color is also disposed in three vertical swaths, reinforcing the symmetry of the image. By contrast, when Dufy returned to the subject in the mid-1930s, he expanded the breadth, varied the angle of view, and included numerous other elements, such as sailboats and a bridge (Laffaille 1972–77, nos. 948–56). The later works are also, invariably, dated on the canvas.

E. B.

PROVENANCE
Marie Cuttoli, Paris; acquired from Galerie Marcel Bernheim, Paris, 1965; Hillman Family Collection

LITERATURE
Laffaille 1972–77, no. 936, p. 15, color ill.

EXHIBITIONS
Bronx 1972 (HC); Roslyn 1977–78 (HC), no. 7, ill.; San Antonio 1980, no. 34; Austin et al. 1979–85 (HC); Brooklyn 1986–87 (HC); Brooklyn 1988 (HC); Phoenix 1991–92 (HC).

THOMAS EAKINS (1844–1916)

17. *Seated Nude I,* c. 1869
Charcoal on paper, 24 x 18 in. (61 x 45.7 cm)
Verso: *Head of a Warrior,* c. 1869
Charcoal

THESE EARLY STUDIES are rare documents of Thomas Eakins's education at the École des Beaux-Arts in Paris. Although already a disciplined draftsman who had studied at the Pennsylvania Academy of the Fine Arts, Eakins entered the École in 1866, in part to gain experience working from the live model. For three years, he studied primarily with the renowned academician Jean-Léon Gérôme, who was admired for his conscientious teaching, precise draftsmanship, and knowledge of human anatomy. Like all entrants to Gérôme's atelier, Eakins was first put to work drawing from plaster casts of ancient sculptures, as exemplified by *Head of a Warrior.* He was then permitted to draw from the live model during morning sessions, five days a week, in which he produced such works as *Seated Nude I.* Based on a male nude model, this

kind of finished study was called an *académie.* Both types of drawings would be judged according to academic standards of accuracy and objectivity.

Although his progress was slow, Eakins relished Gérôme's comment concerning "a feeling for bigness" in his modeling of the human form (letter of March 1867 quoted in Goodrich 1982, vol. 1, p. 23). This compliment accorded with Eakins's growing conviction that nature should not be slavishly copied but vividly re-created. The vantage point of *Seated Nude I*—slightly below eye level—suggests that Eakins had advanced to the front row, a place reserved for favored students. By March 1867 he was allowed to begin painting. He evidently continued, however, to draw from casts and the nude model.

The dating of the small group of Eakins's surviving early, charcoal drawings has been a matter of considerable controversy. Therefore, it is not possible to date the drawings

in the Hillman Collection with certainty. Nevertheless, the customary date of 1869 first provided by Roland McKinney can be supported on the basis of the broad modeling and bold contrasts of light and dark. These qualities suggest the impact of Eakins's studies in the summer of 1869 with Léon Bonnat, as well as his trip later that year to Spain, where he discovered the work of Velázquez and Ribera. Other scholars have suggested that this two-sided drawing was rendered after Eakins's sojourn in Paris, and they compare it to other figure studies of around 1874–76, when he taught an evening life-drawing class at the Philadelphia Sketch Club.

Eakins's academic training in France had a profound impact on his subsequent career as an artist and professor. He emphasized the nude in his rigorous teaching at the Pennsylvania Academy and urged students to aspire to the naturalistic standards of the ancients.

G. S.

PROVENANCE
Susan MacDowell Eakins, Philadelphia; acquired from Babcock Galleries, New York, October 1948; Hillman Family Collection

LITERATURE
Goodrich 1933, no. 18, p. 161 (not dated); McKinney 1942, p. 87 (dated 1869 and credited to Babcock Galleries); Homer 1992, figs. 26, 27, ill. p. 31 (not dated).

EXHIBITIONS
Bronx 1972 (HC); Jamaica 1982 (as *Head of Pericles* and *Male Nude*, c. 1874–76); New York 1982 (exh. brochure, as *Head of Pericles* and *Male Nude*); New York 1992.

17. THOMAS EAKINS *Seated Nude I*

Drawing by
Thomas Eakins

17. (verso) THOMAS EAKINS *Head of a Warrior*

PAUL GAUGUIN (1848–1903)

18. *Torso of a Woman/Tahitian Woman*, 1893
Bronze, 6/10, cast c. 1950, 11½ x 5¾ x 5¼ in.
 (29.2 x 14.6 x 13.3 cm)
Stamped on base: *Cire Perdu C. Valsuani*

GAUGUIN'S FIRST FORAYS INTO SCULPTURE, in 1886 at the start of his career, were clearly intended as money-making ventures. But carving wood and molding clay were to become as central to his artistic production as his better-known work in paint, and after 1894 Gauguin shifted his attention to sculpture (Brettell et al. 1988, p. 58). Indeed, the deliberate crudeness of some of his three-dimensional work would provide the artist with an opportunity to revel directly in raw material that painting could not provide. He produced more than one hundred sculptures during his career.

From Gauguin's first participation in the impressionist exhibitions (the fifth, in 1880), he submitted sculpture along with paintings. But his experimentation in sculpture intensified when the printmaker Félix Bracquemond introduced Gauguin to Ernest Chaplet in June 1886. Chaplet was thought to be one of France's leading ceramicists, having served a thirteen-year apprenticeship at the Sèvres factory. He was also noted for his experimentation with stoneware—brown clay which he decorated with raised flowers, highlighted in gold— for Haviland in Limoges. Gauguin, who had already mastered carving of both marble and wood, was excited by the potential of clay. Under Chaplet's tutelage, he explored the medium to great advantage, capitalizing on its rough texture and gritty surface. His ceramics were apparently created in concentrated periods when he resided in Paris, both before his departure for the tropics and upon his return.

Ceramics were well suited to Gauguin's symbolist desire to capture the essence, or soul, of a work of art. Indeed, the critic Albert Aurier, in a landmark article of 1891, wrote: "How can one adequately describe these strange, barbaric, savage ceramic pieces, into which the sublime potter has molded more soul than clay?" (1891, p. 57). Gauguin might have been inspired by the Peruvian pottery that he would have seen in the collections of both his mother and his guardian, Gustave Arosa (Gray 1963, p. 22). But his clay pots, molded with several handles, figures, and various openings, were never intended to be utilitarian objects.

Gauguin's *Torso of a Woman* in the Hillman Collection is one in an edition of ten bronzes cast from the original unfired clay. Though generally referred to as a Tahitian woman, the statue could not have been made in the tropics, since the raw clay pieces that Gauguin referred to as "clay covered with wax" disintegrated in the hot Tahitian climate. A similar type of clay is used in *Square Vase* (Musée d'Orsay, Paris), which was made in 1894 during Gauguin's stay France in between his two Tahitian trips (Perruchot 1961, p. 49).

Though eroded by time and wear before Curt Valentin had it cast in bronze around 1950, the piece exhibits a brutal force and emotional intensity, accentuated by the truncated arms and legs and the tensely tucked-in abdomen. The simple planes of the face, with its hollow eye sockets, reinforce and enhance the raw and spiritual primitivism that Gauguin sought in his sculpture.

E. E.

PROVENANCE
Acquired from the Buchholz Gallery (Curt Valentin), New York, March 1952; Hillman Family Collection

LITERATURE (pertaining to the original clay)
Gauguin 1946, pls. 24–25; Gray 1963, no. 116, p. 252, ill.

EXHIBITIONS (other versions of the bronze)
New York 1951, no. 34; New York 1958.

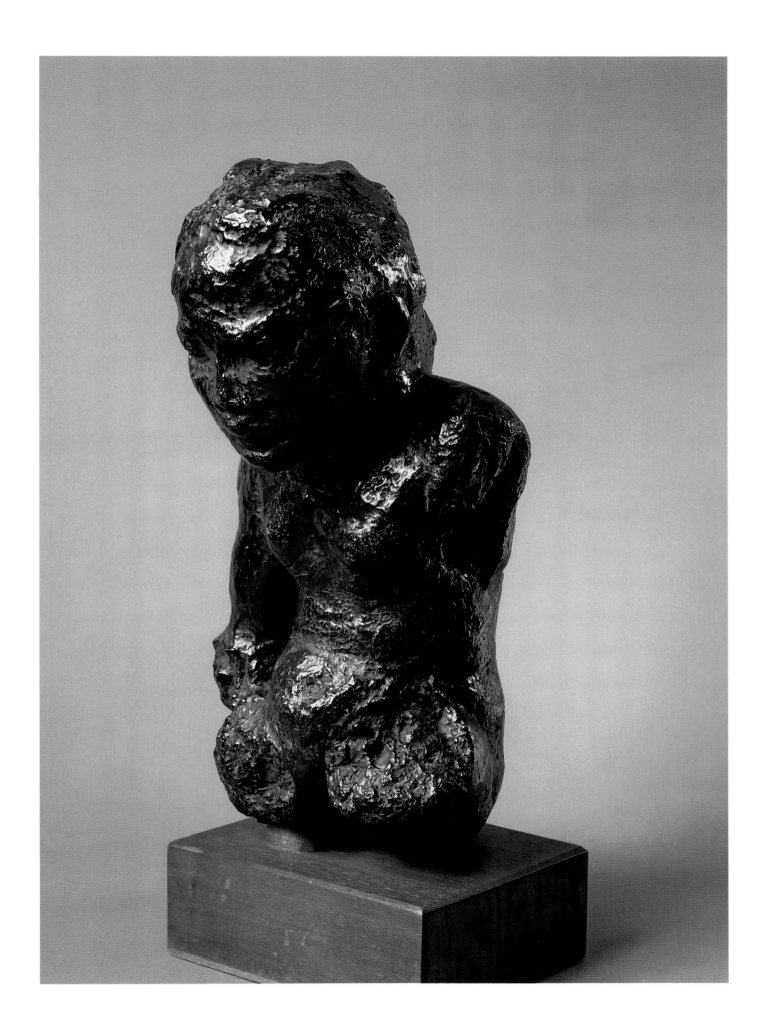

THÉODORE GÉRICAULT (1791–1824)

19. *Flayed Horse*
(*Cheval écorché*), date unknown
Bronze, 1/15, cast 1959, 9⅛ x 8½ x 4½ in.
(23.2 x 21.6 x 11.4 cm)
Stamped on base: *Cire Perdu C Valsuani*

*F*LAYED HORSE IS AMONG the few positively identified sculptures by Géricault. There are no more than nine known sculptural works by the artist, many of which are lost or have an uncertain attribution. Although his sculptural oeuvre was small, Géricault consistently turned to the subjects and styles of his better-known works on canvas and paper.

The horse was a central motif throughout Géricault's career. He had studied with the British-style horse painter Carle Vernet but was temperamentally closer to George Stubbs, whose *Anatomy of a Horse*, of 1766, he copied. Géricault shared Stubbs' quintessentially romantic concern for rendering the horse with both scientific accuracy and empathy for animal passion.

In the *écorché*, the horse is shown trotting, with one foot raised, his partially exposed muscles and tendons set into action. The richly worked surface of the sculpture resembles the animated handling of paint in Géricault's canvases and adds an emotive note to the otherwise anatomically objective study.

The dating of the original wax remains uncertain. Charles Clément, who first catalogued Géricault's work in 1867, states that the *Flayed Horse* dates from the artist's early years of activity (Clément 1867, no. 1, p. 353, and 1868, no. 1, p. 325). More recently, the sculpture (now in the collection of the National Gallery of Art, Washington, D.C.), has been assigned a later date of 1817–24. June Hargrove narrows the years to 1820–24—the last four of the artist's life, but without explanation (Hargrove 1980, no. 151, p. 284 and p. 285 n. 6).

The *Flayed Horse* may derive from the same period as the numerous drawn anatomical studies of equine subjects that are now in the collections of the École des Beaux-Arts, Paris (formerly in the de Varenne collection); the Musée Bonnat, Bayonne; and the Musée des Beaux-Arts, Besançon. Included in the collection of the Musée Bonnat is a pencil study for the *écorché*. The drawings, however, are also not firmly dated. Whereas Germain Bazin altogether avoids dating the equine studies (1987–92, vol. 2, pp. 311–12), Lorenz Eitner assigns them to 1814–15, the period of independent study preceding Géricault's Italian sojourn (1983, p. 333 n. 113). Eitner, however, does not believe that the *écorché* is based on these drawings; instead he considers it to be closely modeled on the *Flayed Horse* by Giovanni da Bologna (Giambologna), which is itself patterned after an even earlier model, the equestrian statue of Marcus Aurelius on the Capitoline Hill in Rome. While the *écorché* closely resembles the muscular structure and position of the Giambologna horse, Géricault made changes to the mouth and tail and replaced the refinement of his model with a more heavily worked surface. The Renaissance sculpture is likely to have been well known to Géricault through one of the many late-eighteenth-century reductions cast by Luigi or Giuseppe Valadier in Rome in 1780 (Eitner 1983, p. 333 n. 113).

In all likelihood, Géricault executed the *écorché* as an academic exercise and it, in turn, was used by the following generation. According to Clément, plaster casts of Géricault's *écorché* "could be found in all the studios" (1867, p. 465, and 1868 p. 222). M. Susse, who had bought the wax original in the 1824 sale of Géricault's estate, was a specialist in plaster casts; however, it is unknown if he was responsible for making copies of the *écorché*. Germain Bazin lists two surviving plaster casts: one in the Louvre and the other in the preserved studio of Paul Huet (1987–92, vol. 5, p. 18 and pp. 132–33, nos. 1446 B and C). As Hargrove has documented, Vincent van Gogh and Odilon Redon are among the artists who subsequently represented Géricault's plaster *écorché* in their own work (1980, p. 285 n. 9). Hargrove suggests that Géricault himself used his own *écorché* as a model, since the same pose is used for the lithograph *Trotting Horse* of 1823 (1980, p. 284 and p. 285 n. 8; Delteil 1924, no. 68, ill.; Clément 1868, no. 70).

The original wax sculpture had belonged to the Maurice Cottier family from 1867 until it was sold to the Lefevre Gallery in London, in 1958. It provided the basis for an edition of fifteen bronze casts produced by the gallery in 1959, under the supervision of Claude Valsuani. The Hillman bronze belongs to this edition. Valsuani made an additional five numbered bronzes, marked H.C. (*hors commerce*, not for sale) for the heirs of Maurice Cottier (Hargrove 1980, p. 284). The wax original was purchased in 1960 by Mr. and Mrs. Paul Mellon and donated to the National Gallery of Art in 1980.

Although the animated surface in part reflects Géricault's painterly handling, it is also, according to Eitner, the result of damage to the wax original. A smoother surface is evident in an earlier bronze cast (National Gallery of Art, Washington, D.C.) made in 1832 by H. Gonnon and Sons, as well as in the earlier plaster casts (Eitner 1983, p. 333 n. 113). Furthermore, in the later cast, changes have been made to the tail and the raised left hind hoof, and the ears are missing (Hargrove 1980, p. 284).

J. B.

PROVENANCE
Acquired from the Lefevre Gallery, London, in July 1960; Hillman Family Collection

LITERATURE (references to the wax original)
Clément 1867 (1), p. 465 and n. 1; Clément 1867 (2), no. 1, p. 353; Clément 1868, p. 222 and n. 1, no. 1, p. 325; Mantz 1872, pp. 382, 384; *Burlington Magazine* 1960, n.p., pl. XVI; Peignot 1965, pp. 46–48; Schmoll 1973, pp. 320–21; Grunchec 1978, p. 149; Hargrove 1980, no. 151, pp. 284–85; Eitner 1983, p. 333 n. 113; Paris 1991, no. 25, p. 335; Bazin 1987–92, vol. 5, no. 1446, pp. 17–20, 131–32.

EXHIBITION (of the Hillman bronze)
Bronx 1972 (HC).

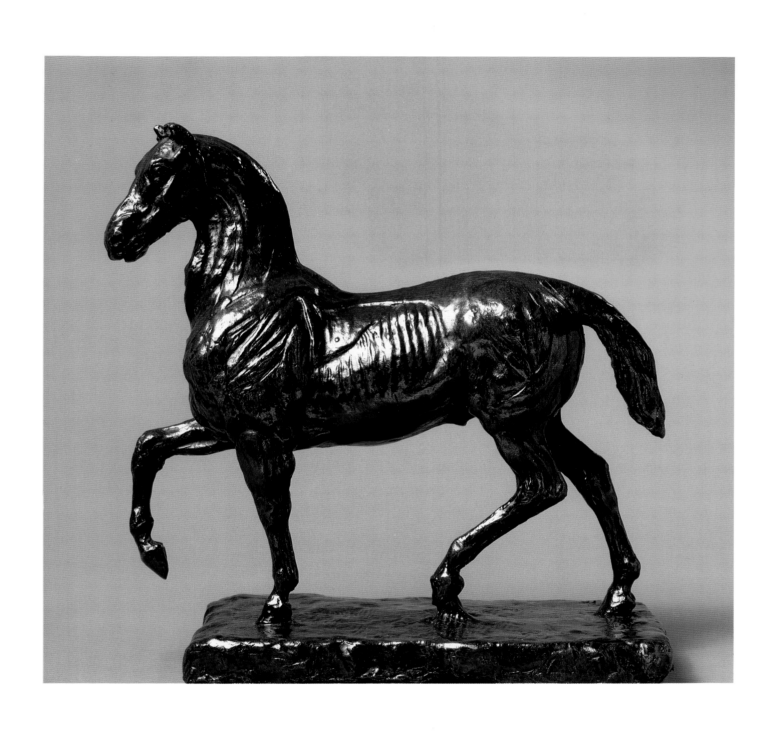

JUAN GRIS (1887–1927)

20. Harlequin with a Guitar
(*Arlequin à la Guitar*), 1917
Oil on panel, 39 ¾ x 25 ⅝ in. (101 x 65 cm)
Signed and dated lower right: *Juan Gris 12-17*

*H*ARLEQUIN WITH A GUITAR was a pivotal painting in Juan Gris's career. It ushered in a new richness of composition, replete with ornamental detail, while introducing an iconography new in his work—that of the Harlequin figure from the commedia dell'arte. Describing the image as "resplendent," James Thrall Soby argued that Gris "was seldom to do anything more impressive in this genre. The picture's alabaster surface and intensely Spanish color are unusually authoritative" (1959, p. 81). Mark Rosenthal concurred, saying that "the virtuosity of this work signals a new, more consistent stylistic phase of Gris' career" (1983, p. 94).

Harlequin with a Guitar was painted during World War I in France, where Gris remained, exempt from military service, because of his Spanish citizenship. Along with Gino Severini, Jacques Lipchitz, and Jean Metzinger, he evolved a new style of synthetic or "crystal" cubism, which sought a greater order and clarity in the geometric analysis of form. In part a reaction to the upheaval of war and in part an effort to legitimize the avant-garde, cubism aligned itself with the values of the French classical tradition. The movement was supported by Léonce Rosenberg, owner of the Galerie de

l'Effort Moderne, who handled Gris's work and that of the other leading cubists, after their German-born dealer, D. H. Kahnweiler, was forced to leave France. *Harlequin with a Guitar* was acquired from Rosenberg by the Swiss entrepreneur G.F. Reber (1880–1959), who established the premier collection of cubism in the years between the world wars.

Typical of Gris's synthetic cubist style, the painting is organized around a rigorous geometric armature, which contains and flattens the internal abstract shapes and descriptive details. The various compositional elements are interlocked or stacked one above the other, denying any perception of spatial recession. The stark contrasts between positive and negative space, light and dark, and the absence of any intermediary modeling reinforce the flatness and exactitude of design. Even the muted color areas are carefully balanced to unify the foreground and background into a single plane. The image, an abstract arrangement of forms, is inspired less by an actual model than by a predetermined ideal.

Harlequin with a Guitar is one of a group of pictures from 1916–17, notably *Portrait of Josette* (Museo del Prado, Madrid) and *Woman with a Mandolin, after Corot* (Kunstmuseum, Basel), that marked Gris's return to the

human figure after years of focusing on still life. The specific subject of the Harlequin also conformed to the new taste for tradition and patriotic references—specifically the long history of the commedia dell'arte, a form of popular, improvised theater. The stock characters of Harlequin and Pierrot were depicted by numerous artists, the most famous example being Watteau's *Gilles* in the Louvre. In 1905 Picasso painted a series of itinerant musicians and acrobats as symbols of the melancholic modern artist and returned to the theme with his *Harlequin* of 1915 (The Museum of Modern Art, New York), painted in a synthetic cubist style. Though he undoubtedly knew of Picasso's work, the direct inspiration for Gris was Cézanne's *Harlequin* of 1889–90 (Collection of Mr. and Mrs. Paul Mellon, Upperville, Va.), after which he made several pencil studies in 1916.

In the Hillman painting, the Harlequin and guitar emerge from a complex play of overlapping and intersecting shapes, patterns, and colors. As Kenneth Silver put it, in *Harlequin with a Guitar* Gris "brought his prismatic style to bear on the popular Latin character" (1989, p. 159). The general distribution of the figure is indicated by decisive outlines, such as the black curves denoting the rim of the hat or fall of the shoulder and the stark angles of a protruding elbow or bended knee. In addition to the hat, a segment of a ruffled collar and the diamond pattern make up Harlequin's traditional dress. On his lap or on a tabletop—the reading is deliberately ambiguous—lies the guitar with its textured trompe-l'oeil wood grain. The pegs, neck, and sound hole are denoted by the most minimal of signs, and Harlequin appears to strum the strings, as indicated by the four black strokes over a schematic rendition of a bridge. Visual puns and echoes abound: the collar ruffles double as the flutes of a column, reinforcing the classical theme, while the diamond pattern also functions as a flat checkerboard, a motif common with Gris at the time. The mask can be read full face, while a profile emerges when the shadowed half is seen in isolation. The split portrait gives rise to a mood both comic and sinister, appropriate to the duality embodied in the Harlequin role.

Along with Picasso and Gris, Severini, Derain, Metzinger, and others painted images of Harlequin and Pierrot in the years during and immediately after World War I. Combining allusions to poetry, music, theater, and art, the commedia dell'arte stood as a potent and enduring

symbol of Latin culture in the face of threatening "barbaric" forces. On a personal level, Gris was drawn to Harlequin for his connotations of melancholy and artifice. The introspective mood announced by Gris's figure paintings of 1916–17 reflect the isolation and guilt he experienced during the war years. From this point forward, Harlequin and Pierrot became favored subjects of the artist, especially after 1920 when he was increasingly plagued by ill health: he painted some thirty-five versions before his death in 1927. In the later years, Gris returned to a more naturalistic style, reintroducing a sense of volume and spatial depth. *Harlequin with a Guitar* remains a singular moment when Gris united an explicitly traditional subject with a most stringent classicizing cubist style.

When this painting was included in the exhibition *Paintings from Private Collections* at the Museum of Modern Art in 1955, Alfred H. Barr, Jr., wrote to the Hillmans: "It's really a wonderful picture which I should have bought for the Museum, but it's good to think that it's in appreciative hands. (I have always been particularly pleased to think that you two like it so much.)"[1]

E. B.

[1] Alfred H. Barr, Jr., to Rita and Alex Hillman, New York, September 19, 1955. Hillman Family Archives.

PROVENANCE
Léonce Rosenberg, Galerie de l'Effort Moderne, Paris, c. 1917 (photo no. 749; stock no. 5557); Dr. G. F. Reber, Lausanne ; Paul Rosenberg, New York; acquired from Paul Rosenberg, New York, November 1952; Hillman Family Collection

LITERATURE
Bulletin de l'Effort Moderne 1927, ill. (as *Figure*); *Cahiers d'Art* 1927, p. 171, ill.; Einstein 1930, ill. p. 274; Einstein 1931, p. 377; Kahnweiler 1947, pl. 40; *Art News* 1959 (HC), p. 33, fig. 6, p. 34; Frankfurter 1960, cover ill. in color and ill. p. 5; Cooper 1971, ill. p. 360; Gaya-Nuno 1975, p. 135; Cooper-Potter 1977, no. 241, p. xix, color pl. VI, p. 313, ill. p. 353; Bonet-d'Ors 1984, no. 29, ill. p. 89; Rosenthal 1983, no. 52, p. 174, p. 94, color ill. p. 97; Roskill 1985, p. 114; Silver 1989, pp. 158–59, fig. 118, p. 160; Kosinski 1991, p. 522 (and featured in an installation photograph, fig. 41, p. 520).

EXHIBITIONS
Zürich 1933, no. 74; New York 1954, no. 19; New York 1955, p. 11, pl. 40; New York et al. 1958, pp. 81, 87, color ill. p. 86; New Haven 1960, no. 95, ill. p. 90; New York 1963; Cologne 1966; New York 1966, checklist no. 69, p. 7; Los Angeles–New York 1970–71, no. 126, pp. 228–29, pl. 280, p. 289; New York 1971 (HC), checklist no. 3, p. 1; Bronx 1972 (HC); Laramie 1972 (HC); Jacksonville–Corpus Christi 1973–74, no. 16, ill.; Paris 1974, no. 69, p. 97, ill.; Baden-Baden 1974, no. 54, color ill.; Roslyn 1977–78 (HC), no. 9, ill.; Austin et al. 1979–85 (HC) (excluding Hunstville, St. Petersburg, Lawrence, and Ames); London 1983, no. 75, p. 172, color ill. p. 173; Washington, D.C.–Berkeley–New York 1983–84, no. 52, p. 179, p. 94, color ill. p. 97; Madrid 1985, no. 61, p. 228, color ill. p. 229; Brooklyn 1986–87 (HC); Brooklyn 1988 (HC).

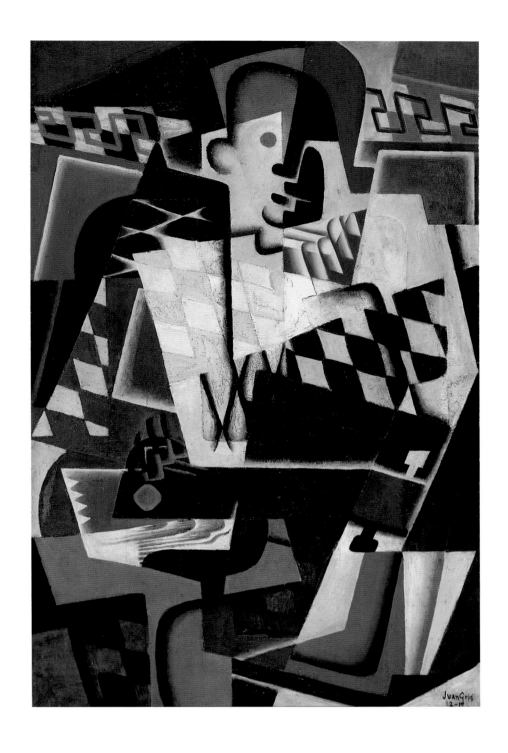

HANS HARTUNG (1904–1989)

21. *Untitled*, 1951
Oil, charcoal, and pastel on paper, 18¼ x 24½ in.
 (46.3 x 62.2 cm)
Signed and dated lower left: *Hartung 51*

Hartung, along with Georges Mathieu, Wols, and Pierre Soulages, was one of the prominent figures of the tachist movement, or *art informel*, in France in the years following World War II. Their completely abstract, gestural painting stood as a challenge to both the older, figurative artists of the School of Paris as well as the proponents of abstract geometric, or concrete, art. Born in Dresden and trained at various German academies, Hartung left his native land for Paris to escape Nazi persecution. By 1937 he had reached his mature style of exhilarating marks, or *taches*, on amorphous patches of color, combining German expressionist angst with French pictorial logic.

Like his contemporaries, the American abstract expressionists, Hartung sought a direct confrontation between his emotional state and the canvas. Though an elaboration of the surrealist technique of automatic writing, Hartung's gestures also bare a graceful deliberation, in the manner of Chinese calligraphy. As shown in the intricate latticework of the Hillman drawing, the compositions evince a dialogue between spontaneity and calculation.

The abstract gestures, which are made up of a repeated vocabulary of crecsents, grids, crosses, spirals, and bands, are fresh to the eye of the viewer but familiar to the hand of the artist. No mere shapes, they are signs that evoke a variety of associations. Early interpreters of Hartung's work, such as Madeleine Rousseau, view the entangled, spiky forms as metaphors of existential crisis, of the struggle, solitude and insecurity of the immediate postwar years (Rousseau-Sweeney-Domnick 1949, pp. 36, 40). Others, such as Henry Geldzahler, who likens Hartung's strokes to "long grasses," see references to nature and elemental forces (1975, n.p.). Hartung himself thought that "the zigzag aspect of a line leaping across the page" stemmed from his childhood fascination with thunder and lightning (Apollonio 1966, n.p.). Ultimately, as James Johnson Sweeney observes, the vitality of Hartung's works "lies in maintaining this balance between something that seems a mere scribble and a meticulous symbolization of something with which we are familiar" (Rousseau-Sweeney-Domnick 1949, p. 4).

In 1936 A. E. Gallatin was the first American to purchase a work by Hartung, but a wider recognition was slow in coming on this side of the Atlantic: Hartung's first museum retrospective did not occur until 1969 at the Museum of Fine Arts, Houston. The Hillmans acquired this work in 1951, a precocious date for collecting Hartung in America. It was in this year that Hartung first exhibited in New York, in the group show *Advancing French Art*, organized by the dealer Louis Carre, and long before the artist's first solo exhibition in the city, held at the Kleeman Galleries in 1957.

E. B.

PROVENANCE
Acquired from the Galerie Rive-Droite, Paris, 1951; Hillman Family Collection

EXHIBITION
Roslyn 1977–78 (HC), no. 10, ill.

BARBARA HEPWORTH (1903–1975)

22. *Standing Figure,* 1934
Marble, 18 ¾ x 5 ¾ x 4 in. (47.6 x 14.6 x 10.2 cm)
Signed with initials: *B H* (?)[1]

I N THE MID-1950S THE HILLMANS began to focus on contemporary British sculpture, purchasing works by Kenneth Armitage, Anthony Caro, Lynn Chadwick, Henry Moore, Hubert Dalwood, and this marble by Barbara Hepworth. This, the only Hepworth in their collection, is a pivotal work in the artist's early maturity, marking her transition to purely nonfigurative imagery. It is also the first of the vertical monoliths or standing figures that she would carve throughout her career, in differing scales and in a variety of material—stone, marble, and wood.

In 1934, when she carved *Standing Figure,* Hepworth gave birth to triplets (she was married to the artist Ben Nicholson). According to J. P. Hodin, it was shortly thereafter that Hepworth relinquished her last figurative references (1961, p. 15). Despite the burden of rearing four children (she had a son from a previous marriage), Hepworth found that one creative activity complemented the other: "Having children suited me well as an artist and I always felt that the time which is given up by a woman artist flows back into this relationship. It is something which nourished art" (Hepworth, quoted in Hodin 1961, p. 15). The movement away from her earlier stylized torsos was also influenced by Hepworth and Nicholson's association in 1933–34 with the British group Unit One and with the Parisian-based Abstraction–Creation, both of which promoted the modernist front of geometric and nongeometric abstract art.

In *Standing Figure* the organic element still dominates Hepworth's approach to the sculptural block; in the late 1930s she turned to a harder-edged, constructivist style. In its material and hieratic simplicity, this marble recalls carved Cycladic figures as well as prehistoric menhirs.

For Hepworth, the technique of direct carving ensured an integral relationship between the emerging shape and the material's innate hardness and surface texture. Here, despite the potential coldness of white marble, the subtle surface undulations and protrusions impart an earthy sensuality and allow for a delicate play of light and shadow. Even the patterns of the veins within the marble enhance the swelling contours of the form. A small conical protrusion at the top suggests an eye or a breast and confirms the anthropomorphic quality of the vertical shape. The curvaceous profile and ovoid form belong to the artist's family of cocoon, egg, and pebble shapes, replete with allusions to genesis, nurture, and the cycle of rebirth.

E. B.

[1] In his catalogue entry Hodin indicates that the piece is signed with initials (no. 62, p. 163). No initials are presently visible on the sculpture, although the bottom surface is obscured by the base.

PROVENANCE
Collection of the artist; acquired from Gimpels Fils, London, November 20, 1956; Hillman Family Collection

LITERATURE
Read 1952, pl. 36; Hodin 1961, no. 62, pp. 20, 163, ill.

EXHIBITIONS
London 1937; London 1954, no. 23, p. 13.

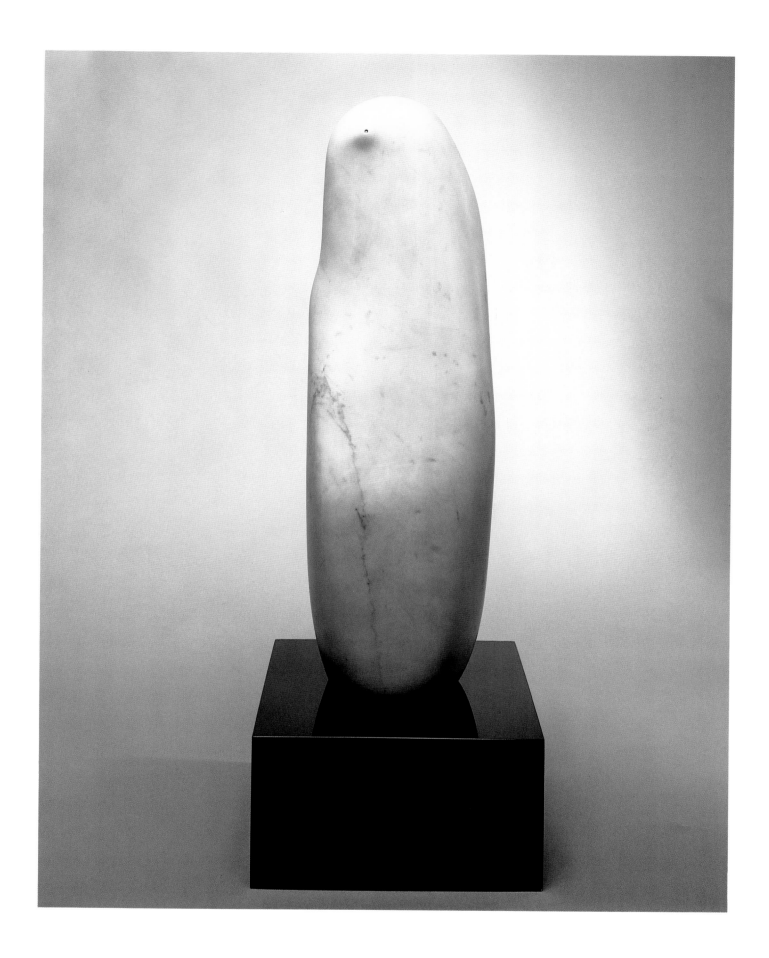

WINSLOW HOMER (1836–1910)

23. *Shepherdess Resting*, c. 1878
Oil on canvas, 8 x 13 in. (20.3 x 33 cm)

W INSLOW HOMER . . . NEVER FULLY FOUND himself until
he found the American shepherdess," G.W. Sheldon
declared in 1882.[1] During the late summer and autumn of
1878, Homer created many plein-air works based on this
idyllic subject at Houghton Farm in Mountainville, New
York. Houghton Farm was owned by Lawson Valentine, the
business partner of Homer's brother Charles and one of the
artist's major patrons.

Working primarily in watercolor and gouache, Homer
experimented with historical and modern images of shepherd-
esses. The pensive young woman in *Shepherdess Resting* wears a
contemporary homespun dress. As in many of these images,
the adolescent shepherdess is shown in a state of repose,
shielding her face from the intense sunlight. This characteris-
tic tactic obscures the figure's identity and enhances the mood
of melancholy reverie.

Homer's images of shepherdesses have been interpreted
as nostalgic symbols of an agrarian past, rapidly slipping away
in the industrialized aftermath of the Civil War. Well aware of
the international popularity of humble peasant images,
Homer had studied the art of Jean-François Millet and the
Barbizon School even before his trip to Paris in 1866–67.

Shown in February 1879 at the American Watercolor
Society's exhibition, Homer's charming watercolors and
gouaches of shepherdesses established his reputation as a
leading American impressionist. Their lack of finish and direct
execution can be compared to the sketchiness and broadly
brushed highlights of *Shepherdess Resting*. His images of
shepherdesses were also regarded as pastoral symbols of purity
and simplicity —"the New England idyllic."[2]

G. S.

[1] G. W. Sheldon, *Hours with Art and Artists* (New York, 1882), p.140.

[2] "The Watercolor Society: A Brilliant Show at the Twelfth Exhibition,"
New York Times, February 1, 1879, p. 5.

PROVENANCE
Charles S. Homer, Prout's Neck, Maine; Carnegie Institute, Pittsburgh
1918–41; Mrs. Edith Halpert, New York; acquired from Babcock
Galleries, Inc., New York, January 1942; Hillman Family Collection

EXHIBITIONS
Bronx 1972 (HC); Phoenix 1991–92 (HC).

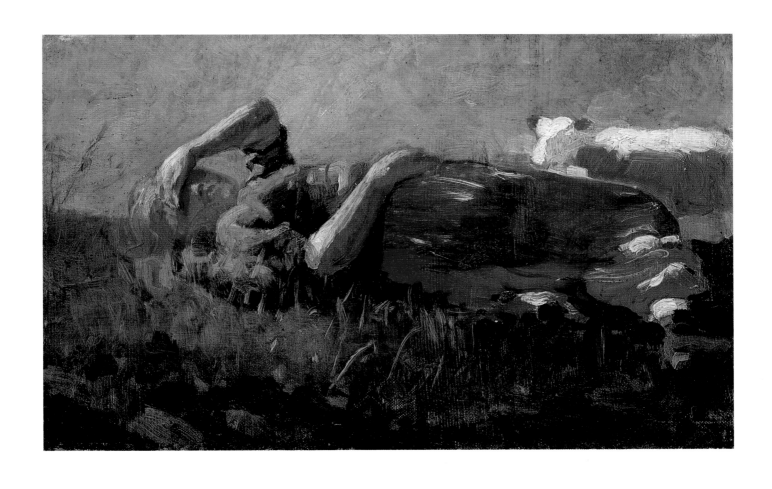

PAUL KLEE (1879–1940)
24. *Mother and Child*
(*Mutter und Kind*), 1929
Ink on paper mounted on heavy paper, 17 ¾ x 12 ½ in.
 (45 x 30.5 cm); secondary support: 22 ¾ x 15 ¼ in.
 (57.6 x 39 cm)
Signed right of upper center: *Klee*; inscribed bottom on
 secondary support: *1929 E8 Mutter und Kind*

BEGINNING IN 1911, when he allied himself with the avant-garde members of the Blue Rider, Klee was strongly influenced by the artistic philosophy of the group's leader, Wassily Kandinsky, who stressed the spiritual over the material aspects of art. Whereas Kandinsky moved toward total abstraction, Klee continued to rely on the visible world for inspiration. A central motif in his art were the powers of creation in nature as they appear in plant, animal, and, as in this drawing, in human life as well. Klee's imagination penetrated outward appearances to reveal inner meanings, as the seen world was transformed and rendered in highly subjective terms.

In a lecture entitled "On Modern Art" delivered at Jena in 1924, during his tenure at the Bauhaus, Klee discussed his method of composing pictures based solely on the relationships between line, tone, and color, in potentially unlimited combinations. In numerous works, he restricted his approach to just one aspect of his pictorial vocabulary. In *Mother and Child*, for example, line alone is used to determine the general outline of shapes and an interior formal scaffolding. Typically, Klee did not begin with a predetermined subject but let one suggest itself through the elaboration of emerging shapes and random signs. In this pen-and-ink drawing, the maze of short strokes and cubist facets evolved into the image of a standing figure holding a smaller one with a round head and out-stretched arms.

The title was likely added afterwards, perhaps to draw out the association of the Madonna and Child. Throughout his career, and particularly during the last years of his life, Klee increasingly turned to idiosyncratic, and decidedly mundane, representations of sacred Christian subjects. In his images, divine personages always exude human character, as in the quirky gestures of this pair. Here the mother and child are no more part of the celestial realm than of the terrestrial world of mortals and nature.

J. B.

PROVENANCE
Klee Gesellschaft, Bern; Ida Bienert, Munich; acquired from Kleeman Galleries, New York, November 1954; Hillman Family Collection

EXHIBITIONS
Bronx 1972 (HC); Phoenix 1975 (HC); Roslyn 1977–78 (HC), no. 11, ill.; Austin et al. 1979–85 (HC); Brooklyn 1986–87 (HC); Brooklyn 1988 (HC).

PAUL KLEE (1879–1940)

25. *Portrait O. T.*
(*Bildnis O. T.*), 1931
Gouache on black paper, mounted on painted cardboard,
19 x 12 ¾ in. (48.5 x 32.5 cm); secondary support,
22 x 14 in. (56 x 36 cm)
Signed lower right: *Klee*; inscribed bottom center on
secondary support: *1931 T.10 Bildnis O.T.*

THE IDENTITY OF KLEE'S SUBJECT in this whimsical portrait remains unknown, despite the clue provided by the initials *O. T.* inscribed at the bottom of the secondary support. Klee renders the portrait with a childlike economy of means and forthrightness, typical of his work during the 1930s. The facial features are indicated by the most minimal of signs: the eyes by two black circles and the mouth by a small horizontal line. He creates, however, the impression of a character at once innocent and serious, like that of a child. Whereas adults were often subject to Klee's biting irony, he depicted children with delight and compassion.

In 1931 Klee ended his association with the Bauhaus, yet the principles of creative method he developed there as a teacher continued to inform his work. In his portraiture, Klee did not aim at visual resemblance but at a spiritual reality that lay behind the world of appearances. His masklike faces stand for the outward expression of an inner life. In a diary entry from 1901 Klee expressed his thoughts on the art of portraiture: "Some will not recognize the truthfulness of my mirror. Let them remember that I am not here to reflect the surface . . . but must penetrate inside . . . My human faces are truer than the real ones" (Klee 1968, pp. 47–48).

The intensity of color also endows *Portrait of O. T.* with expressive capacity, despite the lack of literally described facial features. Betraying the influence of Robert Delaunay, whose work he first saw in Paris in 1912, Klee here uses alternating planes of brilliant hues to define the contours of the face and background space. The mosaic of colored dots and the lines emanating from the core of the face create a decorative pattern rotating around the center of the composition, while revealing the subject's expansive personality.

J. B.

PROVENANCE
Alfred Flechtheim, Berlin; acquired from Marlborough Fine Art, Ltd., London, March 1955; Hillman Family Collection

EXHIBITIONS
London 1955, no. 27, ill.; New York 1971 (HC), no. 4, p. 1; Bronx 1972 (HC); Phoenix 1975 (HC); Rosyln 1977–78 (HC), no. 12, ill.; Austin et al. 1979–85 (HC); Brooklyn 1986–87 (HC); Brooklyn 1988 (HC); Phoenix 1991–92 (HC).

FERNAND LÉGER (1881–1955)

26. *Study for "Nude Model in the Studio"/Composition 1*
(*Study for "Le Modèle nu dans l'atelier"*), 1912
Oil and gouache on brown paper, mounted on board,
 25 ¼ x 19 in. (64 x 48.3 cm)
Initialed and dated lower right: *F.L. '12*

THIS DRAWING BELONGS TO A SERIES of preparatory studies for Léger's oil painting *Nude Model in the Studio* (*Le Modèle nu dans l'atelier*) of 1912–13. It is one of two such gouaches, the other being in the Sprengel Collection, Hanover (Rudenstine 1976, p. 459). *Nude Model* was exhibited at the Salon des Indépendants of 1913, though initially Léger was not quite ready to submit it and sent studies for the work instead. At the last moment the painting was also included (Green 1976, p. 53; Rudenstine 1976, p. 460 n. 2). The Hillman drawing was among the studies already on view during the previews and was singled out for reproduction by Apollinaire in his review in *Montjoie!* of March 18.

Nude Model in the Studio is a key work in Léger's stylistic development, appearing between the lingering descriptive realism of *The Woman in Blue* of 1912 (Oeffentliche Kunstsammlung, Basel) and the more abstract series *Contrasts of Forms* of 1913–14. In the Hillman study, as in the final painting, Léger leaves clues to the subject's identity, such as the row of fingers in the center and at the upper right, or the sequence of curves and half circles that allude to the female anatomy. Without specific reference to the title, however, there is little to orient the viewer, as Léger moves beyond replicating natural resemblance to a work based on the dynamic contrasts of pure painting: lines, forms, colors, and tonal relationships.

The diagonal disposition of the figure bears a striking resemblance to Carlo Carrà's fragmentation of the traditional nude, *Simultaneity: Girl by the Balcony* (1912, Collection R. Jucker, Milan), which was exhibited at the notorious 1912 futurist exhibition in Paris at the Bernheim-Jeune Gallery. Both artists analyze the body and background setting into a series of interpenetrating planes and ellipses, yet Léger's composition is even more radical in the denial of deep space and descriptive referents. Christopher Green, who has written at length on *Nude Model*, argues that the work was particularly influenced by Marcel Duchamp's *Nude Descending a Staircase, No. 2* (Philadelphia Museum of Art), which had been exhibited at the Section d'Or at the end of 1912. Léger's work was a direct response, beginning with the title, which phonetically mimics the Duchamp. "Yet, if it was a response," Green writes, "*Le Modèle nu* was an antagonistic response, and

in the nature of the criticism it levels against Duchamp is found a final demonstration of the anti-descriptive direction of Léger's painting, of its direction toward pure painting" (Green 1976, pp. 54–55).

The Hillman study effectively demonstrates Léger's research into what he termed "pictorial realism"—the systematic juxtaposition of complementary and contrasting elements. Curves are set off by right angles and highlights by deep shadow, while flat planes counteract the spatial illusionism of the tonal modeling. The head, breasts, torso, and limbs of the model are broken down into a continuous surface of visual echoes and dissonances. According to Apollinaire, this and the other studies Léger exhibited in 1913 exemplified the interests of orphism, an offshoot of cubism, which emphasized the sensation of simultaneous light effects. In this drawing in particular, the juxtaposition of transparent strokes of black with the opaque patches of white against the neutral brown paper results in a shimmering, dynamic surface.

E. B.

PROVENANCE
Nell Walden, Berlin; acquired from Marlborough, London, 1955; Hillman Family Collection

LITERATURE
Apollinaire 1913, p. 4, ill.; Flechtheim 1928, no. 57; Franke 1929, no. 35; *Art News* 1959 (HC), p. 34, ill. p. 33; Rudenstine 1976, p. 459, p. 460 n. 2, ill. p. 458, fig. b.

EXHIBITIONS
Paris 1913; Bern 1944–45, no. 336; Zürich 1945, no. 105; Basel 1946, no. 230; Stockholm 1954, no. 50; Laramie 1972 (HC); Jacksonville–Corpus Christi 1973–74 (HC), no. 14, ill.; Phoenix 1975 (HC); Chicago 1975 (HC); Roslyn 1977–78 (HC), no. 16, ill.; New York–Ann Arbor 1980; Austin et al. 1979–85 (HC); Brooklyn 1986–87 (HC); Brooklyn 1988 (HC); Phoenix 1991–92 (HC).

FERNAND LÉGER (1881–1955)

27. *The Two Mannequins*
(*Les Deux Mannequins*), 1938
Gouache and india ink on paper, 18 ½ x 12 ¾ in. (47 x 32.4 cm)
Initialed lower right: *F.L.*; inscribed lower right: *Mme Koenigsberg
en souvenir de l'exposition de Leverkusen N. Léger*

THE TWO MANNEQUINS is typical of a number of Léger's gouaches from the late thirties, which served as exercises in the conception of large-scale compositions and mural painting. The drawing combines Léger's penchant for geometric reduction with his free-floating objects and organic, biomorphic style of the previous decade. Two highly schematized human forms—one frontal, the other in profile—stand against a unified field of deep red. The forms are divided into a series of multicolored geometric areas and circumscribed with stark black lines, which have the effect of carving the figures in stark relief, like slabs of stone or wood. The colors and delineated outlines advance and recede, creating a visual mobility out of purely pictorial means, congenial to the flat plane of the wall.

Léger had always interpreted the human figure along mechanistic lines, beginning with his *Contrast of Forms* series in the years before the World War I, through the standardized body parts and gleaming surfaces of his nudes from the 1920s. Indeed, during the latter, purist period, Leger achieved his desire to render the human form an object like any other. *The Two Mannequins*, however, belong to series of "*poupées*" and "*personnages*" from 1936–38, wherein the dehumanization reached an extreme of formal simplicity and psychological anonymity. Here the head, torso, and limbs are resolved into a single streamlined unit, which resembles a sleek robot or, alternatively, an ancient sarcophagus.

Though it cannot be related to any known painting of the period, the Hillman study can be compared to another gouache of the same year: a maquette for a fireplace mural commissioned by Nelson Rockefeller, for his New York residence (but not used for the mural). This untitled composition (Herbert F. Johnson Museum of Art, Cornell University, Ithaca, N.Y.) contains plant and abstract forms and a single mannequin head of the same type as that in the Hillman gouache. Indeed, both figures are rendered in a yellow-brown-black scheme, suggesting that the Hillman work may belong to a series of studies related to the evolution of the commission.

The inscription at the lower right, by Nadja Léger (née Khodossjevitch), the artist's longtime assistant and second wife whom he married in 1952, reads: "To Madame Koenigsberg, a souvenir of the Leverkusen exhibition." Though the recipient remains unknown, the exhibition referred to is Léger's own, held in the German city of that name in 1955, the year of his death.

E. B.

PROVENANCE
Collection Koenigsberg, Leverkusen (?); acquired from Galerie d'Art Craven, Paris, July 1958, gallery inventory inscribed on verso: *1938 # G 447 les 2 mannequins*; Hillman Family Collection

EXHIBITIONS
Laramie 1972 (HC); Jacksonville–Corpus Christi 1973–74 (HC), no. 15, ill.; Roslyn 1977–78 (HC), no. 16, ill.; New York–Ann Arbor 1980.

ÉDOUARD MANET (1832–1883)

28. *Young Girl on a Bench*
(*Fillette sur un banc*), 1880
Oil on canvas, 29 ½ x 24 in. (74.9 x 61 cm)

MANET WAS THE MASTER OF THE GAZE. Much has been written about this feature of his two great works separated by twenty years, *Olympia* of 1863 (Musée d'Orsay, Paris) and *Bar at the Folies-Bergère* of 1882 (Courtauld Institute Galleries, Home House Trustees, London): the bold, provocative stare of the nude on her bed; the limpid but guarded gaze of the barmaid behind her counter. Both engage the viewer directly in ways that have had a profound effect on the interpretations of these two icons of modern painting. This gift of involving the viewer through the creation of a distinctive and expressive gaze is found in many other works as well. Examples are in portraits such as *Berthe Morisot with Violets* (1872, private collection) or paintings such as *At the Café* (1878, Sammlung Oskar Reinhardt, Winterthur), where the foreground figure's head is turned to look squarely out of the pictorial space into that of the viewer. We see the gift at work here in *Young Girl on a Bench*. The child's open and candid face, regarding the artist/viewer with a patient dignity, is the most immediate feature of the painting's indisputable appeal. Charles Stuckey has referred to the halolike effect of the sitter's wide-brimmed hat and to her "pious beauty."[1] Without depriving the figure of its reality as a young French girl in 1880, one can agree that it does possess those qualities of innocence and purity that lead the mind naturally to religious metaphors. It may very well have been that such metaphors were present at some level in Manet's mind as he observed this girl; he did not paint children often, but when he did he responded concretely to the sitter's personality. In the portrait of Line de Bellio in Kansas City, for example, he gives us a young girl with an equally pronounced gaze but with an entirely different, very worldly, character.

Our positive response to the painting is simultaneous with our awareness of how much Manet was able to tell us with a minimum of descriptive detail. The brushstrokes are rapid, open, and enormously varied, conjuring the effect of shifting sunlight as it falls on a figure through full-leafed trees. With all the variety of touch, there is at the same time a great economy of means; in the construction of the face, dress, and hands, only just enough pigment is used to create a convincing presence, informing us of, say, a sailor suit without providing any detail. Manet loved the shapes and qualities of feminine costume, and one can feel that here, as he indicates the passage of light over the jacket by means of areas of unpainted canvas or rapidly and decisively lays in the shape of

the collar. The hands are mere bars of color such as one might find in a Fauve-period painting by Matisse, but we know that they are quietly folded in the child's lap. In this picture Manet is drawing with color in an adventurous way that, as Stuckey notes, had an immediate effect on the young Toulouse-Lautrec when he saw the work at the Manet sale in 1884, the year after his death.

The sitter was the young daughter of Paul Vayson de Pradenne, a friend of the opera singer Emilie Ambre, in whose garden the painting is set. Emilie Ambre was a summer neighbor of Manet's at Bellevue, a village near Paris where he went in 1880 to rest and take the hydrotherapy treatments recommended by his doctor. She was an admirer of Manet's work and had posed for a portrait in the role of Carmen in 1879. A smaller variant of the painting of Mlle Vayson is in the Barnes Collection, Merion, Pennsylvania.

S. F.

[1] Charles F. Stuckey to Rita Hillman, October 14, 1985. Hillman Family Archives.

PROVENANCE
Vente Manet, Hôtel Drouot, Paris, February 4–5, 1884, no. 24 (as *Enfant sur un banc*); Paul Vayson de Pradenne, Paris; Georges Bernheim, Paris; Mrs. Huddleston Rogers, Paris, 1942; Durand-Ruel Gallery, New York, 1944; acquired from Durand-Ruel Gallery, New York, January 1950; Hillman Family Collection

LITERATURE
Duret 1902, 1919, no. 269; Meier-Graefe 1912, p. 320; Moreau-Nélaton 1926, no. 272; Tabarant 1931, no. 324; Jamot-Wildenstein 1932, vol. 1, no. 384, p. 167, vol. 2, p. 35, fig. 88; Rey 1938, p. 86, ill.; Jewell 1944, p. 71, ill.; Tabarant 1947, no. 349, p. 385; *Art News* 1959 (HC), no. 3, p. 30, ill.; Canaday 1965, pp. x, 27, ill.; Pool-Orienti 1967, no. 311A, p. 113, ill.; Bodelsen 1968, no. 24, p. 343; Rouart-Wildenstein 1975, vol. 1, no. 335, p. 258, ill. p. 259; Orienti 1981, no. 308a, pp. 49–50, ill.

EXHIBITIONS
Paris 1934, no. 17; Detroit 1935, no. 8; New York 1938, no. 10; Los Angeles 1940, no. 30; New York 1940; Cambridge 1942; New York 1943, no. 9, ill.; New York 1946, no. 2; New York 1948, color pl. 1; Chicago 1961; New York 1963, no. 93, p. 9; New York 1965, no. 33; New York 1966, no. 84, p. 8; Philadelphia-Chicago 1966–67, no. 153, pp. 165–67, ill. p. 166 (in Chicago only); New York 1970, no. 47, ill.; New York 1971 (HC), no. 5, p. 1.

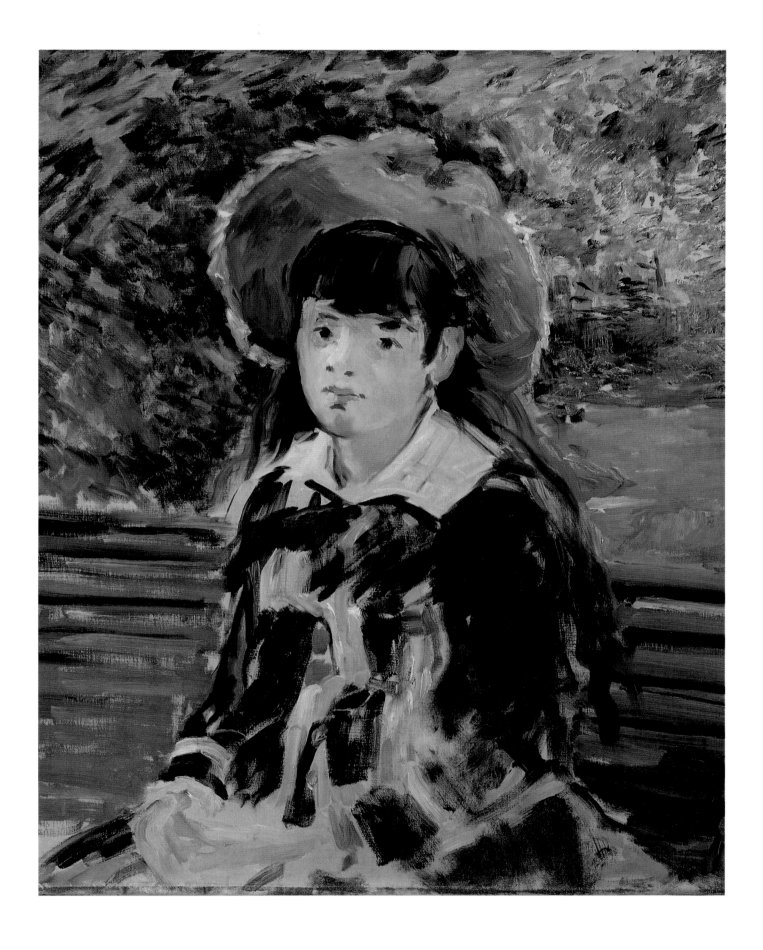

ÉDOUARD MANET (1832–1883)

29. *Young Woman at the Seashore (Annabel Lee)*
(Jeune femme au bord de la mer [Annabel Lee]), 1881
Charcoal and ink wash on paper,
12 ¼ x 9 ⅛ in. (31.1 x 23.2 cm)

IN 1875 STÉPHANE MALLARMÉ's translation of Edgar Allan Poe's *The Raven*, with illustrations by Manet, was published as *Le Corbeau* (New York 1983, no. 151). The project was a source of satisfaction to both artists, who shared the taste for Poe's work that Baudelaire had established among the Parisian vanguard. When in 1881 Mallarmé completed his translation of *Annabel Lee*, he naturally turned to Manet to collaborate on this new project. In the summer of 1881 Manet, whose health continued to fail, was staying in Versailles. From there he wrote to Mallarmé of how much he would have liked to embark on such a venture, "mais aujourd'hui c'est au-dessus de mes forces" (but now it is beyond my strength; Tabarant 1931, p. 562). Some time later that summer he wrote again, evidently feeling better and expressing the hope that he would be able to begin work when he returned to Paris in the fall. As it happened, he did not become involved with the project beyond the stage of drawing the motif we see in the Hillman example, which is found in two other drawings (Rouart-Wildenstein 1975, nos. 435, 437). One of these, in the Museum Boymans-van Beuningen, Rotterdam (New York 1983, no. 152), is the study for the 1879 painting *Young Woman in a Garden* in the Barnes Foundation (Merion, Pa.), which depicts Jeanne Gonzalès, the younger sister of Manet's pupil, Eva Gonzalès. The Hillman drawing is a further development from this sheet.

The figure is that of a young woman seen in profile, dressed in the current fashion of long jacket fitted at the waist, skirt, and bonnet tied under the chin. It is set against the lightly sketched-in setting of a beach, defined principally by the sailboat just offshore. In the Barnes painting the figure is set in a grassy space, closed off at the top by a curtain of trees. By placing the figure in the drawing at the shore, Manet was referring to the first line of the poem, "Many and many a year ago, in a kingdom by the sea."

The drawing has a charm that in no way depends on its links with Poe. The qualities of the figure gain strength from being isolated in the open space of a minimally defined back-ground. The drawing is crisply silhouetted, with firm, rounded curves in the definition of the jacket and skirt. The bonnet, too, has a clear definition, and the youthful quality of the face is accentuated. Manet's love of the line and shape of feminine dress is evident here; we are reminded too of how Seurat would develop this kind of motif only a few years later.

S. F.

PROVENANCE
Vente Manet, Hôtel Drouot, Paris, February 4–5, 1884, no. 150; M. Fromenthal, Paris; Curt Glaser, Berlin; E. Raynal, Paris; acquired from the The New Gallery, New York, October 1955; Hillman Family Collection

LITERATURE
Glaser 1922, pl. VIII; Tabarant 1931, no. 110, pp. 561–62; Tabarant 1947, no. 670, pp. 417–18; de Leiris 1969, no. 592, p. 138 (as *Annabel Lee debout*); Rouart-Wildenstein 1975, vol. 2, no. 436, p. 160, ill. p. 161; New York 1983, p. 386.

EXHIBITIONS
Paris 1884, no. 175 (?) (as *Au bord de la mer*); New York 1959, no. 93; Philadelphia-Chicago 1966–67, no. 136, pp. 150–51, ill.; New York 1971 (HC); New York 1973; Roslyn 1977–78 (HC), no. 17, ill.

MARINO MARINI (1901–1980)

30. *Pomona III*, 1943
Bronze edition of 5 (?), cast 1943,
 16 ¼ x 5 ½ x 4 ¾ in. (41.3 x 14 x 12 cm)
Stamped on the base : *M M*

PORTRAITS, HORSE AND RIDERS, jugglers, and the female nude are the chief subjects of Marini's art. Of the latter category, the *Pomona* series is the most significant, unifying, in a single archetype, the artist's concern for mythic theme and sculptural mass. A Roman agricultural divinity, Pomona presided over orchards and gardens: her name derives from the Latin word *pomum*, meaning "fruit of a tree." Very few of Marini's versions actually bear an apple, the figure's traditional attribute, but instead evoke the idea of ripeness and bounty in the abundance of the female form. Indeed, *Pomona* transcends her title to become a larger symbol of *Tellus Mater*, of the fertility and fecundity of the earth mother herself.

Pomona III belongs to a series of three small bronzes all cast in 1943. The size of the edition is unknown: five examples are documented, including the one in the Hillman Collection (Read–Waldberg–San Lazzaro 1970, p. 341). As a rule, during these years, Marini cast his sculptures with MAF (Fonderia Artistica Milano), and the bronzes were frequently not signed, stamped, or numbered.

Marini represents *Pomona* as a standing nude with swelling hips; the position of the arms invariably draws attention to the fulsome figure. The hair is worn up, often in a braided crown. Compared to the full-size versions, the small bronzes are primitivizing and even brutal in their modeling. In *Pomona III*, the hands meld into the flesh and hair, and the figure is defaced. The absence of facial features—or the blank stares of other examples—underlines the purely symbolic function of the figure as a sexual and life-giving force.

Archaizing treatments of the female nude were part of Marini's repertoire since the late 1920s. It is only with the *Pomona* series, however, beginning in 1939, that he shed all remnants of academic schooling to explore fully the ideological and formal implications of preclassical styles. Marini's interpretation of the Mediterranean ideal—a calm, monumental, voluminous female form—has often been compared to Maillol's, yet his work departs from any idealized canon in favor of the humble and the primitive. In addition to their accentuated rotondity, the sculptures are roughy modeled with uneven, scratched, and abraded surfaces, as if they had been recently excavated, bearing the visual evidence of passing centuries.

Marini worked during the fascist period in Italy when mythic subject matter and neoclassical styles were encouraged by the regime for propagandistic purposes. But Marini, like his slightly older contemporary, Arturo Martini, turned to different sources in the ancient world, specifically to the Etruscan civilization, associated with Marini's native region of Tuscany. Based on excavations and archeological research, the Etruscan style was considered to be infused with poetic imperfection; it was roughly hewn, uncouth, at times whimsical, and hence more inherently humane. For Marini, the Etruscan model evoked a remote and indigenous past, redolent of elementary instincts and nature rituals lost to the modern technological world.

E. B.

PROVENANCE
Acquired from the Buchholz Gallery, New York, September 27, 1949; Rita K. Hillman Collection

LITERATURE
The Currier Gallery of Art Bulletin, Manchester, N.H., December 1953 (?); Read–Waldberg–San Lazzaro 1970, p. 341, listed under no. 140 (*Small Pomona*); Hunter-Finn 1993, p. 159, ill. (another version of the bronze).

EXHIBITIONS
New York 1950, no. 5; Wilmington et al. 1953–54.

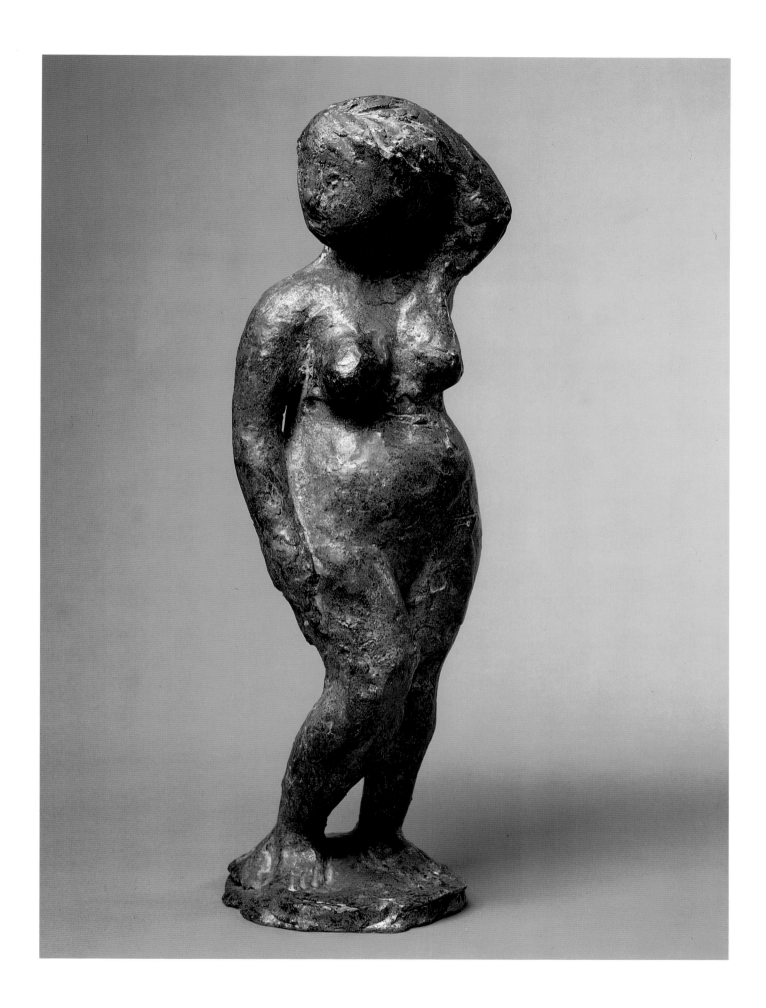

ETIENNE MARTIN (B. 1913)

31. *Portrait of Alex Hillman*
(*Tête de Monsieur Alex Hillman*), 1962
Unique bronze, 11½ x 7½ x 10 in. (29.2 x 19 x 25.4 cm)
Stamped on back at center: *Etienne Martin*; stamped on back
 at left: *Cire Perdue Rosato Paris*

ETIENNE MARTIN'S BUST OF ALEX HILLMAN is the only portrait of the collector ever done. This is fitting, since Martin belongs to the group of postwar French artists who became the focus of Hillman's interests in the last decade of his life. For the most part Hillman was led to the "French Expressionists," as he called them, by the dealer René Drouin. In addition to Jean Fautrier, Pierre Soulages, and Georges Mathieu, Hillman bought the work of several artists who are now lesser known in America, among them Claude Viseux, Jean Ipousteguy, Claude Georges, and Etienne Martin.

Trained at the École des Beaux-Arts in Lyon in the years 1929–33, Martin had set up a studio in Paris by 1938. His career was interrupted by military service, during which time he was taken prisoner in Germany. After the war he met the critic Michel Tapié, who included him in a group show at Drouin's gallery in 1946. When Hillman bought Martin's works in the early 1960s, Martin had not yet established an international reputation: it was only later, in 1966, that he won the Grand Prize for Sculpture at the Venice Biennale. He subsequently became professor of monumental sculpture at the École des Beaux-Arts, Paris, and was the subject of a retrospective at the Musée National d'Art Moderne, Centre Georges Pompidou, in 1984. Since the mid-1950s, Martin has concentrated on his *Demeures* series (Dwellings) in both small-scale and large, cavernous installations. The multichambered, organic sculptures (usually rendered in plaster or wood) explore the dualities of interior and exterior forms, enclosure and exposure.

This bust was likely modeled during a lunch when Hillman visited the artist's studio at 7 rue du Pot de Fer in Paris, in the fall of 1961. A letter from Hillman to Drouin (Hillman Family Archives, October 23, 1961) implies that the portrait commission came about spontaneously from the immediate rapport between the two men:

Will you please thank Etienne Martin for me for one of the most delightful days of my life. As you know, I had a lively lunch with him in his studio and ate myself into a coma and enjoyed every minute of it. I look forward to the bust he is making and hope to receive it very soon. As I understand it, I am to pay $1,000 for this bust. I appreciate it Etienne doing this. It was a mark of affection and kindness on his part. If you could give me a photograph of him, with an inscription to me, I should love that. I think that he is one of the most enchanting and gentle people that I have met in many years.

The portrait is one of three works Hillman owned by Martin. The other two, *The Knot* and *The Garlic Glove* (sold from the collection in the early 1970s; see Appendix), were more typical of Martin's style of energetically entangled masses, inspired by natural forms but ultimately abstract in their configuration. Yet Martin was equally comfortable with literal depiction, as is evident from the likeness achieved in the Hillman head, which emerges from the broken, highly gestural surface of the rapidly worked clay. Hillman's eyes and mouth are slightly upturned in a warm, wry expression. In a letter of February 12, 1962, after receiving photos of the bust from Martin, he complemented the artist: "You really did catch the whole nature and spirit of my appearance. I realized it the first hour you worked on it and it was an exciting experience."

E. B.

PROVENANCE

Commissioned from the artist via Galerie René Drouin, fall 1961; Hillman Family Collection

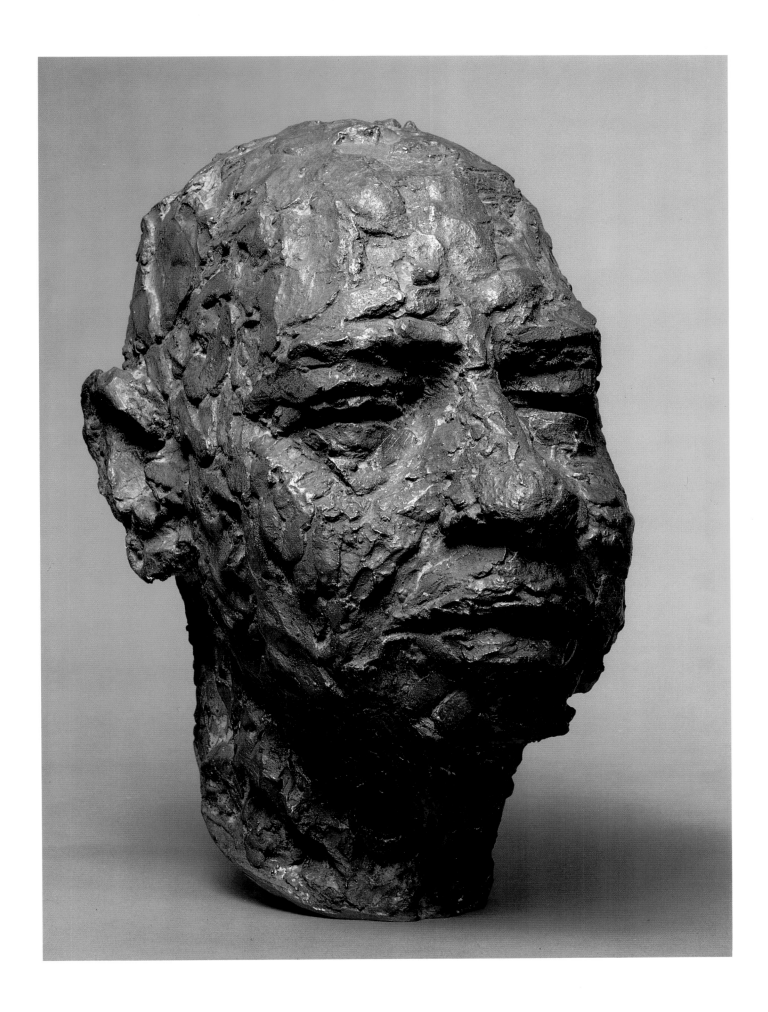

GEORGES MATHIEU (B. 1912)

32. *Gothic Ambiguity*
(*Ambiguité gothique*), 1952
Oil on canvas, 102½ x 37½ in. (260.4 x 95.3 cm)
Signed and dated lower right: *Mathieu 52;*
 and upper right: *Mathieu 51*

GEORGES MATHIEU WAS A LEADING THEORIST and practitioner among the younger generation of Parisian painters in the years following World War II. In 1947–48 he organized a series of exhibitions and included such fellow artists as Wols, Hartung, Camille Bryen, and Jean-Paul Riopelle under the new banner of "lyrical abstraction," or *tachisme*. In reaction against cubism, constructivism, neo-plasticism, and surrealism, Mathieu developed a totally nonfigurative style of random, fluid gestures, which were intended as direct expressions of the artist's psychic energies (see Mathieu 1963).

By negating the role of structured and premeditated composition, Mathieu attempted a painting void of references, bearing only the signs of its own spontaneity and processes by which it was made. Toward this end he championed speed of execution, whereby the rapidity of his gestures was made visible in the tense and vivid calligraphy of strokes, lines, and dashes of paint. In the 1950s, Mathieu went so far as to turn the act of painting into spectacle, completing canvases in a matter of minutes before public audiences. Mathieu's theatrical bent extended to the rhetoric of his paintings' titles, which typically refer to great historical epochs and the European monarchies.

The Hillman canvas was painted at the moment when Mathieu's signature style matured. His favorite color scheme was black, red, and white; he considered the first two to be the "most significant and expressive colors" and chose white for its strength of contrast (Mathieu, cited in Rennes 1969). Indeed, his compositions are based in the most fundamental visual oppositions—the networks of right angles, straight lines, and curves—that they are generated spontaneously without premeditation or prior planning. They bear deliberate resemblance to Asian calligraphy, which Mathieu admired for its infinite expressive possibilities contained within a narrow vocabulary of signs.

Records in the Hillman Family Archives show that Alex Hillman purchased the Mathieu through the agency of Andrew Carnduff Ritchie, curator at the Museum of Modern Art, who was in Paris gathering works for the exhibition of 1955–56, *The New Decade: 22 European Painters and Sculptors*.[1] Hillman already knew of Mathieu through René Drouin, who had mounted the artist's first solo exhibition in Paris in 1950. Two years later the Stable Gallery in New York held Mathieu's first solo show in America. Another work by Mathieu, *The Night* (1954), entered the collection in 1962 (see Appendix).

 E. B.

[1] Andrew Carnduff Ritchie to Alex Hillman, December 10, 1954. Hillman Family Archives.

PROVENANCE
Acquired from Galerie Pierre, Paris, December 1954; Hillman Family Collection.

HENRI MATISSE (1869–1954)

33. *Jeannie*, 1939
Ink on paper, 14 ¾ x 20 ½ in. (37.5 x 52 cm)
Signed and dated lower right: *Henri Matisse 20/3 39*

I N THE 1930S MATISSE turned his attention increasingly to
drawing, prompted by commissions for murals for Albert
Barnes (Merion, Pa.) and a growing number of illustrated
books. *Jeannie* was rendered in March 1939, before Matisse left
Paris in the fall, upon the outbreak of war, for the safety of the
Hôtel Regina in Nice (Barr 1951, p. 241). In 1939 Matisse
published his "Notes of a Painter on His Drawing" in the
journal *Le Point* (Matisse 1939).

Though fluent in a variety of graphic media, Matisse
considered line drawing to be his ultimate achievement as a
draftsman—the result of years of discipline and visual synthe-
sis—as well as the "the purest and most direct translation of
my emotion" (Matisse 1939, reprinted in Flam 1973, p. 81).
Despite the limitations of color, Matisse felt that the varying
thickness of the crisp black line against the white sheet had the
effect of generating light.

The subject of this portrait is probably Jeannie Michels,
a young painter who sat for Matisse, notably for a series of
drawings later exhibited at the Galerie Louis Carré in Paris in
1941 (Monod-Fontaine 1979, p. 126). She leans on a table, her
arms crossed in a pose both assured and voluptuous. As with
most of Matisse's portraits from the late 1930s and early 1940s,
she gazes directly toward the viewer, but simultaneously seems
lost in thought (Elderfield 1984, p. 274).

Despite the distance inherent in the distilled quality of
the line drawing, individual character emerges from the
distinct attitude and features of the sitter. As Matisse attested:
"My models, human figures, are never just 'extras' in an
interior. They are the principal theme in my work. I depend
entirely on my model, whom I observe at liberty, and then I
decide on the pose which best suits *her nature.* When I take a
new model, I intuit the pose that will best suit her from her
un-selfconscious attitudes of repose, and then I become the
slave of that pose" (Matisse 1939, reprinted in Flam 1973,
pp. 81–82).

E. B.

PROVENANCE
Gift of Morris Guttmann (French Art Galleries), New York; Hillman
Family Collection

LITERATURE
Delectorskaya 1986, p. 309, ill. (misdated 1938).

EXHIBITIONS
Roslyn 1977–78 (HC), no. 18, ill.; Brooklyn 1986–87 (HC); Brooklyn
1988 (HC).

HENRI MATISSE (1869–1954)

34. *The Model*
(*Le Modèle*), 1944
Ink on paper, 19 ⅞ x 14 ½ in. (50.5 x 36.8 cm)
Signed and dated lower left: *Henri Matisse 4/44*

THIS HIGHLY ANIMATED DRAWING encompasses a variety of motifs—model, still life, interior, and the artist himself. Its creation follows a period of intense graphic activity during the years 1941–42, culminating in the publication of Matisse's *Dessins: Thèmes et variations* of 1943. By comparison to the drawings of the mid-1930s, in the following decade Matisse worked at great speed (John Golding, Introduction, in Elderfield 1984, p. 16), evident here in the breaks in the lines and the sketchy rendering of certain details such as the model's and artist's hands.

The drawing was done in April 1944, a month after Matisse moved from Nice to the Villa Le Rêve in Vence. Though the model is unidentified, her sweet features and the style of her hair, with the bangs parted to the side, bear resemblance to the model Annélies in the canvas *Girl Reading*, or *Annélies, Tulipes, Anémones* (repro. in Aragon 1971, vol. 2, p. 332). Alfred H. Barr, Jr., considers it to be "probably the most important painting of 1944" (1951, p. 269). The drawing is closely related to the painting, and to its variant in a vertical format (Cassou 1948, pl. 24, cited in Barr). In both images the model looks directly at the viewer, her hands across the book resting on the table, flanked by two vases of flowers, all in front of a decoratively patterned wall.

Matisse typically captures his sitter at the table in an attitude of repose, looking up from her reading to submit to the artist's scrutiny. Matisse shows himself in the act of representation, depicting his hand, pen, and the drawing paper in the lower right-hand corner. He had earlier exploited this visual synecdoche in the series of nude models in the studio of 1935–37. As John Elderfield argues, Matisse's presence emphasizes the privacy and self-containment of his world: "[H]e is the controlling hand. . . . [W]hen he appears in these drawings, it is simply to remind us that he is their medium" (Elderfield 1984, p. 114).

E. B.

PROVENANCE
Gift from André Weil, Paris, sometime in the 1950s; Hillman Family Collection

EXHIBITIONS
Bronx 1972 (HC); Laramie 1972 (HC); Jacksonville–Corpus Christi 1973–74 (HC), no. 4, ill.; Jamaica 1978 (HC); Roslyn 1977–78 (HC), no. 19, ill.; Austin et al. 1979–85 (HC); Brooklyn 1986–87 (HC); Brooklyn 1988 (HC); Phoenix 1991–92 (HC).

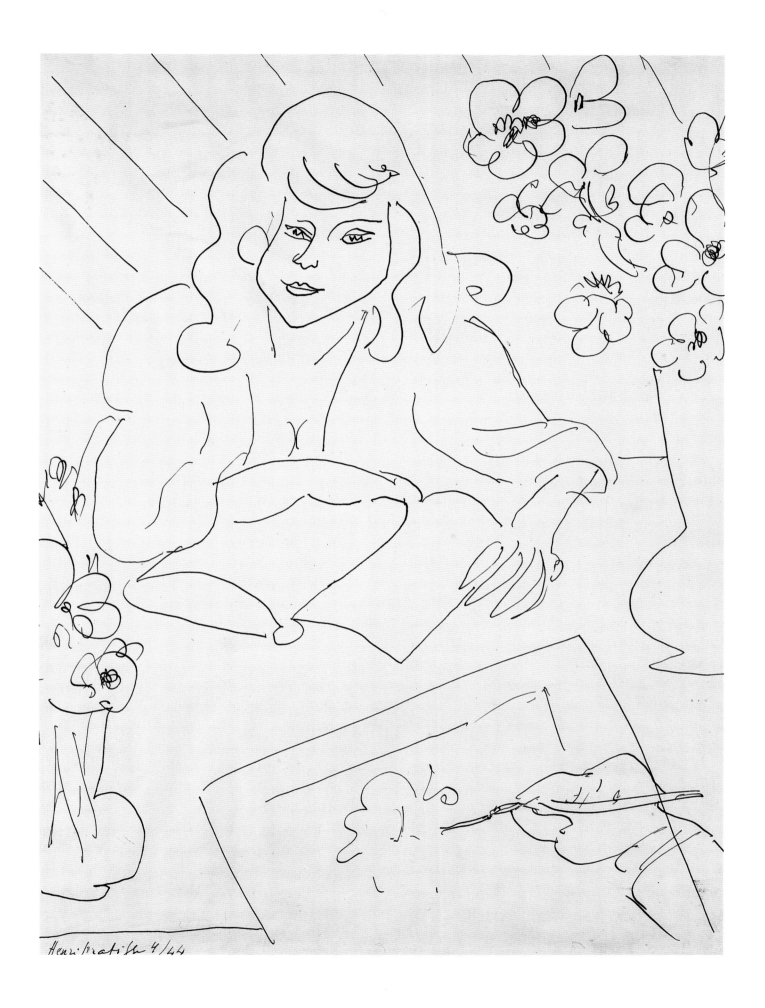

Henri Matisse 4/44

HENRI MATISSE (1869-1954)

35. *The Pineapple*
(*L'Ananas*), 1948
Oil on canvas, 45 ¾ x 35 in. (116 x 89 cm)
Signed and dated lower right: *Matisse 48*

*T*HE PINEAPPLE is one of six large interiors Matisse painted in Vence, at the Villa Le Rêve in the winter and spring of 1948. They represent his last body of completed paintings and were exhibited together the following year at the Musée National d'Art Moderne in Paris, on the occasion of the artist's eightieth birthday. John Elderfield writes that the final canvases are rendered "with broad, virtually uninflected areas of vivid color in a way that recalls his decorative post-Fauve paintings of some forty years before" (New York 1992–93, p. 416).

The other five interiors contain an array of flowers, furniture, patterned curtains and walls: *Plum Blossoms, Green Background* (private collection); *Plum Blossoms, Ocher Background* (private collection); *The Black Fern* (Beyeler Collection, Basel); *Interior with an Egyptian Curtain* (The Phillips Collection, Washington, D.C.); and *Large Red Interior* (Musée National d'Art Moderne, Centre Georges Pompidou, Paris). As Alfred H. Barr, Jr. , has observed, the *Pineapple* is "unique in the group" for its "concentration upon a single object." It is also, in his opinion, "the most fluid in form, the freshest in effect" (1951, p. 277).

The exotic fruit appears in an earlier canvas, *Pineapple and Anemones* (1940, private collection), where it sits in a box on a bed of white tissue, as part of a larger still-life arrangement. Two studies for the Hillman picture reveal the artist's increasing focus on the pineapple, which, with its sensual shape and exuberant, leafy top, flaunts the decorative essence of his art. The first of these, a charcoal sketch (Matisse Archives, repro. in Schneider 1984, p. 652) focuses directly on the tabletop with an emphasis on the strong black outlines of the various motifs. A riotous display of black-and-white pattern fills the more detailed brush-and-ink drawing (Elderfield 1984, no. 138), from the grid of the background wall to the spotted floor, to the licks of the brush denoting flowery forms both "real" and artificial. This study also confirms the identity of the sheet of wrapping paper, which becomes a highly abstracted, billowing form in the final painting.

Here the pineapple sits on a red scalloped-edged plate, now transformed from a decorated ceramic bowl in the brush-and-ink study. The rounded shape of the fruit is set off by the expanding fan of paper behind it, which partially obscures the vase of greenery behind. At the right and left fall verticals of green and red that serve to define the interior space, while a wash of yellow-orange dominates the center, as if the room were flooded by a hot afternoon light. Underneath the table, the yellow-orange area forms an unusual design. Though seemingly abstract, it relates to the spotted shape depicted in the preliminary drawing, which can, in turn, be traced to the outlines of two dogs that lie on the floor in *Large Red Interior*. Michael Mezzatesta suggests that the form may depict Matisse's dog stretching or sleeping, with the tail curling up behind and the limbs extended outward (Fort Worth 1984, pp. 139–40).

The Pineapple was subsequently featured in the sister painting, *Large Red Interior,* which can be considered the culminating image of the entire series (Barr 1951, p. 277). *The Pineapple* occupies one of two walls in the red room, hanging beside a large brush-and-ink study, *Interior by the Window with a Palm*, on the adjacent wall (repro. in Monad-Fontaine 1979, p. 173). As a compositional device, the two rectangles divide the surface in half, but their pairing serves a metaphoric function as well, as Matisse alludes to the opposition between painting and drawing (Schneider 1984, p. 442). In *The Pineapple*, Matisse uses black to define the edges of objects, the space of the room, or even the jutting legs of the table, cutting through the unmodulated areas of brilliant color like scissors through paper. Indeed, more than any of the other Vence interiors, because of its radical simplification of form, *The Pineapple* comes closest to the manner of his contemporaneous cutouts, which reconciled the dual approaches of color and line.

E. B.

PROVENANCE
Acquired from Pierre Matisse Gallery, New York, June 1955; Hillman Family Collection

LITERATURE
Verve 1948; Barr 1951, p. 277, ill. p. 506; Diehl 1954, no. 136, ill.; *Art News* 1959 (HC), color cover; Lassaigne 1959, p. 117; Selz (?), color ill. p. 68; Carlson 1971, p. 164; Aragon 1971, vol. 2, pp. 305, 363, color pl. LXX, p. 341; Monad-Fontaine 1979, p. 100 n.1 and 5; Schneider 1984, pp. 373, 442, 652; AFA 1984 (HC), p. 7, ill.; Flam 1988, p. 335, color pl. 107; Monad-Fontaine–Baldassari–Laugier 1989, p. 115n. 1 and 5 (reprint of 1979 text); Bernier 1991, pp. 21–22, color ill. p. 21.

EXHIBITIONS
Paris 1949, no. 9, ill.; New York 1950, no. 8, ill.; Nice 1950, no. 37, ill. p. 26; Paris 1950, no. 58; New York–Cleveland–Chicago–San Francisco 1951–52, no. 71; Paris 1956, no. 94, p. 34, pl. XXX; Los Angeles–Chicago–Boston 1966, no. 89, p. 118, color ill. p. 192; New York 1966, unnumbered checklist; New York 1970, no. 41, ill.; Paris 1970, no. 202, p. 94, ill. p. 248; Copenhagen 1970, no. 63, ill.; Bronx 1972 (HC); Laramie 1972 (HC); New York 1973, no. 56, color ill.; New York 1975, no. 43; New York 1971 (HC), exhibition checklist no. 6, p. 2; Omaha 1977, p. 36, fig. 68; Roslyn 1977–78 (HC), no. 20, ill.; Austin et al. 1979–85 (HC); Fort Worth 1984, no. 54, pp. 139–40, ill.; Brooklyn 1986–87 (HC); Brooklyn 1988 (HC); New York 1992–93, p. 416, color pl. 386, p. 444.

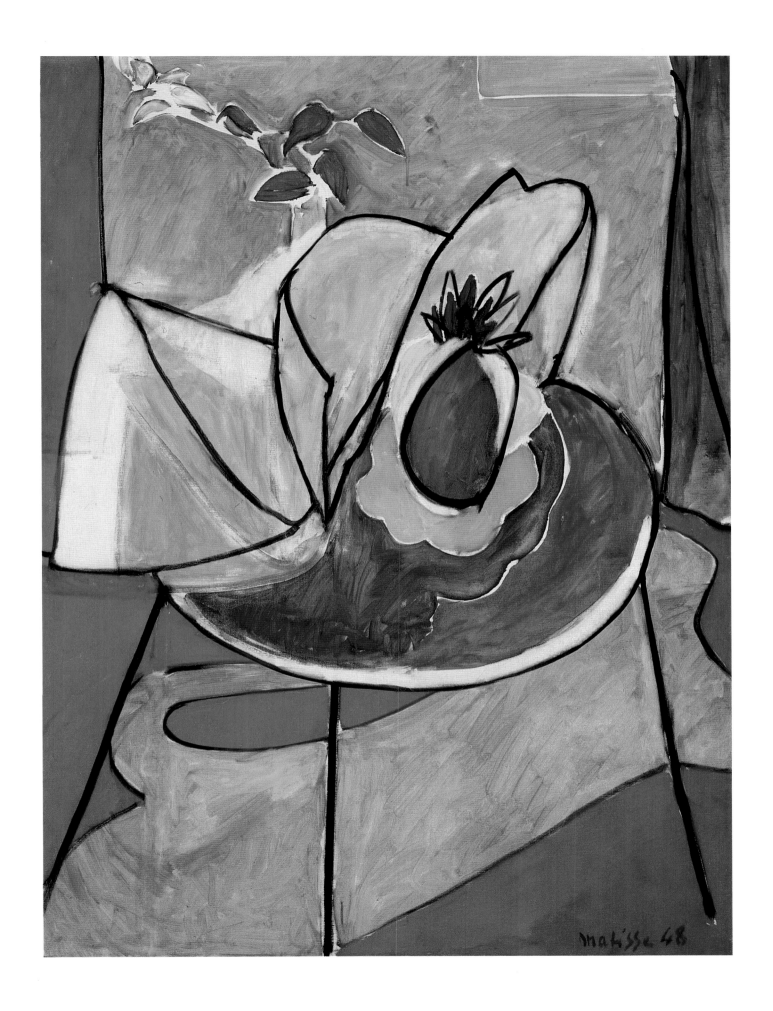

JOAN MIRÓ (1893–1983)
36. *Woman and Bird before the Sun,* 1942
Pastel, gouache, and india ink on paper, 42 x 28 in.
 (106.7 x 71 cm)
Signed lower center: *Miró*

IN 1942 MIRÓ RETURNED to Barcelona, where he re-
mained until the end of World War II. In that year he
began a series of pastels and watercolors, after having concen-
trated on the *Constellations* series since 1940. The latter had
signaled the end of his "cruel" period of mutilated creatures
and embattled compositions and the resurfacing of his earlier
whimsy and childlike wonder (Dupin 1962, p. 369). The
works on paper continued in the same vein and invariably
treat the theme of a personage, usually a woman, with a bird,
hovering in an undefined, effervescent landscape, with a star,
moon, or sun behind (Dupin 1962, nos. 65–72).

The identity of the characters are determined by the most
minimal of signs—linear tracery, dumbbell forms, shimmer-
ing ovoids, and lighthearted squiggles denoting hairs, ears, and
eyes. As Sidra Stich has documented, the images are largely
extricated from the "complex webbing of the *Constellations*"
and are similarly inspired by the pictographs of prehistoric
Iberian rock painting (Stich 1980, pp. 47–49). In the case of
the Hillman pastel, three creatures romp in front of a blazing
pink orb: a human female, typically signifed by a pitch-black
ovoid head and a tangle of entangled lines sprouting breasts;
another earthbound figure with a giraffelike neck and protrud-
ing limbs and orifices; and a bird in flight, with its simple
propeller wings. Here Miró brilliantly exploits the inherent
qualities of the graphic media, drawing out inky line against
vaporous atmosphere, asserting the surface with impenetrable,
velvety fields of color, and illuminating the page with the
powdery aura of pastel.

Though the provenance of the Hillman pastel is unre-
corded, the back of the work bears a label from the Pierre
Matisse Gallery. The gallery held two exhibitions of Miró's
works on paper from the early 1940s in the years 1947 and
1948. The catalogues on both occasions list a pastel, *Woman
and Bird before the Sun* (42 ½ x 28 ¼ in. in 1947; 42 x 28 in. in
1948; see Rose 1982, p. 140). The same pastel may have been in
both shows, and the title, dimensions, and medium listed in
the catalogues correspond to those of the work in the
Hillman Collection. It was probably purchased from the
gallery at a slightly later date, in the early 1950s, before the
Hillmans kept accurate records of their acquisitions.
 E. B.

PROVENANCE
Unknown; likely purchased from the Pierre Matisse Gallery, New York,
in the early 1950s; Hillman Family Collection

EXHIBITIONS
New York 1947 (?); New York 1948 (?).

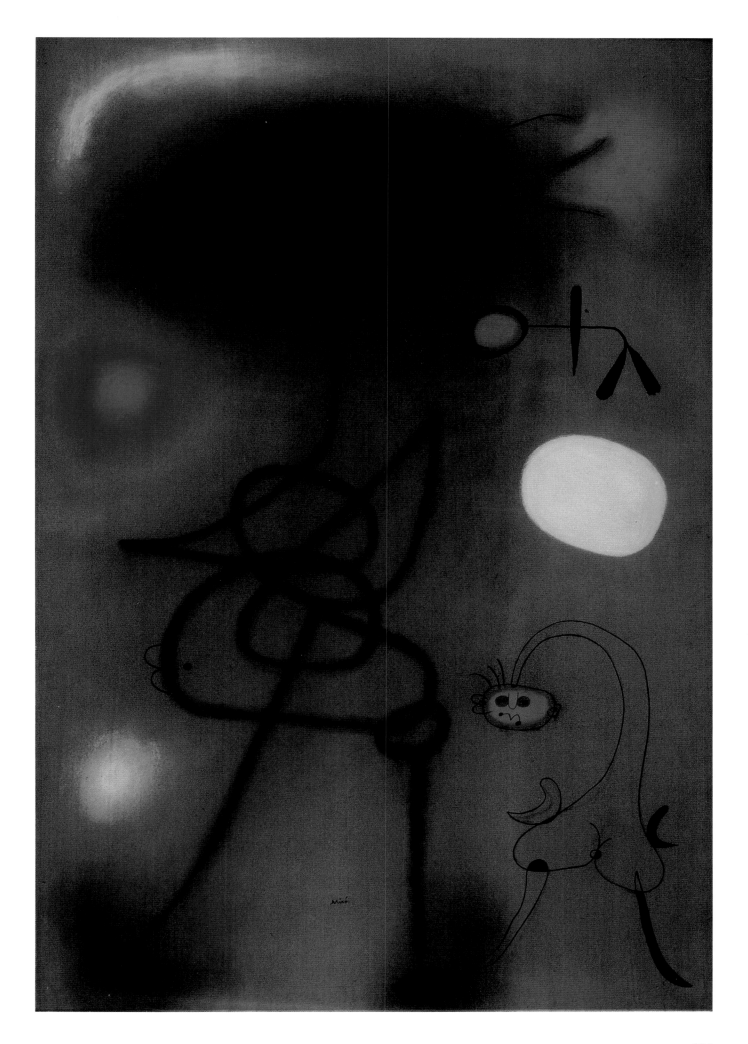

AMEDEO MODIGLIANI (1884–1920)

37. *Portrait of Anna (Hanka) Zborowska*
(*Portrait de Hanka Zborowska*), 1916
Oil on canvas, 30 x 17 ¾ in. (76.2 x 45 cm)
Signed lower left: *Modigliani*

ANNA ZBOROWSKA was the common-law wife of the Polish poet Leopold Zborowski, who in 1916 became Modigliani's devoted supporter and who replaced Paul Guillaume as his primary dealer. Convinced of Modigliani's genius, Zborowski took care of both the artist's career and his daily sustenance. He provided Modigliani with a studio space in his own home, where Anna became a frequent model. In the spring of 1918, when Modigliani's health deteriorated, the Zborowskis took him and his pregnant mistress, Jeanne Hébuterne, to the south of France, where they remained until the following year. Of aristocratic Polish lineage, Anna (Hanka) was from all accounts a formidable woman, who had to mediate between her selfless husband and needy artists (Rose 1990, pp. 151–54). Though she maintained a relatively distant relationship with Modigliani, Zborowska fully participated in her husband's commitment to the artist, while managing their household with already restricted financial means.

This is the first formal portrait of Anna Zborowska Modigliani painted and the only one dating from 1916. Some ten others were painted before Modigliani's premature death in 1920 (Patani 1991, nos. 164, 183–86 [1917]; 237, 239 [1918]; 323–26 [1919–20]). Zborowska's reserved, even haughty, elegance is also captured in two other portraits by Modigliani, both of 1917: a bust-length version of her wearing a high white collar (Galleria Nazionale d'Arte Moderna, Rome) and another in which she is dressed in a swath of black, reclining languorously on a sofa (The Museum of Modern Art, New York). Zborowska also posed for at least two of the artist's notorious nudes, with the presence of a chaperone—their mutual friend Lunia Czechowska (Rose 1990, pp. 151–52).

According to Modigliani's daughter Jeanne, Anna had "a pale, perfect oval of a face, close-set black eyes and a sinuous neck" (Modigliani 1958, p. 77), features congenial to Modigliani's characteristic stylizations. In the Hillman portrait, Modigliani plays with the curves of Zborowska's face and pose, finding formal echoes in the shapes of her fur collar, clasped hands, and the sweep of her hair. The fur collar draws attention to the elongated cylinder of the neck, while the back of the armchair complements the circular disposition of her upper torso. Modigliani used the butt end of the brush to draw into the paint, denoting strands of hair and accentuating the unbroken contour of the arms and shoulders. By comparison to the attention bestowed on the figure, the background is summarily treated in earthy tones of reddish brown. The limited palette and lack of opulence complete the image of an assured and well-born woman now in a bohemian world of few economic resources.

A pencil study for the painting exists (repro. in Vitali 1929, n.p.), in which the model's head tilts distinctly to the left, and the chair is rendered in greater detail. The self-contained, reddish brown oval to the lower left in the painted version is one of a pair of armrests that form part of the upholstery.

E. B.

PROVENANCE
Acquired from René Drouin, Paris, 1950; Hillman Family Collection

LITERATURE
Carli 1952, no. 9, pp. 22, 31, pl. 9 (1917); Ceroni 1958, no. 65, p. 51, ill. no. 65; Roy 1958, color ill. p. 79; *Art News* 1959, inset no. XVI; Russoli 1959, color pl. 11; Ceroni-Piccioni 1970, no. 159, p. 96; Diehl 1977, color ill. p. 74; Patani 1991, no. 162, p. 175, color ill.

EXHIBITIONS
Cleveland–New York 1951, pp. 30–31, 51, ill. p. 31; Rome 1951–52, no. 11, p. 176, pl. CIC; Milan 1958, no. 20, p. 24, ill.; Atlanta 1960, no. 5; Boston–Los Angeles 1961, no. 9, pp. 24, 34, ill. p. 43; Tel Aviv 1971; New York 1971, no. 16, color ill.; Bronx 1972 (HC); Austin et al. 1979–85 (HC) (Oklahoma City, Huntsville, and Ames only); Brooklyn 1986–87 (HC); Brooklyn 1988 (HC).

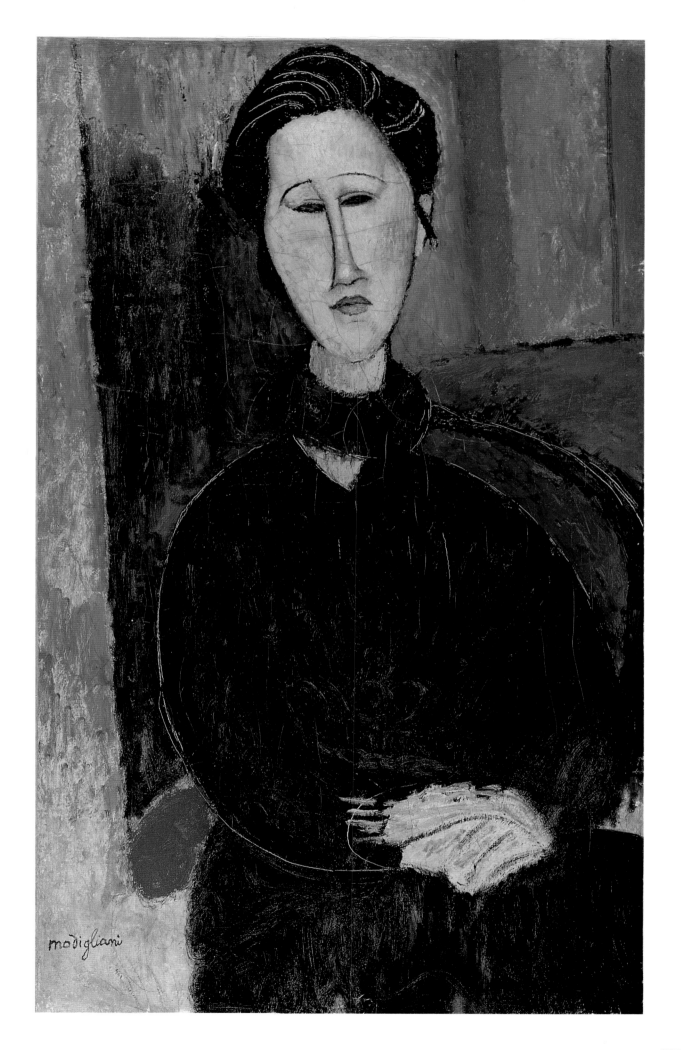

AMEDEO MODIGLIANI (1884–1920)

38. *Head of a Woman/Portrait of Jeanne Hébuterne*, 1917
Pencil on paper, 17 x 13 in. (43.2 x 33 cm)
Signed lower right: *Modigliani*

MODIGLIANI WAS A PROLIFIC DRAFTSMAN, who—whether at a bar, café, or in the studio—never lost an opportunity to sketch his circle of intimates or new acquaintances from the milieu of Montparnasse. Though an unaccountable number of his drawings have been lost, conservative estimates place the extant number of watercolors and drawings at around seven hundred (Patani 1976, p. 25).

Usually bust-length or half-figure, Modigliani's portrait drawings were rendered rapidly without any gesture of deliberation. They combine the impression of individual character with an unerring sense of the principles of pure design. The knowing curve of a brow or an upturned lip capture the essence of the sitter's physiognomy, while uniting the surface in a fluid play of linear arabesques.

Modigliani used both the sharp point and the softer side of the pencil to create variation in the thickness of contour line and, consequently, the illusion of spatial relief. As can be seen in the Hillman drawing, the figures are devoid of interior modeling, while minimum areas of shading around the head and neck accentuate the geometric essence of their forms.

Though the subject of the Hillman drawing is unidentified, it may well be a portrait of Jeanne Hébuterne, the artist's companion, whom he met in 1917. Her coiffure—hair piled high and a center part with a few loose bangs—corresponds to other images of Hébuterne. The widely placed eyes and their glassy gaze (accentuated by the shading of only one eye) recall her highly distinctive features. The treatment of her nose is especially characteristic: Modigliani typically flattened the base and rendered it without nostrils to create a pure wedge shape, drawing out the sensual calm of his lover's face.

E. B.

PROVENANCE
E. Raynal, Paris; acquired from the New Gallery, New York, October 1955; Hillman Family Collection

EXHIBITIONS
Rome 1959, no. 98, p. 56, ill.; Atlanta 1960, no. 36; Roslyn 1977–78 (HC), no. 22, ill.

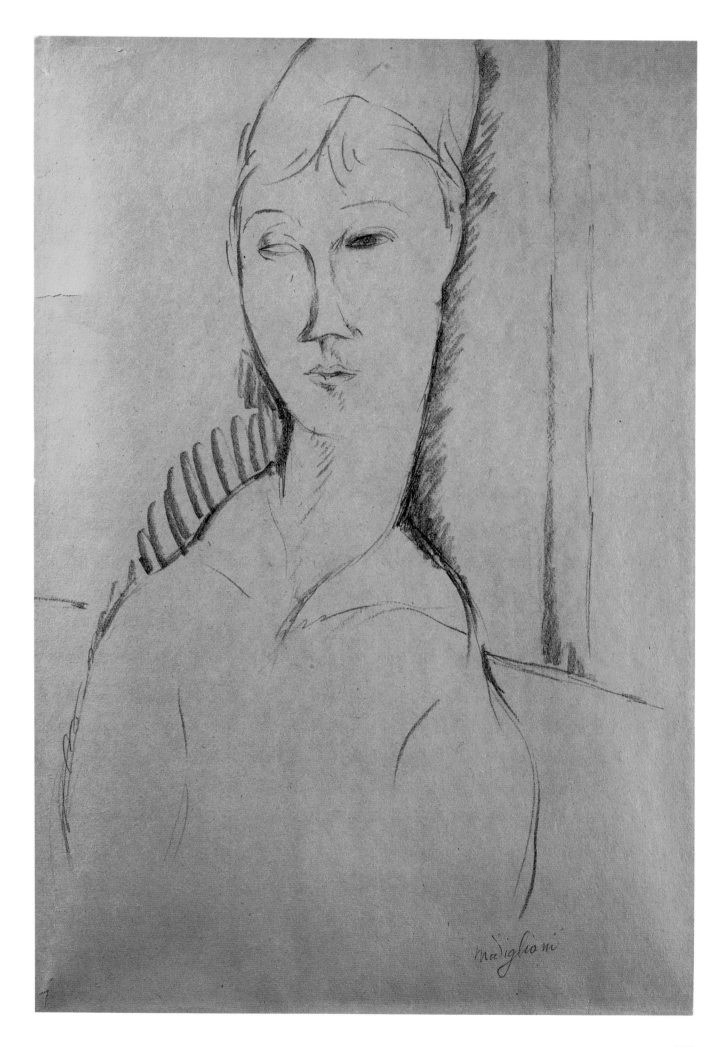

119

PABLO PICASSO (1881–1973)

39. *The Pipe Smokers*
(*Les Fumeurs de pipe*), 1903
Ink on business card, 3 ½ x 5 ¼ in. (9 x 13.5 cm)
Signed lower right, added at a later date: *Picasso*

THIS DRAWING IS SKETCHED on the back of a business card from the dry-goods shop of Sebastia and Carles Junyer Vidal, two brothers—a painter and a critic, respectively—who had recently inherited the business. Picasso found them amiable patrons. According to John Richardson, Picasso spent many hours in their shop, "gossiping with the proprietors and drawing on large sheets of wrapping paper or the back of small trade cards" such as this one (1991, p. 281). Sebastia Junyer would accompany Picasso to Paris in early 1904, paying the first few months' rent on the Bateau Lavoir studio Picasso occupied until 1909 (Richardson 1991, p. 295; see Picasso's series of cartoons recording their arrival, repro. in Zervos 6, nos. 485–89, and Rubin 1980, p. 47).

Picasso did numerous drawings on the backs of the Junyers' cards. Some of these are caricatures of Sebastia Junyer. (See, for example, Zervos 6, nos. 345 and 499, repro. in Palau 1985, p. 338; Sebastia was also the subject of a substantial canvas, Daix-Boudaille 1967, IX.21, repro. in Richardson 1991, p. 283.) However, most of the drawings from this series are devoted to sexual themes. Some mock the desires of rich old men, while others evoke Picasso's own pornographic fantasies. (See the drawings in Zervos 1, nos. 143–54; Palau 1985, p. 337; and Richardson 1991, p. 280).

The Pipe Smokers fits into none of these categories. While it depicts two men, their swollen bellies seem meant to suggest pregnancy, and they have the drooping breasts of aged women. The faces, on the other hand, appear to be individualized portraits. The face of the figure on the right corresponds to that in another sketch identified by Zervos as a portrait of the painter Santiago Rusiñol (Zervos 21, no. 122), a founder of Els Quatre Gats café and one of the chief animators of the *modernista* movement in Barcelona. Rusiñol was an ardent Francophile, and his writings on El Greco and Puvis de Chavannes led the Société Nationale des Beaux-Arts to name him an associate—an event satirized by Picasso on another of the Junyers' business cards (Richardson 1991, pp. 76, 115, 130, 257, 291). The spermlike creatures on Rusiñol's belly in *The Pipe Smokers* may allude to works by Edvard Munch, a hero of the *modernistas*. Rusiñol is shown smoking a cigar thrust vertically into a pipe, apparently a common habit in the Quatre

Gats circle. (See Picasso's portrait sketches of Rusiñol and Ramon Casas, repro. in Palau 1985, p. 191, nos. 435 and 433.)

John Richardson suggests that the figure on the left, with a few strands of hair brushed over his balding pate, might represent the painter, writer, and puppeteer Miquel Utrillo, another founder of Els Quatre Gats. Utrillo also edited the Catalan journal *Pel & Ploma* (*Fur and Feather*), where he glowingly reviewed Picasso's work. (On Utrillo, Els Quatre Gats, and *Pel & Ploma*, see Richardson 1991, pp. 129–32; Utrillo's review is translated in Daix–Bourdaille 1967, p. 333.) "Pel & Ploma" is inscribed on Utrillo's stomach, and the "pregnant" contours of both figures may be a reference to the recent rebirth of this journal, which had ceased publication in 1902 but reappeared in early 1903, before expiring definitively in December of that year. The imagery of pregnancy may also be a distant reflection of Picasso's contemporary studies for his canvas *The Embrace* (Daix-Bour-daille 1967, IX.12; see the related studies in Palau 1985, pp. 332–33).

The sketches done on the Junyers' cards were originally unsigned, and the signature at the lower right of *The Pipe Smokers* seems to have been added some time after 1930. Similar signatures appear on many drawings done on these cards; Picasso presumably signed a large group of them at a time when they were still in the collection of the Junyer family. (The cards reproduced in Zervos 1, nos. 143–54, appear to bear earlier signatures, but Zervos's captions state that these are not authentic.)

P. K.

PROVENANCE
Joan Junyer, Barcelona; acquired from Perls Galleries, New York, 1954; Hillman Family Collection

EXHIBITION
New York 1954.

PABLO PICASSO (1881–1973)

40. *The Bull*
(*Le Taureau*), 1903
Ink and crayon on business card, 3 ½ x 5 ¼ in. (9 x 13.3 cm)
Signed lower left, added at a later date: *Picasso*

L IKE *THE PIPE SMOKERS* (cat. no. 39), *The Bull* is drawn on the back of a card from the Junyer brothers' dry-goods shop. Unusual for these drawings, the subject here is neither caricatural nor pornographic. The bull is a recurrent motif throughout Picasso's career. In the drawings of his youth (see, for instance, the sketches reproduced in Barrachina et al. 1984, pp. 576–78), it generally appears in the context of the bull-fight. In 1933 it returns in the guise of the Minotaur and in a new series of bullfight scenes (see Rubin 1980, pp. 312–10 ff.). In either context, the bull clearly serves Picasso as a symbol of both virility and mortality, profoundly if obscurely linked to his own self-image.

The horns of this bull display dark, seemingly bloodened tips, as if the animal had recently gored a horse or matador. However, this violent association is contradicted by the setting, which seems to represent the bank of a stream or river rather than the dirt of a bullfight ring, and by the animal's static pose, anticipating the *Bull* lithograph of 1945, with its progressively reworked and simplified outlines (see Rubin 1980, pp. 390–91, and Lavin 1993).

What is surprising in the figuration of the 1903 drawing is the profusion of internal contours, represented as indepen-dent curves; they do not connect with the outlines of the head, neck, and flanks. Picasso usually employs such contours sparingly, reinforcing their sculptural value by running them into the profiles of his forms. The reverse S curve of the bull's horns does not appear in Picasso's earlier taurine sketches but is apparent in a 1904 study reproduced in Zervos 22, no. 71.

As with cat. no. 39, the signature seems to have been added at a much later date.

P. K.

PROVENANCE
Joan Junyer, Barcelona; acquired from Perls Galleries, New York, November 1954; Hillman Family Collection

LITERATURE
Zervos 1, no. 46.

EXHIBIT
New York 1954.

PABLO PICASSO (1881–1973)

41. *Study for "La Toilette,"* 1906
Charcoal on paper mounted on pulp, 24½ x 16⅛ in.
(62.2 x 41 cm)
Signed and dated lower right: *Picasso 1906*

THE SUGGESTIVE IMAGE OF A NUDE with her hand raised to her hair, ubiquitous in Picasso's work of 1906, is here combined with the more severe motif of a clothed woman seen in profile, holding a mirror. The figure of the mirror bearer looks back to Picasso's 1905 *Woman with a Fan* (Daix-Bourdaille 1967, XIII.14), repeating not only the earlier figure's pose but even details such as the scarf binding her hair, the sash tied around her waist, and the outline of her lowered hand, which now supports a mirror instead of a fan. Her presence and attire seem to qualify the nude as a courtesan or harem girl.

The relationship between the two works becomes clearer if we examine Picasso's studies for *Woman with a Fan*, which reveal the composite nature of the final image: the pose comes from a drawing of a girl with a "ski-slope" nose and a protruberant chin, wearing a hat (Zervos 22, no. 278), while the outline of the hair comes from a sketch of a different woman (possibly Picasso's mistress at the time, Fernande Olivier), with a more assertive nose and a slightly receding chin (Zervos 22, no. 146). The face in the finished canvas combines features of both models.

In his studies for *La Toilette*, Picasso reproduced the face seen in the second of these sketches; it is modified only slightly in the finished canvas (Albright-Knox Art Gallery, Buffalo). In contrast, he experimented with several different versions of the mirror bearer's costume. In one study she appears completely nude (Zervos 22, no. 430); in another, she is wearing harem pants, cuffed at the ankle (Zervos 22, no. 432). Indeed, these cuffs survive into the present drawing, where they may be interpreted either as cuffs or as ankle bracelets, possibly bound together by a length of chain. In the painting, these forms are consolidated into the hem of a pink skirt or slip, extending below the diagonal border of the blue dress.

The present study is considerably larger than the other surviving ones, and the drawing of both figures is far more precise. (In addition to the studies cited above, see Zervos 22, no. 433, and Zervos 6, no. 736, color repro. in Palau 1985, fig. 1247, p. 448.) Picasso seems to have posed a live model for the nude on the left. The continually fluctuating contours describe the volumes of face, limbs, and torso with remarkable precision; several similar studies show this figure in isolation (see, for instance, Zervos 22, no. 426). In the finished painting, this figure seems both older and more ethereal. Picasso has modified her facial features and lengthened her legs, making her taller than the mirror bearer; furthermore, she is painted with tans and salmon pinks similar to those of the background, giving her form an impression of transparency.

Erased outlines in the study reveal that the figure of the mirror bearer was originally placed about an inch to the right of its present position, so that the two figures were farther apart than in the other studies. The artist, however, apparently repented of this change: courtesan and servant remain closely juxtaposed both in the final study and in the finished canvas. The signature appears to be of the period.

These contrasting figures are deeply evocative, but their precise significance remains difficult to define. Discussing the canvas *La Toilette*, Meyer Schapiro describes it as an allegory of art itself, in which the mirror is "both palette and canvas" and the mirror bearer represents the painter himself (1976, p. 116). John Richardson's observations that the sash around the mirror bearer's waist resembles those worn by Spanish men (but not by Spanish women) might be taken to support this reading. Richardson, however, rejects Schapiro's identification, suggesting instead that both figures in the painting are images of Fernande Olivier, metamorphosed into two different women by the "power of art and love" (1991, pp. 445–47).

P. K.

PROVENANCE
Alfred Flechtheim, Berlin; Hugo Stinnes, Berlin; acquired from French Art Galleries, New York, January 1952; Hillman Family Collection

LITERATURE
Zervos 22, no. 431; Lieberman 1952, p. 22, ill.; Daix-Bourdaille 1967, XV.32; Palau 1985, fig. 1245, p. 448; Chevalier 1991, p. 85, ill.

EXHIBITIONS
Miami 1963, no. 93, p. 60 (?); Bronx 1972 (HC); Laramie 1972 (HC); Jacksonville–Corpus Christi 1973–74 (HC), no. 3; Phoenix 1975 (HC); Roslyn 1977–78 (HC), no. 23; Austin et al. 1979–85 (HC); Brooklyn 1988 (HC).

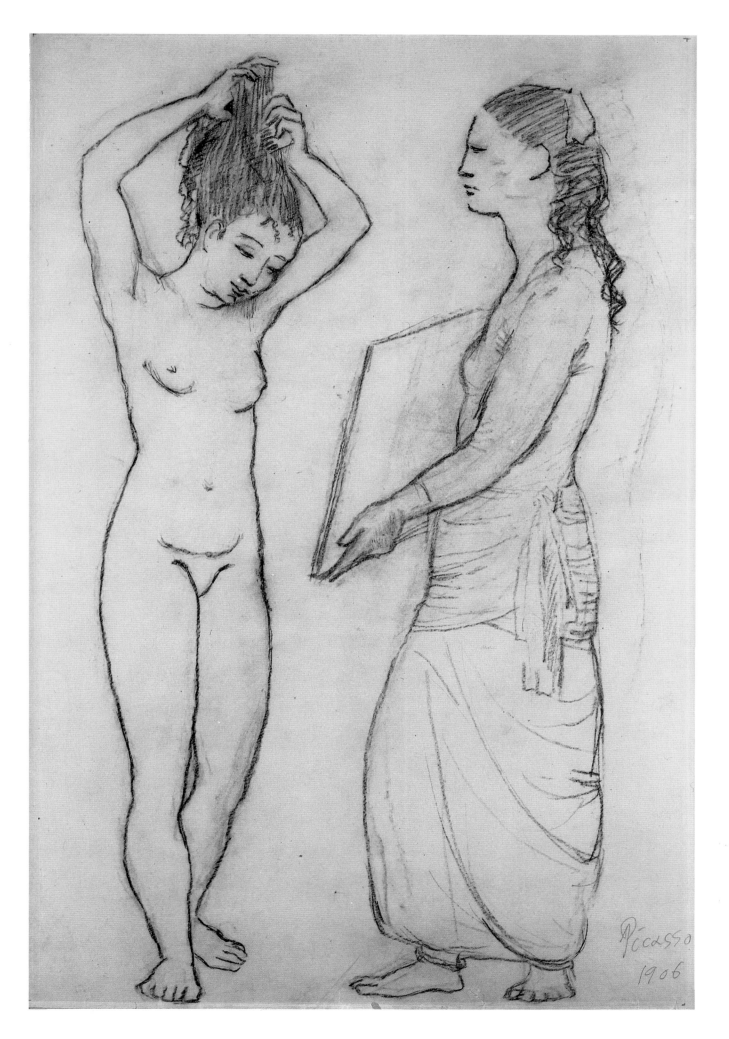

PABLO PICASSO (1881–1973)

42. *Nude and Faun*
(*Le Nu et faune*), 1906
Watercolor on paper, 8 ¼ x 5 ¼ in. (21 x 13.3 cm)
Signed upper left, added at a later date: *Picasso*

THIS WORK BELONGS TO A SERIES of small watercolors that depict a curly-haired nude with a hand raised to her head; she is sometimes accompanied by two horned satyrs (or a satyr and a cupid) and is sometimes alone (Zervos 6, nos. 803, 805, 806, and 808). This theme is also explored in an ink sketch, in which the satyr doffs a top hat and offers the woman a platter of jewelry (Zervos 6, no. 804).

Palau and Rubin suggest that this series may be seen as a development of the figure of the young girl in Picasso's canvas *The Blind Flower Seller* (Daix-Boudaille 1967, XV.62). This canvas, sketched in Gosol, Spain, and painted in Paris, is based on the composition of El Greco's *Saint Joseph and the Infant Jesus*; the girl's pose, curly hair, and air of innocence represent a direct translation of Greco's holy infant. As she grows older, in the subsequent series of drawings, her body assumes the contours of sexual maturity, and she is subjected to the temptations of lust and greed (Palau 1985, pp. 466–67; Rubin 1988, pp. 402–3). The motif of the woman with a faun, however, is already prefigured in the large canvas *Woman with Boy and Goat* (Daix-Boudaille 1967, XV.35), executed earlier in Picasso's stay at Gosol. As John Richardson suggests, the sexualized motif of the girl-woman with satyr may thus precede rather than follow *The Blind Flower Seller* (1991, p. 447 and p. 519 n. 36). The curly hair that symbolizes innocence in one painting may stand for sensuality in another.

In another from canvas Gosol (*Woman with a Comb*, Daix-Boudaille XVI.5; Rubin 1980, p. 71), the woman's gesture of raising her hand to her head is rationalized by the presence of a comb held in her other hand: she is grasping her hair in order to comb it out. The comb is absent in *Nude and Faun*, but the raised arm retains its sensual potency. It is carried over, as Leo Steinberg points out, into the pose of the woman on the right in the monumental *Two Nudes* of late 1906 (Zervos 1, no. 366; color repro. in Rubin 1980, p. 83). Comparing this gesture to that of Michelangelo's Isaiah, on the Sistine Chapel ceiling, Steinberg describes it as a sign of "awareness or self-recognition"—in this case, sexual awareness, as the woman moves from a state of "woman alone" toward the sexual encounter of the *Demoiselles d'Avignon* (Steinberg 1972 [2], p. 42).

In the immediate context of *Two Nudes*, however, the woman's raised hand seems to have been desexualized. It no longer touches her hair, which has in turn lost its sensual curls. This iconographic shift is accompanied by a dramatic stylistic change. The loose brushwork of *Nude and Faun*—like that of *Woman with a Comb*, but on a miniature scale—infuses the entire image with a sensuous tactility. In *Two Nudes*, this tactility is banished from the figures, lingering only in the background drapery. The figures' contours are modeled optically, by light and shade. The comparison between *Woman and Faun* and *Two Nudes* thus reveals not just the continuity of Picasso's work but also the range of techniques he used in his relentless explorations.

P. K.

PROVENANCE
Parke-Bernet Galleries, New York, April 20, 1950, sale 1152, no. 45, p. 10; acquired from Perls Galleries, New York, November 1954; Hillman Family Collection

LITERATURE
Zervos 22, no. 412; Steinberg 1972 (2), p. 42, ill. no. 43; Palau 1985, p. 467, fig. 1335; Steinberg 1988, p. 346, ill. no. 35, p. 347; Rubin 1988, p. 403, ill. no. 19, p. 404.

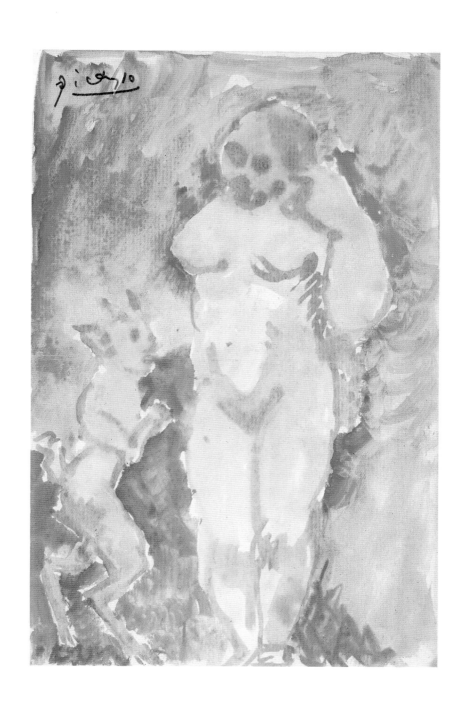

PABLO PICASSO (1881–1973)

43. *Nudes/Three nudes*
(*Nus/Trois nus*), 1906
Gouache on tan paper, 24¾ x 19 in. (62.8 x 48.3 cm)
Signed lower left: *Picasso*

THE TERRA-COTTA COLORING and elongated figures of this large gouache place it among the works from Picasso's stay at Gosol, Spain, in the summer of 1906. The nude woman at the left leans back on a sketchily indicated sofa or bed, gazing downward at a nude youth seated on the floor; one of his hands grasps the neck of a *porron* (a Spanish drinking vessel) while the other arm rests on his raised knee. Between them stands another nude woman, somewhat more thinly painted and hence perhaps an afterthought.

A recent conservator's report reveals that this sheet was originally used for a full-length drawing of a boy, similar to the boy seated on a box at the left in a canvas painted in Gosol, *Two Youths* (Daix-Boudaille 1967, XV.10). The boy was apparently drawn with reddish brown lines on an orange-pink ground. Picasso inverted the sheet, laid in a new ground over the boy's torso, and drew the new group of figures with broader strokes of white and tan, using a thin reddish brown line for the facial features, hair, and other details. The foot or, more precisely, two alternative versions of the foot of the original figure, remains visible at what is now the upper left corner of the sheet. There is also, on the verso of the sheet, a very faint pencil drawing of a seated girl in an armchair, with a wrap covering one arm, possibly a study after Ingres's *Portrait of Mme Devaucay* (Musée Condé, Chantilly).

The three-figure group on the recto appears to be a variant on the composition of a large Gosol canvas, *The Harem* (Daix-Boudaille 1967, XV.40), in which a gigantesque seated male nude is accompanied by four nude young women and an aged crone, squatting in the corner. John Richardson identifies both the gouache *Nudes* and *The Harem* as ironic reworkings of Ingres's *Turkish Bath* (Louvre, Paris), a long-lost harem scene that had been exhibited to great effect in the Ingres retrospective at the 1905 Salon d'Automne (1991, pp. 421 and 447).

The classicizing figures of *Nudes* are accompanied by inscriptions scrawled in Spanish: "Decoration on the walls / flowers / landscape and fruits—a room painted in pink / some white curtains / a sofa, the kind in straw / on it, mauve bolster / marble [illegible] / on it some bowls and a small mirror—maybe some gauze veils—he holds in / his hand / a cigarillo—he holds a *porron* in his hand / a fruit dish here" (trans. in Daix-Boudaille 1967, XV.18). This list of modern furnishings, together with the suggestion of sexual interaction, has led many critics to see *Nudes* as representing the earliest germ of the heroic brothel composition that would occupy Picasso through much of 1907. In a 1955 letter to the Hillmans, Alfred H. Barr, Jr., described the gouache as "beautiful in drawing and fascinating in its anticipations of *Les Demoiselles d'Avignon*" (The Museum of Modern Art, New York).[1] John Richardson similarly describes it as "the first intimation

of the *Demoiselles*" (1991, p. 447). Leo Steinberg stresses the phallic symbolism of the *porron*, which reappears in early studies for the *Demoiselles* (Steinberg 1972 [1], pp. 25–26). In the Musée Picasso's 1988 exhibition devoted to the *Demoiselles d'Avignon*, *Nudes* was reproduced as the first "prodrome" of the 1907 canvas (*Demoiselles* 1988, pp. 14–15).

This exclusive focus on the anticipatory aspects of *Nudes* may to some extent falsify the character of the picture. Stressing the phallic significance of the *porron*, Leo Steinberg insists on the "visual rhyming of spout and phallus." This leads him to describe the boy as "kneeling with penis erect," a disputable reading of the anatomy in question (Steinberg 1972 [1], p. 26). Far from constituting a sexually assertive presence, the boy seems closely related to the prepubescent figures found in canvases from the spring and summer of 1906 such as *Boy Leading a Horse, The Two Brothers, La Coiffure*, and *Two Youths* (see discussion above, and Daix-Bourdaille 1967, XIV.7, XV.9, XIV.20).

The picture should perhaps be read in terms of the differing attitudes of the figures. The open poses and knowing smiles of the two young women suggest sexual experience (albeit of recent vintage). In contrast, the boy's downturned face suggests a reluctance to confront either the women or his own physical maturity; his limbs are folded protectively inward, and his grasp on the handle of the *porron* seems onanistic rather than seductive. If the brothel setting anticipates the *Demoiselles*, the atmosphere of wistful longing has little in common with the brazen sexuality of the later work.

P. K.

[1] Alfred H. Barr, Jr., to Rita and Alex Hillman, New York, September 19, 1955. and Hillman Family Archives.

PROVENANCE
Max Pellequer, Paris; acquired from Marlborough, London, 1955; Hillman Family Collection

LITERATURE
Zervos 1, no. 340; Merli 1948, no. 129 (?); Steinberg 1972 (1), pp. 25–26, fig. 29; *Art News* 1959 (HC), p. 34 ,fig. 11; Daix-Boudaille 1967, XV.18; Moravia-Lecaldano-Daix 1980, no. 253, p. 108; Palau 1985, p. 462, fig. 1309; Richardson 1991, p. 449.

EXHIBITIONS
London 1953, no. 19, p. 11; London 1954, no. 37, p. 21; New York 1955, p. 16; Bronx 1972 (HC); Roslyn 1977–78 (HC), no. 24, ill.; Hartford 1981 (HC); Austin et al. 1979–85 (HC); Brooklyn 1986–87 (HC); Brooklyn 1988 (HC); Paris 1988, no. 12, color ill. p. 15; Phoenix 1991–92 (HC).

PABLO PICASSO (1881–1973)

44. *Head of a Woman*
(*Tête de femme*), 1906–7
Bronze, edition of 4 (?), cast at a later date,
 4 ½ x 3 ⅜ x 3 ¼ in. (11.4 x 8.7 x 8.3 cm)
Signed on base at rear: *Picasso*

I N HIS 1948 VOLUME on Picasso's sculpture, Daniel-Henry Kahnweiler described this small *Head of a Woman* as "a step toward true sculpture in the round, towards *a truly cubic sculpture*." The previous generation of "impressionist" sculptors, Rodin and Medardo Rosso, had broken up the contours of objects in order to capture the play of light across their surfaces. In contrast, Picasso now sought to create a "calm and static" sense of solid form. The smooth skin of *Head of a Woman* represented a deliberate rejection of Rodin's and Rosso's textured surfaces. The only contemporary precedent for Picasso's work, Kahnweiler noted, lay in the sculpture of Gauguin (Kahnweiler 1948, [p. 2]). Werner Spies's interpretation, in his catalogue raisonné of Picasso's sculpture, runs along much the same lines. The symmetrical, "ideal" form of *Head* represents a reaction against Rodin, Rosso, and Antoine Bourdelle, while its smooth surface allows it to withdraw from the "arbitrary play" of light (Spies 1983, p. 32).

A very different interpretation is offered by William Rubin in *"Primitivism" in 20th-Century Art*. Rubin sees *Head* (and the "masklike" faces of Picasso's paintings from the fall of 1906, which it closely resembles) as a direct response to the archaic Iberian reliefs which Picasso had discovered during his stay at Gosol in the summer of 1906. More precisely, Rubin sees Picasso's work of the fall of 1906 as imitating the "stylized features" and "simply modeled surfaces" of the Iberian reliefs. This first, "sculpturesque" phase of Iberianism is followed, in the spring of 1907, by a second phase in which the Iberian forms are flattened and simplified into the graphic vocabulary of the *Demoiselles d'Avignon*. While Rubin detects Gauguin's influence in the *Demoiselles*, he does not seem to consider it relevant to Picasso's 1906 work (1984, pp. 243, 247, 251, and 264).

John Richardson, on the contrary, stresses the importance not only of the Gauguin retrospective at the Salon d'Automne in the fall of 1906 but also of Picasso's friendship with Paco Durrio, a Spanish jeweler and ceramicist who had earlier befriended Gauguin. Durrio possessed a large collection of Gauguin's work, including both ceramics and wood carvings. Seeing Picasso as a second Gauguin, he encouraged him to experiment with ceramic sculpture, and several of Picasso's 1906–7 sculptures seem to have been fired in Durrio's kiln

(Richardson 1991, pp. 456–61; Spies 1983, nos. 7, 9, 22, and 23). The influence of Gauguin's ceramic sculpture is clearly visible in at least one of these works (*Fernande Combing Her Hair*, Spies 1983, no. 7), and most of Picasso's wood carvings from this period are also modeled on Gauguin's (Spies 1983, nos. 6B, 8, and 15–21).

Indeed, the stylistic opposition proposed by Kahnweiler can be seen as one that Picasso discovered within Gauguin's work. On one hand, the medium of ceramic encouraged the use of complex, irregular forms and decorative, light-catching surfaces. On the other, the technique of sculpting by cutting into a wooden block or cylinder promoted simplification, symmetry, and solid mass. As Sidney Geist has noted, the 1906 Gauguin retrospective encouraged not only Picasso but also Brancusi and Derain to experiment with the almost-abandoned technique of direct carving (Geist 1984, p. 346).

From this point of view, the 1906 *Head* represents an attempt to fuse the qualities of these seemingly contradictory approaches. A letter from Douglas Cooper to Alex Hillman written in 1959 refers to a "plaster" of *Head* in an unidentified Paris collection, but the work's subtly undulating surface strongly suggests that it was modeled in clay.[1] (Unfortunately, it has not been possible to trace the original, and it is impossible to know whether the clay was glazed or fired before the bronze impressions were cast). Contrary to the opinion of Kahnweiler and Spies, the play of light across the modeled surface represents a significant aspect of the work's effect. Unlike the strong relief characteristic of Picasso's earlier modeled sculptures, the treatment of the facial features in *Head* seems to imitate the low relief of Gauguin's (and Picasso's own) wood carvings.

This low relief allows Picasso to indicate the facial features without distracting the viewer from the solid, ovoid form of the whole. For the same reason, the model's hair is covered by a kerchief like that found in Picasso's contemporary drawings and paintings (Daix-Boudaille 1967, nos. XV.25, 26, 33, and XV.45–46), so that the hair conforms to the contour of the head. The arcs of the eyebrows, continuing without interruption into the bridge of the nose, also

echo the outline of the head. This stylistic mannerism, which first appears in Picasso's work of the summer of 1906 and continues through the following year, is often attributed to the influence of Iberian sculpture. However, it also appears in Brancusi's 1907 sculptures, and it seems possible that it was inspired by African sculptures in collections available to both artists. (See the Fang heads repro. in Rubin 1984, pp. 290 and 300, and the head of a Congolese wand reproduced in Zayas 1916; de Zayas knew both Picasso and Brancusi.) By renouncing the expressive and descriptive potential of modeled form, Picasso preserves the integrity of sculptural mass.

P. K.

[1]Douglas Cooper, Château de Castille, Argilliers, Gard, March 27, 1959, to Alex Hillman, New York. Hillman Family Archives.

PROVENANCE
Ambroise Vollard, Paris; Heinz Berggruen, Paris; Jean Lenthal, Paris; acquired from Galerie Craven, Paris, spring 1959; Hillman Family Collection

LITERATURE (other versions)
Zervos 2, no. 574; Kahnweiler 1948, [p. 2], fig. 3; Spies 1971, p. 21, p. 301, ill. p. 40; Spies 1983, p. 32, ill. p. 38, no. 12, p. 326, ill. and p. 372; Rubin 1984, p. 248, ill.; *Demoiselles* 1988, p. 425, fig. 82; Richardson 1991, pp. 456–61.

EXHIBITIONS (Hillman version)
Paris 1956; Bronx 1972 (HC).

PABLO PICASSO (1881–1973)

45. Reclining Nude
(*Nu couché au bord de la mer*), 1920
Ink on paper, 9⅞ x 16 in. (25 x 40.6 cm)
Signed lower left: *Picasso*; dated on reverse: *4-9-20*

THE POSE OF *RECLINING NUDE* resembles that of a figure in Picasso's June 1920 *Three Bathers* (Zervos 4, no. 169; also repro. in Rubin 1980, p. 228), and the drawing has often been placed among the group of beach scenes done later that summer (Zervos 4, nos. 75, 105–6, 111–12, 161–67, and 170–74; Zervos 30, nos. 96–97). While *Three Bathers* displays swollen limbs resulting from greatly exaggerated foreshortening, the nudes in these beach scenes are more conventionally classical; indeed, they seem to mark the emergence of the neo-classical style that would prove so influential in the 1920s.

Picasso's stylistic development during these years can be placed in the context of a general postwar "return to order." Artists demonstrated their allegiance to French tradition by utilizing classical forms and motifs (see Silver 1989, passim). Specific precedents for Picasso's imagery can be found in the work of Ingres and Maillol, and in the antique frescoes he first saw during a visit in 1917 to Rome, Naples, and Pompeii. At the same time, Picasso's reclining and gamboling nudes seem to reflect the actual activities of the bathers at Juan-les-Pins, on the Riviera, where he spent the summer of 1920. It should be noted, however, that the linear style of his nudes is anticipated by several nudes drawn in May, in Paris (Zervos 30, nos. 60–62, 65–67, 69). Indeed, Pierre Cabanne suggests that Picasso's decision to spend the summer of 1920 at Juan-les-Pins was prompted by Mediterranean imagery that had begun to haunt his imagination several months earlier (Cabanne 1977, p. 220).

In most of Picasso's neoclassical drawings, form is described exclusively by means of outline. *Reclining Nude*, however, is modeled with a system of hatching based on intersecting curves. The lines of the hatching suggest a rounded surface by their direction as well as by their modulation of light and shade, an approach recalling the technique of sixteenth-century engravers such as Cort and Goltzius. The insistent modeling of *Reclining Nude* might be taken to imply that it was done some time after the nudes of the summer of 1920, and indeed it is dated in Zervos to May 1921, along with a second group of bathers drawn in April and May of that year, long after Picasso's return to Paris (Zervos 4, nos. 225, 243–44, 275, and 287–88).

P. K.

PROVENANCE
Daniel-Henry Kahnweiler, Paris; Galerie Simon, Paris; Perls Galleries, New York; Hillman Family Collection

LITERATURE
Zervos 30, no. 234.

EXHIBITIONS
Little Rock 1987–88, no. 13, p. 49, color ill. p. 41; New York 1954, no. 176; Jamaica 1982, ill.; Hartford 1981 (HC).

PABLO PICASSO (1881–1973)

46. *Three Nudes*
(*Trois Nus*), 1938
India ink on paper, 17 x 26⅜ in. (43 x 67 cm)
Signed lower right: *Picasso*

AFTER FORGING HIS PERSONAL obsessions into the political allegory of *Guernica* (1937, Museo del Prado, Madrid), Picasso returned to the familiar loci of his private world: the studio, the seashore, the dressing room. His major project of the spring of 1938 was an enormous tapestry cartoon, *Women at Their Toilette* (Zervos 9, no. 103; repro. in color in Rubin 1980, p. 357), two-thirds as large as *Guernica*. Although this was never realized as a tapestry, its composition—a central figure flanked by two attendants, one kneeling to comb her hair, the other seated with a mirror on her knees—provided the material for a series of drawings and paintings extending through the end of the summer. *Three Nudes* occupies a central place in this series.

In two drawings done on July 10 (Zervos 9, nos. 171–72), Picasso transferred his figures to the beach, where they were flanked by a wooden cabana—a potent symbol, for him, of forbidden eroticism (Gassman 1981, pp. 50–54, 64–66). He returned them to an interior setting in three large drawings done on August 5. One of these was *Three Nudes*, where the left-hand figure is seated on a stool, the central figure is standing, and the right-hand figure sits in a chair with sticklike arms and uprights. In the other two drawings, the right-hand figure disappears, replaced by a cat sitting on the chair and a child sitting on the floor beneath it. The child's presence suggests that the standing figure in the center represents Marie-Thérèse Walter, who had given birth to Picasso's daughter Maia in 1935. The seated figure on the left has vanished, replaced in one drawing by a recumbent nude (Zervos 9, no. 195) and in the other by a dressing table below an open window (Zervos 9, no. 194).

All three figures are present and seated on the floor in two large drawings done on August 10 and 11 (Zervos 9, nos. 200 and 198). The curtained walls and the regular grid of the flooring suggest that Picasso had now identified his trio with the three odalisques of Delacroix's *Algerian Women* (Louvre, Paris), which he would sketch in 1940 (Zervos 11, nos. 206–7), and which would become the subject of a long series of canvases in the 1950s (discussed at length in Steinberg 1972 [3]).

In a drawing of September 8 (Zervos 9, no. 225), Picasso returned to the subject of women at their toilette, showing one woman, seated in an armchair, putting on a necklace, while a second, crouching on a stool, holds up a mirror for her. The contrast between armchair and stool, here as in *Three Nudes*, indicates the social distance between mistress and servant. However, the sticklike armchair, which Picasso used as a prop in numerous contemporary drawings and paintings of individual women, appears to have had its own symbolic value for

him (see Zervos 9, nos. 130–33, 139, 142, 146–47, 179, 196–97, and 232). With its sharp-edged struts, it appears as a kind of cage or a rack by which models are restrained. In 1945 Picasso told André Malraux: "Women are suffering machines. . . . When I paint a woman in an armchair, the armchair implies old age or death, right? So too bad for her. Or else the armchair is there to protect her" (quoted in Cabanne 1977, p. 342).

Like the other drawings of the series, *Three Nudes* displays a pattern of "spider-web arabesques," which can also be seen as imitating "basketry or chair caning" (Jean Leymarie and Alfred H. Barr, Jr., quoted by Elaine L. Johnson in Rubin 1972, p. 154). What is striking about *Three Nudes*, however, is the pronounced stylistic differences between the figures. The nude on the left, seated on a stool with her knees drawn up, is a recognizable descendant of Picasso's neoclassic figures of the 1920s. The standing figure at center has been assembled from a series of tubular segments. (This figuration seems to derive from other drawings where Picasso treats the breasts as animated tubular forms; compare Zervos 9, nos. 132, 172, and 182.) The seated woman at right is at once more naturalistic and more distorted: while the individual elements of her anatomy are easily recognizable, they have been rearranged into an inhuman landscape of clefts and bulges, prefiguring the monstrous *Woman Dressing Her Hair* of June 1940 (Zervos 10, no. 302; repro. in Rubin 1980, p. 366). The upswept prongs of her hair also recall the hair of ironwork sculpture that Picasso had welded in 1929–30 and retained in his own collection (Spies 1983, nos. 72 and 81).

P. K.

PROVENANCE
Acquired from Perls Galleries, New York, 1954.; Hillman Family Collection

LITERATURE
Zervos 9, no. 192.

EXHIBITIONS
New York 1954 (?); Austin et al. 1979–85 (HC).

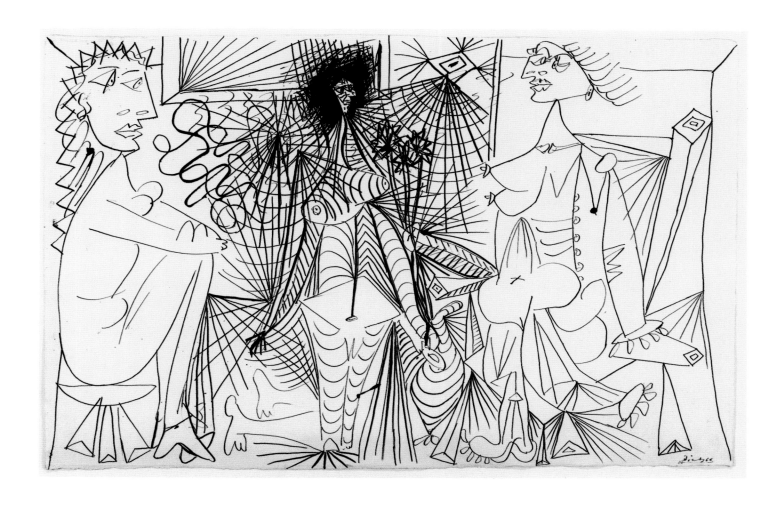

PABLO PICASSO (1881–1973)

47. *Woman in Gray*
(*Femme en gris*), 1942
Oil on panel, 39 ¼ x 31 ⅞ in. (99.7 x 81 cm)
Signed upper left: *Picasso*

*W*OMAN IN GRAY belongs to a series of paintings of
seated women executed with great rapidity in early
August 1942. Related canvases were completed on 3, 5, 9, and
10 of that month (see Zervos 12, nos. 111–14). Of course,
Picasso may have worked on all of these pictures concurrently.
His highly abstracted figurations offer few clues to the identity
of the sitter. Like most of Picasso's portraits of the late 1930s
and early 1940s, they probably depict his current companion,
the surrealist painter and photographer Dora Maar. However,
Picasso seems to have been interested in using abstract forms
to evoke the bleakness of existence in occupied France rather
than to characterize his subject.

The broad-brimmed hat that appears, greatly trans-
formed, in each of these pictures is a typical prop for Picasso's
paintings of Dora Maar. However, similar hats also appear in
his portrait of Maria-Thérèse Walter from the late 1930s (see,
for instance, Zervos 8, no. 324, color repro. in Rubin 1980, p.
336). The hat may have served primarily as a formal device,
providing a wide form to balance the breadth of the shoulders
in the lower part of the picture. It disappears from Picasso's
paintings in the mid-1940s. (When he depicts his new
companion, Françoise Gilot, the small circle of her head is
typically enlarged by large masses of hair, sometimes trans-
formed into leaves corresponding to Picasso's image of her as a
woman-flower—compare Zervos 15, no. 13, and 14, no. 167,
repro. in Rubin 1980, pp. 392 and 394.)

Of the series of portraits from August 1942, *Woman in
Gray* is the canvas in which the sculptural mass of the head has
most convincingly been translated into a series of flat shapes
interlocking in one plane, like the pieces of a jigsaw puzzle. Its
powerful graphic quality was recognized by the pop artist Roy
Lichtenstein, who made it the subject of a painted parody—or
homage—reproducing the composition at almost twice the
scale of the original and replacing the matte gray of the
original background with a screen of benday dots (*Femme au
chapeau*, 1962, private collection; repro. in John Coplans, *Roy
Lichtenstein*, New York, 1972, pl. 1). The apparent flatness of
Picasso's composition, however, should not obscure the
essentially sculptural ideas behind it.

Since 1938 Picasso had been exploring a "horse-faced"
version of the human head (Barr 1946, p. 219), that is, a
figuration in which the brow and nose were combined into a
long, continuous "snout" joined at its upper end to a narrow
lozenge with curved sides, representing the remainder of the
head. Typically, one eye appeared at the top of the snout,
while the mouth and the other eye indented the lozenge of the
head. (See Zervos 9, nos. 214–16 and 228; for this last see color
repro. in Rubin 1980, p. 346). The "horse-faced" head, often
drawn or painted as an imaginary sculpture, was, in fact, a
variant on the great sculpted heads that Picasso had created at

Boisgeloup in 1931, in which the nose emerged as a swollen
phallic form dominating the "bosom" of the face (see esp.
Spies 1983, nos. 111 and 132, and the heads repro. in Rubin
1980, pp. 287–89).

If Picasso's drawn and painted heads of the early 1940s
look back to his sculptures of the early 1930s, they also expose
a surprising artistic debt. Sometimes as part of the "horse-
faced" head, sometimes as part of another figuration, there
frequently appears a three-dimensional crescent-moon shape
(see Zervos 9, no. 346; 10, nos. 433–38; 13, no. 41) virtually
identical to the ridged crescent that appears beneath
Giacometti's 1930 *Suspended Ball*. The sexual, somewhat
sadistic imagery of Giacometti's sculpture—the crescent
seems to have sliced open the cleft in the sphere above it—
appealed strongly to the surrealists, and no doubt to Picasso
as well: indeed, a sketch from early 1932 shows him trying to
adapt Giacometti's forms to his own sculptural idiom
(Zervos 7, no. 370). In his drawings and paintings of 1940–
43, Picasso puts the ridged crescent to several different uses.
As a sculptural form, it can represent either the "snout" or
the lozenge of the "horse-faced" head. Reduced to a flat,
curved shape, it typically represents the "snout" or, even
more specifically, the nose (see Janis 1946, pl. 46, and Zervos
13, nos. 29–33).

The head in *Woman in Gray* does not conform in any
obvious way to the "sculptural" prototype of the "horse-
faced" head: its features have been separated into too many
independent elements, each one realized as a flat shape. For
instance, the face is divided into light and dark curved strips,
one terminating in the nostrils, the other in the mouth.
However, each of these flattened shapes provides a graphic
equivalent for the sculptural form of the ridged crescent.
(The connection is even clearer in the treatment of the
mouth and nose in Janis 1946, pl. 46.) Similarly, the large
"empty" curve at the left provides a graphic equivalent for
the bulge of the back of the head (compare Zervos 11, no.
437). Indeed, this bulge anticipates the contour of the *Death's
Head* of 1943, a bronze in which Picasso would return to an
almost naturalistic conception of sculptural volume, letting
gouges and scratches carry the burden of figuration.

P. K.

PROVENANCE
Galerie Louis Carré, acquired from Galerie Durand-Ruel, Paris, June
1948; Hillman Family Collection

LITERATURE
Zervos 13, no. 50, ill. (mistakenly dated 1943); Paris 1946, color pl. 10.

EXHIBITIONS
Paris 1945, pl. 5; New York 1948, no. 9 ill.; Toronto 1949, no. 26; New
York–Chicago 1957, p. 86, ill.; Philadelphia 1958, no. 208, p. 22,
pl. 208.

CAMILLE PISSARRO (1830–1903)

48. *Peasant Woman with Market Basket*
(*Paysanne portant un panier*), c. 1889
Pastel on paper, 16 ½ x 11 ¾ in. (41.9 x 29.9 cm)
Stamped lower right: *C.P.*

As Christopher Lloyd has noted, Pissarro was a prolific draftsman, comparable only to Degas among his impressionist peers (London-Boston 1980, p. 157). His graphic output increased when he began his large figural compositions in the 1880s, largely in reaction to the perceived formlessness of the impressionist "sensation." Although Pissarro made a range of preparatory studies for individual paintings, he also drew constantly in sketchbooks, which served as compendiums of poses, character types, and motifs.

Here a peasant woman is seen from the back in three-quarter view, facing left. The detailed rendering and disposition of the figure, as if it were a framing element, suggests that it was a study for a specific painting, or an acute empirical exercise for some future use. The monumentality of the figure and her isolation on the sheet contribute a sense of psychological introspection not uncommon to Pissarro's figures (Lloyd 1981, p. 94).

Pissarro works the pastel with long, individuated strokes of color that define the shimmering outline of the form, as well as the folds of the skirt, the stripes of the blouse, and the weave of the wicker basket. Shadow and highlight are created by the quality of hue alone, rather than by cross-hatching or tonal modeling. His handling of the pastel medium remained unchanged by his pointillist experiments in the latter half of the 1880s (Brettell-Lloyd 1980, p. 19); nonetheless Pissarro did turn to pastel with greater frequency during this time, and his knowledge of neo-impressionist color theory undoubtedly enriched his blending and juxtaposition of hues, as with the brilliant blues and greens in this composition.

The subject, with her red-and-white kerchief, striped blouse, apron, and wide-rimmed basket, belongs to a stock character used in Pissarro's images of the market. These form an independent group within his oeuvre, consisting of five oils and numerous works on paper (Lloyd 1985, p. 23). The first examples date from 1881 at Pontoise; after Pissarro moved to Eragny, he concentrated on the nearby market of Gisors, about ten miles south on the river Epte. These local mercantile events offered a mix of social classes, ages, and personalities in trade and in conversation, and bore witness to a new sociological phenomenon. Indeed, Richard Brettell argues

that Pissarro was well aware of the "economic inter-relationship between the fields and the town," and of the entry of the peasant into the bourgeois arena of small commerce (Brettell 1980, p. 29).

Despite the bustling activity, Pissarro's market scenes focus on the human form, and imposing figures invariably dominate the foreground space (Lloyd 1985, p. 25). The level of human interaction also provided ample opportunity for caricature: it is in the market sketches, as the Hillman pastel makes evident, that Pissarro accentuated the bulbous noses and awkward physiques of the peasant class.

E. B.

PROVENANCE
A. Bonin, Paris (sale, Hôtel Drouot, Paris, June 26, 1931, no. 30, p. 9); sale, Galerie Charpentier, Paris, June 13, 1958, no. 30, pl. V; acquired from O'Hana Gallery, London, August 1958; Hillman Family Collection

LITERATURE
Pissarro-Venturi 1939, vol. 2, no. 1581, pl. 302.

CAMILLE PISSARRO

49. *Woman in Profile, Stooping*, c. 1890
Charcoal and watercolor on paper, 6⅛ x 3½ in.
 (15.6 x 8.9 cm)
Initialed lower right: *C. P.*
Verso: *Man with a Hoe*
Charcoal on paper

WHETHER IN A SMALL SKETCH or finished oil, the laboring peasant constituted an epic subject for Pissarro. He rendered numerous studies of women working in the fields, usually stooping or bending as dictated by the earthbound task. The figure in *Woman in Profile, Stooping* is bundling from a larger pile and is either haymaking or gleaning. Peasants gathering the remains of the harvest was the subject of a major painting by Pissarro, *The Gleaners* of 1889 (Kunstmuseum, Basel).

In his sketches of the 1880s Pissarro often used black chalk or charcoal together with watercolor washes, resulting in a complex web of sharp outline, texture, and modeling. Pissarro generally first outlined the figure in charcoal and defined areas of shadow and highlight with long and regular strokes. Watercolor was then brushed across the surface in waves of chiaroscuro; in this example, it is also applied in the manner of cross-hatching with the tip of the brush. The layering of opaque and transparent strokes creates a lively texture that evokes both the straw of the dried grain and the rough material of the peasant's garb. The tenebrist quality of the sketch, the curvilinear play of line, and the organic flow of volume characterize Pissarro's graphic style from the mid-1880s to the early 1890s (Brettell-Lloyd 1980, pp. 19–27).

The verso bears a charcoal drawing of the back of a man carrying a hoe or rake, ambling away from the viewer; Pissarro has shaded the inside of the left leg and overdrawn its contour as if to emphasize the forward motion. In other examples from Pissarro's sketchbooks, images of men digging and women haymaking appear together on the same sheet (Brettell-Lloyd 1980, no. 177).

Though this drawing was purchased by the Hillmans together with *Woman Bending* (see cat. no. 50), the drawings did not come from the same sketchbook: the paper type differs, and there is a slight discrepancy in size.
 E. B.

PROVENANCE
Ludovic Rodo Pissarro; acquired from O'Hana Gallery, London, September 1956; Hillman Family Collection

EXHIBITIONS
Bronx 1972 (HC); Roslyn 1977–78 (HC), no. 28, ill.; Jamaica 1982; Brooklyn 1986–87 (HC); Brooklyn 1988 (HC); Phoenix 1991–92 (HC).

CAMILLE PISSARRO (1839–1903)

50. *Woman Bending,* c. 1890
Ink and watercolor on paper, 5 $^{15}/_{16}$ x 3⅝ in. (15 x 9.1 cm)
Initialed lower left: *C.P.*
Verso: *Figure of a Peasant Woman*
Charcoal and wash

Though it cannot be identified as a study for a specific painting, *Woman Bending* relates to several of Pissarro's grand figural compositions from the late 1880s depicting peasants at work in the field (for example, Pissarro-Venturi 1939, nos. 730 and 857). A prolific draftsman, Pissarro made numerous studies of women gleaning, harvesting, and picking, recording the toil and fatigue of repetitive movements and stooping postures (Pissarro-Venturi 1939, nos. 1397, 1431, and 1464). His sketches of agricultural tasks were also used for a series of prints entitled *Travaux des champs* (*Labors of the Fields*), which began in 1886 as a collaborative project with his son Lucien and continued until his death in 1903.

The bending women seen foreshortened from above was a motif Pissarro favored already a decade earlier (Brettell-Lloyd 1980, p. 198). As in other works of this subject, the horizon line and distant landscape are set high on the page, isolating and anchoring the figure against the background field. The drawing was previously entitled *Woman with Cabbages,* based on its promixity to the etching *Femme dans un potager* (*Woman in a Kitchen Garden*) of 1880, which depicts a woman, seen from the back, working in a cabbage patch. The abundant greenery of the Hillman drawing, however, is rendered in circular bunches rather than as broad, flat leaves. The disposition of the figure and type of vegetation come closer, instead, to the etching *Paysannes dans un champ de haricots* (*Peasants in a Bean Field*) of 1891 and two related studies in the Ashmolean collection (Brettell-Lloyd 1980, nos. 221 and 292). While similar in composition, these works are characterized by heavy outlines in the synthetist manner of Van Gogh and Gauguin. By contrast, *Woman Bending* displays a more fluid handling and mellifluous line.

It is difficult to date precisely Pissarro's late drawings, given the sheer size of his output and his technical and stylistic diversity. The dating of *Woman Bending* to the late 1880s or early 1890s is suggested by the rapid and rugged pen strokes and the use of wash for velvety modeling effects.

The figure on the verso is a schematic outline in chalk with only the slightest indication of wash on the sheet. She is bent at the waist and holds a basket. The angle of the figure repeats, in reverse, that of the figure at the far left in the 1888 painting *Apple picking at Eragny-sur-Epte* (*La culliette des pommes, Eragny-sur-Epte*; Dallas Museum of Fine Arts). The relationship of his sketch to that painting is reinforced by the presence of the basket used for apple picking. The faint outlines of two other figures appear behind her in a row; above, center page, Pissarro drew an unrelated drapery study.

E.B.

Provenance
Ludovico Rodo Pissarro; acquired from O'Hana Gallery, London, 1956;
Hillman Family Collection

Exhibitions
Bronx 1972 (HC); Roslyn 1977–78 (HC), no. 29; Jamaica 1982; Brooklyn 1986–87 (HC); Brooklyn 1988 (HC); Phoenix 1991–92 (HC).

CAMILLE PISSARRO (1830–1903)

51. *Eragny*, 1890
Watercolor on white paper, 9 1/16 x 11 5/8 in. (23 x 29.5 cm)
Signed, inscribed, and dated lower left: *Eragny-1890 1 Aôut
C. Pissarro*

B‍Y 1884 PISSARRO'S HOUSE IN OSNY was too small to accommodate his wife, Julie, and their five youngest children. In April they settled in Eragny-sur-Epte, a small village on the river Epte, about two hours northwest from Paris. The house included a large garden that opened onto an expanse of meadows and a view beyond to the neighboring hamlet of Bazincourt, as recorded in a pointillist canvas of 1886–88, *View from My Window, Eragny-sur-Epte* (The Ashmolean Museum, Oxford).

The view over the meadow to the church at Bazincourt, seen from varying distances, was a frequent motif of the artist in the late 1880s and intermittently in the following decade (Brettell-Lloyd 1980, p. 178, nos. 231–34; Pissarro-Venturi 1939, nos. 725, 727, 739, 812, and 814). The Hillman example belongs to a series of watercolors rendered in 1890, many on the same-sized sheet, and dated, often with the weather conditions noted as well (Thomson 1990, p. 83). The watercolor medium was particularly well suited to capturing the transitory meteorological effects, as well as the artist's emotional reactions while directly observing nature. In this regard, they represent Pissarro's return to the impressionist focus on pure sensation (Thomson 1990, p. 84).

Pissarro's watercolor production reached a zenith in 1890 and in the last decade of his life represented a separate area of research, independent from his paintings (Brettell-Lloyd 1980, p. 32). They either have underdrawing in pencil or ink or are executed in pure color washes, as the Hillman view of Eragny. Here Pissarro defines the undulating surface of the meadow with a repetitive structure of ovoid brushstrokes. The layering of individual transparent planes gives way in the middle ground to the saturated hues of the foliage, evoking the sensation of summer heat and haze on the documented day of August 1, 1890.

Eragny is the most symmetrical of the watercolor compositions, with the church placed, almost hieratically, in the center of the page, and the vertical thrust of the spire equaled by the height of the adjacent trees. It also reveals more of the ecclesiastical structure through the screen of foliage than do the other views. The grouping of shorter trees or shrubs in the middle ground to the right is a constant feature of the series. Given Pissarro's anarchist and atheist convictions (as well as his Jewish background), the emphasis on the church is undoubtedly a formal rather than a religious one, or it may reflect his faith in rural life and the unadulterated beauty of the countryside.

E. B.

PROVENANCE
Parke–Bernet Galleries, New York, April 20, 1950, sale 1152, no. 26; acquired from Gimpel Fils, London, May 1955; Hillman Family Collection

EXHIBITIONS
Bronx 1972 (HC); Laramie 1972 (HC); Jacksonville–Corpus Christi 1973–74, no. 8; Phoenix 1975 (HC); Roslyn 1977–78 (HC), no. 27, ill.; Austin et al. 1979–85 (HC) (except Austin); Brooklyn 1986–87 (HC); Brooklyn 1988 (HC); Phoenix 1991–92 (HC).

ODILON REDON (1840–1916)

52. Poppies in a Green Vase
(*Pavots dans un vase vert*), c. 1910
Pastel on paper, 25¼ x 19 in. (60 x 47.8 cm)
Signed lower right: *Odilon Redon*

F EW NINETEENTH-CENTURY ARTISTS are so associated with a particular subject as is Odilon Redon with his paintings of flowers. Although they do not dominate his artistic production, the flower pictures nonetheless constitute a significant area of concentration after 1895.

Redon evolved slowly as an artist; he enrolled in art classes only after failing his architecture exams in 1862 and devoted the next two decades primarily to work in black and white (his *Noirs*). This included charcoal drawings and, to a larger extent, lithographs, of which he published several significant albums.

Rather than rendering his direct observations of the material world, Redon looked to his imagination to provide fantastical, dreamlike visions of an intangible, untouchable realm. He drew inspiration from sources outside the art-historical mainstream. For example, the crepuscular renderings of the visionary Rodolphe Bresdin were among his most significant influences. In turn, Redon became a critical figurehead for the symbolists, and for the Nabis in particular. While the symbolists looked to him for his unique ability to depict a realm that hovered between reality and the imagination, it is his pastel renderings of flowers that subsequently gained Redon a devoted following.

Redon's move away from black and white to color coincided with his shift in emphasis from the imaginary to the natural world. In a letter of 1895 to Emile Bernard he admitted: "[I]t is true that I am increasingly abandoning the 'Noirs.' Between you and me, the medium has drained me for I believe that it derives its source from the deepest recesses of our very being" (Bernard 1942, pp. 150–51). Contemporaneous with the move to the natural world was Redon's increasing use of pastels. He had used the medium infrequently as early as the 1880s, but they became his preferred medium after his departure from black and white in the next decade. Armand Clavaud, a botanist who became Redon's friend and mentor, possibly encouraged the artist's interest in flowers (Maciejunes 1990, p. 19). Although Redon could explore and experiment with all types of flowers in his wife's garden, he never embraced the natural world exclusively, mixing real and imaginary blooms at will. His use of pastel pushed the medium to its fullest potential and emphasized not only the texture of flower petals, for example, but also, by pressing less hard on the crayon, their immaterial evanescence.

In *Poppies in a Green Vase*, Redon depicts a small arrangement of brightly colored flowers in a vivid green vessel. He added to the high saturation of color in the red, yellow, and purple petals by exerting intense pressure on the crayon to create a dense, powdery effect. Though the arrangement itself

is not large in relation to the size of the page, Redon enhances its presence with subtle shading. The artist surrounds the image with a brown only slightly darker in color than the paper itself. This is applied with a lighter touch in the area of the flowers, leaving parallel hatch marks visible, and more heavily around the green vase, giving weight to the composition. A soft periwinkle blue forms a halo that surrounds the central object and, while echoing the form, adds visual interest to the otherwise undifferentiated top of the page. The spotted accent of yellow pistils spewing forth from the poppies of the same color adds dynamism to the center. Despite a slight indication of a table in the circular form below the vase, the object nonetheless appears to float in an incomprehensible space. The choice of poppies, known for their hallucinogenic properties, reinforces the sense that this small, intensely colored bouquet hovers somewhere between this world and that of our imagination.

Klaus Berger attempts to classify the flower chronology into three phases and identifies thirty-six vase shapes in Redon's paintings and pastels. The vase in this picture corresponds to type 36 of around 1910 (Berger 1964, p. 180), though the exact date of the Hillman pastel remains unconfirmed.

E. E.

PROVENANCE
Richard Buhler, Winterthur; Jacques Laroche, Paris; acquired from M. Knoedler and Co., New York, February 1964 (acquired in trade for Vuillard; see Appendix); Hillman Family Collection

LITERATURE
Mellerio 1923, p. 73.

EXHIBITIONS
Paris 1937, no. 391; Paris 1956–57, no. 103; Paris 1959, no. 33; New York 1966, ill. no. 26, p. 34; New York 1970, no. 37; Bronx 1972 (HC); Laramie 1972 (HC); Brooklyn 1986–87 (HC); Brooklyn 1988 (HC).

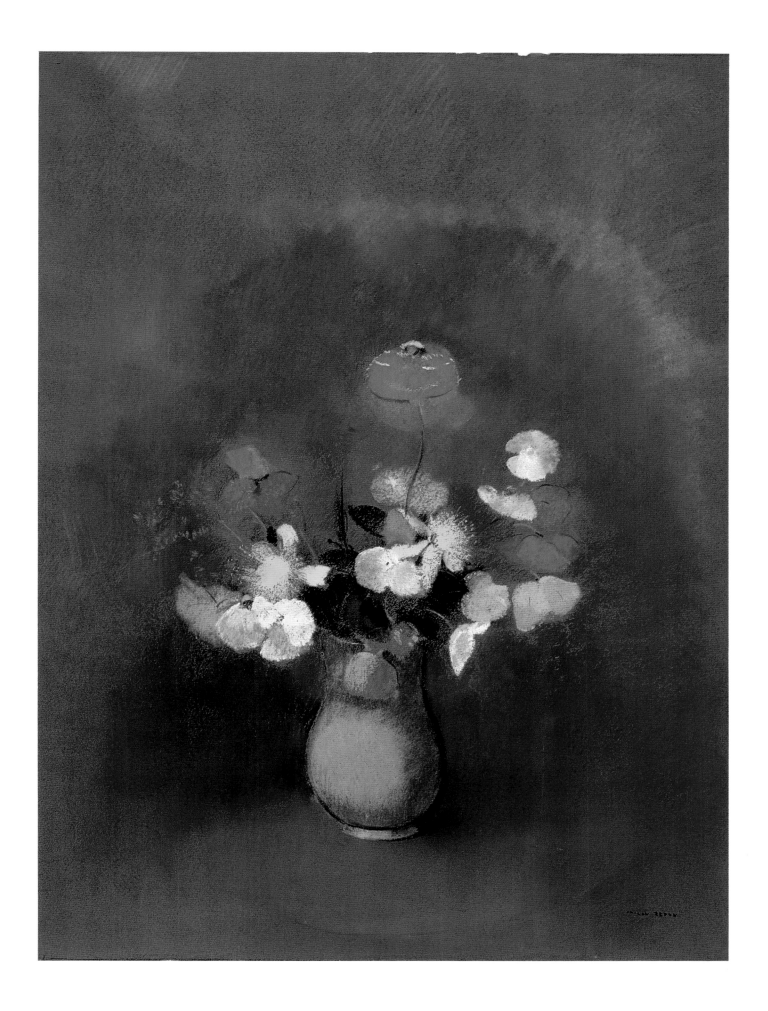

PIERRE-AUGUSTE RENOIR (1841–1919)

53. *River Scene,* c. 1878
Oil on canvas, 6½ x 11 in. (16.5 x 28 cm)
Signed lower right: *Renoir*
54. *Landscape, Paysage,* c. 1878
Oil on canvas, 6½ x 11½ in. (16.5 x 29.2 cm)
Signed lower right: *Renoir*

SMALL IN SCALE, each measuring approximately 6½ by 11 inches, these informal sketches were painted *en plein air*, while Renoir directly observed the scene in front of him. He would typically paint several studies over the course of the day, recording the fluctuations of light and atmosphere. Though there is a strong sense of immediacy conveyed by the fluid brushstrokes, the compositions are nonetheless fully realized. Sketches such as these represent the height of Renoir's commitment to the impressionist movement in the 1870s.

Renoir worked with tiny canvases tacked to his easel, marking the basic outline of the composition with brushstrokes of wet paint. Details were added after the first layer of the rough sketch had dried. In *River Scene*, for example, water and sky are composed of horizontal strokes of blue-gray paint. The sky is relatively loosely painted, while the water is described by tightly knit brushstrokes. They are divided by a strip of landscape, painted in the same wet-brush manner, but in vertical strokes. The outcropping of trees breaks through the otherwise tripartite horizontal division of the surface. Highlights, primarily of red, were applied once the first paint layer was dry. It is these small, but precise, accents that give body to the composition.

Landscape provides more of a recession into depth: a path, summarily indicated with wet, diagonal strokes, recedes abruptly into the distance. At the horizon, a small village peeks out from behind a clump of trees. Here again, Renoir articulates form and space with the most minimal daubs of paint, enhancing the composition with overpainted details.

Renoir exhibited with the impressionists in 1874, 1876, 1877, and 1882. During this period he made daily trips to the suburbs of Paris to observe the verdant beauty of the country-side. Unlike the contemporary landscapes of Monet, however,

Renoir's did not comment on the industrialization of France by including railroad lines, factories, or suburban scenes. Consistent with the rest of Renoir's oeuvre, these lusciously painted studies luxuriate in the sensuality of paint and the idyllic atmosphere of the country on a sunny summer day.

E. E.

River Scene

PROVENANCE
Acquired from French Art Galleries, New York, July 1951; Hillman Family Collection

LITERATURE
Vollard 1918, no. 834, p. 202, ill.

EXHIBITIONS
New York 1968, no. 146; Bronx 1972 (HC); Laramie 1972 (HC); Jacksonville–Corpus Christi 1973–74, no. 6, ill.; Phoenix 1975 (HC); Roslyn 1977–78 (HC), no. 30, ill.; Austin et al. 1979–85 (HC) (except Austin); Brooklyn 1986–87 (HC); Brooklyn 1988 (HC); Phoenix 1991–92 (HC).

Landscape

PROVENANCE
Acquired from French Art Galleries, New York, July 1951; Hillman Family Collection

LITERATURE
Vollard 1918, no. 792, p. 194, ill.

EXHIBITIONS
New York 1968, no. 147; Bronx 1972 (HC); Laramie 1972 (HC); Jacksonville–Corpus Christi 1973–74 (HC), no. 7, ill.; Phoenix 1975 (HC); Chicago 1975 (HC); Roslyn 1977–78 (HC), no. 31, ill.; Austin et al. 1979–85 (HC) (except Austin); Brooklyn 1986–87 (HC); Brooklyn 1988 (HC); Phoenix 1991–92 (HC).

PIERRE-AUGUSTE RENOIR (1841–1919)

55. *Study for "Dance in the Country"*
(*Study for "La Danse à la campagne"*), c. 1882–83
Ink and wash on paper, 17 ½ x 10 ¼ in. (44.5 x 26 cm)

T HIS DRAWING DATES from a critical time in Renoir's career when he returned to the traditional foundations of art in reaction to impressionism. The image of people engaged in lighthearted amusement is a familiar one in Renoir's oeuvre, and the scene of convivial pleasure is enhanced by the wash of light, feathery brushstrokes—an impressionist trademark. Yet as a sketch for *Dance in the Country*, this ink study is a significant example of a preparatory work, at a time when his peers preferred to work directly on canvas. In other ways as well, Renoir departed from his colleagues, embracing neither Manet's fragmented and incoherent reality nor Monet's undermining of the primacy traditionally given to the human presence (House 1985, p. 15). Instead, Renoir sought inspiration in the two acknowledged masters of the first half of the nineteenth century—Ingres and Delacroix—and asserted a new monumentality in his work after a trip to Italy in 1881.

Among Renoir's best-known images, the pair of paintings *Dance in the Country* and *Dance in the City* (1882–83; Musée d'Orsay, Paris) indicate his commitment to harmonious and lively pictures in which the figure is central. (A third, related painting, *Dance at Bougival*, is in the Museum of Fine Arts, Boston.) They constitute one of Renoir's last major tributes to urban and suburban recreation (House 1985, p. 221). When exhibited together at the Durand-Ruel gallery in Paris in 1883, one reviewer described them, respectively, as a "dance of the demi-monde in a suburban cabaret" and a "society dance in a salon" (J. de Marthold, in *La Ville de Paris*, cited in House 1985, p. 237). Indeed, the two pictures span the social spectrum from the earthy and unself-conscious rural types, to the refined, urban bourgeoisie. The former engages the viewer in direct eye contact, whereas the city couple are absorbed in themselves. Although the male model—his friend Paul Lhote—was the same for both pictures, Renoir used Suzanne Valadon for the city dancer, whereas his future wife, Aline Charigot, posed for the country maid. The latter typified the ample forms and simple demeanor of the country woman, in contrast to the sophisticated Parisiennes who dominated his work in the 1870s.

The drawing in the Hillman collection is one of four known studies for the painting. The others, in the Louvre; the Yale University Art Gallery, New Haven; and Budapest (col-lection unknown), each reveal different stages in the development of the composition. Rendered in ink and brown wash, the Hillman study concentrates on the male form and the stark tonal contrasts between his suit and the white dress of his partner, outlined on the blank page. The rapidly executed, emphatic hatch marks, likely inspired by Delacroix's graphic verve, bring out the volume of the figures, while also evoking the swirling movement of the dance.

E. E.

PROVENANCE
Ambroise Vollard, Paris; Edouard Jonas, Paris; acquired from French Art Galleries, New York, 1951; Hillman Family Collection

LITERATURE
La Revue du Louvre et des musées de France 1980, vol. 2, p. 123.

EXHIBITIONS
Rosyln 1977–78 (HC), no. 32, ill.; Brooklyn 1986–87 (HC).

PIERRE-AUGUSTE RENOIR (1841–1919)

*56. Woman with Mandolin/Andrée in Spanish Costume with a
Yellow Turban and a Mandolin*
(*Femme á la mandoline/Andrée en espagnole avec un turban
jaune et une mandoline*), 1919
Oil on canvas, 22 x 22 in. (55.9 x 55.9 cm)
Atelier stamp lower right: *Renoir*

WHEREAS RENOIR'S STUDY FOR *Dance in the Country* of 1882–83 represented a transitional moment in his career, in which he attempted to come to reassert form and composition, his *Woman with Mandolin*, painted in the last year of his life, is a triumph of his late style.

Crippled by arthritis, and having lost his wife in 1915, by 1919 Renoir was isolated and almost completely immobilized. But his late technique belies his physical state. As John House has observed, the aged Renoir exploited the full potential of the oil medium with layers of thin paint built up with fine streaks of varying hues, to create a flickering, almost vibrating surface (London-Boston 1985, p. 278). In his desire to unite foreground and background, and to make figures one with their surroundings, he often embellished them and increased their volume, fusing varied angles of vision into one image. Instead of looking to Delacroix and Ingres, as he had done in his pictures of the 1880s, Renoir turned to Titian, Rubens, and Veronese, both for their ample forms and for the grandeur of their vision.

Although he concentrated on the nude during this late period, Renoir also began to experiment with sculpture and continued to paint portraits and costume pieces. *Woman with Mandolin* is a fine example of the latter, where the accoutrements—traditional symbols for the various senses—are used as a pretext for lush color and pattern. These pictures are intended to touch all the senses, both in the richness of the colors, which seduce the eye, and in the evocation of music alluded to by the mandolin. Other compositions from the last decade of the artist's life include flowers and fruit, by which Renoir touches the senses of taste and smell.

The picture is referred to in the catalogue of Renoir's atelier as *Andrée en espagnole avec un turban jaune et une mandoline*, referring to Andrée Hessling, the muse of his late years, who was to marry his son Jean after the artist's death. Here, her vivid red hair inspired, the saturated tones of the costume, instrument, and background. Renoir juxtaposes the warm tones of pinks, reds, and oranges of the figure with cooler blues and greens in the background, while highlights of bright yellow round out the form. The disposition of the head and arms forms a weighty equilateral triangle, accented by the gentle upward thrust of the mandolin. Echoing the round form of the instrument, the yellow turban offers a bright focus to the top of the composition.

Following Renoir's death, his late pictures were embraced by a public in need of a more optimistic and humane vision, following the horrors of World War I. Renoir's late works inspired, among others, Picasso's classicizing figures of the 1920s. But as John House has argued, Renoir's healthy, idyllic vision was undermined by the challenge of surrealism, as well as by the uses to which classicism was put in Nazi Germany (London-Boston 1985, p. 279). As a result, Renoir's reputation has relied more on his early work than on the timeless images of his final years.

E. E.

PROVENANCE
J. Hessel, Paris; Etienne Vautheret, Paris (sale, Hôtel Drouot, Paris, June 16, 1933, no. 20, p. 27, ill.); acquired from Durand-Ruel Galleries, New York, January 1950; Hillman Family Collection

LITERATURE
Rivière 1921, p. 261, ill.; Paris 1931, vol. 2, no. 704, p. 223, ill.; Pach 1950, pl. 126; *Museum of Modern Art Bulletin* 1953, no. 1077, p. 46; White 1984, p. 280, color ill. p. 282.

EXHIBITIONS
Boston 1939, no. 5, p. 22, ill.; New York 1942, no. 3, ill.; Portland 1942–43; New York 1953; New York 1954, no. 17, ill.; New York 1968, no. 70, color ill.

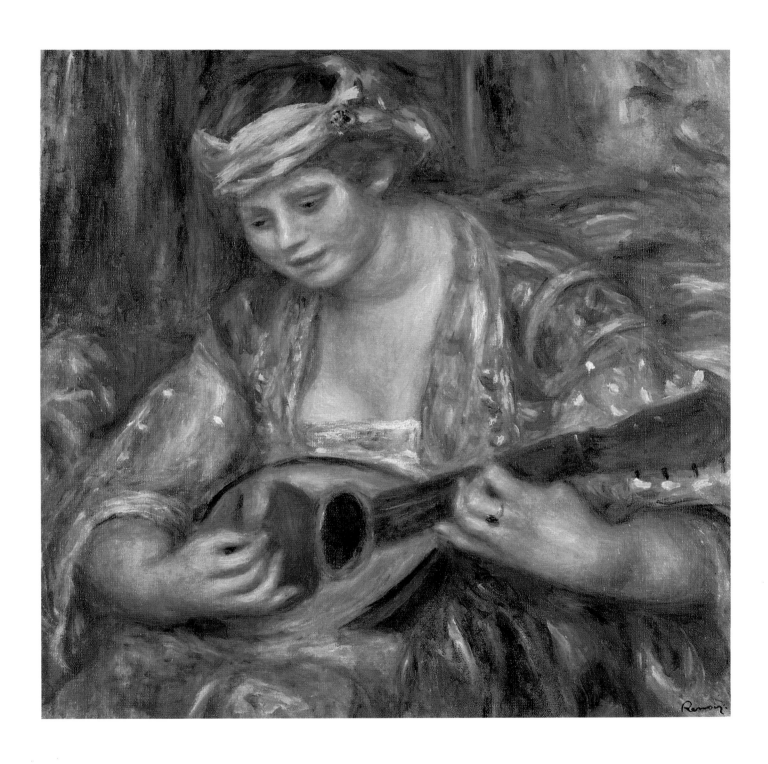

GEORGES ROUAULT (1871–1958)

57. Clowns and the Circus/Two Clowns
(*Clowns et cirque/Deux Clowns*), 1907
Ceramic plaque (manufactured by André Metthey, Asnières),
17 ¾ x 23 ½ in. (45 x 59.7 cm)

ROUAULT BEGAN EXPERIMENTING with ceramics in 1906, no doubt inspired by the interest in arts and crafts that swept through Europe in the last decade of the nineteenth century. Though little studied, Rouault's ceramics were an integral aspect of his artistic production from 1906 until 1913; he exhibited no fewer than 135 during these years at the Salon des Indépendants, the Salon d'Automne, and the Galerie Druet (Lajoix 1992, p. 46). Rouault himself intended a rapport between the ceramic medium and the low-life subjects of his art. Just as he ennobled popular themes, so he elevated the decorative to the level of high art. *Clowns and the Circus*, with the busts of two clowns facing each other, and a third barely perceptible in the background between them, is the most monumental composition documented in the ceramic medium.

Many artists had experimented with ceramics from the 1890s on, including Gauguin (see *Torso of a Woman*, cat. no. 18) and especially others of the next generation. The ceramicist André Metthey (1871–1920), an exact contemporary of Rouault's, ran a studio in Asnières which drew Pierre Bonnard, Maurice Denis, André Derain, Aristide Maillol, Odilon Redon, Maurice Vlaminck, and Edouard Vuillard, among others, all of whom applied their talents to ceramic ware. In addition, the practice of painting on porcelain was one familiar to Rouault from his aunts, named Champdavoine, who had made a practice of it; one of them even painted a portrait of the artist at the age of four (Lajoix 1992, p. 155).

Unlike Gauguin, Rouault did not mold clay (except for two female figures) but instead decorated existing forms. In addition to plaques, Rouault painted vases, candy dishes, and plates. He also did not change his subject matter to suit the more decorative format of ceramic ware. He rendered the same confrontational images of human pathos as in his works in oil on canvas, but these images achieved in ceramic a luminous quality that could be arrived at by repeated firings. Rouault characteristically heated each piece numerous times, adding a new glaze with each successive firing, sometimes reaching eight or ten layers (Lajoix 1992, p. 49). Writing to André Suarès in 1913, Rouault stated: "Ceramic was one of the plastic means chosen by the painter to translate the incandescence of his soul because, uprooted in the imagination of our collective existence, fire has the reputation for purifying everything. From these flames, painting emerges fortified: great and strong" (quoted in Lajoix 1992, p. 50).

Rouault's glazing techniques paralleled his layered applications of watercolor and gouache in the years before World War I. The composition of *Clown and the Circus* bears comparison with two works in watercolor and pastel, both entitled *La Parade*, from 1906 and 1907 (Dorival-Rouault 1988, vol. 1, nos. 90 and 91, p. 41). Although the brushstrokes appear loosely applied to the ceramic plaque, the composition is tightly arranged. The triangular clown hats of the foreground figures are each framed by abbreviated rectangles in the background, which may represent pictures hanging on the wall. The geometric scheme provides balance and weight to the composition and also serves to flatten the space. The small clown is barely perceptible between the two monumental foreground figures. Above him, three female figures hover in an indeterminate space and likely represent the circus group referred to in the title.

E. E.

PROVENANCE
Ambroise Vollard, Paris; acquired from Edouard Jonas, Paris, July 1950; Hillman Family Collection

LITERATURE
Dorival-Rouault 1988, vol. 1, no. C 10, p. 340, ill. (as *Deux Clowns*).

EXHIBITIONS
Brussels–The Hague 1952, no. 14; Paris 1952, no. 113; New York–Cleveland 1953, p. 32; New York 1963; New York 1981.

GEORGES ROUAULT (1871–1958)

58. *The Clown*
(*Le Clown*), 1908
Gouache, pastel, and watercolor on newsprint, 8¼ x 6¼ in.
 (21 x 16 cm)
Signed and dated lower center: *G. Rouault 1908*

Georges Rouault remains one of the most singular artists of the twentieth century. Though his creative life spanned the history of art from symbolism through cubism and abstraction, Rouault embraced neither artistic movements nor theories, steadfastly adhering to his own visionary imagery. Even when he exhibited with the Fauves at the Salon d'Automne, his paintings caused their own, quite different, scandal, mostly because of their blackness of tone (Soby 1945, p. 14).

Rouault was apprenticed to a stained-glass maker at the age of fourteen. He then studied with Gustave Moreau at the École des Beaux-Arts in the same years as Matisse and Albert Marquet, with whom he later exhibited at the Salon des Indépendants and the Salon d'Automne. Singled out as the symbolist master's favorite pupil, Rouault not only emulated his style, with its richness of subject and heavily laden paint detail, but also became the director of the Musée Gustave Moreau at his mentor's death.

The Clown was painted at a time when Rouault had moved away from his symbolist manner toward an independent style. Yet it also exhibits a vibrant colorism achieved without the heavy black outlines characteristic of his mature work. The image emerges from luminous layers of lightly applied watercolor and pastel, with contours carefully applied in black ink. The energetic strokes of black add character to the clown, creating details of costume and the expressionistic deformations of the face. Over the dark ink wash Rouault added watercolor in broad, gestural strokes: orange loosely surrounds the silhouette of the form, and green defines the costume. Accents of yellow pastel highlight the hair, while apricot hue touches the cheek and neck.

Despite the brilliant color washes, this is a stark and brutal image and one that counters the light tone implied by the subject matter. Rouault distorts the face, slashing it through the bridge of the nose with black wash. He extends the bulbous nose beyond the parameter of the profile, further emphasizing its form with orange highlights. The mouth is a mere black gash. From within his distended outline, the clown peers out with a look that hovers between distrust and despair.

Clowns became an iconic theme in Rouault's work, and several images relate closely to this one in the Hillman Collection. The most similar in profile, gaze, and outfit is *Clown sombre* from 1902–3 (Dorival-Rouault 1988, vol. 1, no. 106, p. 48). Although the Hillman picture is not included in the catalogue, it clearly relates stylistically and thematically to the group painted in the first decade of this century.

Never the joyful entertainers of children, Rouault's clowns were symbols of bitterness and alienation. Like his images of prostitutes, they served as examples of those who sell their souls for the enjoyment of others. A deeply spiritual man, Rouault elevated even the most profane subjects to an exalted status. Though his early work did not yet represent specifically Christian imagery, it already expressed a moral reaction, amplified and universalized until it reached the level of religious painting (Venturi 1940, p. 16).

Rouault's identification with the figure of the clown is well expressed in a letter he wrote to Édouard Schuré (quoted in Dorival-Rouault 1988, vol. 1, p. 40):

> The old clown sitting in a corner
> of his caravan in the process of mending
> his sparkling and gaudy costume,
> this contrast of brilliant, scintillating objects,
> made to amuse, and a life of *infinite sadness*,
> if seen from slightly above . . .
> Then I expanded it a little. I saw quite clearly
> that the "Clown" was me, was us, nearly all of us . . .
> this rich and glittering costume, it is given to us by
> life itself,
> we are all *more or less* clowns,
> we all wear a glittering costume,
> but if we are surprised as I surprised the old clown,
> Oh lord! who would dare to say that he was not struck,
> even to the heart, by an immeasurable pity.
> I have the defect (defect perhaps . . . in any case
> it causes me abysmal suffering)
> of leaving no one his glittering costume,
> be he king or emperor. I want to see the soul of
> the man
> in front of me . . . and the greater he is,
> the more mankind glorifies him, the more I fear
> for his soul.
>
> E. E.

PROVENANCE
Ambroise Vollard, Paris; acquired from D. Mouradian and Vallotton, Paris, August 1949; Hillman Family Collection

EXHIBITIONS
Roslyn 1977–78 (HC), no. 33, ill.; New York 1981; Phoenix 1991–92 (HC).

GEORGES ROUAULT (1871–1958)

59. *The Grotesques*
(*Les Grotesques*), c. 1910-1914
Pen, charcoal, and watercolor on light gray paper,
25 x 19 ½ in. (63.5 x 49.5 cm)

*T*HE *GROTESQUES* constitutes one of Rouault's early
attempts at social commentary. In the years prior to
World War I, Rouault began a series of satirical paintings of
judges and other bourgeois functionaries. As James Thrall
Soby mentions, these judges were symbols of bourgeois
corruption and the travesty of justice, much as they had been
for Daumier. Rouault might also have been inspired by Jules
Forain's dark view of middle-class decadence, since that artist's
powerful black-and-white drawings had inspired him early in
his career (Soby 1945, p. 10).

Léon Bloy, whose novel *La Femme pauvre* had formed
the basis of Rouault's spiritual sensibility, had saved the most
violent passages in his book for a condemnation of the
bourgeoisie and its bureaucratic hierarchy. Bloy portrayed the
middle classes as riddled with avarice, cruelty, and vanity, and
Rouault took his somber tone from the author. In the end,
Rouault's interpretation was darker than Daumier's satirical,
somewhat comical, images or Forain's stylish decadence (Soby
1945, p. 17).

According to Soby, Rouault's judges are depicted as
single figures or as perverse trinities. In some examples, two
judges actually frame a crucifixion, though references to the
Holy Trinity are also at times made without specific Christian
iconography, as in the Hillman picture, where two men are
seen full figure and a third is a truncated torso in the bottom
right corner of the composition. The differences in scale
negate a comprehensible recession into depth and place the
picture in a visually unsettling space.

In the œuvre catalogue, Dorival places the date of *The
Grotesques* to 1910–14, when Rouault concentrated less on the
specific subject of judges and more on types classified by the
artist as "grotesques" (Dorival-Rouault 1988, vol. 1, p. 193). In
earlier paintings from 1902–9 Rouault identified some of his
judges with high black hats. Here, the starched shirt collars,
ties, and jackets identify them merely as functionaries, and
whether the characters are in fact judges, financiers, or Salon
jurors remains unclear. Nonetheless, the triumvirate, with two
of the figures gesturing with pointed fingers, is in the process
of passing judgment, and the somber and critical facial
expressions do not suggest a positive resolution. With its
piercing caricatural power, *The Grotesques* looks forward to the
social satires of the German Neue Sachlichkeit artists Otto
Dix and George Grosz.

E. E.

PROVENANCE
Acquired from Galerie André Weil, Paris, October 1956; Hillman
Family Collection

LITERATURE
Dorival-Rouault 1988, vol. 1, no. 635, p. 193, ill.

EXHIBITIONS
Bronx 1972 (HC); Rosyln 1977–78 (HC), no. 34, ill.; New York 1981;
Austin et al. 1979–85 (HC); Brooklyn 1988 (HC); Phoenix 1991–92 (HC).

GEORGES ROUAULT (1871–1958)

60. *The Sexton/The Pedagogue*
(*Le Pédagogue*), 1933
Gouache and india ink over etching, 15 ⅝ x 12 ¾ in.
(39.7 x 32.4 cm)
Signed and dated lower right: *G Rouault 1933*

*T*HE *SEXTON* CONTAINS A COMPLEX INTERPLAY of meaning, image, and technique. Dated 1933, *The Sexton* is a gouache painted over an etching entitled *Le Pédagogue* done for Vollard's book *Les Réincarnations du Père Ubu*. The history of Rouault's collaboration with Vollard is in itself an intricate tale, one that spans the decades from when the two met at Metthey's ceramic studio in 1907 (see cat. no. 57) until Vollard's death in 1939.

Ambroise Vollard was obsessed for decades with Alfred Jarry's absurdist play *Ubu Roi*, which he might have seen when it was performed at the Theatre de L'Œuvre in 1896. This included writing several sequels to it, beginning with *Almanach du Père Ubu*, 1900–1901, illustrated by Pierre Bonnard, and culminating in *Les Réincarnations du Père Ubu* (published in 1932), illustrated by Rouault (Wofsy 1976, p. 89). Rouault was evidently swept up in the frenzy, creating as early as 1913 some preliminary sketches for Vollard's album. By 1918 the artist had completed a significant number of gouache studies, having two years earlier begun the technically challenging role of translating them to copper for etching.

This project was enormously important to both artist and dealer, as it embraced a modern conception of the book: the illustrations were intended to be equal, rather than subservient, to the text (Chapon-Rouault 1978, vol. 1, p. 59). Vollard's reputation as manipulative entrepreneur, which ultimately resulted in a lawsuit brought by Rouault, was first evident in the project for the Ubu volume. Though the etchings were essentially complete by 1919, because of Vollard's manipulations they were not corrected until 1928, and the book was not published until 1932. This no doubt accounts for a date of 1933 on *The Sexton*, which was painted on a final, corrected print. Another smaller and more roughly executed example of the print overpainted with gouache, dated 1931, retained the title *Le Pédagogue* (Soby 1945, p. 117, ill.). It is not known who gave the Hillman work the other title, or when.

The Sexton gains depth and vibrancy from its web of intricately woven lines; for that reason, a short account of Rouault's etching process is helpful to an understanding of the substructure of this work. As Rouault himself stated in the preface to *Les Réincarnations* (cited in Chapon-Rouault 1978, vol. 1, p. 64): "I have always striven to achieve concord and harmony between text, engravings and woodcuts. A lithograph, whether it be light or heavily elaborated, is quite different from an engraving with its subtle resonances and profound harmonies. A woodcut is redolent of its origins which it must preserve, for every material, even the meanest, has its own mark and its own particular beauty."

This project was Rouault's first attempt at engraving on a monumental scale, and he worked the plates in several different ways. Though referred to generically as etchings, these prints in fact employ various techniques. His sketches were transferred to copper by a photogravure process, yet Rouault would entirely rework the plates. He would touch up the surface with acid and a fillet wheel, using a scraper and burnisher on the background. Then he would polish the untouched areas repeatedly to bring out the subtle gradations of light. The contours would then be reworked in aquatint (Chapon-Rouault 1978, vol. 1, p. 66). All of these complex gradations of black and white essentially redefined the potential of the medium.

The title of the work changed when it itself was reincarnated, from *Le Pédagogue*, whose bulbous body and jowly face reflect the artist's sarcastic attitude to those in power, to *The Sexton*, a man of the church, whose role of minor authority was also subject to the artist's derision. As François Chapon states, Rouault sought to evoke a visual contrast between the litheness of the black man whom King Ubu encounters on his travels, a man whose physical grace suggests an innocent freedom, and the massive stature of his oppressors (Chapon-Rouault 1978, vol. 1, p. 67). But Chapon adds that where the figures themselves may be heavy, solid, and unmoving, they are in marked contrast to the vitality that Rouault evokes in his material.

Rouault further emphasizes this contrast between luminous color and ponderous form in his painting. *Le Pédagogue*, with mouth open in the midst of a lecture, is transformed to a closemouthed man of the church with a pointed nose and knickers. The artist uses the space beyond the confines of the etching to complete the legs which were truncated in the print, thereby emphasizing the satire of a grown man of the church with bare knees. The vibrant blackness of the print achieves a glowing color with Rouault's washes of reds and blues, and a warm salmon pink for the flesh of the face and legs. Rouault's deep religiosity is conveyed perhaps more in the facture of the picture, which evokes a stained-glass window, possibly inspired by his early apprenticeship, than by the sexton himself, whose stolid posture conveys the artist's ridicule of meaningless conventions.

During the years that Rouault was under contract with Vollard to produce numerous printed volumes, he did not devote much time to painting. His reworking of the printed image in the early 1930s was surely a way to reaffirm his mastery of paint, and one that he practiced on several prints (Waller 1984, pp. 30–36).

E. E.

PROVENANCE
Ambroise Vollard, Paris; acquired from French Art Galleries, New York, October 1952; Hillman Family Collection

EXHIBITIONS
Bronx 1972 (HC); Laramie 1972 (HC); Jacksonville–Corpus Christi 1973–74, no. 18, ill.; Roslyn 1977–78 (HC), no. 35, ill.; New York 1981; Austin et al. 1979–85 (HC); Brooklyn 1988 (HC); Phoenix 1991–92 (HC).

GEORGES ROUAULT (1871–1958)

61. *The Bathers/Autumn*
(*Les Baigneuses/Automne*), 1938 (?)
Oil on paper (possibly painted over the black-and-white
 aquatint *Automne*), mounted on canvas, 20 ⅝ x 26 ⅝ in.
 (52.4 x 67.6 cm)
Signed lower right: *G. Rouault*

THE BATHERS is a vibrant and powerful painting by
Rouault, singular in its complex composition and facture.
It has its roots in a series of bathers Rouault did in the first
decade of the century (Dorival-Rouault 1988, vol. 1, pp. 99–
102) and is intimately related to a series of black-and-white
and color prints the artist produced between 1922 and 1938.
Though Rouault is known for repeating a limited number of
stock images in oil, the Hillman *Bathers* is the only one of its
kind. Indeed, it presents a technical puzzle that reveals the
artist's creative process in working with a variety of media.

Rouault first depicted groups of bathers in a landscape
around 1907, and may have been inspired to do so by
Cézanne's images, which had been prominently exhibited in
the middle of the decade. Rouault's treatment of the theme,
however, also drew from his own images of prostitutes, which
had evolved from harsh caricatures into more sensuous
odalisque figures by that year (Soby 1945, p. 16). Rouault's
scenes of bathers painted in the years 1907–8 are rendered in a
less tortured manner, free of the emotional turpitude that
characterized his women of the demimonde (Soby 1945, p. 16).
Yet Rouault's images still maintain their distance from the
tranquil beauty envisioned by Matisse (his former schoolmate
and Fauve comrade), in the latter's contemporary series of
nudes in a pastoral setting.

The specific image of the Hillman *Bathers* first appears
in 1922, under the title *Automne*, as one of one hundred trial
prints in photogravure for the *Miserere* suite, commissioned by
Ambroise Vollard. It was not, however, among the fifty-eight
images finally chosen by the artist for the portfolio, engraved
in aquatint during the years 1922–27 and published in 1948
(Chapon-Rouault 1978, vol. 1, p. 193; for the photogravure
Automne, see pp. 316 and 319, no. 149). Rouault subsequently
made large black-and-white lithographs of *Automne* in the
years 1927–33. He never mastered working on stone to the
degree that he did on copperplates for engraving, which
accounts, perhaps, for the numerous reworkings of the stone
before the eleventh and definitive state (Chapon-Rouault
1978, vol. 2, no. 364, p. 360).

Last, but not least, Rouault transcribed *Automne* into an
edition of color aquatints, with two earlier states in black-and-
white sugar aquatint only. These prints are also on a grand
scale, with the image measuring 50.3 x 65.2 cm and the paper,
57.5 x 77.5 cm (Chapon-Rouault 1978, vol. 2, p. 233, no. 288,
and p. 249). Though undated, the aquatint has been assigned
to 1938, with a question mark, by Chapon and Rouault in
their catalogue raisonné of the prints.

The composition, motifs, and color scheme of the color
aquatint is virtually identical to the Hillman *Bathers*. The
latter revels in all of the richness that Rouault brought to his

oil technique in the 1930s, when he took up the brush again
after years of making prints. He illuminates his figures with
vibrant tones of peach, pink, and orange, set off by swaths of
black outline. The application of paint is dense; the glowing
surface emerges from layer upon layer of paint, leaving
visible, at times, the divergent strokes of varying hues
underneath.

What then, is the exact relationship between the oil
version of *Bathers* and the print *Automne*? To begin with, the
painting's dimensions correspond to the image size of the
print. That the image is not in reverse rules out the possibil-
ity that the painting served as a preliminary study for the
composition of the aquatint, even though areas of color,
highlight, and idiosyncratic washes of black are closely
matched.

An examination conducted by the conservator Lucy
Belloli at the Metropolitan Museum of Art in August 1993
revealed the existence of a drawing underneath the oil paint.
The texture and handling are those of a drawing in ink with
the suggestion of wash, possibly in watercolor or gouache,
though the latter effect may also be the result of the bleeding
of the first, thin layers of oil. The density of Rouault's
pigments precludes exact discovery of the underlying ground,
and the conservator's observations neither confirm nor deny
the possibility that the artist painted over a version of the
aquatint.

Given the similar dimensions, composition, and
direction of the images, however, it is feasible Rouault
painted over one of the black-and-white aquatints, or less
probably, rendered an exact ink study after it on the same
size paper, onto which he then painted with oil. In either
case, therefore, *The Bathers* served as an intermediary step: it
is the study for the final state of the print in color, which so
vividly carries over the modulated areas of hue and even the
direction of certain strokes from the painting.

E. E./E. B.

PROVENANCE
Ambroise Vollard; acquired from Perls Galleries, New York, April 1954;
Hillman Family Collection

LITERATURE
Chapon-Rouault 1978, vol. 2, p. 249.

EXHIBITIONS
New York 1954, no. 215, ill.; Westport 1955, no. 2; New York 1956, no.
14, ill.

GEORGES ROUAULT (1871–1958)

62. *The Wise Clown*
(*Le Pierrot sage*), 1943
Oil on canvas, 29 ½ x 22 in. (75 x 56 cm)
Signed center right: *G Rouault*

THE WISE CLOWN is a masterpiece of Rouault's mature style, a visual testament to the artist's having come to terms with his art and with himself. Rouault has always been referred to as a religious painter, not just for his images of Christ but also for the sanctity with which he imbues his renditions of ordinary people. In the years before World War I he gave full vent to his moralizing tedndencies. Later, his works demonstrated more interest in form and color. As Lionello Venturi has argued, the detachment from polemics freed his imagination to create even more powerful, almost mythic images (Venturi 1940, p. 16).

Here the archetypal figure of the clown sits in monumental repose, evoking both pathos and tranquility. He gazes downward, perhaps at the book on his lap or in inner contemplation. A painting of a clown hangs on the wall behind him, and a window ledge supports a vase of flowers in a scene of quiet domesticity.

Rouault painted a similar portrait of a clown in profile, in about 1938, in a bust-length version with the eyes open (Courthion 1962, no. 298, p. 433). The Hillman image evinces a greater degree of serene introspection, in part because of the veiled eyes and in part because of the inclusion of the full torso, culminating in the clown's bare knees. Rather than inviting ridicule, the exposed legs emphasize the clown's vulnerability. The disposition of the bending figure and the lowered head recall numerous images of Christ by Rouault. The figure's attitude appears to be one of prayer, suggesting that the book on his lap is a Bible, the source of his inner peace and his wisdom.

The figure and still-life elements are contained within the artist's characteristic heavy outlines, unlike Rouault's earlier work, where the forms battle with their spiky black contours. Typically, Rouault builds up the composition with heavily encrusted surfaces, allowing bottom layers to shine through with a jewellike radiance. The accumulated texture and dusky luminosity recall the old glass in stained-glass windows that Rouault repaired when he was a young apprentice.

The Wise Clown is an image of particular renown in Rouault's oeuvre, and its sense of resolve is partly due to the artist's synthesis of a variety of historical styles. Between the world wars, Rouault intensively studied Byzantine enamels, Roman mosaics, and Coptic tapestries, and absorbed these coloristic influences into his work (Soby 1945, p. 25). After the death of Vollard in 1939, Rouault was again free to explore the potential of paint, having been liberated from his grueling contract for illustrating books. In his work of the 1940s, Rouault likened himself to Renoir, whose late work was also considered a triumph of seductive color. The new serenity in Rouault's work reflects that of his general outlook. As he stated: "I spent my life painting twilights. I ought to have the right now to paint the dawn" (quoted in Soby 1945, p. 28).

E. E.

PROVENANCE
Galerie Louis Carré, Paris; acquired from Galerie Louis Carré via Durand-Ruel Galleries, New York, November 29, 1949; Hillman Family Collection

LITERATURE
Cahiers d'Art 1940–44, p. 152, ill.; Janson 1952, p. 147, no. 123 in color; Venturi 1948, p. 199, pl. 170; *Los Angeles County Museum of Art Bulletin* 1953, p. 31; Munro 1961, p. 251, color ill.; Courthion 1962, no. 442, p. 445, ill. p. 469 (as *Reflective Pierrot*); Dorival-Rouault 1988, vol. 2, no. 2229. p. 212,

EXHIBITIONS
Paris 1949; Paris 1952, no. 71, p. 30, pl. XIV; Brussels–The Hague 1952, no. 51, p. 55, pl. 43; New York–Cleveland–Los Angeles 1953, p. 29; New York 1981.

GEORGES SEURAT (1859–1891)

63. *Square House*
(*Maison carrée*), c. 1882–84
Conté crayon on paper, 12⅛ x 9⅜ in. (30.7 x 24 cm)

GEORGES SEURAT IS PERHAPS BEST KNOWN for his pointillist paintings and his color theory, although at the time of his death, at the age of thirty-one, he had produced as many as five hundred drawings and several sketchbooks. He consistently exhibited his drawings alongside his paintings, and during his lifetime there was even an exhibition devoted to his works on paper. Although almost one hundred drawings are studies for paintings, from 1882—when his drawing style reached its maturity—until his death, in 1891, he produced approximately 250 drawings independent of any work in oil (Herbert 1958, p. 22).

Seurat began drawing as a boy and was later trained in the atelier of Henri Lehmann. But it was Ingres to whom Seurat looked for his early inspiration and from whom he learned the economy and simplicity of outline that were to become major characteristics of his mature work. Seurat also looked to Millet, whose murky, twilight landscapes obscured details and focused on broad masses of light and dark (Herbert 1958, p. 23).

Seurat's subject matter evolved from depictions of peasants in his early works, through the industrialization of the suburbs around Paris during the first half of the 1880s, to more urban pursuits, such as cafés and circuses in his works after 1886. As Herbert mentions, a gentle melancholy emanates from Seurat's black-and-white drawings, resulting not so much from the specific subject matter but from the sense of isolation that surrounds figures or landscape elements. His drawings emit a richness and sensuality not evident in his rigorously disciplined paintings.

The drawing in the Hillman Collection, *Maison carrée*, exhibits all the poetry of Seurat's most carefully constructed works on paper. Drawn with his characteristic Conté crayon on Michallet paper, the picture capitalizes on the interaction of the solid, greasy medium (easier to handle than charcoal), with the dense, thickly woven rag paper (Herbert 1991, p. 35). Seurat seems not to have outlined his forms at all; rather, they appear to emerge from the darkness, or to hover in the light. The "irradiation" is evident here by the fact that the house, depicted in a middle tone of gray, is surrounded by the darker tones of the hedge behind it and the roof on top. The gray of the building is created by Seurat's lightly grazing his Conté crayon over the rough surface; the black is caught on the top surfaces but not in the deeper valleys of the paper, which it leaves white. When the artist applies greater pressure, such as in the roof, the bush, or the windows, the result is a rich blackness. The abstract linearity of the building, emphasized by a first-floor window cut diagonally at the top, contrasts with the sinuous curve of the unidentified shape that frames the left side of the composition. This might be the juncture of a bush at ground level that merges imperceptibly with a tree,

whose curves continue skyward. This vertical curve is balanced by and echoed in the curve in the road that leads to the house. The sky is white around the dark shapes of the house's roof and the bush behind it, yet it gets progressively dark as it approaches the top of the page, thereby balancing the lower portion of the composition, which is worked to the same degree.

Although this drawing has been titled *Maison carrée: Honfleur*, it is not directly related to the paintings that Seurat completed on the Normandy coast. The seven oils produced during his stay in Honfleur, from June 21 until mid-August 1886, do not focus on any aspects of the tiny town, which had been so beloved by the impressionists. Indeed, Herbert documents only two drawings from Seurat's stay in Honfleur, both of the port (Herbert 1991, p. 252). Rather, the drawing evokes in its focus on architectural geometry the feeling of the industrial sites in the suburbs of Paris that had been the artist's preoccupation during the years 1882–84.

Maison carrée stands out in Seurat's oeuvre for its monumentality and its focus on one flattened architectural form. Two drawings of landscapes, both in the collection of the Metropolitan Museum of Art, seem to relate closely in subject to this one: *Maisons* from 1881–82 (de Hauke 1961 no. 455; Herbert 1991, no. 50), where geometrically divided buildings are offset by the sinuous curve of a tree trunk in the foreground; and *La Cité* (de Hauke 1961, no. 545; Herbert 1991, no. 53), from the same years, which combines the straight lines of a building with a convex curved roof on the right and a concave shadowed tree on the left. The dates for both of these drawings are 1881–82. Given the greater monumentality of *Maison carrée* and its solid and more singular form, it would seem appropriate to date it to just after these other drawings, about 1882–84.

E. E.

PROVENANCE
Émile Seurat, Paris; Mme Émile Seurat, Nice; Collection Silverberg, Bresau; Jacques Seligman and Co., New York; acquired from Parke-Bernet Galleries, New York, December 11, 1948; no. 26, p. 12, ill.; Hillman Family Collection

LITERATURE
Bulliet 1936, pl. 26; Seligman 1947, pp. 23, 33, 69, no. 38, pl. XXVII; *Art News* 1959 (HC), ill. p. 34, no. 10; de Hauke 1961, no. 652.

EXHIBITIONS
Chicago 1935, no. 22; Chicago–New York 1958, no. 65, p. 29; New York 1959, no. 117, ill.; Ann Arbor 1962, no. 141; Bronx 1972 (HC); Chicago 1975 (HC); New York 1977, no. 36; Roslyn 1977–78 (HC), no. 36, ill.; Hartford 1981 (HC)

GINO SEVERINI (1883–1966)

64. Still Life with Ruins, Fruit, Pigeons, and a Compass
(*Natura morta con ruderi, frutta, piccioni e compasso*), 1929
Tempera on paper, 9 ⅞ x 6 ⅞ in. (25 x 17.5 cm)
Signed lower left: *G. Severini*

IN THE LATE TWENTIES Severini took up easel painting in earnest after having dedicated himself to a number of mural commissions in Italy and Switzerland earlier in the decade. In Rome in 1928 he began a new series of still lifes with a specific antique style and iconography that dominated his work until 1930 (Fagiolo dell'Arco 1988, p. 392). Architectural motifs (specifically from the Roman Forum) and tilting slabs or free-standing walls provide a backdrop for a theatrical array of pigeons, musical instruments, amorini, masks, and bowls of fruit.

Though working on a small scale, Severini's fundamental devotion to decoration continued, consistent with his growing interest in the classical world. In particular, he was inspired by the haunting images and exquisite detailing of Roman imperial mosaics and fresco painting. Well-publicized archeological excavations in Pompeii and Herculaneum in the 1920s led Severini to explore new techniques, such as pointillist brushwork painted over matte tempera colors. The motifs of the birds and masks, in turn, derive from the Hall of the Doves, a famous mosaic originally found at Hadrian's Villa in Tivoli, which Severini knew from the Capitoline Museum in Rome (Fagiolo dell'Arco 1988, p. 397). His compositions also emulate the deep trompe-l'oeil shadows and the white stippled highlights of the mosaics. Indeed, Severini's mature work is infused with a respect for the historical and art-historical past, far removed from the harangues against tradition that marked his youthful futurist period.

In the years 1928–32 Severini associated with a group of Italian artists working and exhibiting together in Paris, among them Giorgio de Chirico, his brother Alberto Savinio, Renato Paresce, Mario Tozzi, Filippo de Pisis, and Massimo Campigli. They were led by the French critic Waldemar George, who claimed that the Italians and their work upheld the Mediterranean and, hence, humanist tradition. George deliberately cultivated this ideological stance in reaction to the French surrealists, despite the fact that de Chirico's unsettling Metaphysical Painting, itself an influence on surrealism, pervaded most of the Italians' work. In Severini's still lifes, for example, the perspective is totally illogical, leaving objects unconnected in an ungrounded, fantasy space. Even though the individual motifs are illusionistically detailed, the fragmentary assemblage of disparate elements and deep swaths of shadow heighten the immobility and artificiality of the scene.

The Hillman tempera directly relates to Severini's illustrations for the book *Fleurs et masques*, published in London in 1930 by Frederick Etchells and Hugh MacDonald.

The limited edition of 125 included sixteen plates rendered in *pochoir* (a form of stencil printing), executed by Jean Saudé after designs by Severini (Meloni 1982, p. 129). This image is probably a study for the third plate, entitled *Les Pigeons et le raisin* (*Pigeons and Grapes*), though in the final version, Severini removed the motif of the Roman ruins and the compass, leaving a variation of the composition with tabletop, fruit, and pigeons. Here, the surface organization of tilting planes and contradictory spatial readings reveals Severini's origins as a cubist painter. Moreover, the emblematic presence of the compass—a common motif in his art of the period—underlines the primary importance of geometry for Severini's art. Influenced by the ideas of the philosopher Jacques Maritain, and by his own Catholic conversion in the 1920s, Severini held proportion and measure to be qualities sacred to both art and the human spirit.

E. B.

PROVENANCE
Acquired from Sotheby and Co., London, November 25, 1959, NO. 115; Hillman Family Collection

LITERATURE
Fonti 1988, no. 473, p. 406, ill.

EXHIBITIONS
Roslyn 1977–78 (HC), no. 37, ill.; Brooklyn 1986–87 (HC); Brooklyn 1988 (HC); Phoenix 1991–92 (HC).

169

CHAIM SOUTINE (1893–1943)

65. Little Girl with a Doll
(*La Petite Fille à la poupée*), c. 1919
Oil on canvas, 28 ¾ x 23 ½ in. (73 x 59.7 cm)
Signed lower right: *C. Soutine*

LITTLE GIRL WITH A DOLL is one of Soutine's earliest known images of children. The wizened facial features and distorted hands suggest a child old beyond her years. She clutches a shriveled, distraught-looking doll, while the oversize chair that threatens to envelop her adds to the sense of vulnerability and unease. Though unflattering and void of sentimentality, Soutine's images are not unfavorable toward children; to the contrary, they betray the artist's shared fear of and estrangement from the adult world. His own experiences as a boy undoubtedly contributed to this pessimistic view. Soutine was the tenth of eleven children born to poverty-stricken parents in a shtetl near Minsk, in Lithuania. His father beat him frequently, on occasion for having shown interest in drawing and art, and the artist later recalled his childhood with extreme bitterness (Dunow 1981, p. 28). By 1912, he had made his way to France, where he joined the bohemian circle of Montparnasse.

From 1919 to 1922 Soutine lived primarily in Céret, in the French Pyrenees (with intermittent trips to Paris), painting landscapes and portraits. He always worked from the live model and chose his anonymous sitters from among the working class of the area. Since Soutine did not date his canvases and destroyed many works from the Céret period, establishing a chronology for his work is difficult. *Little Girl with a Doll* was dated 1920 by Elie Faure in his monograph on the artist published in 1929 (no. 10); in the more recent catalogue raisonné it has been revised to about 1919 (Dunow et al., 1993, no. 22, p. 552). Though Courthion places it amid other images from Céret (1972, p. 199), it cannot be determined whether the portrait was painted there or in Paris.

The overall style of the painting argues for an early date, when Soutine was still assimilating a variety of influences and had not yet achieved his mature style of dense and agitated surfaces. Though applied in swirling patterns across the surface, the paint is not thickly impacted, and areas of underpainting emerge to add to the chromatic vivacity. From areas that show through, it is apparent that Soutine prepared the ground with a thin layer of gray-blue, which contrasts with the white pigment of the dress and therefore intensifies its hue.

The color scheme of dark olive (a combination of viridian and prussian blue), red, and black bears comparison to one of Soutine's earliest surviving canvases, *Portrait of a Nurse* of 1916 (Los Angeles County Museum of Art). In both cases, the palette reflects Soutine's early admiration for the realist canvases of Courbet. His study of Cézanne is also apparent in the compressed space, distorted, perspectival view, and in the treatment of the face as a surface of distinctly colored planes.

Yet aspects of *Little Girl with a Doll* also look forward to Soutine's portrait conventions of the mid-1920s. The large expanse of white devoted to the child's dress becomes a favored coloristic and compositional device in his later series *Pastry Cooks* and *Choirboys*, and her grossly distorted shoulders are one of the artist's most characteristic mannerisms. Typically, he posed his sitters head on, seated in or standing near chairs. As with *Little Girl*, the furniture takes on a life of its own, similar to the animated chairs of Van Gogh. With the latter artist Soutine also shared the myth of the tormented artist, who brought his inner anguish to bear on the turbulent surfaces of the canvas.

E. B.

PROVENANCE
Léopold Zborowski, Paris; Jonas Netter, Paris (by 1929); Safier, Washington, D.C.; Parke-Bernet Galleries, New York, April 9–10, 1947, no. 73, p. 66, ill.; J. McGowàn, Beverly Hills, Calif.; acquired from Schoneman Galleries, New York, October 1951; Hillman Family Collection

LITERATURE
Faure 1929, no. 10, ill.; Cogniat 1945, no. 8, ill.; Werner 1953, p. 17; Coates 1953, p. 106; F. P. 1953, p. 42; M. C. 1968, p. 71, color ill., Courthion 1972, p. 199, ill. H.; Dunowet et al. 1993, vol. 2, no. 22, p. 552, color ill. p. 553.

EXHIBITIONS
New York 1953, no. 3; Jerusalem 1968, no. 11; Bronx 1972 (HC); Roslyn 1977–78 (HC), no. 38, ill.; Hartford 1981 (HC); Newark 1984 (HC); Austin et al. 1979–85 (HC); Brooklyn 1986–87 (HC); Brooklyn 1988 (HC).

RAPHAEL SOYER (1899–1987)

66. *Portrait of Walter Quirt*, 1938
Oil on canvas, 9 x 7 in. (22.7 x 17.8 cm)
Signed and dated upper right: *Raphael Soyer 1938*

F ORMING A DISTINCT GENRE within his oeuvre, Raphael
Soyer's intimate portraits of his many artist friends reflect
his great affection and admiration for them. By 1941 he had
created enough of these works to feature them in his solo
show at the Associated American Artists Galleries, which was
also his first exhibition of portraits. A group of twenty-three
portraits, billed as "My Contemporaries and Elders," included
Walter Quirt's portrait, as well as Raphael's twin brother, the
artist Moses Soyer, John Sloan, Reginald Marsh, and one of
many self-portraits.

Walter Quirt was Soyer's neighbor at 3 East Fourteenth
Street from 1934 to 1936. The two artists met each other in the
early 1930s at the politically radical John Reed Club, which
was tied to the Communist Party. In 1932 Quirt became the
secretary of the club's art section. Soyer first made a sketch of
Quirt at a club meeting around 1933 (Minneapolis 1980, fig.
1). Later he painted this small picture of Quirt, whom he
characterized as "an impressive little guy we called 'Shorty'. . .
a very civilized man [who] did his work in a very quiet way"
(Minneapolis 1980, p. 11). Soyer admired Quirt's early
paintings as highly original, social-surrealist work. By the time
Soyer painted this portrait, Quirt was turning away from
leftist causes. The intense, haunted expression on Quirt's face
may reflect his struggle between surrealism and social content
that culminated in his development of an abstract style as he
withdrew into himself.

Soyer's continuing interest in conveying the human
condition of his colleagues culminated in various large-scale
group portraits, such as *My Friends* (1948, The Butler Institute
of American Art, Youngstown, Ohio) and *Portraits at a Party*
(1973–74, Hirshhorn Museum and Sculpture Garden, Wash-
ington, D.C.). His *Homage to Eakins* (1964–65, Hirshhorn
Museum and Sculpture Garden, Washington, D.C.) is a
monumental tribute to America's greatest portraitist for whom
Soyer had a lifelong admiration.

G. S.

PROVENANCE
Walter Quirt, New York (1938-41); probably acquired from the
Associated American Artists in the early 1940s (Associated American
Artists Galleries label on the reverse: *Ledger p70 Rack 4R3A*); Hillman
Family Collection

LITERATURE
Minneapolis 1980, p. 11, ill. p. 14.

EXHIBITION
New York 1941, no. 22 (lent by Walter Quirt).

173

RAPHAEL SOYER (1899–1987)

67. Female Nude Torso, 1930s
Oil on board, 11 ¼ x 9 ¼ in. (28.6 x 23.5 cm)
Signed lower right: *Raphael Soyer*

THIS MASTERFUL STUDY OF a female nude exemplifies the strong impact of the art of Edgar Degas on Raphael Soyer during the 1930s. Already impressed with the lyrical nudes of Jules Pascin, the young introspective artist became, in his words, "fascinated by the art of Degas—worldly, analytical, refined" (Soyer 1946, p. 2). The strong contrasts of light and dark, bold application of paint, subtle color scheme, and sense of the honest, unguarded moment indicate Soyer's appreciation of Degas's "keyhole" bathers. He referred to Degas as "a profound psychologist [who] went very deep into the gestures" of his subjects (see Shenker 1973, p. 56).

Soyer's moody, intimate portrayal of the female nude also evokes the studio-oriented aesthetic of his friend Alexander Brook, "my senior by only a few months, but years ahead . . . in art experience and accomplishment" (Soyer 1946, p. 2). Yet the robust vitality of the half-dressed figure in Soyer's study suggests his own greater involvement with the world beyond the studio, as a leading participant in the Fourteenth Street group, which depicted the activities of the Union Square area in the thirties (see cat no. 4). His depictions of office workers, the unemployed, and female shoppers are similarly immediate, informal, and unidealized representations of contemporary life.

Generally avoiding the use of professional models, Soyer preferred to work with his female friends of the lower East Side who were often dancers, actresses, or artists. Therefore, an empathetic sense of individuality, warmth, and intimacy pervades these richly textured, sensuous studies and distinguishes them from Degas's somewhat more anonymous and obliquely viewed bathers. Soyer further developed his particular sensitivity to nude women as solitary, psychological, and physical beings in numerous paintings and drawings of later decades, which he significantly referred to as portraits.

G. S.

PROVENANCE
Private collection, New York; acquired from Salander-O'Reilly Galleries, New York, May 1986; Hillman Family Collection

174

FREDERIC TAUBES (1900–1981)

68. *Study for "In the Studio"/Torso*, c. 1936
Oil on canvas, 12 ³⁄₁₆ x 10 ¼ in. (31 x 26 cm)
Signed upper right: *Taubes*

THIS TRADITIONAL STUDY of a pensive female model in an interior setting is a characteristic work by the American painter, art researcher, and author Frederic Taubes. Born in Lwow, Poland, Taubes studied at the Academy of Fine Arts in Vienna, where he first became interested in classical antiquity and old-master painting. After World War I, he studied briefly at the Academy of Fine Arts in Munich and the Bauhaus in Weimar. During the 1920s Taubes experimented with a variety of styles, including cubism, expressionism, and the hyperrealism of Neue Sachlichkeit.

After traveling throughout Europe and working as a portrait painter, Taubes settled in New York in 1933. Continuing his career as a successful society portraitist, he established a national reputation as a modern classicist whose work was purchased by major museums. Taubes also embarked on a methodical investigation of old-master painting techniques. He eventually published more than forty books about art, including the standard text, *Oil Painting for the Beginner* (1944).

Taubes's small painting in the Hillman Collection is a study for a larger work of 1936 entitled *In the Studio*, which includes the artist at his easel (Youngstown 1983, no. 8). The bold architectonic monumentality of the figure in the Hillman painting is typical of Taubes's modernist classicizing style, founded in the 1920s in the work of Paul Cézanne, Giorgio de Chirico, Otto Dix, and George Grosz. The vigorous modeling and simplification of the figure also bears affinities with the contemporary work of André Derain. This study is rendered in Taubes's distinctive palette of "greens, warm tans, and the inevitable touches of vermillion," which was regarded as his trademark (Gardner 1939, p. 11).

G. S.

PROVENANCE
Acquired from the Associated American Artists Galleries, New York, April 1941; Hillman Family Collection

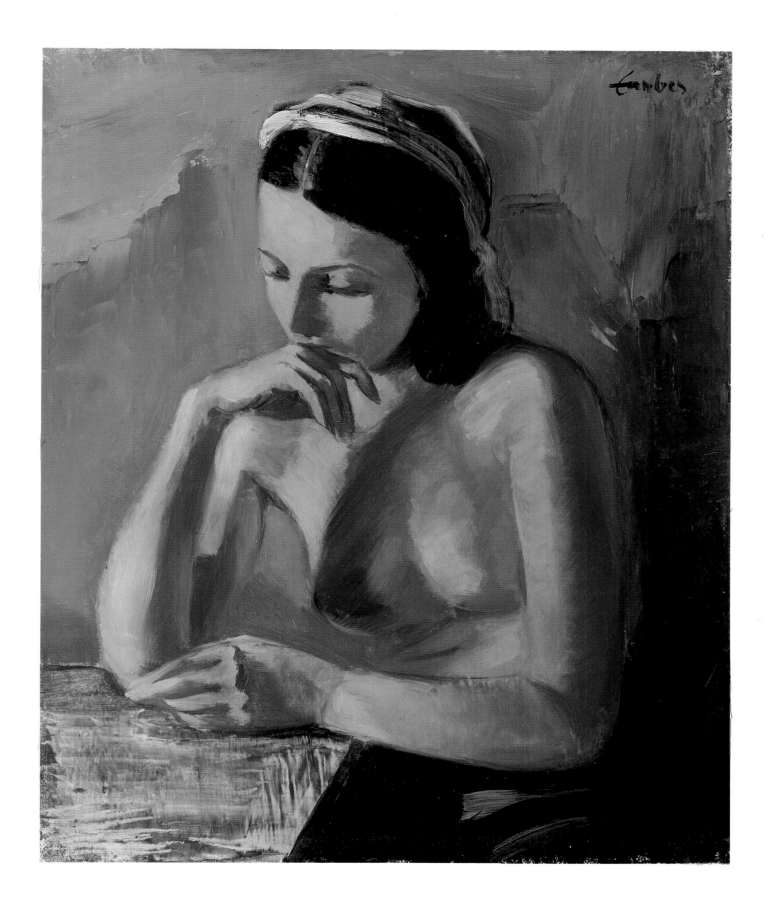

HENRI DE TOULOUSE-LAUTREC (1864–1901)

69. Portrait of Henri Nocq
(*Portrait de Henri Nocq*), 1897
Oil on cardboard, 25 ¼ x 19 ¼ in. (64.2 x 48.2 cm)
Signed and dated lower right: *Lautrec 97*

HENRI NOCQ WAS A BELGIAN craftsman known for his jewelry and medals, who also served as the editor of the Paris *Journal des Artistes*. He is the figure in the white smock in Lautrec's poster *L'Artisan moderne* (1894), and he owned a study for the painting *Au canapé* (Jourdain-Adhémar 1952, p. 102). Here Lautrec captures him in the elegant garb and insouciant manner of a dandy, dressed in a formal black cape and top hat. Charles Stuckey states that this was the last of Lautrec's series of "dandy" portraits and was painted in his studio in the rue Caulaincourt, some time before May 1897, when he moved to a new apartment on the avenue Frochot (Chicago 1979, p. 269).

Nocq stands in front of a summary rendition of the right half of Lautrec's *Marcelle Lender dans "Chilpéric,"* 1896 (Mr. and Mrs. John Hay Whitney, New York), which depicts the Parisian entertainer dancing the bolero in the ballet *Chilpéric*. With his hands on his hips, hidden under his cape, and his feet planted apart, Nocq mimics the stance of the matador (Mlle Lender's dancing partner) in the painting behind him. Yet the dark expanse of his cape distorts his size and creates an unflattering silhouette. In the study for the work, rendered in a narrower format (Dortu 1971, vol. 3, pp. 390–91, pl. 638), Nocq appears with his hat removed and in a more elegant frontal pose. According to Lautrec's biographers, Nocq found the final version to be "merciless" and "spiteful in the extreme" (Lapparent 1928, p. 37; Perruchot 1960, p. 234), although as the provenance indicates, he kept both the painting and the study in his possession (Paris 1931, p. 52).

Henri Nocq is the only "dandy" portrait to include a painting by Lautrec, and the visual pun created by Nocq's awkward pose belies the aloof and unruffled demeanor of the dandy type. As Kermit Champa observed: "Dwarfed by his spreading cape amidst the chaos of Lautrec's atelier, the *flaneur* pose of dandyism is stripped of its elegant self-confidence and appears artificial, even a little foolish" (in New York 1965, p. 84). Stuckey offers a different interpretation of the echoed poses of dancer and dandy, suggesting that Lautrec "wished to draw a parallel between theatrical costume and pose and those rehearsed for daily contemporary life."

E. B.

PROVENANCE
Henri Nocq, Paris; Wildenstein and Co., New York; acquired from Wildenstein and Co., New York, April 1951; Hillman Family Collection

LITERATURE
Duret 1920, pp. 54–55; Coquiot 1913, p. 188, ill. p. 189; Coquiot 1921, pp. 121–22, 125; Astre 1925, p. 82; Joyant 1926, pp. 200, 295, ill.; Joyant 1927 (1), p. 63; Joyant 1927 (2), pp. 154–55, ill. p. 154; Lapparent 1927, p. 34; Lapparent 1928, p. 37; MacOrlan 1934, p. 119; Schaub Koch 1935, p. 212; Mack 1938, p. 270; Lassaigne 1939, p. 167, ill. p. 119; *Town and Country* 1946, color ill., p. 110; *Wolf* 1946, ill. p. 9; Jourdain-Adhémar 1952, p. 102; Dortu 1952, ill. p. 9; Lassaigne 1953, p. 100; Dortu-Grillaert-Adhémar 1955, p. 19; *Pictures on Exhibit* 1956, ill. p. 7; King 1957; Perruchot 1958, pp. 254, 283; Perruchot 1960, p. 234; *Art News* 1959 (HC), p. 31, color ill., p. 34; Sutton 1962, p. 21; Adhémar 1965, p. xxi; Dortu 1971, vol. 3, pp. 390–91, pl. 639; Callegari 1973, color ill. p. 132; Sugana-Sutton 1973, no. 469a, p. 116, ill. p. 117; Caproni 1977, no. 469a, p. 116, ill. p. 117; Reynolds 1984, p. 14, ill.; London-Paris 1991, p. 170, ill. 40b (incorrectly credited to the Thyssen-Bornemisza Collection, Lugano).

EXHIBITIONS
Paris 1902, no. 94; Paris 1914, no. 78; Paris 1931, p. 52, no. 160; New York 1946, no. 31, p. 36, ill. p. 41; Pittsburgh 1947, no. 24, p. 14, ill.; New York 1947, no. 23; New York 1948, no. 16; New Orleans 1953–54, no. 79, p. 52, ill. p. 95; Philadelphia-Chicago 1955–56, no. 69, ill.; New York 1956, no. 41, p. 46, ill. p. 25; Palm Beach 1957, no. 78, exh. brochure; Los Angeles 1959, no. 15, ill.; New York–Waltham, 1962, no. 64, ill.; New York 1963, no. 95, p. 9; Albi-Paris 1964, no. 71, p. 83, ill. p. 85; New York 1964, no. 46, ill.; New York 1965, p. 84, color ill., p. 85; New York 1966, no. 179, p. 16, checklist; New York 1970, no. 89, ill.; Bronx 1972 (HC); New York 1972, no. 67, ill.; Jacksonville–Corpus Christi 1973–74 (HC), no. 12, ill.; Phoenix 1975 (HC); Chicago 1975 (HC); Roslyn 1977–78 (HC), no. 13, ill.; Chicago 1979, no. 85, pp. 268–69, ill.; Austin et al. 1979–85 (HC); Brooklyn 1986–87 (HC); Brooklyn 1988 (HC); Boston–New York 1991, no. 90, color ill. p. 105.

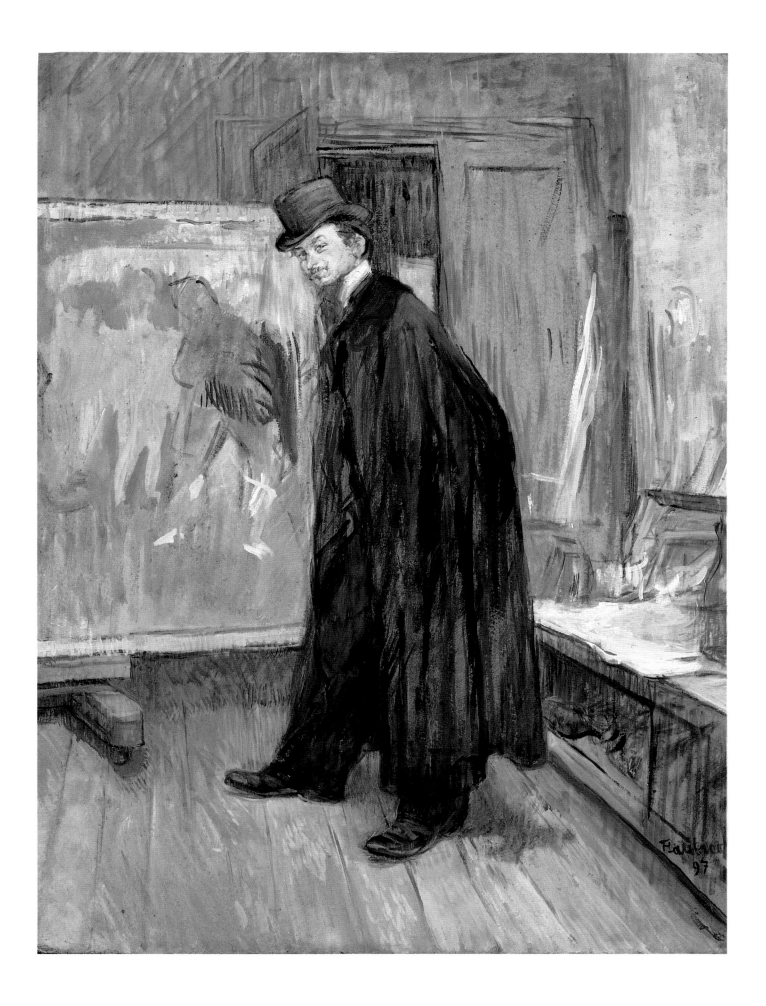

HENRI TOULOUSE-LAUTREC (1864–1901)

70. *At the Circus: Rehearsal*
(*Au cirque: Travail de répétition*), 1899
Colored pencil and black Conté crayon on cardboard, 13 ¾ x 10 in.
(34.9 x 25.4 cm)
Black monogram of the artist lower right; red estate stamp lower right

IN FEBRUARY 1899 TOULOUSE-LAUTREC collapsed in ill health and was sent to the Château Saint-James, an exclusive clinic in Neuilly, near Paris, to be treated for alcoholism. Within weeks of his enforced confinement and detoxification, he requested his friends to bring him a variety of drawing materials and subsequently rendered over fifty works in charcoal, crayon, pastel, ink, and watercolor (Seitz 1967). The ability to work proved essential to his convalescence and was proof of his sanity. As he commented upon his release on May 17, 1899, "I've bought my freedom with my drawings" (Joyant 1926, p. 222)

The majority of images depicted the circus—a favorite theme of Lautrec's—including a series of some thirty-nine detailed drawings in colored crayons and wash. The cast of characters includes acrobats, jugglers, circus animals, and equestrians. Maurice Joyant, Lautrec's childhood friend and later his dealer, subsequently catalogued and titled the individual drawings, describing *At the Circus* as follows: "Mounted on a large horse with a hooked nose and rat-tail, a Haute-Ecole equestrian, dressed in a riding habit and cap, works her horse; they go toward the right. In the right background, a trainer in a sweater and cap, whip in hand, relates it to the milieu of the circus" (Joyant 1927 (1), pp. 237–38). Like other images in the series, the facial expressions of the performers and the exaggerated and looming silhouette of the horse bear a touch of the sinister.

According to Arsène Alexandre's eyewitness account, the circus scenes were "done entirely from memory, without documents, preliminary sketches, notes, points of reference or indications of any kind" (Alexandre 1905, pp. 1–2). Though the works are generally conceded to have been done without the benefit of live models, William Seitz revived the idea that Lautrec probably visited the Cirque Equestre Molier, near the clinic on the rue Bénouville, in the company of a supervisor from the clinic (1967, n.p.). Henri Perruchot has discounted this theory, noting that the director of the Molier circus was traveling abroad in 1899 and that there were no public performances (1960, p. 260). The latter argument, however, does not preclude the possibility that the company continued to rehearse, which would explain, in turn, the absence of an audience in the drawings.

For the most part in this series Lautrec placed the figures in the arena against a background of empty tiers, using the oval form of the ring to frame the action and to flatten the composition in the manner of Japanese prints. Yet the visual dichotomy between outside and inside, near and far, has also been interpreted as a metaphor for Lautrec's confinement (Anne Roquebert in London-Paris 1991, p. 481), and hence as another argument for the source of the series in the artist's imagination. The spatial division is particularly pronounced in the Hillman drawing, in which the slats and tarpaulin of the ring dominating the foreground create a formidable barrier between the performers and the viewer.

While the series was in process, Joyant, a frequent visitor to the clinic, suggested the idea of publishing an album of the circus drawings. In 1902 a dozen images were reproduced in an article by Arsène Alexandre in *Figaro Illustré*, among them *At the Circus; Rehearsal* (labeled *Au cirque [dessin rehaussé]*). Though first announced in 1900, the circus album did not appear until 1905, after Lautrec's death. The Hillman drawing is not included in that portfolio of twenty-two drawings but appears in the second version of *Au cirque*, issued in 1932, which contains the additional seventeen. All thirty-nine were published together for the first time in 1952.

E. B.

PROVENANCE
Maurice Joyant, Paris; Mme Georges Dortu, Paris; acquired from M. Knoedler and Co., New York, October 1950; Hillman Family Collection

LITERATURE
(The following refer exclusively to the drawing *At the Circus: Rehearsal* and not to the series *At the Circus* in general)

Alexandre 1902, ill. p. 14; Joyant (1) 1927, pp. 237–38; Toulouse-Lautrec 1932, no. 7, in color; Mack 1938, p. 219; Henraux 1948, no. 37, in color; Toulouse-Lautrec 1952, no. 29, in color; *Art News* 1959 (HC), p. 34, fig. 9 (as *Equestrienne*); Novotny 1969, p. 51, fig. 30, p. 52; Dortu 1971, vol. 6, p. 864, ill. p. 865; Julien 1991, ill. p. 72.

EXHIBITIONS
Paris 1931, no. 264; Philadelphia-Chicago 1955–56, no. 119, ill. p. 101; New York 1956, no. 79; New York 1964, no. 87, ill; Bronx 1972 (HC); New York 1979; Roslyn 1977–78 (HC), no. 14, ill.; Austin et al. 1979–85 (HC); Brooklyn 1986–87 (HC); Brooklyn 1988 (HC); Phoenix 1991–92 (HC).

MAURICE UTRILLO (1883–1955)

71. *La Rue de la Jonquière*, c. 1909
Oil on canvas, 23 x 31 in. (58.4 x 78.7 cm)
Signed lower left: *Maurice Utrillo V.*

MAURICE UTRILLO WAS BORN in 1883, the illegitimate son of the artists' model and painter Suzanne Valadon. Largely self-taught and not part of any school or movement, Utrillo's distinctive views of Paris brought him considerable renown in his lifetime. Nonetheless, the artist's tragic life, resulting from his mother's neglect and an alcoholism that began before he was ten years old, imbues his pictures with a haunting sadness.

Utrillo's earliest pictures, from about 1903, were heavily impastoed compositions painted *en plein air* in a matter of a few hours. Instead of a gradual layering of the paint, Utrillo applied the pigments directly on the canvas, using no formal sketch or underdrawing to guide him.

By 1909 Utrillo had retreated to his studio and had started to work from picture postcards. This year was also important to him, as three of his works were exhibited at the Salon d'Automne, which was considered an honor for a young artist; yet he was rejected at the same time from the École des Beaux-Arts. Nonetheless, that same year the Hillman Collection picture, *La Rue de la Jonquière*, and several other pictures were purchased by the dealer and editor Louis Libaude (Werner 1981, p. 74). Most significantly, this year also marked the beginning of Utrillo's *manière blanche* (white period), during which some of his finest paintings were conceived.

Traces of Utrillo's debt to impressionism can be found in the subject matter of Parisian cityscapes, but in paintings such as *La Rue de la Jonquière*, the artist discarded his predecessors' light-toned atmospheric effects for a starker vision of urban life. This harsher reality is reflected in both subject and style. The somewhat picturesque streets of Utrillo's native Montmartre were always his subject of choice, but the streets he chose to depict reflected his working-class roots and the somewhat maudlin quality of the former country hamlet after its annexation to the bustling urban sprawl of Paris. In style, too, Utrillo assimilated the whiteness of the plaster facades of the buildings, adding wet plaster to the zinc whites of his oils.

Utrillo would alter the postcard image to suit the painted composition. For example, the plunging perspective of *La Rue de la Jonquière* recalls the compositions of Pissarro, Monet, and Caillebotte, who portrayed the expansive vistas made possible by Haussmann's newly created boulevards. Yet the impressionists' love of atmosphere is subverted here in Utrillo's unpeopled gray-and-white scene. The composition is balanced top to bottom; the sky is the same color as the street, and the buildings, which are slightly whiter, balance the composition from left to right. Touches of color, such as the yellow side of the building on the right and the reds and browns of chimneys, rooftops, and store fronts, relieve the monochromy. The dynamic perspective pulls the viewer's eyes both down to the street and deep into the recesses of the composition, creating one of Utrillo's most captivating images. As Alfred H. Barr, Jr., wrote of *La Rue de la Jonquière*: "The Utrillo is a picture which reveals its qualities slowly. I remember the first time I saw it it seemed to me rather gray, but afterwards I realized how subtle the variations of tones were in the wall surfaces and window shutters."[1]

E. E.

[1] Alfred H. Barr, Jr., to Alex Hillman, September 16, 1955, Hillman Family Archives.

PROVENANCE
Collection Libaude, Paris; acquired from French Art Galleries, New York, July 1951; Hillman Family Collection

LITERATURE
Werner 1952, p. 8, color pl. 9; Pétridès 1959, vol. 1, no. 183, p. 232, ill. p. 233; Werner 1981, p. 74, color pl. 10.

EXHIBITIONS
Washington D.C., 1953–54, no. 3, ill.; New York 1955, p. 20; New York 1957, no. 8, p. 11, ill. p. 23; Pittsburgh 1963, no. 15, ill.; Bronx 1972 (HC); Laramie 1972 (HC); Jacksonville–Corpus Christi 1973–74 (HC), no. 10, ill.; Hartford 1981 (HC).

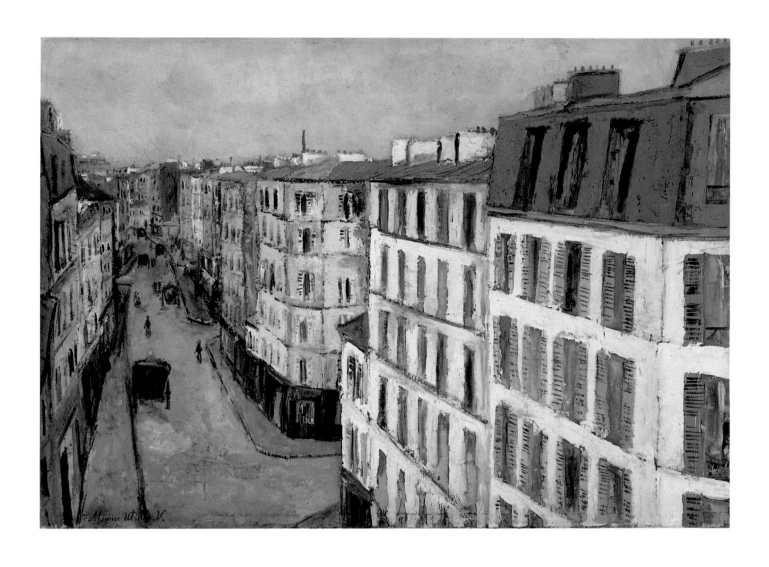

MAURICE UTRILLO (1883–1955)

72. *Moulin de la Galette,* c. 1912
Watercolor and gouache on cardboard,
12 ½ x 20 in. (33.1 x 50.8 cm)
Signed lower center: *Maurice Utrillo V.*

ONTMARTRE, THE HAMLET that rises above and is now incorporated into the city of Paris, has been noted since the Middle Ages for its windmills. Wheat was brought from the north to these mills by draft horses; during the time of Louis XIII there were as many as thirty such mills on the Butte Montmartre (Werner 1981, p. 150). By the 1820s the Moulin de la Galette had been turned into a dance hall and, thus transformed, remained the singular and most famous remnant of the city's agrarian past.

The Moulin de la Galette was a well-known image in nineteenth-century painting, immortalized by Renoir and Toulouse-Lautrec. But whereas these artists' works commemorated the gay or tawdry lives of the Parisians who frequented the café and dance hall, Utrillo's images of the same site tended to focus on empty streets and the isolated image of the tower. In a career devoted to depicting the streets and quotidian life of Montmartre, nothing symbolized Utrillo's work or the hilltop hamlet so eloquently as the windmill, which became as much a symbol for the artist as for Montmartre itself.

Utrillo painted the Moulin de la Galette hundreds of times and from several points of view; sometimes he emphasized the windmill's position high on the hill, its blades isolated against the sky, or at other times, as in the Hillman version, he offered a back view. In this gouache, the blades of the windmill are not given special attention but rather serve to frame the upper right corner of the composition. The main focus of the picture is the street behind the edifice, unpeopled and uninterrupted by buildings which takes up the entire foreground but which quickly vanishes in an abrupt curve to the left. The windmill itself is set back from the gated street and is the only architectural element in a landscape otherwise crowded with leafy trees. Overall, the gouache is lightly applied. Utrillo leaves large areas of the composition untouched, using the brown cardboard as a middle ground from which to work up to the whites for highlights and down to the darker colors for depth.

This work does not figure in the catalogue raisonné of Utrillo's work, though there are several examples of similar compositions (Pétridès 1959, vol. 2, p. 178, nos. 664–65; Pittsburgh 1963, no. 109). Given that the gouache was exhibited at the Art Institute of Chicago (1941) and sold at Parke-Bernet (1943) during the artist's lifetime, however, its authenicity is not in doubt.

E. E.

PROVENANCE
Perls Galleries, New York; acquired from Parke-Bernet, New York, April 29, 1943, no. 33, p. 24, ill.; Hillman Family Collection

EXHIBITIONS
Chicago 1941; Bronx 1972 (HC); Laramie 1972 (HC); Jacksonville–Corpus Christi 1973–74, no. 11, ill.; Roslyn 1977–78 (HC), no. 23, ill.; Austin et al. 1979–85 (HC).

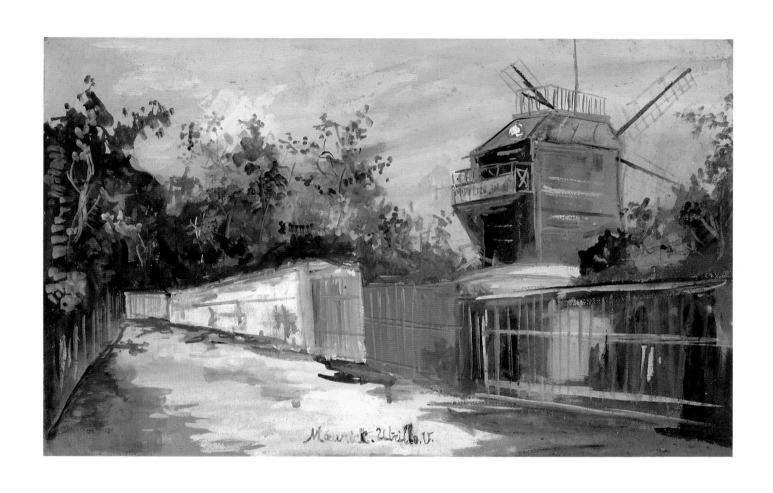

Maurice Utrillo. V.

WOLS [WOLFGANG SCHULTZE] (1913–1951)

73. *Untitled 1*, c. 1940–45
Watercolor, pen, and ink on paper,
 6 ¾ x 5 in. (17.2 x 12.7 cm)

74. *Untitled 2*, c. 1940–45
Watercolor, pen, and ink on paper,
 4 ¾ x 6 ¼ in. (12 x 15.9 cm)

75. *Untitled 3*, c. 1942–43
Watercolor, pen, and ink on paper,
 7 ¾ x 4 ¾ in. (19.5 x 12 cm)

76. *Untitled 4*, c. 1942–46
Watercolor, pen, and ink on paper,
 6 ¼ x 3 ¼ in. (16 x 8.2 cm)

77. *Untitled 5*, c. 1947–49
Watercolor, pen, and ink on paper,
 8 ½ x 5 ¼ in. (21.9 x 13.5 cm)

THE GRAPHIC WORK of German-born Alfred Otto Wolfgang Schulze (known as Wols) proved a critical bridge between French surrealism and development of *art informel* in the years immediately following World War II. After having trained at the Berlin Bauhaus, Wols left Germany for Paris in 1932. While he was briefly interned as a foreigner in 1940, he began to concentrate on watercolors and drawings, rendered with an automatic technique and biomorphic style. He went into hiding in the French Midi during the German occupation, where he continued to produce images redolent of organic growth and decay and tinged with human suffering. Wols returned to Paris in 1946, where the dealer René Drouin had already organized an exhibition of his work the year before. After his premature death in 1951, Wols was heralded by a younger generation of artists, such as Hans Hartung and Georges Mathieu, as the precursor of lyrical abstraction, or *tachisme*.

The five watercolors in the Hillman Collection exemplify Wols's masterful graphic technique and his intricately woven, hybrid forms that fluctuate between abstraction and figuration, the cosmic and the minute. As Roger Cardinal has written, Wols collapses contours literally and figuratively, since his fluid, pulsating forms are in a constant state of metamorphosis. The weird overlapping of identities from man to beast, solid to transparent, structured to unformed, sets up a process of "inexhaustible figuration" within the individual images (René Guilly cited in Cardinal 1978, n.p.).

Wols produced most of his watercolors and drawings in the 1940s: he rarely used titles and never dated his work. Nonetheless a basic chronology has been established based on stylistic development and themes. Of the five watercolors in the Hillman Collection, the first two can be dated generally to 1940–45; *Untitled 2* is related to a group of crossed or knitted ribbon forms painted in a pinkish red hue (Zürich 1989, pp. 157–60). The third image, with its grotesque human profile resembles *Idiot with Long Hair* of 1942–43 (Zürich 1989, p. 211). The fourth can be identified as a vertical tower city, a theme that occupied Wols from 1942 to 1946. More specifically, the mosaiclike composition comes closest to those dated 1944–45 (Zürich 1989, pp. 240–45). Finally, *Untitled 5*, with its amorphous color patches and open contours, may belong to a later series of watercolors (1947–49) categorized as *art informel* and related to his contemporary experiments in large-format paintings in oil on canvas (Zürich 1989, pp. 176–91).

There are no records of acquisition of the five works in the Hillman archives. Drouin held the first Wols exhibitions in Paris in 1945 and 1947, organized his first American show at the Hugo Gallery in New York in 1950, and continued to handle the work after the artist's death. Given the Hillmans' close relationship with Drouin, and his guidance in their purchase of other postwar French artists, it can be assumed that the Hillmans also acquired the Wols watercolors through him. The lack of records also argues for the fact that the drawings were acquired at the beginning of Hillmans' foray into *art informel*, likely in the early 1950s.

E. B.

PROVENANCE
Unknown; likely acquired from Galerie René Drouin, Paris, in the 1950s; Hillman Family Collection

74. WOLS. *Untitled 2*

73. WOLS. *Untitled 1*

74. WOLS. *Untitled 3*

76. WOLS. *Untitled 4*

77. WOLS. *Untitled 5*

WILLIAM ZORACH (1889–1966)

78. *Portrait of Rita Kanarek Hillman*, 1935
Unique bronze, 14 ¾ x 11 ½ x 10 ¾ in.
(37.4 x 29.2 x 27.3 cm)
Signed and dated on back at center: *Zorach 1935*

RITA HILLMAN WAS BORN TO Rudolph Kanarek and Bertha Goodman in New York in 1912. Her father had been a banker in Hamburg, Germany, but, on immigrating to America, invested in the budding communications industry and owned a number of radio and record companies before his premature death in 1927. Rita Kanarek met and married Alex Hillman in 1932, during her junior year at New York University, where she majored in psychology.

Alex Hillman was introduced to Zorach in the following year and soon after commissioned this portrait of Rita. He knew of Zorach's work through the sculpture *The Spirit of the Dance*, commissioned for Radio City Music Hall in 1932, and which had been a subject of controversy for its blatant nudity. (Hillman's office was just down Fifth Avenue, at 44th Street.) The portrait bust was the first sculpture the Hillmans owned. It is also one of the few pieces left in the collection that speaks of Hillman's first interest, contemporary American artists, among them Eugene Speicher, Alexander Brook, and Charles Burchfield.

This image of Rita Hillman numbers among Zorach's first portraits; the bronze medium was also unusual for Zorach at the time, since he preferred direct carving to modeling in clay or casting. The precise delineation of the perfectly symmetrical features and the broad, smooth surface of the face betray his training in the hard materials of stone and marble. The pupils of the almond-shaped eyes are barely inscribed, creating the impression of an idealized, if remote, calm. When several friends at the time commented that Rita did not look like the bronze, Hillman retorted, "But she will."

E. B.

PROVENANCE
Commissioned from the artist; Hillman Family Collection

LITERATURE
Wingert 1938, no. 80, p. 64.

EXHIBITION
Newark 1984–85, p. 50, ill.

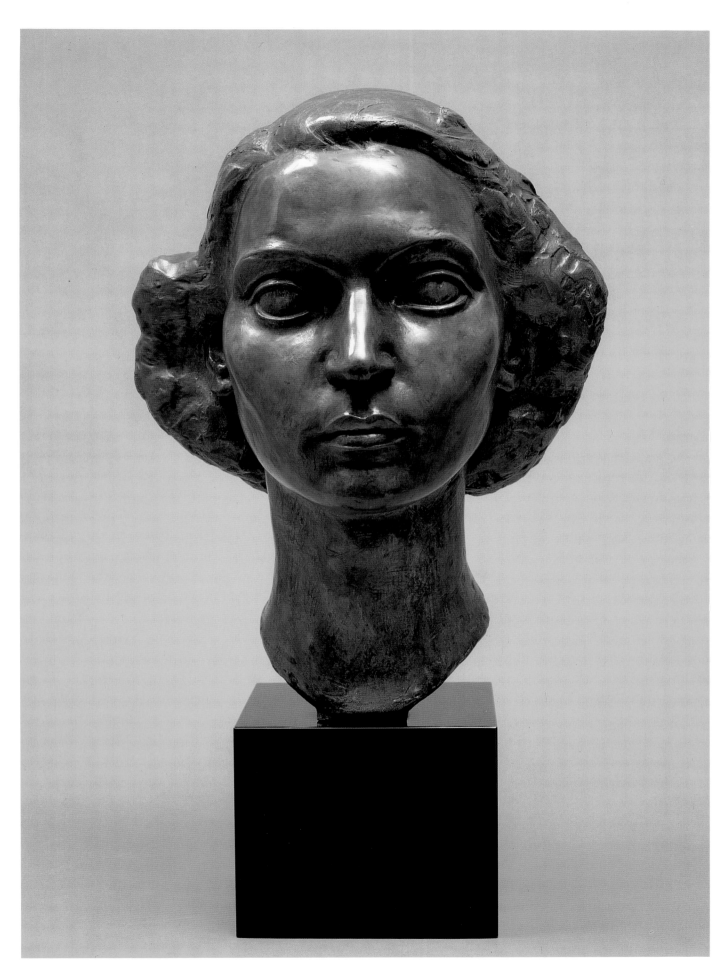

Appendix

1

7

2

9

KENNETH ARMITAGE

1. *Standing Group*, 1954
 Bronze, 6½ x 10 in. (16.5 x 25 cm)
 > PROVENANCE
 > Acquired from Gimpel Fils, London,
 > November 1956.
 > Sold: Parke-Bernet Galleries, New York,
 > March 1, 1972, sale 3322, no. 21A, ill.

KENNETH ARMITAGE

2. *Girl without a Face*, c. 1958
 Bronze, 14¾ in. (37.5 cm)
 > PROVENANCE
 > Acquired from the artist, December 1959.
 > Sold: Parke-Bernet Galleries, New York,
 > February 26, 1970, sale 2996, no. 70, ill.

KENNETH ARMITAGE

3. *Sprawling Woman*, c. 1958
 Bronze, 3/6 (Susse Fondeur, Paris)
 8¾ x 26 in. (22 x 66 cm)
 > PROVENANCE
 > Acquired from the artist, December 1959.
 > Sold: Parke-Bernet Galleries, New York,
 > March 1, 1972, sale 3322, no. 21K, ill.

FRANCO ASSETO

4. *Red VIII (Rosso VIII)*, 1958
 Mixed media on canvas, 39¾ x 27½ in.
 (101 x 70 cm)
 > PROVENANCE
 > Acquired from Tournabuoni Gallery,
 > Florence, April 1959.
 > Sold: Parke-Bernet Galleries, New York,
 > April 25, 1969, sale 2843, no. 117.

MAX BAND

5. *Flowers (Fleurs)*, n.d.
 Oil on canvas, 16 x 13 in. (41 x 33 cm)
 > PROVENANCE
 > No record of acquisition.
 > Sold: Parke-Bernet Galleries, New York,
 > May 21, 1969, sale 2867, no. 131.

BETI

6. *Salt (Sel)*, 1961
 Mixed media on canvas, 36 x 28½ in.
 (91 x 72 cm)
 > PROVENANCE
 > Acquired from Galerie René Drouin,
 > Paris, August 1961.
 > Sold: Parke-Bernet Galleries, New York,
 > April 25, 1969, sale 2843, no. 64.

GEORGES BRAQUE

7. *Yo*, c. 1939–45
 Painted plaster, 8 x 10¼ in. (20 x 26 cm)
 > PROVENANCE
 > Acquired from Samuel M. Kootz, New
 > York, August 1949.
 > Donated to the American Friends of the
 > Israel Museum, New York, December 1981.
 > Reference: Francis Ponge, *Braque le
 > réconciliateur* (Geneva, 1946), color
 > pl. 2 (dated 1943).

CHARLES BURCHFIELD

8. *Pippin House, East Liverpool, Ohio*, 1920
 Watercolor and gouache on paper,
 26 x 19⅜ in. (66 x 49.2 cm)
 > PROVENANCE
 > No record of acquisition.
 > Gift of Mr. and Mrs. Alex Hillman to the
 > Museum of Modern Art, New York,
 > May 1950.

10

12

II

ANTHONY CARO

9. *Cigarette Smoker 1* (*Lighting a Cigarette*), 1957
Bronze, 3/10, ½ H. 12 in. (30.5 cm)
PROVENANCE
Acquired from Gimpel Fils, London,
March 1960.
Sold: Parke-Bernet Galleries, New York,
April 25, 1969, sale 2843, no. 25, ill.
Reference: Dieter Blume, *The Sculpture
of Anthony Caro, 1942–1980: A Catalogue
Raisonné*, Verlag Galerie Wentzel
(Cologne, 1982), vol. 4, no. A 79 p. 52,
ill. p. 21.

CESAR [BALDACCINI]

10. *Construction*
Metal, H. 14 in. (35.5 cm)
PROVENANCE
Acquired from Galerie René Drouin,
Paris, February 1959.
Sold: Parke-Bernet Galleries, New York,
March 1, 1972, sale 3322, no. 21D.

PAUL CÉZANNE

11. *The Drunkards* (*Les Ivrognes*), c. 1872–75
Oil on canvas, 15 x 19¼ in. (38 x 49 cm)
PROVENANCE
Ambroise Vollard, Paris; received in
exchange with Renoir, *Woman in a
Blue Blouse* (Appendix no. 77), for
Renoir, *Bather* (Appendix no. 76),
August 1951.
Sold: Sotheby and Co., London,
July 6, 1960, sale no. 136, ill.
Reference: Lionello Venturi, *Cézanne:
Son art —son oeuvre* (1936; reprint,
San Francisco 1989), vol. 1, p. 117,
no. 235; vol. 2, pl. 63.

LYNN CHADWICK

12. *Dancing Figures*, c. 1955
Bronze and cement, H. 15½ in. (39 cm)
PROVENANCE
Acquired from Gimpel Fils, London,
November 1956.
Sold: Parke-Bernet Galleries, New York,
February 26, 1970, sale 2996, no. 71,
ill.

JEAN-BAPTIŞTE CHEREAU

13. *Untitled*, 1967
Mixed media on fabric, 32 x 48 in.
(81 x 122 cm)
PROVENANCE
No record of acquisition; probably
through Galerie René Drouin, Paris.
Sold: Parke-Bernet Galleries, New York,
April 26, 1969, sale 2843, no. 53.

JEAN-BAPTISTE CHEREAU

14. *Untitled Composition*, 1960
Mixed media, 40 x 27¼ in.
(101.5 x 69 cm)
PROVENANCE
Acquired from Galerie René Drouin,
Paris, December 1960.
Sold: Parke-Bernet Galleries, New York,
April 26, 1969, sale 2843, no. 87.

GUSTAVE COURBET

15. *The Stream of the Breme* (*Le Ruisseau de la
Breme*), c. 1875
Oil on canvas, 45 x 35 in. (114 x 89 cm)
PROVENANCE
Leo Gerstle, New York; traded in partial
exchange for Matisse, *Standing Figure*
(Appendix no. 60) with New Gallery,
New York, April 1957.
Sold: E. V. Thaw and Co., Inc., New
York (formerly New Gallery),
January 1963.

MODEST CUIXART

16. *Painting*, 1958
Mixed media on canvas (latex and synthetic
polymer paint with metallic powders)
74⅝ x 51¼ in. (225 x 130.1 cm)
PROVENANCE
Acquired from Galerie René Drouin,
Paris, c. 1959–60.
Donated to the Museum of Modern Art,
New York, April 1960.
Reference: *Painting and Sculpture Acquisi-
tions*, exh. cat., The Museum of Modern
Art, (New York, 1960) p. 34, ill.

MODEST CUIXART

17. *Untitled*, 1958
Mixed media on canvas, 41 x 32 in.
(104 x 81 cm)
PROVENANCE
Acquired from Galerie René Drouin,
Paris, c. 1959.
Donated to the Fogg Art Museum,
Harvard University, December 1966.

19

20

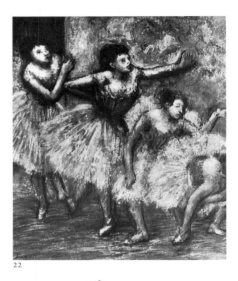

22

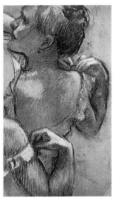

24

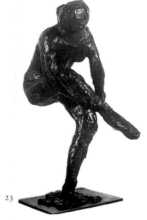

23

MODEST CUIXART
18. *Untitled Composition*, c. 1958
Mixed media on canvas, 39½ x 32 in.
(100 x 81 cm)
PROVENANCE
Acquired from Galerie René Drouin,
Paris, June 1958.
Sold: Parke-Bernet Galleries, New York,
April 25, 1969, sale 2843, no. 119.
Reference: *Before Picasso; After Miró*,
exh. cat., The Solomon R.
Guggenheim Museum (New York,
1960), n.p.

MODEST CUIXART
19. *Painting*, 1958
Mixed Media on canvas
50½ x 37½ in. (128 x 95 cm)
PROVENANCE
Acquired from Galerie René Drouin,
Paris, c. 1959.
Sold: Parke-Bernet Galleries, New York,
April 26, 1969, sale 2843, no. 65.
Reference: *Recent Spanish Painting and
Sculpture*, exh. cat., The Museum of
Modern Art (New York, 1960), p. 21.

MODEST CUIXART
20. *Painting*, 1959
Mixed media on canvas, 64 x 51 in.
(163 x 130 cm)
PROVENANCE
Acquired from Galerie René Drouin,
Paris, c. 1959–60.
Sold: Parke-Bernet Galleries, New York,
April 26, 1969, sale 2843, no. 50, ill. p. 21.
Reference: *Recent Spanish Painting and
Sculpture*, exh. cat., The Museum of
Modern Art, (New York, 1960), n.p.

SALVADOR DALÍ
21. *The Head of an Angel Exploding*, 1952
Ballpoint pen and ink on paper,
21¾ x 16¾ in. (55 x 43 cm)
PROVENANCE
Acquired from Carroll Carstairs Gallery,
New York, January 1953.
Sold: Parke-Bernet Galleries, New York,
December 18, 1968, sale 2784, no. 79, ill.

EDGAR DEGAS
22. *Four Dancing Girls* (*Quatre Danseuses*),
c. 1903
Pastel on paper, 33 x 28½ in. (84 x 72 cm)
PROVENANCE
Ambroise Vollard, Paris; Marcel Guiot,
Paris;,acquired from M. Knoedler and
Co., New York, December 1949.
Sold: Parke-Bernet Galleries, New York,
November 20, 1968, sale 2767, no. 41,
color ill. p. 71.
Reference: P. A. Lemoisne, *Degas et son
œuvre* (Paris, 1946), vol. 3, no. 1431*ter*,
ill. p. 819.

EDGAR DEGAS
23. *Dancer Putting on Her Stocking* (*Danseuse
mettant son bas*), 1896–1911
Bronze, cast 1919–21; (No. 70/HER.D.),
H. 17 in. (43 cm)
PROVENANCE
Acquired from Marcel Bernheim, Paris,
October 10, 1963.
Sold: Parke-Bernet Galleries, New York,
March 1, 1972, sale 3322, no. 21J, ill.
Reference: John Rewald, *Degas's Complete
Sculpture: Catalogue Raisonné*, new ed.
(San Francisco, 1990), cat. no. LVIII,
no. 70; p. 154 (ill. of another in the ed.)

EDGAR DEGAS
24. *Dancer Adjusting Her Strap* (*Jeune danseuse
rajustant son épaulette*), c. 1897
Charcoal and pastel heightened with white
on paper, 17 x 9¼ in. (43 x 23.5 cm)
PROVENANCE
Atelier Edgar Degas, Deuxième Vente,
Paris, 1918, no. 139, ill.; René De Gas,
Paris; acquired from Galerie André Weil,
Paris, September 4, 1957.
Sold: Parke-Bernet Galleries, New York,
November 20, 1968, sale 2767,
no. 40, ill. p. 69.
Reference: P. A. Lemoisne, *Degas et son
oeuvre*, (Paris, 1946), vol. 3, no. 1276,
ill. p. 741.

EDGAR DEGAS
25. *Woman Drying Herself* (*Femme s'essuyant
le cou*), c. 1894
Pastel on paper, 25½ x 21½ in. (65 x 55 cm)
PROVENANCE
Atelier Edgar Degas, Première Vente,
Paris, 1918, no. 232, ill.; Collection
Kapferer, Paris; Parke-Bernet
Galleries, New York, January 17, 1945,
sale 625, no. 59, ill.; acquired from
Durand-Ruel Galleries, New York,
January 1946.
Donated to the Museum of Modern Art,
1954.
Reference: P. A. Lemoisne, *Degas et son
œuvre* (Paris, 1946), vol. 3, no. 1172, ill.
p. 681; and vol. 4, p. 97.

27

28

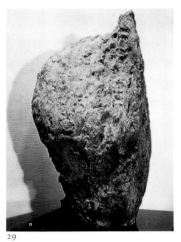

29

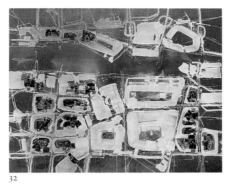

32

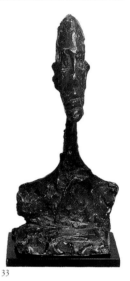

33

JEAN DUBUFFET
26. *The Gypsy* (*La Gitane*), 1954
Oil on canvas, 36½ x 29¼ in.
(93 x 73 cm)
PROVENANCE
Acquired from Pierre Matisse Gallery,
New York, December 1954.
Sold: Parke-Bernet Galleries, New York,
November 20, 1968, sale 2767, no. 74,
ill. p. 139.
Reference: Peter Selz, *The Work of Jean
Dubuffet,* exh. cat., The Museum of
Modern Art (New York, 1962), no. 111,
color ill. p. 95.

JEAN DUBUFFET
27. *Charcoal Landscape* (*Paysage charbonneux*),
1946
Oil and mixed media on canvas,
38 1/8 x 63¾ in. (97 x 162 cm)
PROVENANCE
Acquired from Galerie René Drouin,
Paris, c. 1950.
Sold: Parke-Bernet Galleries, New York,
February 25, 1970, sale 2994, no. 64,
color ill.
Reference: *Dubuffet Retrospektive*, exh.
cat., Akademie der Kunst (Berlin,
1980), no. 47, ill. p. 54, and p. 310.

JEAN FAUTRIER
28. *Two Colored Lines* (*Deux Lignes colorées*),
1958
Mixed media on paper, mounted on canvas,
39½ x 32 in. (100 x 81 cm)
PROVENANCE
Acquired from Galerie René Drouin,
Paris, June 1958.
Sold: Parke-Bernet Galleries, New York,
May 14, 1970, sale 3050, no. 13, ill.
Reference: Palma Bucarelli, *Jean Fautrier:
Pittura e materia* (Milan, 1960),
no. 391 (as *Construction*), p. 360, ill.

JEAN FAUTRIER
29. *Head of a Hostage* (*Tête d'otage*), 1943
Bronze, edition of 6, H. 18¾ in. (48.5 cm)
PROVENANCE
Acquired from Galerie René Drouin,
Paris, July 1961.
Sold: Parke-Bernet Galleries, New York,
February 26, 1970, sale 2996, no. 73; ill.
Reference: *Fautrier, 1898-1964,* exh. cat.,
Musée d'Art Moderne de la Ville de
Paris (Paris, 1989), no. 182, (ill. of
another in the edition).

JEAN FAUTRIER
30. *Blue Seas,* 1960
Mixed media on paper, mounted on canvas,
23½ x 32 in. (60 x 81 cm)
PROVENANCE
Acquired from the artist via Galerie René
Drouin, Paris, March 1961.
Sold: Parke-Bernet Galleries, New York,
May 14, 1970, sale 3050, no. 15.

ERNEST FIENE
31. *Fields in Spring,* n.d.
Oil on canvas, 8¼ x 12¼ in. (21 x 31 cm)
PROVENANCE
Acquired from Associated American
Artists Gallery, New York, no record
of date.
Sold: Parke-Bernet Galleries, New York,
April 30, 1969, sale 2848, no. 304.

CLAUDE GEORGES
32. *Untitled,* 1958
Oil on canvas,
58 x 45½ in. (147 x 115.5 cm)
PROVENANCE
Acquired from Galerie René Drouin,
Paris, June 1958.
Sold: Parke-Bernet Galleries, New York,
April 25, 1969, sale 2843, no. 118.

ALBERTO GIACOMETTI
33. *Small Head of Diego,* 1955
Bronze, 1/2 (Susse Fondeur, Paris),
H. 10¼ in. (26 cm)
PROVENANCE
Acquired from the Pierre Matisse Gal-
lery, New York, December, 1955.
Sold to Galerie Maeght, New York,
December 1980.

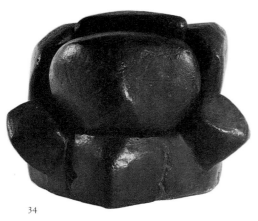

34

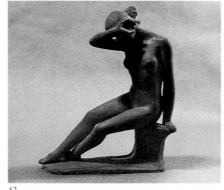

42

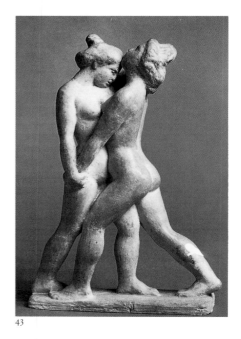

43

JEAN IPOUSTEGUY
34. *Duguesclin*, 1959
 Bronze, 4/6 (A. Valsuani, cire perdue,
 Paris), 9½ x 13¾ in. (24 x 35 cm)
 PROVENANCE
 Acquired from Galerie Claude Bernard,
 Paris, September 1961.
 Sold: Parke-Bernet Galleries, New York,
 February 26, 1970, sale 2996, no. 72, ill.

ERIC ISENBURGER
35. *Still Life*, n.d.
 Oil on canvas, 8 x 15 in. (20 x 38 cm)
 PROVENANCE
 No record of acquisition.
 Sold: Parke-Bernet Galleries, New York,
 April 30, 1969, sale 2848, no. 300.

PETER LANYON
36. *Harvey's Pool*, 1954
 Oil on board, 38½ x 23¼ in. (98 x 59 cm)
 PROVENANCE
 Acquired from Gimpel Fils, London
 February 1955.
 Sold: Parke-Bernet Galleries, New York,
 April 25, 1969, sale 2843, no. 51.

MARIE LAURENCIN
37. *Ophelia* (*Ophélie*), 1934
 Oil on canvas, 17¾ x 14¾ in.
 (45 x 37.5 cm)
 PROVENANCE
 Acquired from Edouard Jonas, Paris
 ` April 1953.
 Sold: Parke-Bernet Galleries, New York,
 November 20, 1968, sale 2767,
 no. 42, ill.

HENRI LAURENS
38. *Woman with a Guitar* (*Femme à la guitare*),
 1921
 Bronze, 3/6, H. 11 in. (28 cm)
 PROVENANCE
 Acquired from Galerie André Weil, Paris,
 1960.
 Sold: Parke-Bernet Galleries, New York,
 March 1, 1972, sale 3322, no. 21C, ill.
 References: *Henri Laurens*, exh. cat.,
 Grand Palais (Paris, 1967), no. 5, ill.

HENRI LAURENS
39. *Farewell* (small version) (*Le Petit Adieu*),
 1940–41
 Bronze, 5/6 (C. Valsuani, cire perdue),
 H. 10 in. (25 cm)
 PROVENANCE
 Acquired from Galerie Claude Bernard,
 Paris, December 1960.
 Sold: Parke-Bernet Galleries, New York,
 March 1, 1972, sale 3322, no. 21H, ill.
 Reference: *Henri Laurens, 1885-1954*,
 exh. cat., Sprengel Museum (Hannover,
 1985), no. 13, color ill. p. 39.

FERNAND LÉGER
40. *Girl with Flowers* (*La Jeune Fille au bouquet*),
 1921
 Oil on canvas, 25½ x 19¾ in. (65 x 50 cm)
 PROVENANCE
 Léonce Rosenberg, Paris; acquired from
 Jacques Lindon, New York, May 1952;
 traded, with Picasso, *Still Life*
 (Appendix no. 75), for Matisse, *The
 Pineapple* (no. 35), with Pierre Matisse
 Gallery, New York, June 1955.
 Reference: Georges Bauquier, *Fernand
 Léger: Catalogue raisonné, 1920-1924*,
 Adrien Maeght (Paris, 1992),
 no. 295, color ill. p. 165.

JOHN LEVEE
41. *Untitled*, 1955
 Oil on canvas, 35 x 47¼ in. (89 x 120 cm)
 PROVENANCE
 Acquired from Galerie Rive Droite, Paris,
 March 1955.
 Sold: Parke-Bernet Galleries, New York,
 April 25, 1969, sale 2843, no. 63.

ARISTIDE MAILLOL
42. *Seated Woman Covering Her Eyes*
 (*Jeune Fille assise se voilant les yeux*), 1900
 Terra-cotta, H. 8¼ in. (21 cm.)
 PROVENANCE
 Ambroise Vollard, Paris; acquired from
 R. Ullman, Paris.
 Sold: Sotheby's, New York, May 10,
 1989, sale 5850, no. 343, color ill.
 Reference: *Aristide Maillol: 1861–1944*,
 exh. cat., The Solomon R.
 Guggenheim Museum (New York,
 1975), no. 32, ill.

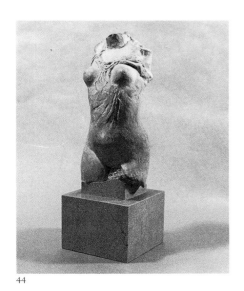

44

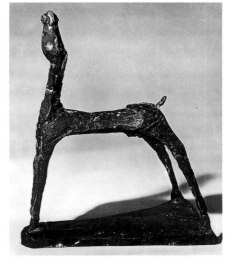

55

57

ARISTIDE MAILLOL
43. *The Wrestlers* (*Les Lutteuses*), 1900
Terra-cotta, H. 7¼ in. (18.5 cm)
 PROVENANCE
 Ambroise Vollard, Paris; acquired from R.
 Ullman, Paris.
 Sold: Sotheby's, New York, May 10,
 1989, sale 5850, no. 340, color ill.

ARISTIDE MAILLOL
44. *Draped Torso* (*Torse à la chemise*), 1900
Plaster, H. 8¼ in. (21 cm)
 PROVENANCE
 Ambroise Vollard, Paris; acquired from R.
 Ullman, Paris.
 Sold: Sotheby's, New York, May 10,
 1989, sale 5850, no. 342, color ill.

The following ten plasters by Maillol were for-
 merly in the collections of Ambroise Vollard
 and R. Ullman, Paris. They were purchased
 as a group by Alex Hillman in 1958 and do-
 nated to the Brooklyn Museum in 1990.

45. *Standing Nude Arranging Her Hair,*
 (*Debout se coiffant*), 1907
 Plaster, 14¾ x 5 x 3⅝ in. (37.5 x 13 x 9 cm)

46. *Standing Nude without Arms,*
 (*Femme sans bras*) n.d.
 Plaster, 11⅜ x 3 x 3 in. (29 x 7.6 x 7.6 cm)

47. *Crouching Woman with Crab*
 (*Femme au crabe*), 1930
 Plaster, 6⅝ x 6⅜ x 6 in. (16.7 x 16.2 x
 15.2 cm)

48. *Standing Nude with Both Hands behind
 Head,* (*Baigneuse aux bras levés*), 1930
 Plaster, 11⅜ x 5 x 5¼ in. (29 x 12.7 x 13.3 cm)

49. *Crouching Woman Fixing Her Hair,*
 (*Jeune Fille accroupie, se coiffant*), 1895
 Plaster, 8 x 4 x 4⅝ in. (20.3 x 10.2 x
 11.6 cm)

50. *Standing Nude with Hand Behind Head*
 (*Baigneuse debout, se coiffant, coude levé*), 1921
 Plaster, 11½ x 4⅞ x 2⅞ in. (29.2 x 12 x
 7 cm)

51. *Seated Woman Holding Her Feet*
 (*Se tenant les duex pieds*), c. 1930
 Plaster, 7½ x 5⅜ x 5⅛ in. (19 x 13.7 x
 13.2 cm)

52. *Walking Nude without Arms* (*Study for "Action
 in Chains without Arms"*) (*Etude pour
 "L'action enchaînée sans bras"*), 1905
 Plaster, 15¼ in. (38.7 cm)

53. *Seated Nude with Hand over Face* (*Jeune Fille
 assise se voilant les yeux*), 1900
 Plaster, 8⅞ x 7 ⅜ x 3¼ in. (22.3 x 18.7 x
 8.3 cm)

54. *Washerwoman* (*La Lavandière*), 1896
 Plaster, 5 x 11⅛ x 8¼ in. (12.7 x 18.7 x
 8.3 cm)

MARINO MARINI
55. *Horse* (*Cavallo*) 1951
 Bronze, H. 16 in. (40.5 cm)
 PROVENANCE
 Acquired from Curt Valentin Gallery,
 New York, November 1953.
 Sold: Parke-Bernet Galleries, New York,
 March 1, 1972, sale 3322, no. 21B, ill.
 Reference: Variant of *"Gertrude," the
 Little Horse,* bronze, ed. of 5, H. 9¾ in.,
 mistakenly attributed to the Alex
 Hillman Collection, New York, in
 Patrick Waldberg and Herbert Read,
 Marino Marini: Complete Works (New
 York, 1970), no. 292.

ETIENNE MARTIN
56. *The Knot* (*Le Noeud*), 1937
 Bronze, 1/6 (Susse-Fondeur, Paris), H. 19 in.
 (48 cm)
 PROVENANCE
 Acquired from Galerie René Drouin,
 Paris, June 25, 1961.
 Sold: Parke-Bernet Galleries, New York,
 April 25, 1969, sale 2843, no. 28, ill.

ETIENNE MARTIN
57. *The Garlic Clove* (*L'Ail*), 1962
 Bronze, 3/6, H.17 in. (43 cm)
 PROVENANCE
 Acquired from Galerie René Drouin,
 Paris, May 1962.
 Sold: Parke-Bernet Galleries, New York,
 April 25, 1969, sale 2843, no. 28.

61

68

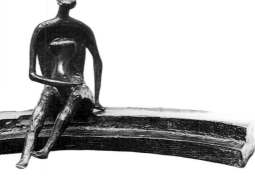
66

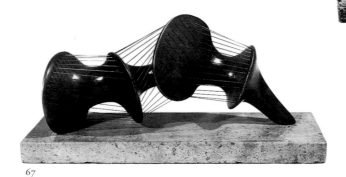
67

GEORGES MATHIEU
58. *Night* (*La Nuit*), 1954
 Casein on board, 19½ x 25 in. (50 x 64 cm)
 PROVENANCE
 Everett Ellin Gallery, Los Angeles;
 acquired from Sotheby and Co. London,
 August 31, 1962.
 Sold: Parke-Bernet Galleries, New York,
 April 25, 1969, sale 2843, no. 52.

HENRI MATISSE
59. *Figure in an Interior*
 (*Figure dans un intérieur*), n.d.
 Oil on canvas, dimensions unrecorded
 PROVENANCE
 Acquired from Carroll Carstairs Gallery,
 New York, April 1951; traded, for
 Rouault, *The Bathers* (no. 61), Picasso,
 Three Nudes (no. 46), and Modigliani,
 Madame Dorival (Appendix no. 65),
 with Perls Galleries,New York, April
 1954.

HENRI MATISSE
60. *Standing Figure*, n.d.
 Pencil on paper, dimensions unrecorded
 PROVENANCE
 No record of acquisition
 Traded for Courbet, *The Stream of the
 Breme*, with New Gallery, New York,
 April 1957.

BERNARD MEADOWS
61. *Crab* (*Tank*), 1956
 Bronze, 3/6, H. 12 in. (35 cm)
 PROVENANCE
 Acquired from Gimpel Fils, London,
 April 1959.
 Sold: Parke-Bernet Galleries, New York,
 April 25, 1969, sale 2843, no. 27.

BRUCE MITCHELL
62. *New England Winter Scene*, n.d.
 Oil on canvas, 13¾ x 21¼ in. (35 x 54 cm)
 PROVENANCE
 No record of acquisition.
 Sold: Parke-Bernet Galleries, New York,
 April 30, 1969, sale 2848, no. 305.

BRUCE MITCHELL
63. *New England Harvest Scene*, 1936
 Gouache on board, 17¼ x 29½ in.
 (44 x 75 cm)
 PROVENANCE
 No record of acquisition.
 Sold: Parke-Bernet Galleries, New York,
 April 30, 1969, sale 2848, no. 303.

BRUCE MITCHELL
64. *New England Village*, n.d.
 Gouache on board, 7½ x 6½ in.
 (19 x 16.5 cm)
 PROVENANCE
 No record of acquisition.
 Sold: Parke-Bernet Galleries, New York,
 April 30, 1969, sale 2848, no. 301.

AMEDEO MODIGLIANI
65. *Madame Dorival*, 1917
 Pencil on paper, 16⅞ x 10⅜ in.
 (43 x 26 cm)
 PROVENANCE
 Marcel Bernheim, Paris; traded, with
 Rouault, *The Bathers* (no. 61), and
 Picasso, *Three Nudes* (no. 46), in
 exchange for Matisse, *Figure in an
 Interior* (Appendix no. 59), with Perls
 Galleries, New York, April 1954; traded,
 for Modigliani, *Head of a Woman*
 (no. 38), and Manet, *Young Woman at
 the Seashore (Annabel Lee)*(no. 29), with
 New Gallery, New York, October 1955.
 Reference: Arthur Pfannstiel, *Modigliani:
 L'Art et la vie* (Paris, 1929, p. 49.

HENRY MOORE
66. *Seated Female Nude* (*Femme nue assise*),
 c. 1956–57
 Bronze, 8/8 (*C. Valsuani*), unpublished cast,
 measurements unrecorded
 PROVENANCE
 Acquired from Galerie André Weil, Paris,
 July 1958.
 Sold to Harold Diamond, New York,
 October 1972.

HENRY MOORE
67. *Stringed Reclining Figure*, 1939
 Bronze and string, 1/9, L. 10 in. (25 cm)
 PROVENANCE
 Acquired from Reid and Lefevre Gallery,
 London, September 1957.
 Sold: Parke-Bernet Galleries, New York,
 March 1, 1972, sale 3322, no. 21E, ill.
 Reference: David Sylvester. ed., *Henry
 Moore Sculpture and Drawings 1921–
 1948*, (London, 1957), vol 1, p. 12,
 no. 206, ill. (of another version) p. 133

71

73

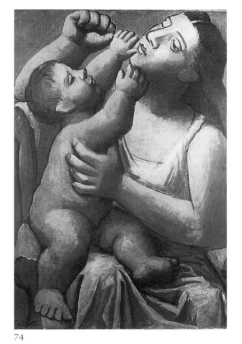

74

75

ZORAN MUSIC
68. *Dalmatian Motif* (*Motivo dalmata*), 1952
Oil on canvas, 23 ¾ x 9 in. (60 x 22 cm)
PROVENANCE
Acquired from Editions du Cavallino,
Venice, n.d.
Sold: Parke-Bernet Galleries, New York,
May 21, 1969, sale 2867, no. 132,
ill. p. 65.

JERRY PANTZER
69. *Untitled,* 1966
Painted plaster, H. 37 in. (94 cm)
PROVENANCE
Acquired from Galerie René Drouin,
Paris, July 1961.
Sold: Parke-Bernet Galleries, New York,
April 25, 1969, sale 2843, no. 29.

ANTOINE PEVSNER
70. *Column of Peace* (*La Colonne de la paix*), 1954
Bronze, 1/3 (Susse-Fondeur, Paris)
53 x 35½ x 19 ¾ in. (135 x 90 x 50 cm)
PROVENANCE
Acquired from Galerie René Drouin,
Paris, 1959.
Donated to the Metropolitan Museum
of Art, New York, October 1981, in
memory of Richard Alan Hillman.
Reference: Pierre Peissi and Carola
Giedion-Welcker, *Antoine Pevsner*
(Neuchâtel, 1961), no. 112, p. 153
(additional version ill. in color)

ANTOINE PEVSNER
71. *Construction in Space in the Third and Fourth
Dimensions,* (*Construction spatiale aux
troisième et quatrième dimensions*), 1961
Bronze, 40 x 30 in. (103 x 77 cm)
PROVENANCE
Acquired from Galerie René Drouin,
Paris, 1962.
Donated to the Israel Museum, in memory
of Richard Alan Hillman, 1967.
Reference: Pierre Peissi and Carola
Giedion-Welcker, *Antoine Pevsner*
(Neuchâtel, 1961), no. 118, ill. pp. 134–35.

PABLO PICASSO
72. *Woman in a Chair,* 1910
Oil on canvas, 28 ¾ x 23 ⅝ in. (73 x 60 cm)
PROVENANCE
No record of acquisition.
Donated to the Museum of Modern Art
New York, 1953.
Reference: *Painting and Sculpture Acquisi-
tions,* exh. cat., The Museum of Modern
Art, New York, 1951), ill.

PABLO PICASSO
73. *Woman in a Chemise*
(*Femme en chemise*), 1920
Pencil on paper, 15 x 8 in. (38 x 20 cm)
PROVENANCE
Daniel-Henry Kahnweiler, Paris; acquired
from Buchholz Gallery (Curt Valentin),
New York, October 1948.
Donated to the American Friends of the
Israel Museum, New York, 1991.
Reference: Paul Eluard, *A Pablo Picasso*
(Geneva and Paris, 1945), p. 106, ill.

PABLO PICASSO
74. *Mother and Child* (*Mére et enfant*), 1921
Oil on canvas, 38¼ x 28 in. (97 x 71 cm)
PROVENANCE
Alfred Flechtheim, Berlin; Franz von
Mendelsohn, Berlin; his daughter, Mrs.
Paul Kempner, New York; acquired
from Curt Valentin Gallery, New York,
1950.
Sold: Sotheby's, New York, November 15,
1989, sale 5850, no. 47, color ill.
Reference: Christian Zervos, *Pablo
Picasso,* vol. 4, *Œuvres de 1920 à
1922* (Paris, 1951), pl. 103, no. 289.

PABLO PICASSO
75. *Still Life,* 1920
Oil on canvas, 25 ½ x 36 ¼ in. (65 x 92 cm)
PROVENANCE
Dr. F. G. Reber, Lausanne; acquired from
M. Knoedler and Co., New York,
February 1951.
Traded (no. 35) with Léger, *Girl with
Flowers* (Appendix no. 40), for Matisse,
The Pineapple, with Pierre Matisse Gal
lery, New York, June 1955.
Reference: Christian Zervos,
Pablo Picasso, vol. 4, *Oeuvres de 1920 à
1922* (Paris, 1951), pl. 67, no. 198 (as
Guitare sur une table).

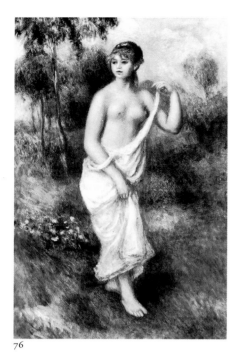

76

78

82

87

PIERRE AUGUSTE RENOIR
76. *Bather* (*Baigneuse*), c. 1892
Oil on canvas, 52 x 21 in. (132 x 53 cm)
PROVENANCE
Purchased from the artist by Durand
Ruel, Paris, June, 1892; Ambroise
Vollard, Paris; Jacques de Zoubaloff,
Paris; Madame Bruna Castagna, Paris;
acquired from Parke-Bernet Galleries,
New York, February 25, 1943, sale 437,
no. 44 (as *Fillette demi-nue*), ill. p. 27.
Traded, for Cézanne, *The Drunkards*
(Appendix no. 11), and Renoir,
Woman in a Blue Blouse, (Appendix
no. 77), to Édouard Jonas, Paris,
August 1951.
Reference: *Tableaux Modernes*, Galerie
Charpentier (Paris, March 30, 1954),
no. 95, pl. 37.

PIERRE AUGUSTE RENOIR
77. *Woman in a Blue Blouse* (*Femme au chemise bleu*), 1906
Oil on canvas, 21⅞ x 18⅜ in. (55 x 47 cm)
PROVENANCE
Received in exchange, with Cézanne,
The Drunkards (Appendix no. 11), for
Renoir, *Bather*, from Édouard Jonas,
Paris, August 1951.
Donated to *Fifty Modern Paintings and
Sculptures Especially Donated for the
Benefit of the Thirtieth Anniversary
Fund of the Museum of Modern Art, New
York*, Parke-Bernet Galleries, New York,
April 27, 1960, no. 19, color ill.
Reference: Ambroise Vollard, *Tableaux,
pastels et dessins de Pierre-Auguste Renoir*
(Paris, 1918), vol. 1, no. 97, ill. p. 25.

JEAN-PAUL RIOPELLE
78. *Echo on the Horizon* (*Echo d'horizon*), 1954
Oil on canvas, 38 x 51 in. (96.5 x 129.5 cm)
PROVENANCE
Acquired from the artist, via Pierre
Matisse Gallery, New York, 1954.
Sold: Parke-Bernet Galleries, New
York, May 14, 1970, sale 3050, no. 16.

GEORGES ROUAULT
79. *Two Nudes* (recto and verso), c. 1905
Oil on paper, 39⅜ x 25½ in.
(100 x 45 cm)
PROVENANCE
No record of acquisition.
Donated to the Metropolitan Museum
of Art, New York, 1949.
Reference: *The Metropolitan Museum of
Art Summer Bulletin* (1950): 28.

JACOB GETTLER SMITH
80. *Italian Street Scene*, 1929
Watercolor on paper, 14½ x 19 in.
(37 x 48 cm)
PROVENANCE
No record of acquisition.
Sold: Parke-Bernet Galleries, New York,
May 21, 1969, sale 2867, no. 130.

KURT SONDERBERG
81. *Untitled*, 1959
Oil on canvas, 43 x 27½ in. (109 x 70 cm)
PROVENANCE
Acquired from Galerie René Drouin,
Paris, September 1960.
Sold: Parke-Bernet Galleries, New York,
April 25, 1969, sale 2843, no. 88.

PIERRE SOULAGES
82. *Composition (December 29, 1951)*, 1951
Oil on canvas, 31⅞ x 51¼ in. (81 x 130 cm)
PROVENANCE
Acquired from Galerie Louis Carré,
Paris, December 1954.
Sold: Parke-Bernet Galleries, New York,
May 14, 1970, sale 3050, no. 14.
Reference: Andrew Carnduff Ritchie,
ed., *The New Decade: 22 European
Painters and Sculptors*, exh. cat., The
Museum of Modern Art (New York,
1955), no. 22, p. 109, ill. p. 41.

PIERRE SOULAGES
83. *Untitled Composition*, 1954
Oil on canvas, 36¼ x 25½ in. (92 x 65 cm)
PROVENANCE
Acquired from Galerie Rive Droite, Paris,
March 1956.
Sold: Parke-Bernet Galleries, New York,
November 20, 1968, sale 2767, no. 75, ill.

CHAIM SOUTINE
84. *Portrait of a Woman*, 1926
Oil on canvas, 15¼ x 12 in. (39 x 31 cm)
PROVENANCE
M. Gérard, Paris; M. Mazella, Paris;
acquired from Galerie d'Arte Moderne,
Paris, July 1950.
Donated to the Museum of Modern Art,
New York, December 1954, and sub-
sequently sold to New Gallery, New
York, 1955.

88

89

EUGENE SPEICHER
85. *Hill at Eddyville, Spring*, n.d.
Oil on canvas, 14½ x 22 in. (37 x 56 cm)
PROVENANCE
No record of acquisition.
Sold: Parke-Bernet Galleries, New York,
April 30, 1969, sale 2848, no. 302.

GRAHAM SUTHERLAND
86. *The Gourd, No. 5*
Oil on composition board,
measurements unrecorded
PROVENANCE
No record of acquisition.
Donated to the Museum of Modern
Art, New York, May 1950.

LESLIE THORTON
87. *The Archers*, n.d.
Bronze wire, H. 30 in. (76 cm)
PROVENANCE
Acquired from Gimpel Fils, London,
December 1959.
Sold: Parke-Bernet Galleries, New York,
April 25, 1969, sale 2843, no. 26.

CLAUDE VISEUX
88. *Petrification*, c. 1958
Bronze, H. 31 in. (79 cm)
PROVENANCE
Acquired from Galerie René Drouin,
Paris, 1959.
Sold: Parke-Bernet Galleries, New York,
April 25, 1969, sale 2843, no. 28a.

EDOUARD VUILLARD
89. *Woman Seated in a Room*
(*Dame assise devant une lampe*), 1899
Oil on canvas, H. 28 x 27 in. (71 x 69 cm)
PROVENANCE
Vuillard estate, Paris;acquired from
Maurice Renoir, Paris, August 1950.
Traded for Redon, *Poppies in a Green Vase*
(no. 52), with M. Knoedler and Co.,
New York, 1964, and subsequently sold
at Sotheby and Co., London, April 29,
1964.
Reference: Andrew Carnduff Ritchie,
Edouard Vuillard, exh. cat., The Museum
of Modern Art (New York, 1954), p. 102,
color ill. p. 62.

FRITZ WINTER
90. *Arriving Blue* (*Kommendes Blau*), 1954
Oil on canvas, 39½ x 29½ in. (100 x 75 cm)
PROVENANCE
Acquired from Gallery Kleeman, New
York, November 1954.
Sold: Parke-Bernet Galleries, New York,
April 25, 1969, sale 2843, no. 66.

GABRIEL ZENDEL
91. *Still Life with a Coffee Pot*, 1948
Oil on Masonite, 25½ x 31¾ in. (65 x 81 cm)
PROVENANCE
Acquired from Durand-Ruel Galleries,
New York, 1949.
Sold: Parke-Bernet Galleries, New York,
May 21, 1969, sale 2867, no. 129.

Bibliography

INCLUDES EXHIBITIONS

OF THE

HILLMAN FAMILY

COLLECTION

GENERAL REFERENCES
ON THE
HILLMAN FAMILY COLLECTION

AFA, 1983, 1984 (HC)
"Selections from the Collection of the Alex Hillman Family Foundation." In *The American Federation of Art Exhibition Program.* New York, 1983, 1984.

Art News 1959 (HC)
H. L. F. "Alex L. Hillman: Courbet to Dubuffet." *Art News* 58 (October 1959): 30–34.

Austin et al. 1979–85 (HC)
Selections from the Collection of the Alex Hillman Family Foundation (circulated by the American Federation of Arts, catalogue no. 26). University of Texas, Austin, January 21–May 13, 1979; University of Michigan Museum of Art, Ann Arbor, August 31–December 14, 1980; Oklahoma Museum of Art, Oklahoma City, September 1–November 29, 1982; Huntsville Museum of Art, Hunstville, Alabama, January 23–August 21, 1983; Museum of Fine Arts, St. Petersburg, Florida, September 17, 1983–January 1, 1984; Spencer Museum of Art, University of Kansas, Lawrence, February 1–June 16, 1984; Huntington Gallery, Huntington, West Virginia, September 16, 1984–January 6, 1985; Arkansas Art Center, Little Rock, February 3–April 14, 1985; Joseph and Margaret Muscarelle Museum of Art, College of William and Mary, Williamsburg, Virginia, May 11–August 11, 1985; Brunnier Gallery and Museum, Iowa State University, Ames, August 27–November 24, 1985.

Bronx 1972 (HC)
Paintings, Drawings, and Sculpture from the Alex Hillman Family Foundation. Bronx Museum of the Arts, New York, April 10–May 2, 1972.

Brooklyn 1986–87 (HC)
Exhibition of Works from the Alex Hillman Family Foundation. The Brooklyn Museum, New York, February 15, 1986–January 5, 1987.

Brooklyn 1988 (HC)
Modern Masters: French Art from the Alex Hillman Family Foundation Collection. The Brooklyn Museum, New York, June 9–August 15, 1988.

Chicago 1975 (HC)
Five Works by Modern French Painters from the Alex Hillman Family Foundation. The Smart Gallery, University of Chicago, October 9–December 15, 1975.

Hartford 1981 (HC)
Modern Masters from the Collection of a New York Foundation. Joseloff Gallery, Hartford Art School, Connecticut, October 15–November 21, 1981.

Jacksonville–Corpus Christi 1973–74 (HC)
The Alex Hillman Collection. Jacksonville Art Museum, Jacksonville, Florida, October 18–December 2, 1973; Art Museum of South Texas, Corpus Christi, December 13, 1973–January 27, 1974.

Jamaica 1978 (HC)
Drawings by Modern Masters from the Alex Hillman Family Foundation. Jamaica Arts Center, Jamaica, New York, March 1–April 16, 1978.

Laramie 1972 (HC)
The Hillman Collection. The University of Wyoming Art Center, Laramie, November 1972.

Newark 1984 (HC)
Modern Masters: Selections from the Collection of the Alex Hillman Family Foundation and the Newark Museum, Newark, New Jersey. Newark Museum of Art, June 26–September 3, 1984.

New York 1971 (HC)
Summer Loan Exhibition: Paintings from New York Collections. Collection of Mrs. Alex Hillman and the Alex Hillman Family Foundation. The Metropolitan Museum of Art, New York, July–November 1971.

Phoenix 1975 (HC)
Selections from the Alex Hillman Collection. Phoenix Art Museum, January 17–February 2, 1975.

Phoenix 1991–92 (HC)
Paintings and Drawings from the Alex Hillman Family Foundation. University of Arizona Museum of Art, Phoenix, December 3, 1991–May 3, 1992.

Roslyn 1977–78 (HC)
Modern Masters: Paintings and Drawings from the Alex Hillman Family Foundation. Nassau County Museum of Fine Arts, Roslyn, New York, December 19, 1977–February 12, 1978.

PIERRE BONNARD
Literature
Dauberville 1992
Jean Dauberville and Henry Dauberville, *Bonnard: Catalogue raisonné de l'œuvre peint, révisé et augmenté, 1888–1905*. Paris, 1992.

Exhibitions
Brooklyn 1990–91
Monet and His Contemporaries. Impressionism and Post-Impressionism at the Brooklyn Museum. The Brooklyn Museum, New York, September 14, 1990–June 3, 1991.

Cleveland–New York 1948
Pierre Bonnard. Cleveland Museum of Art and The Museum of Modern Art, New York, 1948.

Springfield 1941–46
Museum of Fine Arts, Springfield Mass., 1941–46.

GEORGES BRAQUE
Literature
Braque 1968
Catalogue de l'œuvre de Georges Braque, vol. 5, *Peinture, 1924–1927*. Paris, 1968.

L'Esprit nouveau 1921
Waldemar George. "Georges Braque." *L'Esprit nouveau*, no. 6 (1921): 638–56.

Golding 1988
John Golding. *Cubism: A History and an Analysis, 1907–1914*. 3d ed. Cambridge, Mass., 1988.

Isarlov 1932
George Isarlov. *Georges Braque*. Paris, 1932.

Metropolitan Museum of Art Bulletin 1967
Claus Virch. "The Annual Summer Loan Exhibition." *The Metropolitan Museum of Art Bulletin* 26 (Summer 1967): 29–34.

Valsecchi-Carrà 1971
Marco Valsecchi and Massimo Carrà. *L'opera completa di Braque*. Milan, 1971.

Worms de Romilly–Laude 1982
Nicole Worms de Romilly and Jean Laude. *Braque: Cubism. 1907–1914*. Paris, 1982.

Exhibitions
London 1983
The Essential Cubism, 1907–1920. Tate Gallery, London, April 27–July 10, 1983.

New York 1953
Collectors' Choice: Masterpieces of French Art from New York Private Collections. Paul Rosenberg Gallery, New York, March 17–April 18, 1953.

New York 1954
Cubism to 1918: Picasso, Braque, Gris. Perls Galleries, New York, January 4–February 6, 1954.

New York 1956
Modern European Paintings from New York's Private Collections. The Metropolitan Museum of Art, New York, June 22–September 30, 1956.

New York 1957 (1)
Impressionist and Modern Paintings from Private Collections: Summer Loan Exhibition. The Metropolitan Museum of Art, New York, Summer 1957.

New York 1957 (2)
Federation of Jewish Philanthropies Exhibition. Waldorf Astoria Hotel, New York, October 28–November 1, 1957.

New York 1960
Paintings from Private Collections: Summer Loan Exhibition. The Metropolitan Museum of Art, New York, Summer 1960.

New York 1961
Paintings from Private Collections: Summer Loan Exhibition. The Metropolitan Museum of Art, New York, Summer 1961.

New York 1962
Paintings from Private Collections: Summer Loan Exhibition. The Metropolitan Museum of Art, New York, Summer 1962.

New York 1963
Paintings from Private Collections: Summer Loan Exhibition. The Metropolitan Museum of Art, New York, Summer 1963.

New York 1964
Georges Braque, 1882–1963: An American Tribute. Perls Gallery et al., New York, April 7–May 2, 1964.

New York 1966
Summer Loan Exhibition: Paintings, Drawings, and Sculpture from Private Collections. The Metropolitan Museum of Art, New York, Summer 1966.

New York 1967
Paintings from Private Collections: Summer Loan Exhibition. The Metropolitan Museum of Art, New York, Summer 1967.

New York 1970
The Protean Century, 1870–1970, for the Benefit of the Hopkins Center Art Gallery, Dartmouth College. Knoedler & Co., New York, February 9–25, 1970.

PAUL CÉZANNE
Literature
Adriani 1981
Gotz Adriani. *Paul Cézanne. Dibujos*. Barcelona, 1981.

Andersen 1967
Wayne V. Andersen. "Cézanne, Tanguy, Choquet." *Art Bulletin* 49 (June 1967): 137–39.

Andersen 1970
Wayne V. Andersen. *Cézanne's Portrait Drawings*. Cambridge and London, 1970.

Bernard 1925
Emile Bernard. *Sur Paul Cézanne*. Paris, 1925.

Berthold 1958
Gertrude Berthold. *Cézanne und die alten Meister*. Stuttgart, 1958.

De Beucken 1951
Jean de Beucken. "Un Portrait de Cézanne: Deuxième Partie, 1881 à 1906." *France-Illustration: Le Monde Illustré, Supplement Théatral et Littéraire*. August 25, 1951, 2–32.

De Beucken 1960
Jean de Beucken. *Cézanne*. Munich. 1960.

De Boisdeffre–Cabanne–Cogniat 1966
Pierre de Boisdeffre, Pierre Cabanne, and Raymond Cogniat. *Cézanne*. Paris, 1966.

Canaday 1959
John Canaday. "Cézanne's Way." *New York Times*, November 8, 1959, section 2, p. 15.

Chappuis 1973
Adrien Chappuis. *The Drawings of Paul Cézanne: A Catalogue Raisonné*. 2 vols. London, 1973.

Frankfurter 1953
Alfred M. Frankfurter. "Arcadia on Paper." *Art News* 51 (February 1953): 28–45, 66–67.

Gatto-Orienti 1970
Alfonso Gatto and Sandra Orienti. *L'opera completa di Cézanne*. Milan, 1970.

Gowing 1973
Lawrence Gowing. "Introduction." In *Watercolor and Pencil Drawings by Cézanne*. Exh. cat. Newcastle upon Tyne–London, 1973.

Lichtenstein 1964
Sara Lichtenstein. "Cézanne and Delacroix." *Art Bulletin* 46 (March 1964): 55–67

Lichtenstein 1975
Sara Lichtenstein. "Cézanne's Copies and Variants after Delacroix." *Apollo* 101 (February 1975): 116–27

Loran 1930
Erle Loran. "Cézanne's Country." *The Arts* 16 (April 1930): 521–51.

Nicodemi 1944
Giorgio Nicodemi. *Cézanne Disegni*. Milan, 1944.

Novotny 1938
Fritz Novotny. *Paul Cézanne*. Vienna, 1938.

Perruchot 1961
Henri Perruchot. *Cézanne*. Cleveland and New York, 1961.

Philadephia 1983
Cézanne in Philadelphia Collections. Exh. cat. Philadelphia Museum of Art, 1983.

Reff 1958
Theodore Reff. "Studies in the Drawing of Cézanne." Ph.D. diss., Harvard University, 1958.

Reff 1960
Theodore Reff. "Book Review: Gertrude Berthold. *Cézanne und die alten Meister*. Stuttgart, 1958," *Art Bulletin* 42 (June 1960): 145–49.

Reff 1962
Theodore Reff. "Cézanne's Bather with Outstretched Arms." *Gazette des Beaux-Arts* 59 (March 1962): 173–90.

Reff 1964
Theodore Reff. "Letter to the Editor." *Art Bulletin* 46 (September 1964): 425.

Reff 1977
Theodore Reff. "Painting and Theory in the Final Decade." In *Cézanne: The Late Work*. Exh. cat. The Museum of Modern Art, New York, 1977.

Rewald 1936
John Rewald. *Cézanne et Zola*. Paris, 1936.

Rewald 1939
John Rewald. *Cézanne: Sa Vie, son œuvre, son amitié pour Zola*. Paris, 1939.

Rewald 1977
John Rewald. "The Last Motifs at Aix." In *Cézanne: The Late Work*. Exh. cat. The Museum of Modern Art, New York, 1977.

Rewald 1978 (1)
John Rewald. "Les Dernières Motifs à Aix." In *Cézanne: Les Dernières Années*. Exh. cat. Grand Palais, Paris, 1978.

Rewald 1978 (2)
John Rewald, ed. *Paul Cézanne: Correspondance*. Paris, 1978.

Rewald 1983
John Rewald. *Paul Cézanne: The Watercolors*. Boston, 1983.

Rewald-Marschutz 1936
John Rewald and L. Marschutz. "Cézanne et la Provence." *Le Point*, August 1936.

Rivière 1923
Georges Rivière. *Le Maître Paul Cézanne*. Paris, 1923.

Rivière 1936
Georges Rivière. *Cézanne: Le Peintre solitaire*. Paris, 1936.

Schapiro 1968
Meyer Schapiro, "The Apples of Cézanne: An Essay on the Meaning of Still Life." (1968), In *Modern Art: 19th and 20th Centeries, Selected Papers*. New York, 1978.

Venturi 1936
Lionello Venturi. *Cézanne: Son art—son oeuvre*. 2 vols. Paris, 1936. Reprint. San Francisco, 1989.

Venturi 1978
Lionello Venturi. *Cézanne*. Geneva, 1978.

Wadley 1975
Nicholas Wadley. *Cézanne and His Art*. London, 1975.

Exhibitions

Aix-en-Provence 1956
Exposition pour commémorer le cinquantenaire de la mort de Cézanne. Pavillon de Vendôme, Aix-en-Provence, July 21–August 15, 1956.

Basel 1936
Paul Cézanne. Kunsthalle Basel, 1936.

Brooklyn 1990–91
Monet and His Contemporaries: Impressionism and Post-Impressionism at the Brooklyn Museum. The Brooklyn Museum, New York, September 14, 1990–June 3, 1991.

Chicago–New York 1952
Cézanne: Paintings, Watercolors, and Drawings. The Art Institute of Chicago, February 6–March 16, 1952; The Metropolitan Museum of Art, New York, April 4–May 18, 1952.

The Hague 1956
Paul Cézanne, 1839–1906. Gemeentemuseum, The Hague, June–July 1956.

Jamaica 1982
Master Drawings from New York Private Collections. Jamaica Arts Center, Jamaica, New York, October 26–December 1, 1982.

Liège–Aix-en-Provence 1982
Cézanne. Musée Saint-Georges, Liège, March 18–May 9, 1982; Musée Granet, Aix-en-Provence, June 12–August 31, 1982.

London-Leicester-Sheffield 1946
Cézanne. Tate Gallery, London; Museum and Art Gallery, Leicester; Graves Art Gallery, Sheffield, 1946.

Madrid 1984
Paul Cézanne. Museo Español de Arte Contemporaneo, Madrid, March–April 1984.

Newcastle upon Tyne–London 1973
Watercolor and Pencil Drawings by Cézanne. Laing Art Gallery, Newcastle upon Tyne, September 19–November 4, 1973, Hayward Gallery, London, November 13–December 30, 1973.

New York 1953
Landscape Drawings and Watercolors, Bruegel to Cézanne. The Pierpont Morgan Library, New York, January 31–April 11, 1953.

New York 1957
Impressionist and Modern Paintings from Private Collections: Summer Loan Exhibition. The Metropolitan Museum of Art, New York, Summer 1957.

New York 1959 (1)
French Master Drawings: Renaissance to Modern. Charles E. Slatkin Galleries, New York, February 10–March 7, 1959.

New York 1959 (2)
Cézanne: Loan Exhibition, for the Benefit of the National Organization of Mentally Ill Children. Wildenstein and Co., New York, November 5–December 5, 1959.

New York 1961
Masterpieces: A Memorial Exhibition for Adele R. Levy, Benefit of the Citizens' Committee for Children of New York, Inc. Wildenstein and Co., New York, April 6–May 7, 1961.

New York 1963 (1)
Cézanne Watercolors: A Benefit Exhibition for the Scholarship Fund of the Department of Art History and Archaeology, of Columbia University. M. Knoedler and Co., New York, April 2–20, 1963.

New York 1963 (2)
Artist and Maecenas. A Tribute to Curt Valentin. Marlborough-Gerson Gallery, New York, November–December 1963.

New York 1966
Summer Loan Exhibition: Paintings, Drawings, and Sculpture from Private Collections. The Metropolitan Museum of Art, New York, Summer 1966.

New York–Ann Arbor 1980
Cézanne/Léger. Grey Art Gallery and Study Center, New York University, February 25–April 7, 1980; University of Michigan Museum of Art, Ann Arbor, August 31–December 14, 1980.

New York–Houston 1977–78
Cézanne: The Late Work. The Museum of Modern Art, New York; October 7, 1977–January 3, 1978; Houston, The Museum of Fine Arts, January 26,–March 19, 1978.

Paris 1935
Cézanne. Galerie Renou et Collé, Paris, 1935

Paris 1950
Cézanne. Galerie Baugin, Paris, 1950.

Paris 1955
De David à Toulouse-Lautrec: Chefs-d'oeuvres des collections américaines. Musée de l'Orangerie, Paris, April 20–July 3, 1955.

Paris 1978
Cézanne: Les Dernières années, 1895–1906. Grand Palais, Paris, April 20–July 23, 1978.

Poughkeepsie–New York 1961
Centennial Loan Exhibition. Vassar College, Poughkeepsie, New York, and Wildenstein and Co., New York, 1961.

Tokyo-Kyoto-Fukuoka 1974
Exposition Cézanne. National Museum of Western Art, Tokyo, March 30–May 19, 1974; Museum of the City of Kyoto, June 1–July 17, 1974; Fukuoka Cultural Center, July 24–August 18, 1974.

Tübingen 1978
Paul Cézanne: Das zeichnerische Werk. Kunsthalle Tübingen, October 20–December 31, 1978.

Vienna 1961
Paul Cézanne, 1839–1906. Österreichische Galerie, Oberes Belvedere, Vienna, April 14–June 18, 1961.

Washington-Chicago-Boston 1971
Cézanne: An Exhibition in Honor of the Fiftieth Anniversary of the Phillips Collection. The Phillips Collection, Washington D.C., February 27–March 28, 1971; The Art Institute of Chicago, April 17–May 16, 1971; Museum of Fine Arts, Boston, June 1–July 3, 1971.

Zürich 1956
Paul Cézanne, 1839-1906. Kunsthaus Zürich, August 22–October 7, 1956.

GIORGIO DE CHIRICO
Literature

L'Arte Moderna 1967
"Metafisica, dada e surrealismo," *L'Arte Moderna* 7, no. 55 (1967).

Calvesi 1992
Maurizio Calvesi, ed. *Giorgio de Chirico: Pictor optimus*. Exh. cat. Palazzo delle Esposizione. Rome, 1992.

Daftari 1976
Fereshteh Daftari. "Giorgio de Chirico: Self-Portrait." Entry in *Modern Portraits: The Self and Others*. Exh. cat. Wildenstein and Co., New York, 1976.

Dictionnaire 1938
Dictionnaire abrégé du surréalisme. Paris, 1938.

Encyclopedia universalis 1972
"Peintre metaphysique." In *Encyclopedia Universalis*. Paris, 1972.

Fagiolo dell'Arco 1981
Maurizio Fagiolo dell'Arco. *Giorgio de Chirico: Il tempo di Apollinaire, Paris, 1911–1915*. Rome, 1981.

Fagiolo dell'Arco 1984
Maurizio Fagiolo dell'Arco. *L'opera completa di de Chirico, 1908–1924*. Milan, 1984.

Fagiolo dell'Arco–Baldacci 1982
Maurizio Fagiolo dell'Arco and Paolo Baldacci. *Giorgio de Chirico: Paris, 1924–1929*. Milan, 1982.

Gaffé 1946
René Gaffé. *Giorgio de Chirico: Le Voyant*. Brussels, 1946.

London Bulletin 1938
Giorgio de Chirico. "Mystery and Creation." *London Bulletin*, no. 6 (October 1938): 14–20.

Minemura 1986
Toshiaki Minemura. *De Chirico*. Tokyo, 1986.

Rubin 1968
William Rubin. *Dada and Surrealist Art*. New York, 1968.

Schmied et al. 1980
Wieland Schmied et al. *De Chirico: Leben und Werk*. Munich, 1980.

Sloane 1958
Joseph Sloane. "Giorgio de Chirico and Italy." *Art Quarterly* 21 (1958): 3–22.

Soby 1941
James Thrall Soby. *The Early Chirico*. New York, 1941.

Soby 1955
James Thrall Soby. *Giorgio de Chirico*. New York, 1955.

Zervos 1938
Christian Zervos. *Histoire de l'art contemporain*. Paris, 1938.

Exhibitions

Bennington 1960
Surrealist Art: An Exhibition of Paintings and Sculpture, 1913–1946. Bennington College, Bennington, Vermont, April 7–29, 1960.

Ferrara 1981
La metafisica. Museo documentario. Palazzo Massari, Ferrara, 1981.

Hanover-Paris 1970
Giorgio de Chirico. Kestner Gesellschaft, Hanover, July 10–August 30, 1970; Musée d'Art Moderne, Paris, September–October 1970.

London 1938
Giorgio de Chirico, 1911–1917. London Gallery, London, October 14–November 12, 1938.

London 1978
Dada and Surrealism Reviewed. Arts Council of Great Britain, Hayward Gallery, London, January 11–March 2, 1978.

London 1989
Italian Art in the Twentieth Century. The Royal Academy of Arts, London, January–February 1989.

Milan 1970
Giorgio de Chirico. Palazzo Reale, Milan, April–May 1970.

Munich-Paris 1982–83
Giorgio de Chirico der Metaphysiker. Haus der Kunst, Munich, November 17, 1982–January

30, 1983; Centre Georges Pompidou, Paris, February 24–April 25, 1983.

New York 1943
Masterworks of Early de Chirico. The Art of This Century Gallery, New York, October 5–November 6, 1943.

New York 1968
Rousseau, Redon, and Fantasy. The Solomon R. Guggenheim Museum, New York, May 31–September 8, 1968.

New York 1976
Modern Portraits: The Self and Others. Wildenstein and Co., New York, October 20–November 28, 1976.

New York et al. 1982–83
De Chirico. The Museum of Modern Art, New York, March 31–June 29, 1982; Tate Gallery, London, August 4–October 3, 1982; Haus der Kunst, Munich, November 16, 1982–January 30, 1983; Centre Georges Pompidou, Paris, February 22–April 25, 1983.

Paris 1938
Exposition internationale du surréalisme. Galerie Beaux-Arts, Paris, 1938.

Venice 1979
La pittura metafisica. Palazzo Grassi, Venice, 1979.

EDGAR DEGAS
Literature
Boggs 1985
Jean Sutherland Boggs, "Degas at the Museum: Works in the Philadelphia Museum of Art and John G. Johnson Collectionh" In *Philadelphia Museum of Art Bulletin* 81 (Spring 1985): 2–48.

Boggs et al. 1988
Jean Sutherland Boggs et al. *Degas.* Exh. cat. The Metropolitan Museum of Art, New York, and the National Gallery of Canada, Ottawa, 1988.

Browse 1949
Lillian Browse. *Degas Dancers.* London, 1949.

Lemoisne 1946
Paul-André Lemoisne. *Degas et son eouvre.* 4 vols. Paris, 1946.

Millard 1976
Charles W. Millard. *The Sculpture of Edgar Degas.* Princeton, N.J., 1976.

Pingeot 1991
Anne Pingeot. *Degas Sculptures.* Paris, 1991.

Rewald 1990
John Rewald. *Degas's Complete Sculpture.* 3d ed. San Francisco, 1990.

Tinterow 1988
Gary Tinterow. "A Note on Degas's Bronzes." In Boggs et al. 1988, pp. 609–10.

Vente II, 1918
Catalogue des tableaux, pastels et dessins par Edgar Degas et provenant de son atelier. Galeries Georges Petit, Paris, December 11–13, 1918.

Vente III, 1919
Catalogue des tableaux, pastels et dessins par Edgar Degas et provenant de son atelier. Galeries Georges Petit, Paris, April 7–9, 1919.

Vente IV, 1919
Catalogue des tableaux, pastels et dessins par Edgar Degas et provenant de son atelier. Galeries Georges Petit, Paris, July 2–4, 1919.

Exhibitions
Amsterdam 1991–92
Degas/Sculptor. Van Gogh Museum, Amsterdam, November 29, 1991–January 26, 1992.

London 1957
French Masters. O'Hana Gallery, London, June–September 1957.

Paris 1921
Expositions des sculptures de Degas. Galerie Hébrard, Paris, May–June 1921.

Paris 1931
Exposition Degas: Portraitiste sculpteur. Musée de l'Orangerie, Paris, Summer 1931.

ANDRÉ DERAIN
Literature
Parke-Taylor 1982
Michael Parke-Taylor. *André Derain in North American Collections.* Exh. cat. Norman Mackenzie Art Gallery, University of Regina, Saskatchewan, 1982.

Sutton 1959
Denys Sutton. *André Derain.* London, 1959.

JEAN DUBUFFET
Literature
Loreau 1966
Max Loreau. *Catalogue des travaux de Jean Dubuffet. Fascicule 1: Marionnettes de la ville et de la campagne.* Paris, 1966.

RAOUL DUFY
Literature
Laffaille 1977
Maurice Laffaille, *Raoul Dufy: Catalogue raisonné de l'oeuvre peint.* 3 vols. Geneva, 1972–77.

Perez-Tibi 1989
Dora Perez-Tibi. *Dufy.* New York, 1989.

Exhibitions
London 1983–84
Raoul Dufy, 1877–1953. Arts Council of Great Britain, Hayward Gallery, London, November 1983–February 1984.

Paris 1936
L'Oeuvres récentes de Raoul Dufy. Gallery Kaganovitch, Paris, June 1936.

San Antonio 1980
Raoul Dufy. Marion Koogler McNay Art Institute, San Antonio, Texas, May 4–June 29, 1980

San Francisco–Los Angeles 1954
Raoul Dufy, 1877–1953. San Francisco Museum of Art, May–July 1954; Los Angeles County Museum, July–September 1954.

THOMAS EAKINS
Literature
Goodrich 1933
Lloyd Goodrich. *Thomas Eakins: His Life and Work.* New York, 1933.

Goodrich 1982
Lloyd Goodrich. *Thomas Eakins.* 2 vols. Cambridge, Mass., 1982.

Homer 1992
William Innes Homer. *Thomas Eakins: His Life and Art.* New York, 1992.

McKinney 1942
Roland McKinney. *Thomas Eakins.* New York, 1942.

Exhibitions
Jamaica 1982
Master Drawings from New York Private Collections. Jamaica Arts Center, Jamaica, New York, October 26–December 1, 1982.

New York 1982
American Watercolors and Drawings, 1870–1920. Grey Art Gallery and Study Center, New York University, January 12–February 13, 1982.

New York 1992
Thomas Eakins: Art and Archive. Babcock Galleries, New York, October 29–December 5, 1992.

PAUL GAUGUIN
Literature
Aurier 1891
Albert Aurier. "Néo-traditionnistes: Paul Gauguin." *La Plume* (September 1, 1891), trans and reprinted in Brettell et al. 1988, p. 57.

Brettell et al. 1988
Richard Brettell et al. *The Art of Paul Gauguin.* Exh. cat. National Gallery of Art, Washington, D.C., 1988.

Gauguin 1946
Lettres de Gauguin. Paris, 1946.

Gray 1963
Christopher Gray. *Sculpture and Ceramics of Paul Gauguin.* Baltimore, 1963.

Perruchot 1961
Henri Perruchot. *La Vie de Gauguin.* Paris, 1961.

Exhibitions
New York 1951
Sculpture by Painters. Buchholz Gallery (Curt Valentin), New York, 1951.

New York 1958
Sculpture by Painters. Gallery Chalette, New York, October 16–November 29, 1958.

THÉODORE GÉRICAULT
Literature
Bazin 1987–92
Germain Bazin. *Théodore Géricault: Étude critique, documents et catalogue raisonné.* 5 vols. Paris, 1987–92.

Burlington Magazine 1960
"Notable Works of Art New on the Market." *Burlington Magazine* 102 (June 1960): pl. XVI.

Clément 1867 (1)
Charles Clément. "Géricault," *Gazette des Beaux-Arts* 22 (May 1867): 449–81.

Clément 1867 (2)
Charlés Clément. "Catalgue de l'oeuvre de Géricault." *Gazette des Beaux-Arts* (October 1867): 351–72.

Clément 1868
Charles Clément. *Géricault: Étude biographique et critique.* 2d ed. Paris, 1868.

Delteil 1924
Loys Delteil. *Le Peintre-graveur illustré (XIXe et XXe siècles).* Vol. 18, *Théodore Géricault.* Paris, 1924.

Eitner 1983
Lorenz Eitner. *Géricault: His Life and Work.* London, 1983.

Grunchec 1978
Philippe Grunchec. *L'opera completa di Géricault.* Milan, 1978.

Hargrove 1980
June Hargrove. "Théodore Géricault." In Peter Fusco and H. W. Janson, eds. *The Romantics to Rodin: French Nineteenth-Century Sculpture from North American Collections.* Exh. cat. Los Angeles County Museum of Art, 1980.

Mantz 1872
Paul Mantz. "Le Galerie de M. Maurice Cottier." *Gazette des Beaux-Arts* 5 (May 1872): 375–97.

Paris 1991
Géricault. Exh. cat. Galeries nationales du Grand Palais, Paris, 1991.

Peignot 1965
Jérôme Peignot. "Géricault Sculpteur." *Connaissance des Arts* 155 (January 1965): 46–51.

Schmoll 1973
M. J. A. Schmoll. "Géricault sculpteur: A propos de la découverte d'une statuette en plâtre d'un moribond." *Bulletin de la Société de l'Histoire de l'art Français* (1973): 319–31

JUAN GRIS
Literature
Bonet-d'Ors 1984
Juan Manuel Bonet and Carlos Führer d'Ors. *Los genios de la pintura española: Juan Gris*. Madrid, 1984.

Bulletin de l'Effort Moderne 1927
Bulletin de l'Effort Moderne, no. 32 (February 1927).

Cahiers d'Art 1927
"Quelques notes de Juan Gris sur ses récherchés." *Cahiers d'Art* 2, nos. 4–5 (1927): 170–71.

Cooper 1971
Douglas Cooper "The Temperament of Juan Gris." *The Metropolitan Museum of Art Bulletin*. 29 (April 1971): 358–62.

Cooper-Potter 1977
Douglas Cooper and Margaret Potter. *Juan Gris: Catalogue raisonné de l'oeuvre peint*. Paris, 1977.

Einstein 1930
Carl Einstein. "Juan Gris: Texte Inédit." *Documents* 2, no. 5, (1930): 267–75.

Einstein 1931
Carl Einstein. *Die Kunst des 20. Jahrhunderts*. Berlin, 1931.

Frankfurter 1960
Alfred Frankfurter. "Why Are Yalemen the Best Collectors?" *Art News* 59 (Summer 1960): 5, 46–48, 74.

Gaya-Nuno 1975
Juan Antonio Gaya-Nuno. *Juan Gris*. Boston, 1975.

Kahnweiler 1947
Daniel-Henri Kahnweiler. *Juan Gris: His Life and Work*. Trans. Douglas Cooper. London and New York, 1947.

Kosinski 1991
Dorothy Kosinski. "G. F. Reber: Collector of Cubism." *Burlington Magazine* 133 (August 1991): 519–31.

Rosenthal 1983
Mark Rosenthal. "Juan Gris: The 'Perfect' Cubist." In *Juan Gris*. Exh. cat. University Art Museum, Berkeley, Calif., 1983.

Roskill 1985
Mark Roskill. *The Interpretation of Cubism*. Philadelphia, London, and Toronto, 1985.

Silver 1989
Kenneth E. Silver. *Esprit de Corps: The Art of the Parisian Avant-Garde and the First World War, 1914-1925*. Princeton, N.J., 1989.

Soby 1958
James Thrall Soby. "Juan Gris." In *Juan Gris*. Exh. cat. New York, The Museum of Modern Art, 1958.

Exhibitions
Baden-Baden 1974
Juan Gris. Kunsthalle Baden-Baden, July 20–September 29, 1974.

Cologne 1966
Juan Gris. Museum am Ostwall and Wallraf-Richartz Museum, Cologne, 1966.

London 1983
The Essential Cubism, 1907–1920. Tate Gallery, London, April 27–July 10, 1983.

Los Angeles–New York 1970–71
The Cubist Epoch. Los Angeles County Museum of Art, December 15, 1970–February 21, 1971; The Metropolitan Museum of Art, New York, April 7–June 7, 1971.

Madrid 1985
Juan Gris, 1887–1927. Salas Pablo Ruiz Picasso, Paseo de Recoletos, Madrid, September 20–November 24, 1985.

New Haven 1960
Paintings, Drawings, and Sculpture Collected by Yale Alumni. Yale University Art Gallery, New Haven, Conn., May 18–June 26, 1960.

New York 1954
Cubism to 1918: Picasso, Braque, Gris. Perls Gallery, New York, January 4–February 6, 1954.

New York 1955
Paintings from Private Collections. The Museum of Modern Art, New York, May 31–September 5, 1955.

New York et al. 1958
Juan Gris. The Museum of Modern Art, New York, April 9–June 1, 1958; Minneapolis Institute of Arts, June 24–July 24, 1958; San Francisco Museum of Art, August 11–September 14, 1958; Los Angeles Museum of Art, September 29–October 26, 1958.

New York 1963
Paintings from Private Collections: Summer Loan Exhibition. The Metropolitan Museum of Art, New York, Summer 1963.

New York 1966
Summer Loan Exhibition: Paintings, Drawings, and Sculpture from Private Collections. The Metropolitan Museum of Art, New York, Summer 1966.

Paris 1974
Juan Gris. Orangerie des Tuileries, Paris, March 14–July 1, 1974.

Washington, D.C.–Berkeley–New York 1983–84
Juan Gris. National Gallery of Art, Washington, D.C., October 16–December 31, 1983; University Art Museum, Berkeley, February 1–April 8, 1984; The Solomon R. Guggenheim Museum, New York, May 18–July 15, 1984.

Zürich 1933
Juan Gris. Kunsthaus Zürich, April 2–26, 1933.

HANS HARTUNG
Literature
Apollonio 1966
Umbro Apollonio. *Hans Hartung*. Trans. John Shepley. Milan, 1966.

Geldzahler 1975
Henry Geldzahler. *Hans Hartung: Paintings, 1971–1975*. Exh. cat. The Metropolitan Museum of Art, New York, 1975.

Rousseau-Sweeney-Domnick 1949
Madeleine Rousseau, James Johnson Sweeney, and Ottomar Domnick. *Hans Hartung*. Stuttgart, 1949.

BARBARA HEPWORTH
Literature
Hodin 1961
J. P. Hodin. *Barbara Hepworth*. New York, 1961.

Read 1952
Herbert Read. *Barbara Hepworth: Carvings and Drawings*. London, 1952.

Exhibitions
London 1937
Catalogue of Sculpture by Barbara Hepworth. The Lefevre Gallery, London, October 1937.

London 1954
Barbara Hepworth: Retrospective Exhibition, 1927–1951. Whitechapel Gallery, London, April 8–June 6, 1954.

PAUL KLEE
Literature
Klee 1968
Felix Klee, ed. *The Diaries of Paul Klee, 1898–1918*. Trans. Pierre B. Schneider et al. Berkeley, Los Angeles, and London, 1968.

Exhibition
London 1955
Twentieth-Century Masters. Marlborough Fine Art, Ltd., London, February–April 1955.

FERNAND LÉGER
Literature
Apollinaire 1913
Guillaume Apollinaire. Review of the 1913 Salon des Indépendants. *Montjoie!*, no. 3 (March 18, 1913).

Flechtheim 1928
Alfred Flechtheim. *Fernand Léger*. Berlin, 1928.

Franke 1929
Gunther Franke. *Wege abstrakter Malerei*. Munich, 1929.

Green 1976
Christopher Green. *Léger and the Avant-Garde*. New Haven and London, 1976.

Rudenstine 1976
Angelica Zander Rudenstine. *The Guggenheim Museum Collection: Painting, 1880–1945*. Vol. 2. New York, 1976.

Exhibitions
Basel 1946
Francis Picabia, Sammlung Nell Walden. Kunsthalle Basel, 1946.

Bern 1944–45
Der Sturm, Sammlung Nell Walden aus den Jahren 1912 bis 1920. Berner Kunstmuseum, 1944–45.

New York–Ann Arbor 1980
Cézanne/Léger. Grey Art Gallery and Study Center, New York University, February 25–April 7, 1980; University of Michigan Museum of Art, Ann Arbor, August 31–December 14, 1980.

Paris 1913
Salon des Indépendants. Paris, 1913.

Stockholm 1954
Wanderausstellung 132: Der Sturm, Samling Nell Walden, Expressionister, Futurister, Kubister. Des Riksforbundet for bildande Konst, Stockholm, 1954.

Zürich 1945
Sammlung Nell Walden und Dr. Othmar Huber, Expressionisten, Kubisten, Futuristen. Kunsthaus Zürich, 1945.

ÉDOUARD MANET
Literature
Bodelsen 1968
Merete Bodelsen. "Early Impressionist Sales, 1874–1894." *Burlington Magazine* 110 (June 1968): 331–48.

Canaday 1965
John Canaday. "Olympia's Progeny." *New York Times*, October 31, 1965, p. X 27, ill.

De Leiris 1969
Alain de Leiris. *The Drawings of Édouard Manet.* Berkeley, 1969.

Duret 1902, 1919
Théodore Duret. *Histoire d'Édouard Manet et de son oeuvre.* Paris 1902. Reissued 1919, with a supplement.

Glaser 1922
Curt Glaser. *Édouard Manet: Faksimiles nach Zeichnungen und Aquarellen.* Munich, 1922.

Jamot-Wildenstein 1932
Paul Jamot and Georges Wildenstein. *Manet.* 2 vols. Paris, 1932.

Jewell 1944
Edward Alden Jewell. *French Impressionists.* New York, 1944.

Meier-Graefe 1912
Julius Meier-Graefe. *Édouard Manet.* Munich, 1912.

Moreau-Nélaton 1926
Etienne Moreau-Nélaton. *Manet raconté par lui-même.* 2 vols. Paris, 1926.

Orienti 1981
Sandra Orienti. *Tout Manet, 1873–1883.* Paris, 1981.

New York 1983
Manet, 1832–1883. Exh. cat. The Metropolitan Museum of Art, New York, 1983.

Pool-Orienti 1967
Phoebe Pool and Sandra Orienti. *The Complete Paintings of Édouard Manet.* New York, 1967.

Rey 1938
Robert Rey. *Manet.* Paris, 1938.

Rouart-Wildenstein 1975
Denis Rouart and Daniel Wildenstein. *Édouard Manet: Catalogue raisonné.* 2 vols. Paris, 1975.

Tabarant 1931
Adolphe Tabarant. *Manet: Histoire catalographique.* Paris, 1931.

Tabarant 1947
Adolphe Tabarant. *Manet et son oeuvres.* Paris, 1947.

Exhibitions
Cambridge 1942
French Painters of the Nineteenth Century. Fogg Art Museum, Cambridge, Mass., 1942.

Chicago 1961
Treasures of Chicago Collectors. The Art Institute of Chicago, April–May 1961.

Detroit 1935
French Nineteenth-Century Paintings. Society of Arts and Crafts, Detroit, Michigan, 1935.

Los Angeles 1940
The Development of Impressionism. Los Angeles County Museum, January 12–February 28, 1940.

New York 1938
Boudin to Cézanne. Durand-Ruel Galleries, New York, 1938.

New York 1940
Eighteenth-and Nineteenth-Century French Paintings. Durand-Ruel Galleries, New York, 1940.

New York 1943
One Hundred and Fortieth Anniversary Exhibition. Durand-Ruel Galleries, New York, 1943.

New York 1946
Six Nineteenth-Century French Artists. Durand-Ruel Galleries, New York, March 25–April 30, 1946.

New York 1948
Nineteenth- and Twentieth-Century French Paintings, Twentieth-Century American Paintings, III. Durand-Ruel Galleries, New York, 1948.

New York 1959
French Master Drawings: Renaissance to Modern. Charles E. Slatkin Galleries, New York, February 10–March 7, 1959.

New York 1963
Paintings from Private Collections: Summer Loan Exhibition. The Metropolitan Museum of Art, New York, Summer 1963.

New York 1965
Olympia's Progeny, for the Benefit of the Association for Mentally Ill Children. Wildenstein and Co., New York, October 28–November 27, 1965.

New York 1966
Summer Loan Exhibition: Paintings, Drawings, and Sculpture from Private Collections. The Metropolitan Museum of Art, New York, Summer, 1966.

New York 1970
One Hundred Years of Impressionism: A Tribute to Durand-Ruel, for the Benefit of the New York University Art Collection. Wildenstein and Co., New York, April 2–May 9, 1970.

New York 1973
Quoth the Raven: Homage to Edgar Allan Poe. The Metropolitan Museum of Art, New York, July 11–September 3, 1973.

Paris 1884
Exposition des oeuvres d'Édouard Manet. École Nationale des Beaux-Arts, Paris, June 5–28, 1884; list of works reprinted in Moreau-Nélaton 1926, vol. 2, pp. 127–32.

Paris 1934
Quelques Oeuvres importantes de Corot à Van Gogh. Galerie Durand-Ruel, Paris, 1934.

Philadelphia-Chicago 1966–67
Édouard Manet. Philadelphia Museum of Art, November 3–December 11, 1966; The Art Institute of Chicago, January 13–February 19, 1967.

MARINO MARINI
Literature
Hunter-Finn 1993
Sam Hunter and David Finn. *Marino Marini: The Sculpture.* New York, 1993.

Read–Waldberg–San Lazzaro 1970
Herbert Read, Patrick Waldberg, and G. di San Lazzaro. *Marino Marini: Complete Works.* New York, 1970.

Exhibitions
New York 1950
Marini. Buchholz Gallery, New York, February 14–March 11, 1950.

Wilmington et al. 1953–54
Mario Sironi—Marino Marini. Delaware Art Center, Wilmington, October 27–November 24, 1953; Currier Gallery of Art, Manch-ester, New Hampshire, December 8, 1953–January 5, 1954; Baltimore Museum of Art, January 18–February 15, 1954; Akron Art Institute, Akron, Ohio, March 1–29, 1954.

GEORGES MATHIEU
Literature
Mathieu 1963
Georges Mathieu. *Au delà du tachisme.* Paris, 1963.

Rennes 1969
Mathieu. Exh. cat. Musée des Beaux-Arts de Rennes, 1969.

HENRI MATISSE
Literature
Aragon 1971
Louis Aragon. *Henri Matisse: Roman.* 2 vols. Paris, 1971.

Barr 1951
Alfred H. Barr, Jr. *Matisse: His Art and His Public.* Exh. cat. The Museum of Modern Art, New York, 1951.

Bernier 1991
Rosamond Bernier. *Matisse, Picasso, Miro as I Knew Them.* New York, 1991.

Carlson 1971
Victor Carlson. *Matisse as a Draughtsman.* Exh. cat. Baltimore Museum of Art, 1971.

Delectorskaya 1986
Lydia Delectorskaya. *"L'apparente facilité": Henri Matisse, Peintures de 1935–1939.* Paris, 1986.

Diehl 1954
Gaston Diehl. *Henri Matisse.* Paris, 1954.

Elderfield 1984
John Elderfield. *The Drawings of Henri Matisse.* Exh. cat. The Museum of Modern Art, New York, and Hayward Gallery, London, 1984.

Flam 1988
Jack Flam, ed. *Matisse: A Retrospective.* New York, 1988.

Lassaigne 1959
Jacques Lassaigne. *Matisse.* Lausanne, 1959.

Matisse 1939
Henri Matisse. "Notes of a Painter on His Drawing." Trans. and reprinted in Jack Flam, ed., *Matisse on Art.* London, 1973. (Originally published as "Notes d'un peintre sur son dessin." In *Le Point*, no. 21 [July 1939]: 80–82.

Monad-Fontaine 1979
Isabelle Monad-Fontaine. *Matisse: Oeuvres de Henri Matisse, 1869–1954.* Collections du Musée National d'Art Moderne, Paris, 1979.

Monad-Fontaine–Baldassari–Laugier 1989
Isabelle Monad-Fontaine, Anne Baldassari, and Claude Laugier. *Matisse: Oeuvres de Henri Matisse.* Collections du Musée National d'Art Moderne, Paris, 1989.

Schneider 1984
Pierre Schneider. *Matisse.* Trans. Michael Taylor and Bridget Stevens Romer. Paris, 1984.

Selz 1965.
Jean Selz. *Matisse.* New York, 1965.

Verve 1948
"Les Tableaux peints par Henri Matisse à Vence de 1944–48." *Verve* 6, nos. 21–22 (1948).

Exhibitions
Copenhagen 1970
Matisse: En retrospektiv udstilling. Statens Museum for Kunst, Copenhagen, October 9–November 30, 1970.

Fort Worth 1984
Henri Matisse: Sculptor-Painter. Kimbell Art Museum, Fort Worth, May 26–September 2, 1984.

Los Angeles–Chicago–Boston 1966
Henri Matisse Retrospective. University of California, Los Angeles, Art Galleries, January 5–February 27, 1966; The Art Institute of Chicago, March 11–April 24, 1966; Museum of Fine Arts, Boston, May 11–June 26, 1966.

New York 1950
Selections 1950. Pierre Matisse Gallery, New York, 1950.

New York 1966
Gauguin and the Decorative Style. The Solomon R. Guggenheim Museum, New York, June–September 1966.

New York 1970
The Protean Century, 1870–1970 for the Benefit of the Acquisitions Fund, Hopkins Center Art Galleries, Dartmouth College. Knoedler Galleries, New York, January 15–March 15, 1970.

New York 1973
Henri Matisse, for the Benefit of Lenox Hill Hospital, New York. Acquavella Galleries, New York, November 2–December 1, 1973.

New York 1975
The Object as Subject: Still-Life Paintings from the Seventeenth to the Twentieth Century, for the Benefit of the Metropolitan Opera Association, Inc. Wildenstein and Co., New York, April 4–May 3, 1975.

New York 1992–93
Henri Matisse: A Retrospective. The Museum of Modern Art, New York, September 24, 1992–January 12, 1993.

New York–Cleveland–Chicago–San Francisco 1951–52
Henri Matisse. The Museum of Modern Art, New York, November 13, 1951–January 13, 1952; The Cleveland Museum of Art, February 5–March 16, 1952; The Art Institute of Chicago, April 1–May 4, 1952; San Francisco Museum of Art, May 22–July 6, 1952.

Nice 1950
Henri Matisse. Musée de Nice, Galeries des Ponchettes, Nice, 1950.

Omaha 1977
The Chosen Object: European and American Still Life. Joslyn Art Museum, Omaha, Nebraska, April 23–June 5, 1977.

Paris 1949
Henri Matisse: Oeuvres récentes, 1947–1948. Musée National d'Arte Moderne, Paris, 1949.

Paris 1950
Henri Matisse. Maison de la Pensée Française, Paris, 1950.

Paris 1956
Retrospective Henri Matisse. Musée National d'Art Moderne, Paris, July 28–November 18, 1956.

Paris 1970
Henri Matisse: Exposition du centenaire. Grand Palais, Paris, April–September 1970.

JOAN MIRÓ
Literature
Dupin 1962
Jacques Dupin. *Joan Miró: Life and Work.* New York, 1962.

Rose 1982
Barbara Rose. *Miró in America.* Exh. cat. Museum of Fine Arts, Houston, 1982.

Stich 1980
Sidra Stich. *Joan Miró: The Development of a Sign Language.* Exh. cat. Washington University Art Gallery, St. Louis, and David and Alfred Smart Gallery, University of Chicago, 1980.

Exhibitions
New York 1947
Miró. Pierre Matisse Gallery, New York, May 13–June 7, 1947.

New York 1948
Miró. Pierre Matisse Gallery, New York, March 16–April 10, 1948.

AMEDEO MODIGLIANI
Literature
Carli 1952
Enzo Carli. *Modigliani.* Rome, 1952.

Ceroni 1958
Ambrogio Ceroni. *Amedeo Modigliani: Peintre.*

Ceroni-Piccioni 1970
I dipinti de Modigliani. Milan, 1970.

Diehl 1977
Gaston Diehl. *Modigliani.* Trans. Eileen B. Hennessy. New York, 1977.

Pastani 1991
Osvaldo Patani. *Amedeo Modigliani: Catalogo generale: Dipinti.* Milan, 1991.

Pfannstiel 1929
Arthur Pfannsteil. *Modigliani.* Paris, 1929.

Roy 1958
Claude Roy. *Modigliani.* Trans. James Emmons and Stuart Gilbert. NewYork, 1958.

Russoli 1959
Franco Russoil. *Modigliani.* New York, 1959.

Exhibitions
Atlanta 1960
The Art of Amedeo Modigliani. High Museum of Art, Atlanta, March 31–April 17, 1960.

Boston–Los Angeles 1961
Modigliani: Paintings and Drawings. Museum of Fine Arts, Boston, January 19–February 25; Los Angeles Country Museum of Art, March 28–April 30, 1961.

Cleveland–New York 1951
Modigliani: Paintings, Drawings, Sculpture. The Cleveland Museum of Art, January 31–March 18; The Museum of Modern Art, New York, April 10–June 10, 1951.

Milan 1958
MosÝtra di Amedeo Modigliani. Palazzo Reale, Milan, November–December 1958.

New York 1971
Amedeo Modigliani, for the Benefit of the Museum of Modern Art. Acquavella Galleries, New York, October 14–November 13, 1971.

Rome 1951–52
VI Quadriennale Nazionale d'Arte di Roma. December 1951–April 1953.

Rome 1959
Modigliani. Galleria Nazionale d'Arte Moderna, Rome, January–February 1959.

Tel Aviv 1971
Jewish Masters of Modern Art. Tel Aviv Museum, April 1971.

PABLO PICASSO
Literature
Barr 1946
Alfred H. Barr, Jr. *Picasso: Fifty Years of His Art.* New York, 1946.

Barrachina et al. 1984
Jaime Barrachina et al. *Picasso: Catálogo de pintura y dibujo.* Museo Picasso de Barcelona, Barcelona, 1984.

Cabanne 1977
Pierre Cabanne. *Pablo Picasso: His Life and Times.* New York, 1977.

Chevalier 1991
Denys Chevalier. *Picasso: The Blue and Rose Periods.* New York, 1991.

Daix-Boudaille 1967
Pierre Daix and George]Boudaille. *Picasso: The Blue and Rose Periods.* Trans. Phoebe Pool. Greenwich, Conn., 1967.

Demoiselles 1988
Les Demoiselles d'Avignon. 2 vols. Exh. cat. Musée Picasso, Paris, 1988.

Gassman 1981
Lydia Gassman. "Mystery, Magic, and Love in Picasso, 1925–1938: Picasso and the Surrealist

Poets." Ph.D. diss., Columbia University, 1981.

Geist 1984
Sidney Geist, "Brancusi." pp. 345–67. In vol. 2 of William Rubin, ed., *"Primitivism" in 20th-Century Art.* Exh. cat. The Museum of Modern Art, New York, 1984.

Janis 1946
Harriet Janis and Sidney Janis. *Picasso: The Recent Years, 1939–1946.* Garden City, N. Y., 1946.

Kahnweiler 1948
Daniel-Henry Kahnweiler and Brassaï. *Les Sculptures de Picasso.* Paris, 1948.

Lavin 1993
Irving Lavin. "Picasso's Bull(s): Art History in Reverse." *Art in America* 81 (March 1993): 76–93, 121, 123.

Lieberman 1952
William Lieberman. *Pablo Picasso: Blue and Rose Periods.* New York, 1952.

Merli 1948
Joan Merli. *Picasso: El Artista y la obra de nuestro tiempo.* Buenos Aires, 1948.

Moravia-Lecaldano-Daix 1980
Alberto Moravia, Paolo Lecaldano, and Pierre Daix. *Tout l'oeuvre peint de Picasso. 1: Périodes bleue et rose.* Paris, 1980.

Palau 1985
Josep Palau i Fabre. *Picasso: The Early Years, 1881–1907.* Barcelona, 1985.

Paris 1946
Picasso Paintings, 1939–1946. Paris, 1946.

Richardson 1991
John Richardson, with the collaboration of Marilyn McCully. *A Life of Picasso. Volume I, 1881–1906.* New York, 1991.

Rubin 1972
Wiliam Rubin. *Picasso in the Collection of the Museum of Modern Art.* New York, 1972.

Rubin 1980
William Rubin, ed. *Picasso: A Retrospective.* Exh. cat. The Museum of Modern Art, New York, 1980.

Rubin 1984
William Rubin. "Picasso," pp. 241–343. In vol. 1 of William Rubin, ed., *"Primitivism" in 20th-Century Art.* Exh. cat. The Museum of Modern Art, New York, 1984.

Rubin 1988
William Rubin, "La Genèse des *Demoiselles d'Avignon*," pp. 367–487. In vol. 2 of *Demoiselles* 1988.

Schapiro 1976
Meyer Schapiro. "Picasso's *Woman with a Fan*: On Transformation and Self-Transformation" (1976), pp. 111–20. In Meyer Schapiro, *Modern Art, 19th and 20th Centuries: Selected Papers.* New York, 1978.

Silver 1989
Kenneth E. Silver. *Esprit de Corps: The Art of the Parisian Avant-Garde and the First World War, 1914–1925.* Princeton, N.J., 1989.

Spies 1971
Werner Spies. *Sculpture by Picasso, with a Catalogue of the Works.* New York, 1971.

Spies 1983
Werner Spies, with Christine Piot. *Picasso: Das plastische Werk.* Berlin, 1983.

Steinberg 1972 (1)
Leo Steinberg. "The Philosophical Brothel, Part 1." *Art News* 71, no. 5 (September 1972): 20–29.

Steinberg 1972 (2)
Leo Steinberg. "The Philosophical Brothel, Part 2." *Art News* 71, no. 6 (October 1972): 38–47.

Steinberg 1972 (3)
Leo Steinberg. "The Algerian Women and Picasso at Large," pp. 125–234. In Leo Steinberg, *Other Criteria: Confrontations with Twentieth-Century Art*. New York, 1972.

Steinberg 1988
Leo Steinberg. "Le Bordel philosophique." Trans. and modification of Steinberg 1972 (1) and (2), pp. 319–65. In vol. 2 of *Les Demoiselles* 1988.

Zayas 1916
Marius de Zayas. *African Negro Art and Its Influence on Modern Art*. New York, 1916.

Zervos
Christian Zervos. *Pablo Picasso*. 32 vols. Paris, 1932–78.

Exhibitions
Jamaica, 1982
Master Drawings from New York Private Collections. Jamaica Arts Center, Jamaica, New York, October 26–December 1, 1982.

Little Rock 1987–88
Picasso: The Classical Years, 1917–1925. Arkansas Art Center, Little Rock, December 4, 1987–January 31, 1988.

London 1953
Important French Masters. Marlborough, London, February–March 1953.

London 1954
French Masters of the Nineteenth and Twentieth Centuries. Marlborough Fine Art, London, October–November 1954.

Miami 1963
Renoir to Picasso. Lowe Art Museum, University of Miami, 1963.

New York 1948
Picasso. Durand-Ruel Galleries, New York, May 3–29, 1948.

New York 1954
Collection of Modern French Painting. Perls Galleries, New York, 1954.

New York 1955
Paintings from Private Collections. The Museum of Modern Art, New York, May 31–September 5, 1955.

New York–Chicago 1957
Picasso: Seventy-fifth Anniversary Exhibition. The Museum of Modern Art, New York, May 22–September 8, 1957; The Art Institute of Chicago, October 29–December 8, 1957.

Paris 1945
Twenty-one paintings by Picasso. Galerie Louis Carré, Paris, June 20–July 13, 1945.

Paris 1956
Contemporary Sculpture. Galerie Craven, Paris, 1956.

Paris 1988
Les Demoiselles d'Avignon. Musée Picasso, Paris, January 26–April 18, 1988.

Philadelphia 1958
Picasso. Philadelphia Museum of Art, January 8–February 23, 1958.

Toronto 1949
Picasso. Art Gallery of Toronto, April 1949.

CAMILLE PISSARRO
Literature
Brettell 1980
Richard Brettell. "Camille Pissarro: A Revision," pp. 13–37. In London-Boston 1980.

Brettell-Lloyd 1980
Richard Brettell and Christopher Lloyd. *A Catalogue of the Drawings by Camille Pissarro in the Ashmolean Museum, Oxford*. Oxford, 1980.

Lloyd 1981
Christopher Lloyd. *Camille Pissarro*. New York, 1981.

Lloyd 1985
Christopher Lloyd. "The Market Scenes of Pissarro." *Art Bulletin of Victoria*, no. 25 (1985): 16–32.

London-Boston 1980
Camille Pissarro, 1830–1903. Exh. cat. Arts Council of Great Britain, Hayward Gallery, London; Museum of Fine Arts, Boston, 1980.

Pissarro-Venturi 1939
Ludovic Rodo Pissarro and Lionello Venturi. *Camille Pissarro. Son Art–son oeuvre*. 2 vols. Paris, 1939.

Thomson 1990
Richard Thomson. *Camille Pissarro: Impressionism, Landscape and Rural Labour*. Exh. cat. City Museum and Art Gallery, Birmingham, and The Burrell Collection, Glasgow, 1990.

Exhibition
Jamaica 1982
Master Drawings from New York Private Collections. Jamaica Arts Center, Jamaica, New York, October 26–December 1, 1982.

ODILON REDON
Literature
Berger 1964
Klaus Berger. *Odilon Redon: Fantasy and Color*. Trans. M. Bullock. London, 1964.

Bernard 1942
Emile Bernard. *Lettres de Vincent van Gogh, Paul Gauguin, Odilon Redon, Paul Cézanne, Elénur Bourges, Léon Bloy, Guilluaume Apollinaire, Joris-Karl Huysmans, Henry Le Groux à Emile Bernard*. 2d ed. Tonnerre, 1942.

Maciejunes 1990
Nannette V. Maciejunes. "Odilon Redon: An Art According to Myself," pp. 15–21. In *Odilon Redon: The Ian Woodner Family Collection*. Memphis, 1990.

Mellerio 1923
André Mellerio. *Odilon Redon: Peintre, dessinateur et graveur*. Paris, 1923.

Exhibitions
Paris 1937
Chefs d'oeuvres de l'art français. Palais National des Arts, Paris, 1937.

Paris 1956–57
Odilon Redon. Orangerie des Tuileries, Paris, October 1956–January 1957.

Paris 1959
Natures mortes françaises du XVII siècle au XX siècle. Galerie Daber, Paris, April 9–May 6, 1959.

New York 1966
Impressionist Treasures from Private Collections in New York, for the Benefit of St. Luke's Hospital Center Building Fund. M. Knoedler and Co., New York, January 12–January 29, 1966.

New York 1970
Odilon Redon, Benefit for the Lenox Hill Hospital. Acquavella Galleries, New York, October 22–November 21, 1970.

PIERRE-AUGUSTE RENOIR
Literature
House 1985
John House. "Renoir's Worlds." pp. 11–18. In London-Boston 1985.

London-Boston 1985
Renoir. Exh. cat. Hayward Gallery, London; Museum of Fine Arts, Boston, 1985.

Museum of Modern Art Bulletin 1953
"Painting and Sculpture Acquisitions, July 1, 1951–May 31, 1953." *The Museum of Modern Art Bulletin* 20 (1953): nos. 3–4, pp. 42–47.

Pach 1950
Walter Pach. *Renoir*. New York, 1950.

Paris 1931
L'Atelier de Renoir. 2 vols. Paris, 1931.

La Revue du Louvre 1980
"Pierre-Auguste Renoir: *La Danse à la campagne*." *La Revue du Louvre et des musées de France* (February 1980): 123.

Rivière 1946
Georges Rivière. *Renoir et ses amis*. Paris, 1921.

Vollard 1918
Ambroise Vollard. *Pierre-Auguste Renoir: Paintings, pastels and drawings*. Paris, 1918. Reprint. San Francisco, 1989.

White 1984
Barbara Ehrlich White. *Renoir: His Life, Art, and Letters*. New York, 1984.

Exhibitions
Boston 1939
The Sources of Modern Painting. Museum of Fine Arts, Boston, March 2–April 9, 1939.

New York 1942
Masterpieces by Renoir after 1900, for the Benefit of Children's Aid Society. Durand-Ruel Galleries, New York, April 1–April 25, 1942.

New York 1953
The Museum of Modern Art, New York, extended loan, October 21, 1952–February 18, 1954.

New York 1954
The Last Twenty Years of Renoir's Life. Paul Rosenberg and Co., New York, March 8–April 3, 1954.

New York 1968
Four Masters of Impressionism, for the Benefit of The Lenox Hill Hospital. Acquavella Galleries, New York, October 24–November 30, 1968.

Portland 1942–43
Fiftieth Anniversary Exhibition, 1892–1942. Portland Art Association, Portland, Oregon, December 2, 1942–January 3, 1943.

GEORGES ROUAULT
Literature
Cahiers d'Art 1940–44
Cahiers d'Art, nos. 15–19 (1940–44): 152, ill.

Chapon-Rouault 1978
François Chapon and Isabelle Rouault. *Rouault: Oeuvre gravé*. 2 vols. Monte Carlo, 1978.

Courthion 1962
Pierre Courthion. *Georges Rouault*. New York, 1962.

Dorival-Rouault 1988
Bernard Dorival and Isabelle Rouault. *Rouault: L'Oeuvre peint*. 2 vols. Monte Carlo, 1988.

Janson 1952
H. W. Janson and Dora Jane Janson. *The Story of Painting for Young People*. New York, 1952.

Lajoix 1992
Anne Lajoix. "Rouault céramiste." pp. 43–51. In *Rouault: Première période, 1903–1920*. Exh. cat. Musée National d'Art Moderne, Centre Georges Pompidou, Paris, 1992.

Los Angel]ounty Museum of Art Bulletin 1953
"Rouault Retrospective Exhibition." *Los Angeles County Museum of Art Bulletin* 5 (Summer 1953): 7–34.

Munro 1961
Eleanor C. Munro. *Golden Encyclopedia of Art*. New York, 1961.

Soby 1945
James Thrall Soby. *Georges Rouault*. Exh. cat.
 The Museum of Modern Art, New York,
 1945.

Venturi 1940
Lionelli Venturi. Introduction. In *Rouault:
 Retrospective Loan Exhibition*. Exh. cat. Insti-
 tute of Contemporary Art, Boston; The
 Phillips Memorial Gallery, Washington,
 D.C.; and San Francisco Museum of Art,
 1940.

Venturi 1948
Lionello Venturi. *Georges Rouault*. Paris, 1948.

Waller 1984
Bret Waller, "Rouault's Abandonné: Transforma-
 tions of an Image." *Porticus* 7 (1984): 30–36.

Wofsy 1976
Alan Wofsy. *Georges Rouault: The Graphic
 Work*. San Francisco, 1976.

Exhibitions
Brussels–The Hague 1952
Georges Rouault Retrospective. Palais des Beaux
 Arts, Brussels; Municipal Museum, The
 Hague, 1952.

Los Angeles 1953
Georges Rouault. Los Angeles County Museum
 of Art, June 29–August 15, 1953.

New York–Cleveland–Los Angeles 1953
Rouault Retrospective Exhibition. The Museum
 of Modern Art, New York; The Cleveland
 Museum of Art; Los Angeles County Mu-
 seum of Art, 1953.

New York 1954
Collection of Modern French Paintings. Perls
 Galleries, New York, March 8–April 10 and
 April 12–May 15, 1954.

New York 1956
Georges Rouault. Perls Galleries, New York,
 November 12–December 22, 1956.

New York 1963
Summer Loan. The Metropolitan Museum of
 Art, New York, 1963.

New York 1981
Georges Rouault. The Grey Art Gallery, New
 York University, April 27–May 30, 1981.

Paris 1949
Galerie Durand-Ruel, Paris, 1949.

Paris 1952
Georges Rouault. Musée National d'Art
 Moderne, Paris, July 9–October 26, 1952.

Westport 1955
An Exhibition: Works of Georges Rouault. Leonid
 Kipnis Gallery, Westport, Conn., May 14,
 1955.

GEORGES SEURAT
Literature
Bulliet 1936
Clarence Joseph Bulliet. *The Significant
 Moderns and Their Pictures*. New York, 1936.

de Hauke 1961
C. M. de Hauke. *Seurat et son Oeuvre*. 2 vols.
 Paris, 1961.

Herbert 1958
Robert Herbert. "Seurat's Drawings." pp. 22–
 25. In *Seurat: Paintings and Drawings*. Exh.
 cat. The Art Institute of Chicago and The
 Museum of Modern Art, New York, 1958.

Herbert 1991
Georges Seurat, 1859–1891. Exh. cat. The Metro-
 politan Museum of Art, New York, 1991.

Seligman 1947
Germain Seligman. *The Drawings of Georges
 Seurat*. New York, 1947.

Exhibitions
Ann Arbor 1962
A Generation of Draughtsmen. University of
 Michigan Museum of Art, Ann Arbor, April
 22–May 29, 1962.

Chicago 1935
Seurat. Renaissance Society, University of Chi-
 cago, 1935.

Chicago–New York 1958
Seurat: Paintings and Drawings. The Art Insti-
 tute of Chicago, January 16–March 7, 1958;
 The Museum of Modern Art, New York,
 March 24–May 11, 1958.

New York 1959
French Master Drawings: Renaissance to Modern.
 Charles E. Slatkin Galleries, New York, Feb-
 ruary 10–March 7, 1959.

New York 1977
*Seurat: Drawings and Oil Sketches from New
 York Collections*. The Metropolitan Museum
 of Art, New York, September 29–November
 27, 1977.

GINO SEVERINI
Literature
Fagiolo dell'Arco 1988
Maurizio Fagiolo dell'Arco. "'Appelles d'Italie':
 Gino Severini, 1928–1938, Un francese a
 Roma," pp. 391–99. In Fonti 1988.

Fonti 1988
Daniela Fonti. *Gino Severini: Catalogo ragionato*.
 Milan, 1988.

Meloni 1982
Francesco Meloni. *Gino Severini. Tutta l'opera
 grafica*. Reggio-Emilia, 1982.

CHAIM SOUTINE
Literature
M. C. "Chaim Soutine." *Israel Magazine* 1
 (1968): 69–71.

Coates 1953
Robert M. Coates. "The Art Galleries: Soutine
 and Mondrian." *New Yorker*, November 21,
 1953, pp. 90–92.

Cogniat 1945
Raymond Cogniat. *Soutine*. Paris, 1945.

Courthion 1972
Pierre Courthion. *Chaim Soutine: Peintre du
 déchirant*. Lausanne, 1972.

Dunow 1981
Esti Dunow. "Chaim Soutine, 1893–1943."
 Ph.D. diss., New York University, 1981.

Dunow et al. 1993
Esti Dunow, Guy Loudmer, Klaus Perls, and
 Maurice Tuchman. *Chaim Soutine (1893–
 1943): Catalogue raisonné*. 2 vols. Cologne,
 New York, and Paris, 1993.

F. P. 1953
F[airfield] P[orter]. "Reviews and Previews." *Art
 News* 52 (December 1953): 42.

Faure 1929
Elie Faure. *Soutine*. Paris, 1929.

Werner 1953
Alfred Werner. "Soutine: Affinity for an Alien
 World." *Art Digest* 28 (November 15, 1953):
 17–18.

Exhibitions
New York 1953
Chaim Soutine, 1894–1943. Perls Galleries, New
 York, November 2–December 5, 1953.

Jerusalem 1968
Chaim Soutine. Israel Museum, Jerusalem, May
 14–August 5, 1968.

RAPHAEL SOYER
Literature
Minneapolis 1980
Walter Quirt: A Retrospective. Exh. cat. Univer-
 sity Gallery, University of Minnesota, Minne-
 apolis, 1980.

Shenker 1973
Israel Shenker. "Raphael Soyer." *Art News* 72
 (November 1973): 54–57.

Soyer 1946
Raphael Soyer. *Raphael Soyer*. New York, 1946.

Exhibition
New York 1941
Raphael Soyer. Associated American Artists Gal-
 leries, New York, March 18–April 7, 1941.

FREDERIC TAUBES
Literature
Youngstown 1983
Taubes. Exh. cat. The Butler Institute of Ameri-
 can Art, Youngstown, Ohio, 1983.

Gardner 1939
Paul Gardner. *An Appreciation of the Work of
 Frederic Taubes*. New York, 1939.

HENRI TOULOUSE-LAUTREC
Literature
Adhémar 1965
Jean Adhémar. *Toulouse-Lautrec: His Complete
 Lithographs and Drypoints*. New York, 1965.

Alexandre 1902
Arsène Alexandre. "Toulouse-Lautrec." *Figaro
 Illustré*, no. 145 (April 1902): 2–24.

Alexandre 1905
Arsène Alexandre. "Note sur les vingt-deux
 dessins aux crayons de couleur." In *Toulouse
 Lautrec: Au cirque*. Paris, 1905.

Astre 1925
Achille Astre. *Henri de Toulouse-Lautrec*. Paris,
 1925.

Callegari 1973
Piera Callegari. *La vita e l'arte di Toulouse-
 Lautrec*. Milan, 1973.

Caproni 1977
Giorgio Caproni. *L'opera completa di Toulouse-
 Lautrec*. Milan, 1977.

Coquiot 1913
Gustave Coquiot. *Henri de Toulouse-Lautrec*.
 Paris, 1913.

Coquiot 1921
Gustav Coquoit. *Lautrec*. Paris, 1921.

Dortu 1952
M. G. Dortu. *Toulouse-Lautrec*. Paris, 1952.

Dortu 1971
M. G. Dortu. *Toulouse-Lautrec et son oeuvre*. 6
 vols. New York, 1971.

Dortu-Grillaert-Adhémar 1955
M. G. Dortu, Madeleine Grillaert, and Jean
 Adhémar. *Toulouse-Lautrec en Belgique*. Paris,
 1955.

Duret 1920
Théodore Duret. *Lautrec*. Paris, 1920.

Henraux 1948
Marie Delaroche-Vernet Henraux. *Henri de
 Toulouse-Lautrec, dessinateur*. Paris, 1948.

Jourdain-Adhémar 1952.
Francis Jourdain and Jean Adhémar. *Toulouse-
 Lautrec*. Paris, 1952.

Joyant 1926
Maurice Joyant. *Henri de Toulouse-Lautrec, I*.
 Paris, 1926.

Joyant 1927 (1)
Maurice Joyant. *Henri de Toulouse-Lautrec,
 1864–1901, II*. Paris, 1927.

Joyant 1927 (2)
Maurice Joyant. "Toulouse-Lautrec." *L'Art et les artistes* (February, 1927): 145–73.

Julien 1991
Edouard Julien. *Lautrec.* New York, 1991.

King 1957
Leone King. "Lautrec Exhibit Rounds out Season for Four Arts Society." *The Palm Beach Post*, March 16, 1957.

Lapparent 1927
Paul de Lapparent. *Toulouse-Lautrec.* Paris, 1927.

Lapparent 1928
Paul de Lapparent. *Toulouse-Lautrec.* Trans. W. F. H. Whitmarsh. London, 1928.

Lassaigne 1939
Jacques Lassaigne. *Toulouse-Lautrec.* Trans. Mary Chamot. London, 1939.

Lassaigne 1953
Jacques Lassaigne, *Le Goût de notre temps—Lautrec.* Geneva, 1953.

London-Paris 1991
Toulouse-Lautrec. Exh. cat. Hayward Gallery, London, and Musée d'Orsay, Paris, 1991.

MacOrlan 1934
Pierre MacOrlan. *Lautrec.* Paris, 1934.

Mack 1938
Gerstle Mack. *Toulouse-Lautrec.* New York, 1938.

Novotny 1969
Fritz Novotny. *Toulouse-Lautrec.* London, 1969.

Perruchot 1958
Henri Perruchot. *La vie de Toulouse-Lautrec.* Paris, 1958.

Perruchot 1960
Henri Perruchot. *Toulouse-Lautrec.* Cleveland and New York, 1960.

Pictures on Exhibit 1956
"Toulouse-Lautrec in New York." *Pictures on Exhibit* 19 (April 1956): 6–7.

Reynolds 1984
Gary Reynolds. *Giovanni Boldini and Society Portraiture, 1880–1920.* Exh. cat. Grey Art Gallery and Study Center, New York, 1984.

Schaub Koch 1935
E. Schaub Koch. *Psychoanalyse d'un peintre moderne.* Paris, 1935.

Seitz 1967
William Seitz. *Henri de Toulouse-Lautrec, At the Circus: A Suite of Drawings.* New York, 1967.

Sugana-Sutton 1973
G. M. Sugana and Denys Sutton. *The Complete Paintings of Toulouse-Lautrec.* London, 1973.

Sutton 1962
Denys Sutton. *Lautrec.* London, 1962.

Toulouse-Lautrec 1932
Henri Toulouse-Lautrec. Au cirque, II. Dix-sept dessins aux crayons de couleur. Paris, 1932.

Toulouse-Lautrec 1952
Toulouse Lautrec: Au cirque. Thirty-nine Crayon Drawings in Color. Monte Carlo, 1952.

Town and Country 1946
Town and Country 100 (November 1946): 109.

Wolf 1946
Ben Wolf. "The Art and Times of Toulouse-Lautrec: Misshapen Genius." *Art Digest* 21 (November 1, 1946): 9.

Exhibitions

Albi-Paris 1964
Centenaire de Toulouse-Lautrec. Palais de la Berbie, Albi, June–September 1964; Petit Palais, Paris, October–December 1964.

Boston–New York 1991
Pleasures of Paris: Daumier to Picasso. Museum of Fine Arts, Boston, June 5–September 1, 1991; IBM Gallery of Science and Art, New York, October 15–December 28, 1991.

Chicago 1979
Toulouse-Lautrec: Paintings, The Art Institute of Chicago, October 6–December 2, 1979.

Los Angeles 1959
Henri de Toulouse-Lautrec, Los Angeles Municipal Museum of Art, May 27–June 28, 1959.

New Orleans 1953–54
Masterpieces of French Painting through Five Centuries, 1400–1900, in Honor of the 150th Anniversary of the Louisiana Purchase. Isaac Delgado Museum of Art, New Orleans, October 17, 1953–January 10, 1954.

New York 1946
A Loan Exhibition of Toulouse-Lautrec, for the Benefit of the Goddard Neighborhood Center. Wildenstein and Co., New York, October 23–November 23, 1946.

New York 1947
Summer Exhibition. Wildenstein and Co., New York, 1947.

New York 1948
French Portraits of the Nineteenth Century. Wildenstein and Co., New York, Summer 1948.

New York 1956
Toulouse-Lautrec: Paintings, Drawings, Posters, and Lithographs. The Museum of Modern Art, New York, March 20–May 6, 1956.

New York 1964
Toulouse-Lautrec, for the Benefit of the Citizens' Committee for Children of New York. Wildenstein and Co., New York, February 5–March 14, 1964.

New York 1965
Olympia's Progeny, for the Benefit of the Association for Mentally Ill Children. Wildenstein and Co., New York, October 28–November 27, 1965.

New York 1966
Summer Loan Exhibition: Paintings, Drawings, and Sculpture from Private Collections. The Metropolitan Museum of Art, New York, Summer 1966.

New York 1970
One Hundred Years of Impressionism: A Tribute to Durand-Ruel, for the Benefit of the New York University Art Collection. Wildenstein and Co., New York, April 2–May 9, 1970.

New York 1972
Faces from the World of Impressionism and Post-Impressionism. Wildenstein and Co., New York, November 2–December 9, 1972.

New York 1979
In Celebration of Drawing. Paul Rosenberg and Co., New York, October 24–November 24, 1979.

New York–Waltham 1962
Modern French Painting. Wildenstein and Co., New York, April 11–April 25, 1962; Rose Art Museum, Brandeis University, Waltham, Massachsetts, May 10–June 13, 1962.

Palm Beach 1957
Paintings and Prints by Henri de Toulouse-Lautrec, 1864–1901. The Society of the Four Arts, Palm Beach, Florida, March 15–April 7, 1957.

Paris 1902
Exposition Toulouse-Lautrec. Galerie Durand-Ruel, Paris, 1902.

Paris 1914
Exposition retrospective de l'oeuvre de H. de Toulouse-Lautrec. Galerie Manzi-Joyant, Paris, June 15–July 11, 1914.

Paris 1931
Exposition H. de Toulouse-Lautrec. Musée des Arts Décoratifs, Palais du Louvre, Paris, April 9–May 17, 1931.

Philadelphia-Chicago 1955–56
Toulouse Lautrec. Philadelphia Museum of Art, October 29–December 11, 1955; The Art Institute of Chicago, January 2–February 15, 1956.

Pittsburgh 1947
Paintings, Drawings, Prints, and Posters by Henri Toulouse-Lautrec, 1864–1901. The Museum of Art, Carnegie Institute, Pittsburgh, March 6–20 April 1947.

MAURICE UTRILLO
Literature
Pétridès 1959
Paul Pétridès. *L'Oeuvre complet de Maurice Utrillo.* 2 vols. Paris, 1959.

Werner 1952
Alfred Werner. *Maurice Utrillo.* New York, 1952.

Werner 1981
Alfred Werner. *Maurice Utrillo.* New York, 1981.

Exhibitions
Chicago 1941
Twentieth International Exhibition of Watercolors. The Art Institute of Chicago, 1941.

New York 1955
Paintings from Private Collections. The Museum of Modern Art, New York, May 31–September 6, 1955.

New York 1957
Maurice Utrillo, for the Benefit of Hadassah Medical Relief Association. Wildenstein and Co., New York, January 24–March 2, 1957.

Pittsburgh 1963
Paintings by Maurice Utrillo. The Museum of Art, Carnegie Institute, Pittsburgh, October 18–December 1, 1963.

Washington, D.C., 1953–54
Early Paintings by Maurice Utrillo. The Phillips Gallery, Washington, D.C., December 6, 1953–January 11, 1954.

WOLS
Literature
Cardinal 1978
Roger Cardinal. "The Later Works of Wols: Abstraction, Transparence. Tao." In Peter Inch, ed., *Circus Wols: The Life and Work of Wolfgang Schultz.* London, 1978.

Zürich 1989
Wols: Bilder, Aquarelle, Zeichnungen, Photographien, Druckgraphik. Exh. cat. Kunsthaus Zürich, 1989.

WILLIAM ZORACH
Literature
Wingert 1938
Paul S. Wingert. *The Sculpture of William Zorach.* New York and Chicago, 1938.

Exhibition
Newark 1984–85
American Bronze Sculpture, 1850 to the Present. The Newark Museum, October 18, 1984–February 3, 1985.

Index

Page numbers in *italics* indicate illustrations

Produced by Perpetua Press, Los Angeles

Edited by Letitia O'Connor and Fronia Simpson

Designed by Dana Levy

Typeset in Adobe Garamond on a Macintosh II Computer using Pagemaker 5.0

Indexed by Academic Indexing Service, Berkeley

Printed by La Cromolito, Milano